THOMSON

COURSE TECHNOLOGY

Professional ■ Technical ■ Reference

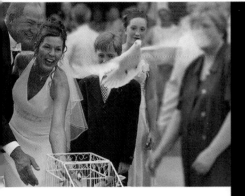

MASTERING

Digital

Wedding

Photography

A Complete
and Practical Guide
to Digital Wedding
Photography

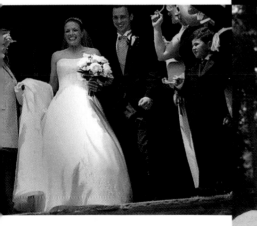

James Karney

Featuring photographs contributed by
Mark Ridout and TriCoast Photographers
Mike Fulton and Cody Clinton

Important: Thomson Course Technology PTR cannot provide software support. Please contact the appropriate software manufacturer's technical support line or Web site for assistance.

Thomson Course Technology PTR and the author have attempted throughout this book to distinguish proprietary trademarks from descriptive terms by following the capitalization style used by the manufacturer.

Information contained in this book has been obtained by Thomson Course Technology PTR from sources believed to be reliable. However, because of the possibility of human or mechanical error by our sources, Thomson Course Technology PTR, or others, the Publisher does not guarantee the accuracy, adequacy, or completeness of any information and is not responsible for any errors or omissions or the results obtained from use of such information. Readers should be particularly aware of the fact that the Internet is an ever-changing entity. Some facts may have changed since this book went to press.

Educational facilities, companies, and organizations interested in multiple copies or licensing of this book should contact the Publisher for quantity discount information. Training manuals, CD-ROMs, and portions of this book are also available individually or can be tailored for specific needs.

ISBN-10: 1-59863-329-5

ISBN-13: 978-1-59863-329-0

Library of Congress Catalog Card Number: 2006909691

Printed in the United States of America

07 08 09 10 11 BU 10 9 8 7 6 5 4 3 2

Publisher and General Manager, Thomson Course Technology PTR:
Stacy L. Hiquet

Associate Director of Marketing:
Sarah O'Donnell

Manager of Editorial Services:
Heather Talbot

Marketing Manager:
Heather Hurley

Acquisitions Editor:
Megan Belanger

Marketing Assistant:
Adena Flitt

Project Editor:
Jenny Davidson

Copy Editor/Technical Reviewer:
Bud Paulding

PTR Editorial Services Coordinator:
Erin Johnson

Interior Layout Tech:
Bill Hartman

Cover Designer:
Mike Tanamachi

Indexer:
Lalia Wilson

Proofreader:
Kim V. Benbow

THOMSON

COURSE TECHNOLOGY

Professional ■ Technical ■ Reference

Thomson Course Technology PTR, a division of Thomson Course Technology
25 Thomson Place ■ Boston, MA 02210 ■ http://www.courseptr.com

To the memory of Jake Rotello, fellow Marine, and the photographer and mentor who introduced me to the wedding business.

Semper Fidelis

About the Author

James Karney has a unique viewpoint on wedding photography developed through 30 years as an award-winning professional photographer and teacher. He started as a wedding apprentice in high school and has covered weddings full- and part-time over three decades. He developed and taught the 18-month photography certificate program at South Georgia Tech.

He is an accomplished computer journalist, whose work has appeared in *PC Magazine*, *Windows Magazine*, *Computer Shopper*, and *Internet World*. His books include the Golden-Lee bestseller *Upgrade and Maintain Your PC*, *The Power of CorelDRAW*, and the Microsoft Press *Training Kit for A+ Certification*.

He is a graduate of the US Navy Photographic School, and holds a bachelor's degree in communications from Excelsior College as well as a master of science in computer technology from Nova Southeastern University.

Foreword

This book you hold in your hands is going to rock your world. It is intended as a creative companion for those who possess a passion for extraordinary wedding photography. Whether you are just delving into this fascinating and emotional aspect of photography, or you have already been bitten by the incurable bug that drives us toward creating richer, more romantic, and artistic masterpieces, this book will open your eyes to so many possibilities and ways of creative expression.

It is my belief that we make great strides in our creativity by beginning with small steps.

When starting my career, I was truly amazed at how hard and challenging wedding photography really was. It was hit or miss. You either capture the moment or miss it entirely. I've met many photographers taking on their first weddings who lack the basic fundamental skills to be able to react to the moment, assess their surroundings, and achieve the perfect look for a once-in-a-lifetime moment. This is why I'm passionate about teaching and sharing my knowledge, to help others go from tiny beginner steps to jumping into the fast-paced world of wedding photography, armed with the concepts and skills necessary to express your artistic abilities and capture amazingly beautiful images.

My talented business partner, Cody Clinton, and I each shared a vision of honing our skills and bringing our love of fashion and glamour photography to the international wedding arena. TriCoast Photography is a realization of those dreams. With ever-increasing popularity, our successful business has allowed us the freedom to share our knowledge and accomplishments with others. We are honored to have our work and our fresh and fun techniques showcased in this publication, along with many other talented individuals. Mr. James Karney, your author, has used his amazing insights to bring this book to life and we commend him for his achievements and success.

I sincerely hope that one page at a time, one technique at a time, you will become more and more familiar with your own creative strengths and truly master the art of digital wedding photography.

Now, let's rock your world!

Mike Fulton
The "Willy Wonka" of Wedding Photography
TriCoast Photography
www.TriCoastPhoto.com

Acknowledgments

It always amazes me that a book ever gets published, and few would without the support of friends and the skills of a professional staff. This one is no exception.

Thanks to my fellow photographers Mark Ridout, Mike Fulton, Cody Clinton, Nikki McLeod, Rudy Pollak, Dave Maynard, and Rose Mary Lalonde for the great images, and conversations (the best over a beer) on photographic techniques and philosophy.

Examining and commenting on your fantastic images has moved me to work even harder on my own skills. I owe you the next round. The same is true for my son Terry, an accomplished photographer, who helped keep the focus of the book on the reader. Thanks also to my younger children: Shannon, Arwyn, and Rhyannon. They helped clear a tired mind with smiles and hugs during long days of writing.

My long-time friend and often editor, Bud Paulding, brought his dedication, attention to detail, and insightful comments on content and style. Bud is a true Wordsmith, and superbly handled both copy and technical editing, as he has done several times before. Bud also assembled Appendix B. Once again, you have done an outstanding job. Thanks to Lalia Wilson, who ably handled the indexing, thankfully with a much easier timetable than on our last project.

Megan Belanger and Stacy Hiquet at Thomson oversaw the project. Megan may have gotten less sleep than her author, thanks to the birth of her first child during the project. They both are very professional women whose wisdom in the ways of publishing helped guide the team to success. Thanks also to Jenny Davidson, our project editor, and to Bill Hartman and the design team at Thomson. A special thank you note to Heather Hurley, for her rush job to get out advance posters and flyers in time for the workshop following the WPPI convention. A final note of thanks to my agent, Dr. Neil Salkind, and the staff of Studio B for their support on this project.

Contents

Chapter 3
Equipment Matters 25

Chapter 4
It Is *Digital* Photography—Computers
and Software 51

Chapter 5
The Wedding Photographer and the Web 75

PART II
PHOTOGRAPHY 169

Chapter 9
The Big Day: Photographing More Than
Just a Wedding 171

Chapter 10
Photographing the Main Event 189

Chapter 11
Making the Formals Creative and Fun 207

Chapter 12
The Other Wedding Party—Covering the
Reception 221

PART III
PRODUCTION . 241

Chapter 13
After the Wedding—All Those Pictures! 243

Chapter 14
Images into Pictures—The Art of Image
Processing 261

Chapter 15
Crafting the Image 289

Chapter 16
Proofing, Selling, and Printing 317

Chapter 17
Multimedia Marriages, DVDs, and the
Electronic Album 341

Chapter 18
Albums Demystified 369

Chapter 19
After the Honeymoon 401

Index 405

Introduction

Why This Book

Welcome to *Mastering Digital Wedding Photography*, a practical guide to the art, craft, and business. Perhaps you are just beginning a photographic career, or you may be a seasoned professional planning to add weddings to your assignment list or a film photographer making the change to digital. This book was written with all of you in mind. This book covers the entire endeavor, from setting up shop and choosing gear, through the event, to keeping the clients happy and having them refer new customers after their prints are delivered.

The only assumptions made about the reader are as follows: an avid interest in wedding photography, a familiarity with cameras and computers, and the desire to learn more about all three topics. It has been designed to offer a good foundation for the novice at covering weddings and the information needed to make the transition from film to digital for the newly converted.

It goes beyond the basics. I've had the help of some really outstanding wedding photographers who have contributed both images and insights into their style of work and photographic vision. Their images are based on years of experience on how to gauge exposure, see and use lighting, pose subjects, and play with the image once it is captured.

There is one important fact to keep in mind whenever photographers discuss style, technique, and the art of our profession. There are only two people that really have to be pleased by the final product—the client and the photographer. Styles change (and vary widely by location and with age), and artistic sensitivity is a personal matter. If you and the client are happy with the pictures, you are doing a good job. Of course, there is always room for improvement.

Also take note that the workflow is based mostly on one photographer's way of doing things, and using his software library. I tend to use a variety of tools, relegating Photoshop to a supporting role. When showing my workflow, I've focused on the task and the techniques more than the tools. Other very successful photographers use other products; some use Photoshop alone. Experiment with your workflow; photography software is constantly changing—most of the time for the better.

I've been covering weddings since my days as a studio apprentice in high school. For over 30 years as a professional, weddings have always been a part of my income and passion. When I made the transition from film in 2002, it seemed simple. Big-name cameras worked with my existing film lenses and offered familiar controls, Adobe Photoshop was already on my computer, and all the other required photographic equipment (strobes, meters, etc.) still worked the same. And I had the advantage of ready access to expert advice and software updates as a computer book author and frequent contributor to *PC Magazine*. How hard could it be?

Well, this new medium requires a different shooting style from film to get the most from the technology. The digital sensor is not film. It responds to light differently and is much more sensitive to white balance and color temperature variations. There may be magnification ratios to consider, which turn a normal 50mm lens into a mild telephoto due to a smaller image area compared to 35mm film. The early cameras had small buffers which made precisely timing a shot, like the bouquet toss, imperative.

The initial joy of instant feedback from the camera and the power of computer editing gave way to shock, with the realization of the increased level of effort required by workflow issues and file management demands, resulting from the mass of images taken at each wedding. In the days of roll film, we took perhaps 200 pictures; with digital, a two-photographer wedding can easily capture five times that number of exposures. Multiply that by, say, 20 weddings a year, and you'd better have a management system—if you want to find a specific file.

The productivity and workflow issues require more attention as well. It's one thing to take 15 or 20 minutes (or maybe a day) editing and playing with a really fine image for fun, but multiply that by a hundred or so, and even a big wedding fee becomes "slave wages" fast. And that's only one aspect of change. Printed proofs are becoming an endangered species, and the proof book album with them. That's because it's too easy for clients to scan and pirate the images. Enter online proofing and DVD-based slideshows. Masked albums have given way to digitally created flush-mount designs and short-run four-color-press books.

The market is still shifting. We are in the third phase of a revolution. The technology is mature enough to rival film, and now the best photographers are raising client expectations with outstanding work. While much of the basic event coverage is the same, the style has shifted to a more fashion-magazine style, accompanied by sophisticated DVD multimedia shows.

With all of this activity in the profession, the shelves in bookstores lacked a comprehensive guide. So, with a combination of my personal experience and the help of several friends who are masters in their own right, this project was born.

How to Use This Book

This book is both a guide and a resource. The material is designed to meet the needs of the newcomer to wedding photography, those making the transition from film to digital, and photographers wanting to improve their trade and style. For the total newcomer, a front-to-back reading will probably work best. Those with experience can pick and choose the order to suit their needs.

Keep in mind that the practice is still a matter of individual style and personal preference, both yours and the clients'. While the methods work, most should be adapted to suit personal taste and the wishes of the person paying for the services. The products and vendors mentioned are the ones I have found valuable. There are competitors, and such things are a matter of personal taste and temperament.

The following chapters proceed in order through the entire domain of wedding photography from drawing up a business plan and acquiring tools, through developing photographic skills and covering weddings, and on to the processing of images and designing of albums and multimedia productions.

Part I—Preparation

Part I is an overview and brief survey of wedding photography, with emphasis on the changing technical and stylistic trends in the market. This part also includes coverage of the business aspect of wedding photography.

Chapter 1: The Once and Future Wedding Photographer

In some ways, the profession of wedding photographer has changed little in the last half-century. It still requires solid technical skills: the ability to choose the proper exposure, work with different kinds of lighting, and to take excellent pictures under pressure.

Today, images and album designs by accomplished wedding photographers are much closer to the style and polish found in high-end fashion and travel magazines than the traditional albums of the '60s and '70s, or even the photojournalist movement of the '80s and '90s. Proof books have given way to online galleries, eCommerce shopping carts, and high-definition DVD multimedia productions. The Internet lets us market our services around the globe. To succeed and grow profits, or to even stay competitive, modern wedding photographers need a solid business plan and good marketing skills just as much as skills with the camera and the computer.

Chapter 2: Business First

The diverse nature of today's wedding market requires good business practices and proper planning. This chapter details the process of defining the local market, developing a successful business model, and gathering the required resources.

Chapter 3: Equipment Matters

Photography is an equipment-intensive profession. This chapter covers choosing the right photographic gear, and how to buy it wisely. Weddings are not the kind of assignment you can re-shoot if something goes wrong, so there are also tips on back-ups and proper care and storage of the tools.

Chapter 4: It Is *Digital* Photography—Computers and Software

Both at the event and back in the studio, computer technology plays a major part in the successful wedding assignment. This chapter covers the bits and bytes—assembling a computer system and a software library.

Chapter 5: The Wedding Photographer and the Web

The Internet has become an essential marketing and customer service tool for any professional photographer. That goes double if you do weddings. This chapter covers site options, designing your own or commissioning an artist, choosing a provider, and the all-but-settled debate of Flash or HTML.

Chapter 6: Preliminaries: Booking the Event

A wedding booking is a lot like a car deal. There is rarely a fixed price. Even with packages there are always options. For the client it is a big ticket item (often one of the most expensive elements of the event), and the buyer is looking for high quality at the lowest price. Good booking skills make for bigger profits and happier clients, and this chapter provides the details of the process.

Chapter 7: Getting Ready for the Big Day

Weddings are a chaotic event, with a host of players. The photographer must show up ready to work and be able to function no matter what difficulties arise. This chapter covers the steps required to make sure both the equipment and photographer are ready.

Chapter 8: Photographic Technique: The Gateway to Style

Covering a wedding requires the reporting skills of a photojournalist, the action-capturing abilities of a sports photographer, and the posing and lighting skills of a portrait photographer. We have to manage a crowd, shoot moving subjects, and capture the emotions of the day. It calls for working fast, yet with a professional touch. This chapter explains camera and lighting techniques used in wedding photography, and how to develop and hone your skills.

Part II—Photography

Chapters 9 through 12 focus on photographing the entire wedding event.

Chapter 9: The Big Day: Photographing More Than Just a Wedding

While every wedding day is unique, virtually all include the same basic elements. This chapter walks the reader through the event step-by-step and shows how to capture images that really convey the feeling of *this* wedding in a way that will please the client and provide the pictures needed to create a polished album. It also shows how to make the best use of the time before the ceremony to obtain pictures with a special touch.

Chapter 10: Photographing the Main Event

When the bride starts down the aisle, the photographer shifts into the mode of a true photojournalist, telling the story without the ability to direct events. This chapter focuses on how to be in the right place at the right time, and work with the tools of location, timing, perspective, and available light.

Chapter 11: Making the Formals Creative and Fun

Weddings are one of the few times when extended families are together. Formals and groups are often a change of pace between the wedding and the reception. They often have to be taken quickly, so that the bride, groom, and their honored guests can be at the party on time. This chapter deals with posing, crowd management, and getting images that show style and the personalities of the subjects.

Chapter 12: The Other Wedding Party—Covering the Reception

After the wedding comes the party, but little respite for the busy photographer. There is much to do as the couple dine, toast, dance, cut cake, and often cut up for the camera. There are also the challenges of the bouquet and garter tosses to manage before the couple makes the grand exit and the event comes to a close.

Part III—Production

Chapters 13 through 19 cover the post-wedding realm: processing and workflow, from digital asset management through processing and imaging, and on to album design and slideshow production.

Chapter 13: After the Wedding—All Those Pictures!

The rice and birdseed are thrown, the doves flown home, and the bride and groom are safely off on the honeymoon. The photographer may have over 1,000 images to process and proof. With the right workflow and software, the images can be on the Internet in a couple of days. This chapter covers digital asset management and getting the pictures culled and ready for proofing.

Chapter 14: Images into Pictures—The Art of Image Processing

While some wedding photographers capture images as JPEGs, most take advantage of the extra control and editing capability of their camera's native RAW format. Here we look at how to use RAW editors to speed workflow, proofing, and perform primary processing tasks.

Chapter 15: Crafting the Image

With good shooting and processing, most images are ready for proofing. The best images, those that will be showcased in the album, a portfolio, or be printed for display, deserve special attention. All files sent to a printer or lab have to be color calibrated to ensure the color and exposure are the same on paper as on the screen. This chapter shows how to design an effective imaging workflow and the basics of effective retouching.

Chapter 16: Proofing, Selling, and Printing

Some photographers still provide paper proofs, but there are better ways. This chapter demonstrates how to handle paper proofs, and then shows how online and DVD presentations can cut costs, protect against image theft, and result in more profits.

Chapter 17: Multimedia Marriages, DVDs, and the Electronic Album

Proofing is only one way multimedia is used in wedding photography. High quality productions are gaining popularity with both clients and photographers. In fact, that's the way Mark Ridout delivers all his work, using the same program we will here—Photodex ProShow Producer.

Chapter 18: Albums Demystified

The traditional wedding album, a leather-bound collection of prints, has given way to custom layouts resembling magazine coverage of major events. These new flush-mount products offer a new service that lets the photographer provide more pictures at lower cost with greater profits. The trick is in keeping production time and expense to a minimum. This chapter shows how it's done.

Chapter 19: After the Honeymoon

Smart photographers don't consider delivering the prints and album the end of the arrangement with the new couple. Most brides have a wedding party with at least one prospective bride—a potential client. The bride and groom will need portraits of their growing family before long. This chapter covers marketing and follow-up guidelines, as well as archiving suggestions.

We've included two bonus appendices on the book's companion website. You can find them at www.courseptr.com/downloads. Enter the name of the book and you will be directed to the files.

Appendix A: Resource Guide

We mention quite a few favorite programs, photographic tools, business vendors, and helpful organizations in our discussions. The resource guide is a ready reference with contact information and personal notes on some of the listings.

Appendix B: Color Calibration

Proper color calibration and accurate white balance are critical factors in professional digital photography. This primer, provided by DisplayMate Technologies founder Dr. Raymond Soneira, covers the technical details in depth and dispels many of the myths on the subject.

About the Contributors

Three dedicated wedding photographers: Ontario-based Canadian Mark Ridout and TriCoast Photography Texans Mike Fulton and Cody Clinton have joined with me to provide most of the photographs that brighten these pages. Mark, Mike, and Cody are also active on the photographic workshop circuits, and we are considering joining forces for a combined short-course road show when our combined schedules permit. Here are short biographies on each of us.

James Karney

James Karney has a unique viewpoint on wedding photography developed through many years as an award-winning professional photographer and teacher. He started his career as a wedding apprentice in high school and has covered weddings full- and part-time for over three decades. He also served as a Marine Corps photographer, newspaper photojournalist, medical photographer, and developed and taught the 18-month photography certificate program at South Georgia Tech.

He is an accomplished computer writer, whose work has appeared in *PC Magazine*, *Windows Magazine*, *Computer Shopper*, and *Internet World*. His books include the Golden-Lee bestseller *Upgrade and Maintain Your PC*, *Discovering LightZone*, *The Power of CorelDRAW*, and the Microsoft Press *Training Kit for A+ Certification*.

He is a graduate of the US Navy Photographic School, and holds a bachelor's degree with emphasis in communications from Excelsior College as well as a master of science in computer technology from Nova Southeastern University.

Mike Fulton

Born and raised just south of Houston in Brazoria County, Mike Fulton started his career in photography as teenager with his father's camera. The hobby continued through his high school years and into college while studying criminal justice. His passion for the art of photography grew, and he made the switch to professional shortly after graduating. Starting his photography work in fashion and glamour, Mike soon found his work being displayed in publications ranging from art magazines to calendars.

After a short tour in the motion picture industry, he found his true passion in wedding photography. His work blends his love for fashion and glamour with an eye for capturing the beauty of the wedding day with an editorial flair. Mike is an instructor with Photography Allstars, a high-quality one-on-one mentoring website; he also teaches his own Illuminations Workshop, which specializes in wireless flash and video light techniques. He offers a variety of editing tools and learning materials at www.findingcolor.com, with his business partner Cody Clinton.

Cody Clinton

Cody is another native of the Texas gulf coast. Like Mike, his love for photography began at a young age, and he began developing his skills photographing friends and co-workers at local sporting events, family reunions, and his true passion, weddings. He uses his high energy and artistic personal style and uniqueness to create special moments for the brides, grooms, and their family and friends.

Mark Ridout

Mark Ridout is a creative photographer (with a very wry sense of humor) whose expertise extends to a range of mediums and formats. He has worked as a photojournalist for major newspapers and magazines, with major advertising agencies on corporate accounts, and on special assignments for corporate clients in the United States, France, England, Cuba, the Dominican Republic, and locations throughout his native Canada.

He has an aptitude for staging exceptional posed compositions as well as putting people at ease for more informal style portraits. Mark has photographed Richard Petty for STP, Al Jarreau, Sheila E, and sipped champagne from the Stanley Cup after photographing it for a New York Rangers hockey player. His wedding business started with a couple of weddings a year and has now grown to over 20 weddings per year. He is a frequent speaker at workshops and trade shows. For more information on his schedule and an excellent Photodex ProShow tutorial DVD, check out www.ridoutphotography.com. (As you do, remember the remark about a wry sense of humor.)

And with a bit of help from Dr. Raymond Soneira, Nikki McLeod, Rudy Pollak, David Maynard, Cliff Mautner, and Rose Mary Lalonde

Ray Soneira is a great resource when it comes to the technical details of using color with computers. He generously contributed the information in Appendix B with the same grace and enjoyable conversation as he has offered over the years when I called with questions on other projects.

Nikki McLeod is our token native Scot. She lives and operates a full-service studio in South West Fife and works on location throughout Britain. Her wedding photography tends to images replete with grooms in kilts and bridal portraits that include the Scottish landscape. She provided a break from men in tuxedos and insight into the wedding market in Great Britain.

Rudy Pollak is the resident technical expert at Classic Albums. A former wedding photographer, he provided the product pictures in Chapter 18 and offered insights on how to streamline the album submission process.

Cliff Mautner shared images of his website along with insights into his wedding photography philosophy and style.

Dave Maynard came through on short notice to provide the product picture of the Expodisc that appears in Chapter 8 and insight on his experiences training new apprentices and assistants as they learned to cover weddings. Rose Mary Lalonde kindly allowed us to use her image of a bridal couple from her Sharing page on the Photodex website.

Now that we have all been properly introduced, sit back and enjoy the conversation. But keep your camera and imagination handy while reading, and be prepared to join in.

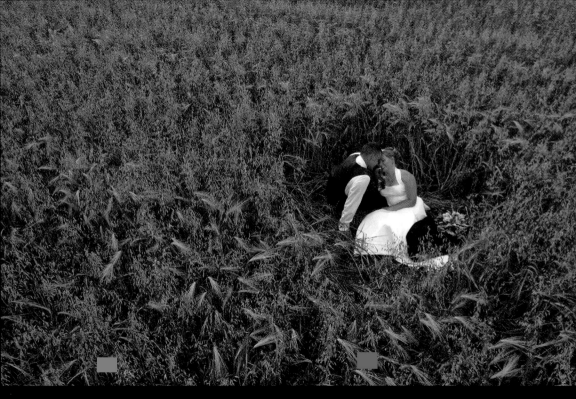

Photograph by Mark Ridout

Part I

Preparation

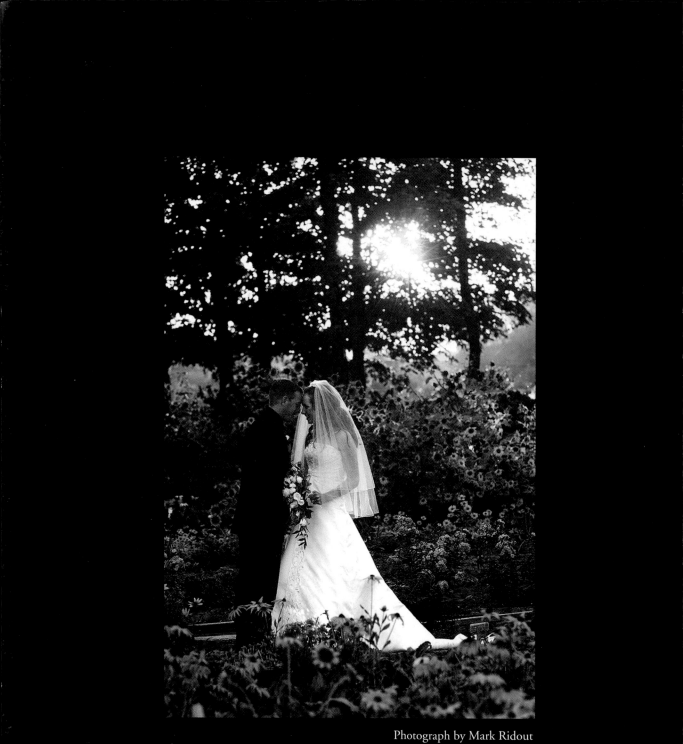

Photograph by Mark Ridout

1

The Once and Future Wedding Photographer

To a guest in the audience, a wedding looks like a quiet and well-ordered event. Family and friends gather, the groom waits at the altar while the bride makes a grand entrance. Then the couple exchanges vows, they kiss, and the assembly retires to enjoy the reception party. There are variations. Different cultures and religions have their own special traditions. Some weddings are big, some small; some are in a big church with rituals, others in a living room, or a beautiful outdoor setting with just a few words.

Throughout the entire event, there is usually one person present whose job is to be constantly busy, carefully observing every detail, with the knowledge that there is no room for error or omission—the photographer. To him or her, the event is a non-stop quest for images that tell the story of the day, to capture the special moments and tender emotions. There is the need to be alternatingly unobtrusive and in charge, to change pace at a moment's notice—and to always be in the right place at the right time (see Figure 1.1).

Something Old

In some ways, the profession of wedding photography has changed little in the last half-century. It still requires solid technical skills: the ability to choose the proper exposure, work with different kinds of lighting, and to take excellent pictures under pressure.

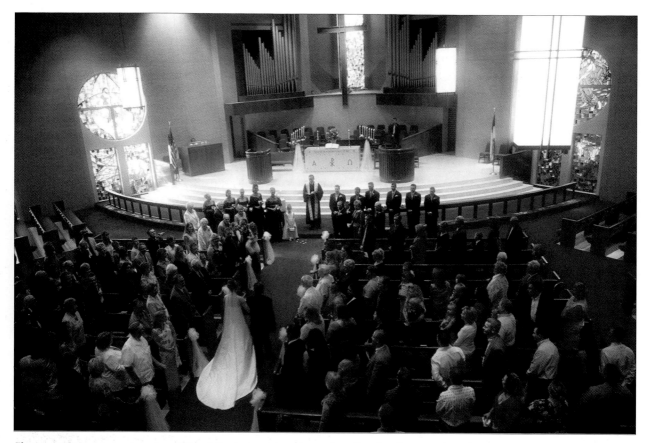

Figure 1.1 Weddings are quiet affairs, full of meaning and emotion. For the photographer, they are a time of constant motion in the quest for compelling pictures. (Image by TriCoast Photography)

It still requires good people skills, and the ability to seamlessly enter into the couple's joy and the day's celebration. The photographer must deal with nervous brides and grooms, shy friends and children, demanding parents and wedding planners, and tired wedding party members, always engaging them to cooperate in the creative process. Finally, the job requires stamina, the ability to keep going for hours while lugging camera gear, and mentally staying sharp.

For many portrait studios, newspaper photographers, and part-time professionals, weddings have long been a seasonal income source. Many full-time professionals gained valuable experience working as second shooters; there are few assignments that have as many demands as covering a wedding.

From the early 1960s until the 1980s, most photographers used medium-format cameras, and during the average wedding, would take from 40 to 80 pictures. The pictures generally followed the same sequence, and the results from one event looked much like another. Most couples purchased a leather album containing a predicable collection of matted prints.

Then, in the 1980s the 35mm camera started making its way into the wedding market, complete with motor drive and high-quality zoom lenses. These photographers, and their clients, traded the "cleaner" results provided by a larger negative for a more spontaneous result. The pictures looked less formal. A more photojournalistic style started to show up in proof books and albums. The market began to change.

Something New

The pace of change accelerated with the arrival of professional quality DSLRs (Digital Single Lens Reflex) cameras and advanced editing programs like Adobe Photoshop. The grainy look of 35mm is gone (except as a special effect). But that is only part of the story. The revolution is still moving far beyond the original horizon, powered by photographers' creativity and the power of imaging technology and an ever-increasing array of new tools and toys.

In some ways, the revolution has come full circle. In the 1950s, most studios used 4x5 black and white sheet film, and did their own developing, printing, and retouching. The new "lab" is now the computer, black and white is making an artistic comeback, and many photographers use several software programs to process, enhance, design, and manage their work. Exotic and antique techniques,

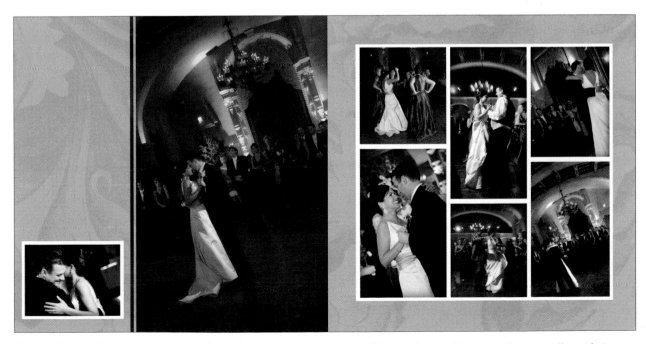

Figure 1.2 Excellent digital photography and image enhancement, a sophisticated editorial style, and custom album design are part and parcel of today's up-scale wedding market. (Images and page layout by TriCoast Photography)

including infrared, split-toning, canvas, and custom-textured papers are part of our repertoire.

Today, images and album designs by accomplished wedding photographers are much closer to the style and polish found in high-end fashion and travel magazines than the traditional albums of the 60s and 70s, or even the photojournalist movement of the 80s and 90s. Proof books have given way to online galleries, eCommerce shopping carts, and high-definition DVD multimedia productions. The Internet lets us market our services around the globe.

Digital cameras free us from the cost of film, letting us shoot far more images. Instant feedback on an LCD panel makes it safer to try risky exposures and

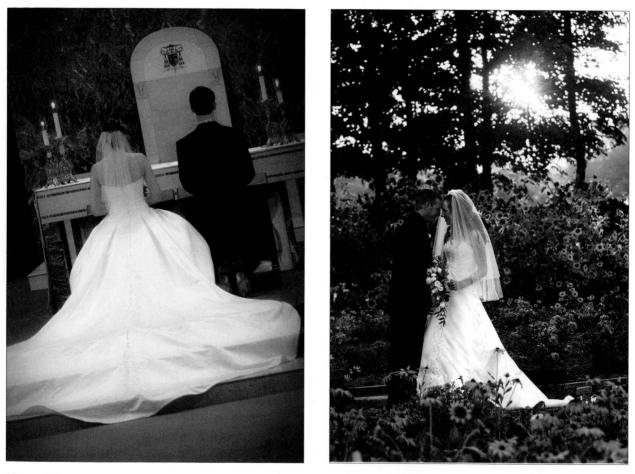

Figure 1.3 Black and white, toned prints, and textured papers are once again regular product offerings to clients, thanks to digital technology and editing software. (Photography by TriCoast Photography)

Figure 1.4 Wedding photography demands excellent photographic skills and the ability to work with light and color; add to that an expert hand with editing software and an understanding of the final presentation media. (Photograph by Mark Ridout)

experiment with more daring poses. Wireless-controlled multiple remote compact flash units allow use of elaborate (and precise) lighting that once required a studio setting.

We can even offer slideshows of the day's photographs at the reception—even pictures taken *at* the reception. Advanced editing software lets us enhance and polish images, retouch, add special effects, and (for the skilled practitioner) produce stunning pictures. New album products and four-color presses can turn files into heirloom coffee-table books.

But It's Not Just Tools

Film or digital, the camera only records the image. It is the photographer's skill and creativity that brings it to life. Quality work still requires the same basic camera skills needed in 1980 with a film SLR, in 1960 with a medium format camera, and before that with a view camera.

Darkroom skills are being replaced by knowledge of editing software and the pressure-sensitive tablet. The need to learn new software seems unending. Just as in the days of film, some photographers do all the work themselves. They process the RAW files, do the retouching, design the albums, produce the slideshows, and even manage their own websites. Others focus on the photography itself, and outsource some or all of the production and business aspects.

It Is a Business

Weddings are big business. High-end packages from well-known photographers command prices of $5,000 and up, depending on the services and products provided. That's before the travel expenses. As I write this, Mark Ridout is with a client in Jamaica, while Mike Fulton and Cody Clinton are packing for an assignment in Kenya.

Of course, most brides get married closer to home, and many are on a more limited budget. Even there, it's a busy market. In medium-sized towns, a semi-annual bridal fair can draw over 2,500 determined brides. According to the producer of the show, that was only 10 percent of the market. Clients often start shopping for a photographer well over a year in advance. In fact, the photographer is often the first thing on their shopping lists. Several brides asked for suggestions about where to hold their weddings as they booked my services last year.

At a recent industry networking event at a posh country club, in that same medium-sized town, over 80 vendors showed up to meet and greet. The group included representatives from restaurants, wedding chapels, caterers, limousine services, travel agents, hair salons, makeup artists, bakers, purveyors of custom

chocolates, wedding planners, and videographers. Almost half the group were photographers.

There has never been a time in wedding photography with as much competition for clients as today. Brides are comparison shopping for price, style, products, and service. The Internet makes it easy to find vendors, see their work, and compare rates. To succeed and grow profits, to even stay competitive, modern wedding photographers need a solid business plan and good marketing just as much as skills with the camera and the computer.

It takes time, practice, and dedication to develop a solid wedding photography practice. The word *practice* is deliberate. As Gene Smith said, the goal is always ahead on the horizon. It is learned by doing.

The first solo wedding is much like the first time flying a plane alone. You are out there all by yourself, and nothing can save you from disaster but your own skill. Mine was just before my seventeenth birthday, after assisting at a dozen weddings

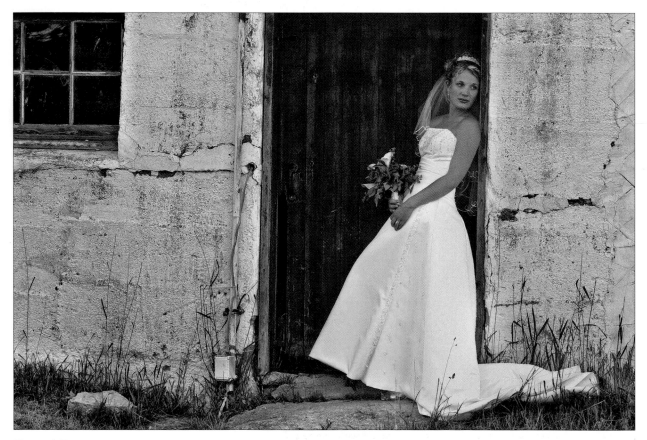

Figure 1.5 Proper perspective and good business skills are just as important to success as good photography and composition. (Image by Mark Ridout)

in the preceding year. The studio had three weddings that Saturday. Jake, my mentor, gave me the smallest. The bride and groom had just graduated from high school, the minister from a three-year bible school. (He had done fewer weddings than I had.) They were asking me for advice.

It's not a good idea to solo without a solid foundation. Basic picture taking, and some wedding coverage skills can be honed with other types of photography, and with formal training and workshops. Only the actual event can train the eye and give a sense of the flow of the wedding day. Many photographers start with a friend's wedding, or assist an established photographer to gain experience and develop confidence, before accepting a paying client.

The ability to record a wedding event is just the beginning. It takes time to develop a personal style. Even the busiest wedding photographers only cover 20 to 30

Figure 1.6 Today's wedding photographer is not limited to one style or look, and can move well beyond the traditional "list" when setting up an image. Consider this bold, glamorous high-key rendition by Mark Ridout. It would fit right in on the pages of a high-class fashion magazine. Then compare it with Figure 1.7.

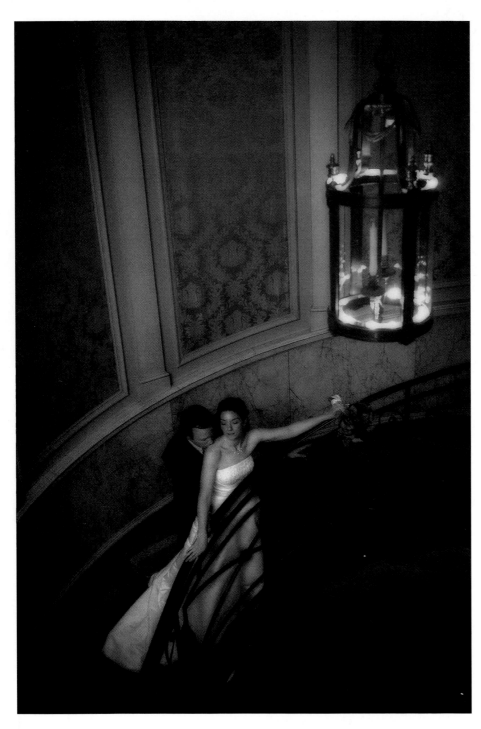

Figure 1.7 The only element of style that this picture shares with Figure 1.6 is the excellent skill with which it is executed. Here his treatment is a dark and rich low-key effect. The feel and sweep of the composition is more that of a fine painting.

events each year. They spend much more time dealing with the business side of things. That's in addition to meeting with clients and the hours spent at the computer editing images and doing design.

The title of this chapter was chosen to underscore that we work in a changing and demanding profession. It offers great rewards. We get to join with people celebrating, get to take pictures, and get paid for it. It also demands that we be able to grow as the technology improves, and continue to improve our work

Next Up

Before we start booking clients, we have to set up shop. First step, organize the business. For those with little experience, it can be a daunting task. Accounting, marketing, and all that paperwork—not a favorite pastime for most picture people. We won't cover all the details in this book, but we can map them out and show you where to get help—and a good bit of it is free.

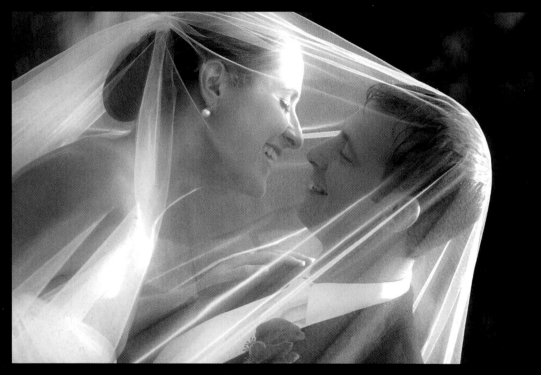

Photograph by TriCoast Photography

2

Business First

Photography is part art, part craft. Successful wedding photography is also a business. In fact, the time actually spent taking pictures is one of the smallest parts of the average photographer's business. Planning and setting up the business is so important that it comes before choosing equipment and setting up an imaging workflow in this book. That's because we have to budget expenses, line up vendors, and have a working marketing effort before we are ready to take on clients (or even get them).

Gotta Have a Plan

There are details on choosing equipment, setting up workflow and websites, and creating promotional media in the following chapters. Right now, we are centering our attention on planning a strategy for success and setting up shop. The first step is drawing up a business plan. There are whole books devoted to that topic, but the basics are simple. (We'll also discuss getting help—much of it free—shortly.) Unless you are trying to obtain a business loan, it does not have to be fancy, just well thought out.

A business plan is basically a detailed road map of your goals, the resources needed to achieve them (money, equipment, time, and people are all considered resources), a method for tracking progress, and dealing with obstacles. The first step is to decide just what your business really is, and what is needed to make it profitable. With those facts, a roadmap can be created and discussed

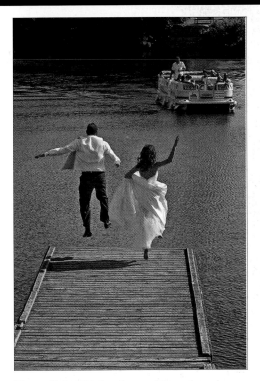

Figure 2.1 This is a fun wedding photo by Mark Ridout, and nobody really would expect the couple to catch the departing water taxi. Entering the wedding photography market without planning has even less chance of real success.

with business experts. The next section is not designed to be a detailed list, just to get the thinking process started. Then we'll look at the specific issues related to the business of wedding photography.

Set Short- and Long-Term Goals

It's hard to hit a target unless you know what it is. Take some time to consider what both your immediate and long-term goals are. Do you want to become a full-time wedding photographer? Is it a part-time job for a second source of income? How much money do you want to make? Perhaps the goal is a career in some other aspect of photography and covering weddings is a way to gain overall experience.

Determine your ultimate business objective, like "a studio with two photographers" or a "full-time wedding business with 25 weddings per year," and map short-term goals to reach the big one.

Many of today's most successful wedding photographers started out either working for an established photographer or photographing friends' weddings to gain experience and collect a portfolio. Then they moved on to developing their own clients and developing their business. As they get busier, many hire assistants and second shooters.

There are studios that handle weddings, but primarily focus on other markets (like families and seniors). Some actually farm out photographing weddings to freelancers for a fixed shooting fee, and they handle the rest of the workflow. For these assignments, you'll need a portfolio and adequate equipment.

For those without experience an entry path is as a photographer's assistant. They start with simple tasks and (with the right mentor) progress to photographing their own weddings. Along the way, they purchase more equipment, produce a portfolio, and develop a referral network.

Know Your Resources

So what's required to reach your goals? Are your short-term plans realistic? It's time to draw up a resource list. Resources are anything that's required to reach an objective, including people, equipment, time, money, and skills.

A road trip is a good example. If you plan to drive from one town to another, you need a car (with tag and insurance), a driver (with a license), gas, driving skills, road money, and knowledge of the route and the location of the destination. Some things are more critical than others are, and some are only important on occasion. Some folks drive without insurance or a valid license. That can save money, but only until the first accident or traffic stop.

A successful photography business also requires resources, including technical and business skills, insurance and licenses, marketing, clients, a lab, etc. Part-timers can build up slowly, expanding as clients and money allow. If you are considering going full time, is there enough cash on hand to cover living and business expenses until clients start paying the bills?

Another resource to consider is the available client pool that is likely to hire your services. How big is the wedding market in your area? What is the competition, and what are the going rates and expenses for coverage?

You Don't Have to Go It Alone

That may sound like a daunting list, and a lot of work in doing the planning. As a small business person, there is free help available. The U.S. Small Business Administration offers both online and real-person advice on starting and operating a business. Their website (www.sba.gov) has details and information on locating an advisor. In addition to their own programs and information guides, the SBA coordinates and supports volunteers who offer free consultations and can be a valuable source for developing a local business network.

The National Advisory Council (NAC) is a collection of appointed volunteers who partner with the SBA to counsel and assist small businesses and provide expert advice, ideas, and opinions on SBA programs and small business issues.

SCORE (Service Corps of Retired Executives at www.score.org) provides free mentors who provide one-to-one business advising sessions on a full range of business topics. They also offer workshops and seminars on a variety of business issues, as well as online small business advice via e-mail.

These two websites can put you in touch with seasoned business experts who can help get things started. These offices are also a good source of information on how (and when) to obtain business permits, local networking opportunities, marketing ideas, and finding vendors like accountants and tax experts. Sometimes it's easier to hire a skill than learn it.

Networking with other professional photographers is a good business practice and source of industry information. Consider joining a trade society, such as the Professional Photographers of America (PPA) at www.ppa.com, Wedding and Portrait Photographers International (WPPI) at www.wppionline.com, or signing up on the Digital Wedding Photographers' Forum. Their members are excellent sources of information on suppliers and business trends, and the interaction and taking part in their learning programs help keep up motivation.

Additional Resources: Your Providers

Weddings are big business, and there are other firms that are willing to help you succeed—because you are their real customer. These include camera stores, processing labs, album companies, your bank or credit union, your camera maker, website hosts, etc.

When figuring costs, be sure to check for special discounts, sales, and wholesale prices. For example, firms like Classic Albums will give you a deep discount on a sample album. During the off season, many labs do the same for large prints. Taking advantage of these offers can reduce costs and improve your image. Obtain product brochures, leather and liner sample kits, and any other available marketing aids.

Credit unions and commercial banks provide services including checking accounts, credit card processing, and loans for small businesses, and they are more than happy to discuss their offerings. The professional societies and local insurance agents can provide quotes and recommendations on equipment and liability polices. Both are good to have.

The big camera makers cater to professionals, but only to registered members of their respective clubs. These organizations offer a variety of benefits—and are usually free. As a Nikon owner, I've relied on them for fast repairs and tech support. Some vendors have loaner programs and training programs. Most require proof that you both are a working professional and use their products.

Figure 2.2 Vendors and service providers can be allies when planning and outfitting your business. (Image by TriCoast Photography)

Doing the Paperwork and Playing the Numbers Game

Once you have set goals and assembled the facts about resources and costs, it's time to handle the part of planning that most of us tend to avoid: budgeting and bookkeeping. Some photographers choose to farm this out to a professional, employee, or a spouse. Even those who do should have a good idea of the fundamental principles and their own numbers. There are several reasons for record keeping, and several types of records to keep.

First is to have a basic budget. Knowing the cash on hand, projected income, and expenses is critical to success and good planning. Can you really afford that new lens? Are you charging enough for each package? Without numbers, it's only a guess. (Of course, at first, with limited data, it's still at best an educated guess on income). You also need good records to manage your taxes.

If you don't want (or have the volume to need) a bookkeeper, consider a software program like QuickBooks. Professional bookkeepers are often willing to set up the program to suit your needs for a small fee. As business picks up, you may want to have assistance for keeping your records in order and filing tax reports.

Figure 2.3 Wedding photographers don't need to be superheroes to catch the "brass ring" of profit, but they do need to keep a good set of books and track income and expenses. (Mark Ridout Photography)

Product Lines and the "Joy" of Pricing

Often one of the most difficult parts of starting a new photography business is deciding how much to charge and how to bundle services to sell to clients. A photograph or wedding album is a physical product, and the basic production costs are easy to determine. Many newcomers go astray and only look to make a "good profit" over basic expenses.

For example, let's say that printing lab costs and binding for an album with 30 "sides" is $400. So it might sound really good to charge $700 to cover a wedding and offer such a product—to a novice. After all, the bride's Aunt Susie might be willing to use her new digital camera and send the pictures to the drug store lab and get a "photo book" for expenses. And you may be in competition with a

reporter at the local newspaper who gets to use the company camera and needs extra cash, and who is willing to do the job for bottom dollar.

Let's consider the real costs and exactly what a professional wedding photographer is really selling. That is how we really find out what to charge and how to market our products.

First, there are the tangible expenses that have to be factored. There are cameras and lenses, flash equipment, computers, memory cards, software, gear bags, a tripod, and all the other products that we need to be able to properly cover a wedding (including backups).

Add the cost of marketing, a website, insurance, taxes, and payments to vendors, travel, professional development, and a personal profit for taking the risks of being in business.

Then there is the value of having an experienced professional with the creative skills to do a superior job and produce a polished result. Some people want to shop for a bargain, and new photographers may have to cater to them and price accordingly as they build a reputation. That does not mean taking a loss.

So just getting more from the client than it costs to have the album or prints produced is far from making a profit, or even simply recovering your own expenses.

Pricing Basics

We just highlighted the cost factors for wedding photographers, but there are no fixed rules for what to offer and charge. These are matters of personal preference, as well as knowing your clients—and turning a level of profit and being properly compensated for the work and skill needed for the project. The real trick is in balancing what you are worth, the costs of doing business, and matching product and price to your market. If you have a small business advisor, it's a good idea to visit and discuss your pricing structure once it is drafted.

Just what to charge and what to offer depends on the photographer, the market, and the client. As the provider, what are you willing to provide and what will you outsource? If a photographer does all printing in-house, that adds to the work level, and may or may not reduce costs. The same is true for album design, retouching, and framing.

High-end clients are willing to pay more, but they expect more as well. Carriage-trade couples will expect prints and DVDs in presentation folders. Bargain hunters may ask for small proofs and then scan and make their own prints, and will avoid complete packages.

Mark Ridout uses a fixed-price method, and does not cover receptions. He provides a slideshow and high-resolution images to all of his clients. Some photographers price coverage by the hour and sell a variety of print packages.

I offer several packages and provide a full day of coverage and an engagement session with all of them. The basic package is the coverage and images on disc only. The upscale packages add web proofing and a slideshow, plus some prints. The top-of-the-line bundle includes two additional albums and a variety of extras. There are a la carte options available as well. To prevent piracy, our studio provides proofs via a DVD slideshow and watermarked online shopping.

More Paperwork: The Contract

Couples getting married are entering into a contractual relationship, and so is the photographer. They are contracting with us for an exchange of services, and usually goods exchange, for a sum of money. The best way to insure that everyone knows exactly what is being paid for, and what the terms are, is with a signed contract. We keep ours simple. The old one only a lawyer could love, and it scared clients with three pages of references to acts of God and natural disasters.

Now we have a simple form that lists the parties, the provided services and products, the dates, the prices and payments, the exceptions, and copyright and model release statements. There are blanks for signatures, the date signed, and a witness.

Since it is a legal document, it's a good idea to have a lawyer examine any form you choose to use. Groups like the PPA and some books of legal business forms may have good samples. Whatever you choose, get a signed contract.

We also ask the couple to fill out a form that lists all the other providers, the size of the wedding party and the schedule of events for the wedding. That helps to plan, and adds to our list of wedding vendors for networking purposes.

Marketing and Sales

Once the business planning and pricing are done, it's time to start marketing. It's not the same thing as sales, even though they are often linked. In order to get bookings, the brides (or their parents) have to know about your services and develop an interest in hiring *you*. Most areas have several wedding photographers, and some clients are willing to pay extra in travel costs to get a big-name photographer. Those big names usually become big names due to a successful marketing campaign.

More Planning…

Effective marketing is an ongoing process, and it helps to have a plan and a calendar. Keeping your name and "brand" before the public is a big part of marketing. When a soon-to-be bride asks someone if they know of a photographer, you want your name mentioned. The person may have only heard of you, not hired you. But it's still a referral. Very few people have not heard of Coke, Pepsi, Toyota, or GM, yet they spend lots of money each year to keep their names before the buying public.

Of course, they make lots of money and have a good-sized marketing budget. Most photographers start out small, and even the big names don't usually have big marketing budgets. So a plan and priorities are in order.

Setting up a marketing calendar is a good first step. Find out about bridal shows (sometimes called bridal fairs) and note the dates. Some can be very expensive, some are free. Many are commercial events at convention halls, others are small events hosted by wedding venues. Ask other photographers and other wedding suppliers (like florists and caterers) which shows offer the most exposure for the money.

To compete at these shows requires samples, display materials, and handouts. They add to the initial cost, but most can be reused or reprinted. Some photographers have fancy booths; others use tables provided by the company putting on the shows.

Most shows take place during the prime wedding planning seasons in January-February and August-October time frames. These are also good times to have ads and listings in print and online magazines. Once again, it's a good idea to check out how effective each marking vehicle is. Each marketing area is different and what may be a very strong source of leads in one region may be weak in another. Track what brings in business and keep an eye on what works for the more successful photographers in your area.

It's important to realize that marketing builds over time. Don't expect one ad or listing to bring in a flood of responses the first time. Still, if something fails to be worth its keep, consider something else. Let's look at some of the other more popular marketing methods.

The Internet

A good website and a custom e-mail address are two of the most powerful tools in today's wedding market. Clients will look for local photographers via search engines as they start searching. If you use display ads and phone listings as part of your marketing strategy, make sure they include your web and e-mail addresses.

Figure 2.4 Good websites are more than just simple information. They offer clients a view into the photographer's style, personality, and way of doing business. There is no doubt when visiting it, that Mark's website showcases his personality and sense of humor as an integral part of the design.

A good website with images and information lets prospective clients see your work, making them qualified leads when they call. Those that reach you via other referrals can be directed to your site before the first meeting to increase their interest in your services. Of course, all that depends on having an effective web presence. Details on setting up a website are covered in Chapter 5.

Business Cards and Brochures

Business cards are a must, and they should have both contact information and at least one of your images. I keep a stash of 100 or so in the car, and make sure several are in my wallet at all times. If asked for one, I give two or three. They may have friends interested in hiring a photographer.

Many retail firms have bulletin boards where customers can place their cards; I make sure to do so every time I see one. These cards become mini-ads. Once again, leave several, so people can take one without leaving the space blank. Next time you visit, check and refresh if needed. We print 4x6 photos with a single image and basic contact information (including website) on a black leather background. These are even better to post, since they are more eye-catching. Bulk print runs between 10-15 cents each using online print labs.

Brochures can hold more information and pictures than a card. We have several designs printed up and renew them at the start of the winter season. They are excellent handouts at bridal shows and as mailers to follow up requests to the website or from phone calls. We have an Adobe PDF version of each that can be delivered via e-mail.

Networking and Displays

There are lots of firms seeking wedding clients in your area, and not all are photographers. Even those that are can be allies as well as competitors. And they are all both marketing venues and people to market! The average wedding uses a minister, priest or rabbi, a florist, a DJ or band, needs a location, hires somebody to handle food, buys drinks, rents formalwear, buys gowns, has invitations printed, needs makeup and hair styles, as well as the photographer and maybe a videographer. In short, a small-business community.

All of those firms can be sources of leads, if they are asked to refer a photographer. All of them. If another photographer is booked, the bride often asks for a suggestion of an alternate. If you know of reputable vendors and are willing to suggest them, talk to *them* about suggesting *you*.

Remember the vendor list we ask for with the contract? We let all of the folks on that list know that we have pictures from the wedding they work on, and provide a free 8x10 print for their portfolio—complete with our logo in the corner and a set of cards and brochures.

Ask for some of theirs and hand them out as appropriate; then do what doctors do when making a referral, let the other vendor know you suggested them. Even if the bride does not follow through, they will thank you for the consideration. We track the referrals we get as well.

If you have a collection of prints that highlight the work of another vendor, like a florist or hair salon, consider a display. In fact, consider posting a display anywhere you can (within reason).

Advertisements, Listings, and Direct Mail

Bridal magazines and websites, the yellow pages, local newspapers, and radio and television stations, etc., all offer to market your name for a fee. Once again, you need to compare cost to generated leads and exposure. We used to run display ads in the yellow pages, but now only have a small in-line listing. Most referrals from the phone book tended to be last-minute bargain shoppers. Other cities may be different. The same is true for print ads.

Local business groups and the Chamber of Commerce often have their own directories and welcome materials. They may not be a great source of business, but are often free to members, so worth doing. Direct mail can be very effective—and up to date. Some bridal shows and magazines offer to sell contact lists.

Growing along with the Business

As your business grows, your goals, plans, and marketing should grow as well. We actually review all aspects of our operation late each year. Are our prices still on target and making a profit, do we need more help, and is our marketing effective?

The overall budget is considered, and we meet with an advisor at the local SBA affiliate to get an outside opinion on both our practices and progress.

Of course, growing a business is not a once-a-year event. Keep an eye on the local business news. Is there a new bridal shop, venue, florist, church, or other vendor opening up in town? Is a new minister being installed at an existing church? Be the first to welcome them to the local wedding-provider community.

Next Up

Photography is an equipment-intensive endeavor, and professional work calls for professional equipment. We turn our attention next to setting up the gear bags needed to cover a wedding properly.

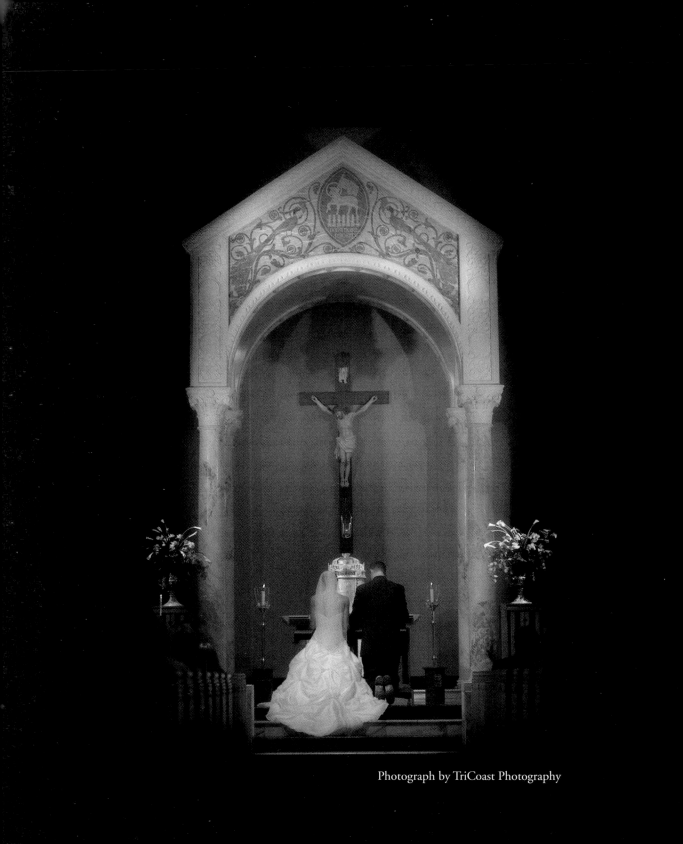

Photograph by TriCoast Photography

3

Equipment Matters

Wedding photography is an equipment-intensive profession, and digital wedding photography is even more so. The gear you pack has a lot to do with the technical quality of your pictures and the types of wedding coverage you can offer clients (artistic quality is another discussion). This chapter focuses on how and where to shop for camera gear; we'll save computer equipment for Chapter 4. The tricks are in knowing what you really need and how to be a smart shopper—so that you still have gas money to get to the church with all that fancy equipment. If you're an experienced film professional, you will find the acquisition process familiar, but with some notable technical variations.

The Essential Camera Bag

The basic gear used to take most of the pictures at any wedding fits into a single camera bag. A couple of camera bodies (always carry a back-up), three or four lenses, two or more "on camera" type strobes (yep—always carry a back-up), memory cards, cables, a light meter, gray card, and a basic care/repair kit. A similar bag is carried by each photographer covering a wedding if there is more than one shooter. Additional lighting equipment, etc., is above and beyond the basics. Some weddings call for advanced lighting equipment and other tools of the trade.

Let's start by exploring the primary contents in detail, then move on to the "extras" packed in the secondary bags. Keep in mind that there is no "perfect" equipment collection. Each photographer gathers, pares, replaces, and upgrades as personal preference, needs, money, and techniques change.

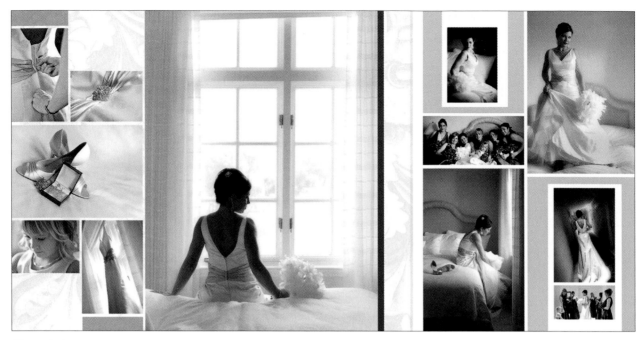

Figure 3.1 Wedding assignments are demanding, both of the photographer and the equipment. Producing professional results, like the images on this TriCoast Photography album, requires arriving well prepared and well packed.

Camera Bodies

No matter the brand, the amount of money spent, the photographer's level of experience, or the number of cases full of goodies going on the shoot, professional gear always centers on the primary camera body. This camera is the heart of the system. Its brand and features are major factors in what you can add to the kit and the overall cost. You don't have to buy the fanciest or newest, but solid construction, speed, and ease of use are critical factors. So also are the range and quality of lenses available for a particular body.

For professional digital wedding photography, there is only one real choice when it comes selecting a camera: a quality digital single lens reflex (DSLR) with removable lenses. The secondary body can be an older or a less-featured model. Keep in mind that the back-up will have to do the work if the primary fails.

Figure 3.2 Solid construction is a must when choosing a camera. Quality DSLR bodies like Nikon D2Xs are made with strong, lightweight metal.

Notice I avoided the word "professional" in the definition, and used "quality." "Professional" is a misleading term. Flagship DSLR models from the two big names, Canon and Nikon, have price tags of $5,000 and up—without lenses, extra batteries, or memory. Second-tier "prosumer" models and competing products from well-respected makers like Fuji, Kodak, Pentax, and Olympus offer the same key features and use the same technology as the top-of-the-line editions from the Big Two. They will lack some of the fancy features of the flagship models, but still have the muscle and resolution to cover a wedding. The money saved can be used to buy better lenses.

The third-level "advanced amateur" model may cut that price in half, but usually lacks the durability, performance, metering, and advanced lighting features of its most robust siblings. The major vendors offer a range of products to suit your budget and shooting style. Some manufacturers offer camera bodies and accessories for just the professional, prosumer, or advanced amateur markets.

Must-Have Features and Basic Buying Considerations for Wedding Photographers

Digital camera manufacturers are constantly designing new, exciting toys to entice us into spending more money. New is nice, but we don't have to have the most advanced or the most powerful gadget, rather, one that will reliably capture the images we sell to our clients—no matter the brand or the price tag. As a rule, professional and the better prosumer models are suited for use as a primary camera. If the budget allows, a matched pair is best. Your cameras don't have to be identical, but should use the same lenses and accessories (saves money), and have similar controls (avoids confusion). A well-chosen third-tier camera might suffice for a second body.

The important thing is choosing a camera that will suit *your* needs, shooting style, and budget. If at all possible, actually handle and shoot with the product before making the purchase. You will have to carry it for hours at a wedding. The placement of controls, the weight, viewfinder placement, shutter noise, and the quality of the LCD display can only be evaluated in person. No matter the brand or model, there are critical features both bodies must have. The following list shows you the basics of what to look for and avoid when shopping.

Interchangeable Lenses

There are two reasons interchangeable lenses are at the top of my shopping list—compatibility and quality. If you have been shooting pictures for any length of time, you've already invested money in existing lenses. The expense of replacing lenses to fit a new camera can be prohibitive. If you are just starting out, lenses will still be a significant part of the purchase process, and not all models (or even lines of cameras) may offer the types of lenses you want to use.

The camera body must be able to mount professional-quality lenses with wide apertures. The low-light conditions found in most churches require fast lenses, whether fixed-focus or zoom. (Almost all of mine are f/ 2.8 or faster.) If you're just starting out, or if the existing lenses are not up to the demands of shooting a wedding, then choosing a system with quality optics is a must. After we finish discussing camera features, we'll look more closely at selecting lenses.

Image Sensor Characteristics

All cameras are basically a black box with recording media, lens, and a shutter. The sensor is the part of a digital camera that records the image, which is then saved as a file. The first consideration when examining sensor characteristics is the base resolution. This is usually given in megapixels (mp for short). For wedding photographers a 10mp sensor is a good starting point. Higher resolution is nice, but not really needed. In fact, a good 6mp unit will produce a sharp 8x10 print—the largest enlargement for an average wedding photo. More megapixels mean finer detail and tone, bigger images, and also buying bigger memory cards. (This book assumes the reader has a basic understanding of photographic technology and terms. If you want a basic discussion of the topic, consider a book like *Mastering Digital SLR Photography* by David Busch, also from Course Technology.)

Some professional and prosumer cameras have sensors the same size as a 35mm negative; most are about two-thirds that size. The smaller sensors have a smaller image area, with a corresponding lens-magnification factor. A 50mm lens used with a smaller sensor will produce a picture that looks more like one shot with an 85mm lens on a 35mm camera. (The actual factor varies with the design; more about that topic when we discuss lenses.)

Sensor speed and signal noise are important (and related) factors. A sensor's speed is its sensitivity measured in ISO values, just like film. Smaller numbers (50-100 ISO) produce images with more fine detail and less distortion (noise). Unlike when using film, you can change the speed between each shot if desired. That is a real plus during a wedding, when light levels can vary dramatically.

Figure 3.3 The image sensor for the Nikon D200 DSLR.

To make the cut, the camera must be able to record using ISO values between 100 and 1600—with acceptable quality. (Some cameras have ratings from 100-800 and Hi-Speed modes, which offers basically the same performance range.) Keep in mind that the higher the ISO, the more noise. Noise is like grain in film. Noise degrades detail, but faster speeds let you shoot in lower light levels, use a faster shutter speed to stop action, or use a smaller aperture to obtain greater depth of field.

It's a good idea to obtain sample images at various ISO settings for the cameras under consideration and examine them for quality. These are often available at the vendor's website or a third-party site that reviewed the product. Look at detail, skin tone, noise, and color. Manipulating them in your regular software is also a good idea, and consider making a sample print. Different model sensors, even if from the same vendor or with the same pixel count, can vary greatly in output quality.

Note

Some people wonder why a professional 4mp DSLR creates images with more detail than an 8mp point-and-shoot or cell-phone camera. Pixel count is not the ultimate arbiter of image quality. Even if you built a full-fledged DSLR and professional lens around a cell-phone sensor, it would not produce professional results. No, it's not the label, it's sensor size. The cell phones and point-and-shoot products create pictures with smaller pixels. That cuts cost and lets them fit cameras into smaller spaces. But when it comes time to edit and print the results, the difference in quality is noticeable. That's something to point out to clients who wonder if the local newspaper reporter (with the paper's "high-end" point-and-shoot) or Aunt Susie with her cell-phone camera can't do the job.

Exposure Controls and Ergonomics

There are few events as technically challenging as a wedding when it comes to exposure and shooting style. They take place in bright sun and dim churches, in the shade of mountains and the harsh glare of a sandy beach. Extreme backlighting fools light meters (no matter how sophisticated), and rapidly moving subjects require fast shutter speeds. The professional photographer's results are expected to show detail in white gowns and black tuxedos in the same image. You can't rely on the camera's automatic functions to always choose the proper settings. The ability to take full manual control of exposure, ISO speed, color balance, and focus is a must.

Well-designed and organized camera controls are essential, along with professional-quality white-balance settings, and a full range of shutter speeds, from Time or Bulb to at least 1/4000 of a second. Solid construction, tight seals to keep out dust and grit, and well-placed controls are also important. If at all possible, get your hands on the actual camera before buying. When I upgraded to the Nikon D200, the difference in the control placement from the D100 was so distracting that I sold the older camera rather than keep it as a back-up unit. (The radical improvement in design and image quality was worth it!)

Some cameras let you define custom shooting configurations (like white balance, exposure, flash modes, etc.) that can be set with a quick menu selection, and offer user-definable function buttons. That makes it easy to keep shooting when moving between indoors or outdoors, to add flash, or to invoke a custom white balance. This feature is found on many professional and better prosumer models. I have one that is set to spot-meter mode, and I use it to pinpoint the exposure for a shot on the most important detail (like the wedding gown or the bride's face).

Burst Rate and Auto-Focus Capability

Portions of the wedding day, like the bouquet and garter tosses or the newlyweds running the gauntlet of rice and birdseed, require fast shooting. Your camera should be able to record a series of at least six or seven full-resolution RAW images at a burst rate of at least 4 frames per second without pause. A good burst rate is also a plus when shooting a series of group shots or catching the action on the dance floor. You don't *ever* want to have to wait for the camera.

Moving subjects, especially in dim light, can be hard to focus. Advanced auto-focusing and computer-aided tracking ability make getting a perfect picture much easier. Sustained high burst rates and predictive focus are not found on budget DSLRs, but adequate performance in both burst rate and auto-focus are available on the better prosumer models.

Viewfinders, Playback, and Read-Outs

The early film SLR viewfinders showed only the image reflected through the prism and mirror. Modern editions provide an amazing amount of information in the viewfinder window: exposure, ISO speed, metering mode, white balance, battery levels, etc. Some are easier to read than others. The better ones also offer built-in diopter correction for owners who wear glasses. Make sure your eyes and the viewfinder are compatible before paying the money.

Not all viewfinders are created equal. The very best (read expensive) show the exact area that will be in the final image file. Most of them crop part of the area,

meaning that you will get more in the picture than you see in the viewfinder. That kind of precision is a must for things like scientific records. It isn't much of a problem for wedding photographers, but it's best to keep the frame coverage around 94 percent or better. (94 percent means that there is 3 percent of the picture on each side of the window that won't show up in the viewfinder while you're composing).

The LCD monitor displays the pictures already taken, along with histograms, focus points, shooting data, and so on. It also displays the menu options for adjusting advanced camera settings. If possible, test-view both functions, both in a dim room and bright sunlight. When working, you will have to rely on the LCD to make sure you got the shot. Some cameras provide much better data reports and previews than others.

Figure 3.4 Don't forget to consider how comfortable a camera feels in your hands, and how easy the controls are to adjust. Wedding assignments last several hours and require frequent changes in settings.

File Formats and Memory

When you press the shutter button, the sensor produces a RAW image, the unprocessed data created at the moment of exposure. Examined without processing, most RAW images look a little fuzzy, dark, and have a slight color cast. First looks can be deceiving. A RAW file is like a negative, without the data loss that comes with post-processing. If you want the most control when editing your images, choose a camera that allows you to work with the RAW files, and use them.

The drawback to working in RAW mode is file size. A 10mp RAW file takes about 15MB of storage space, a 6mp file uses almost 10MB. Given the high burst rate and write speed of the current crop of DSLRs, I shoot all my images in RAW. Not all digital cameras let you save the RAW file, and automatically convert the picture into JPEG format. For me, not being able to save files in RAW format is a deal-breaker. RAW files and RAW editing programs offer the most advanced tools for manipulating your images. We'll cover that topic in detail when we give an overview of software programs in Chapter 4, and more detail in Chapter 14.

There are some photographers who would rather work with JPEGs and buy fewer memory cards. If you are *sure* your exposure is right on the mark, that you won't need to tweak the color balance, or have to adjust highlight and shadow detail, or don't want to use some of the advanced editing tools that are only available in RAW editing programs like Nikon Capture NX, Capture One, Bibble RAW, or LightZone—feel free to use JPEG. The speed of the current crop of DSLRs in RAW mode and the now (relatively) reasonable cost of memory make shooting RAW the wise way to go.

That brings us to memory cards. The dominant card format in professional and prosumer cameras is the removable Compact Flash (CF) card, which is about the size of a large commemorative postage stamp. They come in a variety of write speeds and memory capacity. Faster and larger take a bigger chunk of money out of your wallet faster.

Memory write speed is important, and so is compatibility. Slow cards tie up the buffer's memory. When the buffer is full, the camera will have to stop while the files are written out. That could mean missing an important shot, like the woman catching the bouquet. Not all cards are certified to work in all cameras. Double-check before you buy. A camera that uses different cards from your existing bodies, say SD rather than CF format, will mean buying a new set of cards and the inability to share them between units.

When stocking up on cards, consider how many pictures you shoot at a wedding, and then add a margin of safety. Multiply the number of images by the size of a single file, and buy enough cards to handle the job. It is temping to buy a few high-capacity cards. I don't. Smaller-capacity cards reduce the risk of lost images in the event of a card failure, and take less time to back up during the event. In our studio, we use cards that hold between 50 to 100 images each.

Power Considerations

Wedding photography is battery-intensive, especially if you check the image and/or the histogram in the LCD frequently. Some shooters get less than one-quarter of the battery's rated number of exposures. If you are buying a model that just came on the market, spare batteries may be in short supply. Order several at the same time and be safe. Some models offer an accessory battery pack that houses two batteries. The one for the Nikon D200 comes with an accessory tray that can power the camera with a set of AA batteries or the regular Lithium Ion rechargeable type. While I've never had to use it on a shoot, it's always in the camera bag—just in case.

Some battery chargers are better than others. If one model will seat two batteries at once, or cycles a charge significantly faster than another, consider performance

as well as price. Watch out for third-party products here. After-market batteries may not exactly match the camera's specifications, and using them may void your warranty.

Reliability and Reputation

Some elements of the buying decision are less tangible. How reliable is the camera maker, how solid is the design of the equipment you are considering under the stress of wedding photography, and what kind of technical/repair support is offered? The best way to find out is to become familiar with the vendor's website, as well as sites that offer reviews and user-support forums. The same is true for other items on your list, not just cameras.

Figure 3.4a The camera's LCD display must be large enough and bright enough to use in both sunlight and dark churches

Product Line Comparisons

Examining a single vendor's product line is a good way to see how the price/feature/performance equation works and find the model that fits your needs and style of shooting. Then it's easy to comparison shop for both features and price against other vendors. The table below details some key features of the Nikon DSLRs offered in early 2007, limiting the list to models with 6mp sensors or better. It's easy to see how the D2Xs (at $4,999) outshines the others feature-wise, but the D200 is worthy of serious consideration as a primary body—especially given its $1400 street price). The D80 lacks the speed, buffer capacity, focusing ability, and flash sync connection to compete as a serious shooter's main tool, but would make a good backup or assistant's camera.

We can see the potential suitability of each body to the needs of a wedding photographer from this short list of features. The D2X and D200 both support full RAW files, while the D80 and D40 only write compressed versions. The compression reduces the ability to retain highlight detail (like the fabric in a wedding gown). The buffer size, burst rates, and shutter lag times of the D2Xs and D200 offer an extra edge when shooting fast and furious—as during the bouquet toss and the "big kiss. " To conserve space, the table doesn't detail control buttons. On the D2Xs and D200 there are individual buttons for setting ISO and white balance, along with a variety of other professional controls that are either combined or lacking on the lower-priced models. They also are built with solid magnesium-alloy bodies.

When comparing products for an important purchase, it's always wise to get some real-world opinions and then check the facts. See how the D200 and D80 both have the same pixel count? Many people, even educated reviewers, assume that both models share the same sensor—not true. The D200 uses Sony's ICX483AQA four-channel sensor, while the D80 employs the ICX493AQA two-channel edition. The wider data path is part of why the D200 has faster performance.

There are other differences that make the most robust models worth digging deeper in the wallet. They generally have more focusing sensors and more image information in the display. That can translate into faster tracking when shooting, and better feedback when checking settings or the results of an exposure. That translates into happier clients and more sales.

Table 3.1 Nikon DSLR Product Line Comparison

Camera	D2Xs	D200	D80	D40
Sensor Megapixels	12.2	10.2	10.2	6.1
Max. Image Size	4288x2848	3872x2592	3872x2592	3008x2000
File Formats	NEF*, Compressed NEF, TIFF, JPEG	NEF, Compressed NEF, JPEG	Compressed NEF, JPEG	Compressed NEF, JPEG
Full Frame Buffer Capacity (RAW)	16 images	19 images	6 images	5 images
Max. Burst rate	5fps**	5fps	3fps	2.5fps
Shutter Lag	37ms	50ms	80ms	114ms
Auto-Focus sensors	11 (CAM 2000)	11 (CAM 1000)	11 (CAM 1000)	3 (CAM 530)
Flash Connections	Hot Shoe & PC	Hot Shoe & PC	Hot Shoe	Hot Shoe
Top Panel LCD	yes	yes	yes	no
Memory Type	CF	CF	CF	SD
Body Type	Metal	Metal	Plastic	Plastic
Control Buttons	Full array	Full Array	Limited	Limited
Price***	$4999	$1699	$999	$599****

*NEF (Nikon Electronic Format) is the Nikon term for RAW.
**Full frame burst mode; the D2Xs can shoot at 8fps in 2X crop mode.
***Manufacturers suggested list price; street prices vary.
****The D40 is only sold with a kit lens; the other cameras are available without a lens.

In short, you do get what you pay for, and camera vendors don't leave any money on the table when it comes to professional gear. The flagship models do offer more power, performance, and ease of use. The best of the prosumer cameras are more-than-capable alternatives. Those just starting out on a limited budget, or looking for a less-expensive back-up unit, can "shop down" to the next tier, but the amateur models like the D40 lack the prowess for the active environment of modern nuptials.

Tip

The CF card (and the cameras that use them) slot will also accept microdrives. These are small hard drives. A 4GB model costs about $125. A high-end 4GB CF card runs about $250. While the price is tempting, it is a risk. Hard drives are a lot more fragile than CF memory. I had one. And it died after about two years. It was used only in the studio. The original 512MB CF card I bought at the same time is slow, but it is still working six years later.

Choosing Lenses

Once the make and brand of your camera bodies have been chosen, it's time to evaluate the lenses. If at all possible, don't scrimp on quality with lenses. Whether buying new, or considering keeping existing lenses that will work with your new cameras, make sure they are up to the demands of wedding coverage.

Crop Factor and the Angle of View

Before going into the details of lens design and assembling a workable collection, we need to discuss the topics of angle of view, and what has come to be known as the "crop factor." Most DSLRs don't see the world through lenses the same way as 35mm film SLRs. The reason is simple: they have a smaller image area than the 24x36mm format of 35mm film (it cuts costs). If you take a picture with a lens of the same focal length on two cameras with different-sized image areas, the small area will only record a portion of the picture.

It's simple optics, and works the same way in both film and digital photography. In short, a "normal" 50mm lens on a 24x36mm sensor works more like a moderate telephoto (in the 70-80mm range) on most digital cameras. An 80mm lens is actually a "standard" lens on a 2 1/4" square medium-format camera like the Hasselblad, and a 50mm lens on that camera is a moderate wide angle.

If you are already familiar with 35mm camera lenses, you can use the relative magnification factor for your camera's sensor to compare how a lens will function. For example, with a factor of 1.5 a 200mm telephoto will have the same magnification as a 300mm lens. The image created by that same camera with a 17mm lens will look like one shot with a 25mm lens on a 35mm camera. The table below gives the magnification factors for some of the more popular professional and prosumer vendors' cameras.

Table 3.2 Magnification Factors

Magnification factor	Cameras
1.x	Canon EOS 1Ds, 1Ds mkII, Kodak DCS, 14/c (Canon lens mount), 14/n (Nikon lens mount)
1.3	Canon EOS 1D, 1D mkII
1.5	Nikon DSLRs (also Fujifilm DSLRs)
2.0	Nikon D2x/D2Xs in 6.1mp crop mode

The most precise way of determining how a lens functions (as a wide angle, normal, or telephoto) is by using the angle of view that is reproduced on the sensor or film. Angle of view (AOV) is the portion of a circle that is cast by the lens as an image. It is listed in degrees, using the vertical, horizontal, or diagonal length of the imaging area. That makes it easy to compare lenses, even if they work with different size sensors or films. Camera and lens manufacturers list magnification, angle of coverage, and general usage guidelines for their products.

A roughly 35-40 degree horizontal angle of view (side to side across the sensor or film area) is typically found on "normal" lenses, like a 50mm on a 1x sensor, or a 35mm lens on a 1.5 sensor. Any number significantly above that, and the lens falls into the wide-angle category; lower numbers denote telephoto performance.

Note

When discussing angle of view options in the rest of the book, I'll give horizontal AOV values and matching millimeter values for a lens placed on a 1x sensor (the same as 35mm film) to avoid confusion or having to give magnification variables. For example, a 50mm and its 40-degree AOV are considered normal field of coverage for a 1x sensor. The Resource Guide gives the web addresses of sites with AOV look-up tables and comparison charts.

The Essential Lens Collection

Most of a wedding can be covered with normal and moderate wide-angle lenses—if you can get close enough to the ceremony. That means having lens capability to cover the 65-40 degree AOV. Primary lenses needed for that coverage with a 1x sensor would be a 50 or 55mm normal, either a 35mm or 28mm wide angle, and a 24mm wide angle. A telephoto with a 15-20 degree AOV is good choice as a moderate telephoto or portrait lens. A primary in the 7-10 degree AOV range is very handy for close-ups from the back or side during the ceremony. That equates to a 200mm or 300mm telephoto.

That's quite a collection, and having primary lenses means changing optics frequently, or having two or more camera bodies at the ready with different lenses mounted. Today's digital arsenal offers some excellent zoom lenses that can greatly simplify things. A single zoom in the 28-85mm range on a 1x sensor, coupled with an 80-200 zoom makes a good pair. Adding a fish-eye provides the ability to produce everything from close-ups to near-panorama views.

That's the approach I've taken in outfitting my D200 setup with its 1.5x sensor, centering on three lenses. A mid-range 17mm-55mm zoom is the workhorse for most of the day, giving way to the 80-200mm zoom when I need more reach, and a 10.5mm fish-eye goes on when I want to record a near 180-degree sweep. The full kit includes a 50mm f/1.4 for extreme low-light conditions, and a 105mm f/2.8 macro for close-ups of small details (like rings and flowers) as well as some tight portraits.

The Rise of the "Digital" Lens

The crop factor has led to the design of new lenses built to take advantage of specific sensor formats, using the smaller image size to make lenses that produce a smaller projected image (the circle of illumination). That usually results in a more compact design, and—sometimes—a significantly lower cost.

Take the example of the just-mentioned Nikkor 10.5mm f/2.8 G DX digital fish-eye with a 180-degree angle of view, designed for the 1.5x Nikon format. It sells for about $600, and with dimensions of 2.5" by 2.5" is almost exactly the same size as the 50mm f/1.4 35mm film-format lens. It weighs in at less than 11 ounces. A 35mm format 14mm Nikkor extreme wide angle with a much narrower 114-degree angle of view (90 degrees when placed on a 1.5x digital sensor) has a street price of $1500, and weighs in at almost 24 ounces.

Matters of Quality and the Need for Speed

Professional-quality lenses cost more for good reason. They generally have better optics than consumer models, with better contrast and resolution, thus improving the quality of your image. They are built to take the punishment of a busy work environment. In today's digital world, good lenses tend to be more of a long-term investment than cameras. Cheap lenses don't hold up over time. In fact, many of the better older models designed for film years ago are still fine performers (and often a good value).

When you hold the shutter down and fire a series of fast shots, the lens diaphragm and focusing gears are working hard. The helical mounts and bearings get a lot of exercise as well when tracking the action of the day. Less-expensive lens barrels are often made of plastic (and sometimes even their "glass"), while the professional models have metal barrels and precision glass with custom coatings to reduce flare and improve image contrast. This is especially true with zoom lenses. Some less-expensive models drift into their most extended position when facing down. They don't have tight-enough helical threads to handle the weight of the lens—a clue that the push-pull of rapid adjustment will cause problems over time. Some budget lenses even have plastic mounts, and lack the tight secondary seal that quality products have to reduce the risk of dust and grit getting inside.

A wider aperture means a brighter image for faster focusing as well as the ability to use a faster shutter speed. Church interiors can be very dim during the actual service, a time when you usually have to shoot using available light. Even with high ISO settings, obtaining acceptable results is much easier with a lens that can shoot at f/ 2.8 or faster—read "professional quality."

To cut costs, most mass-market zoom lenses have a variable maximum aperture, which can vary about two f/stops between the near and far end of the range. Their widest maximum aperture is often 3.5 at the wide end of the range, and f/4.5 or even f/5.6 at the telephoto end. Designing and building a fast fixed-aperture zoom is much more difficult and expensive than producing a "kit" model.

If you choose to, or have to, use manual exposure, then a fixed aperture is even more of a necessity—especially with flash. You can't set the shutter speed quickly when you have to double-check or estimate the f/stop, and when you zoom with a variable-aperture lens, the exposure shifts with the AOV.

Quality lenses don't come cheap. The table below shows the price and primary features for three mid-range zooms designed by Nikon. Two are "kit" lenses, designed to provide a companion mid-range zoom that will still keep the overall cost of a camera like the D40 or D70 reasonable. The 17-5mm is a lens that fits the "spared no expense" motto, and it shows in both quality and price. While the others are acceptable budget lenses, they lack the performance and image quality of a professional lens.

Table 3.3 Midrange Nikon DX Zooms Compared

	AF-S 17-55mm G f/2.8 IF ED DX	AF-S 18-70mm f/3.5-4.5 G DX	AF-S 18-55mm f/3.5-5.6G DX
Lens			
Design	14 elements in 10 groups, 3 ED, 3 aspherical	15 elements in 13 groups (three ED glass lens elements, one aspherical lens element)	7 elements in 5 groups (with 1 ED glass element and 1 hybrid aspherical lens element)
Maximum Reproduction Ratio	1:5	16.2	1:3.2
Maximum Aperture	f/2.8	f/3.5@18mm, f/4.5@	f/3.5@18mm, f/5.6@55mm
Minimum Aperture	f/22	??	f/22-f/36
All Glass	yes	no	no
Construction	Metal	Plastic	Plastic
Manual Focus Override	yes	yes	no
Rotate filter during zoom	no	?	yes
Filter Size	77mm	67mm	52mm
Cost*	$1200	$265	$150

*Costs shown are U.S. "street prices" for new lenses at the time this table was complied.

Yes, the 17-55mm is over four times as much as its 18-70mm sibling and almost *10 times* that of the low-cost 18-55mm. Yet the advice still stands. Look beyond the sticker shock. Kit and budget lenses cut corners in a very competitive market. The filter sizes for the three lenses above disclose the diameter of the units, and it's easy to see how much more material went into the 17-55mm zoom. Also consider that the effective 55mm aspect of the professional lens is f/2.8 to f/22, while the kit 18-55mm is actually f/5.6 to f/36. Quite a difference when shooting in low light conditions.

Also consider that most optics don't show full quality (sharpness, contrast, full brightness across the image, lack of aberrations) when used wide open,. They look better stopped down two or more stops so that the light is not passing through the most extreme curve of the outer edge of the lens.

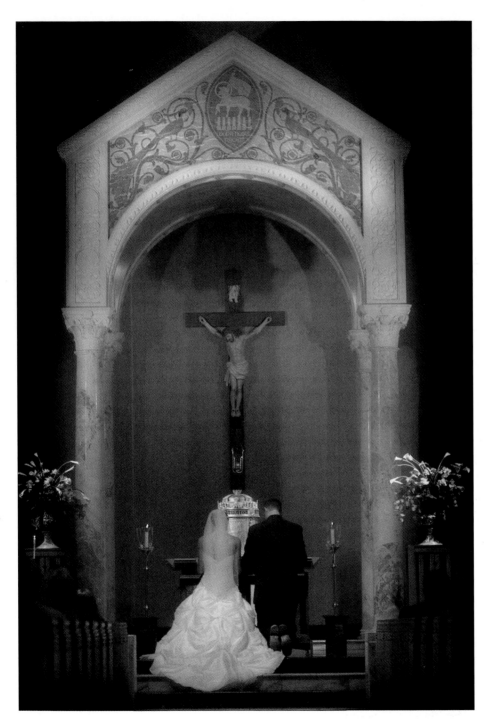

Figure 3.5 Most wedding ceremonies are taken without the use of flash, in dim lighting conditions. Fast, professional quality zoom lenses are not cheap, but earn their keep with results and ease of use. Images like this one require first-class equipment. (Photography by TriCoast Photography)

Elegant design extras, like the ability to manually override the automatic focus without having to adjust the switch settings, or having a barrel that does not rotate during zoom (a hassle when using graduated neutral density and polarizing filters) cost more and are often missing in budget designs.

The basic advice: get a professional-quality lens. If you are shopping for a mid-range zoom, it does not *have* to be the most expensive. There are less-expensive third-party lenses that can make the cut. There are also prime lenses (rather than zooms), used-lens markets, and occasionally, reconditioned products for sale. Buy lenses that produce results that meet the challenges of photographing weddings in your style, and which produce the exceptional images worth your fee.

A detailed review or discussion of photographic optics and aberrations is beyond the scope of this chapter. The resource material provides links to websites and publications that provide detailed information on a variety of lenses that is updated on a regular basis. They are good places to start your hunt for the right lens to meet your shooting style, budget, and camera model.

Flash Units

Weddings rarely take place in rooms with even lighting or with lighting that comes from just one source. When possible, we use fill flash or even full flash to produce well-lit images and exposures that freeze subject movement and camera jitter.

The best results are usually obtained with "dedicated" strobes which take full advantage of the advanced flash metering and exposure technology built into today's professional and prosumer DSLRs. Together they do an exquisite job of balancing light output to the existing illumination for natural-looking results. Many can be fired using a command module, which provides remote control over output and exposure compensation levels in secondary flash units.

It's a good idea to bring at least two dedicated strobe units, one with an external battery pack to allow fast recycle times. The full recycle time (maximum power, full discharge) for a top-of-the-line model like the Nikon SB-800 is about 6 seconds using just the internal AA batteries. That drops to under 3 seconds with an external battery pack.

Shop around when looking for dedicated strobes and battery packs. The camera makers set the standard, and then third-party vendors like Quantum and Metz push the performance envelope for both speed and power. Consider total output, how fast the unit recycles, the angle of coverage (you don't want dark corners with wide-angle shots), remote control features, and cost.

Figure 3.6 High-end dedicated compact strobe units designed by camera makers, like this Nikon SB-800, offer wireless control, advanced metering capability, and high speed shutter synchronization.

Figure 3.6a Quantum's Qflash 5d-R is a high-end compact flash with an impressive array of accessories including powerful external battery packs that dramatically reduce recycle times between exposures.

While the dedicated units will work on the camera's hot shoe, most wedding photographers and photojournalists place the flash off-camera to reduce both harsh shadows and red-eye. That usually means a cable and some form of bracket. Some shooters prefer a "potato-masher" (named due to its shape) strobe that is designed as a remote unit and can take advantage of tools like a bare bulb.

For large group shots (and there are almost always some of those to shoot after the ceremony), or to light the reception, studio-style strobes are part of many wedding photographers' kits. Umbrellas, reflectors, and light stands round out many collections.

If you are new to advanced lighting techniques and equipment, it's a good idea to seek out advice and practice before actually using the gear at a real wedding. PPA (Professional Photographers Association) meetings, and other photographers, are good sources of information. Assisting a more seasoned professional is a good way to see how to set up and use lights.

Light Meters

Certainly, the cameras will have sophisticated built-in meters. Nonetheless, I still carry a separate incident/flash meter for a couple of reasons. An incident meter measures intensity falling on the subject, not the amount of light reflected to the camera position; an incident reading provides a true average of the scene. It isn't fooled by backlighting or material having high- or low-reflectance levels (like white gowns and dark suits). The flash meter makes it easy to balance the strobe lights for the group shots or to light up events at the reception.

Basic dual-purpose models like the venerable Minolta IIIF are good starter meters. It can be found used for around $140 and lets you take both ambient and flash readings (and even combine and compare several readings with its memory function).

State-of-the-art models like Sekonic's L-758DR Digital-Master add lots of bells and whistles—and cost. It is an incident/flash/reflective 1-degree spot-meter all in one. The $499 L-758DR can be programmed to match the sensitivity of up to three cameras, as well as their dynamic range. You can then set a highlight or shadow value so that the unit can warn you if a portion of the image will be outside the recordable range of the camera.

It sports a Pocket Wizard–compatible radio trigger which can trip and measure several strobes remotely, and then the analyzing function can combine flash and ambient readings, as well as show the percentage of flash in the total exposure. This kind of power may not be essential for a one-photographer wedding in a small church, but can be a real timesaver with a more complicated event and lighting situation.

Depending on the demands of the job (and the available equipment), a photographer may bring along high-powered strobes, additional lighting gear, reflectors, and backgrounds. My personal kit always also includes a tripod and a small ladder.

Figure 3.7 The Sekonic L-758DR DigitalMaster offers a complete exposure metering/analysis solution and wireless operation.

Brackets and Tripods

Most of the wedding day is photographed hand-held, often with flash or fill-flash lighting. Most pros use a custom bracket to keep the flash head positioned above the lenses and far enough away to eliminate "red-eye" in subjects. That position also reduces or eliminates the harsh shadow from the flash by casting it lower and behind the subject. Look for brackets with a comfortable grip and a quick-release tripod-mounting plate. The better ones feature a rotating device that does not require releasing a locking mechanism. That is a real plus, but adds to the cost.

Tripods are a great image-enhancement device, even at "reasonable" shutter speeds, and also reduce the strain of carrying the gear. Fixed shooting positions from a hidden location, say at the side of altar, in the back of the church, or in the choir loft, are all good locations for a three-legged assistant. Well-designed camera brackets and tripod heads have quick release plates, and I have extra plates. They sit on the camera base and my 80-200 tripod shoe. All I have to do to change locations is snap one into place. They are small enough to be out of the way when the camera is being hand-held. Be sure that your tripods are not blocking an aisle or fire exit!

Memory and Batteries

Memory and batteries are small items that have to work and last the entire event. That means buying products that will be sure to work in your gear flawlessly, and get more than enough for the job. Be sure to match all compatibility and performance demands. Memory performance varies with the price. You may not need the fastest ones if your camera does not shoot or write that fast.

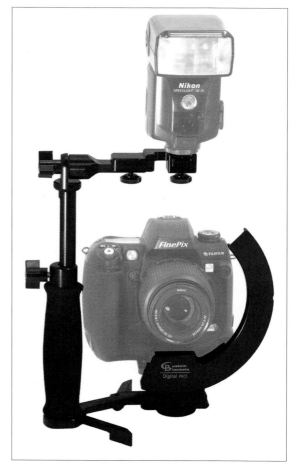

Figure 3.8 Flash brackets are designed more for function than looks, improving the appearance of flash pictures.

Rechargeable batteries save money, but be sure to have a set of back-ups. It's hard to tell when many flashes are about to die. I keep a fresh set of single-use batteries for each device in the kit—just in case. Know the warning signals for when a card or rechargeable is about to fail, and replace it before the next wedding.

Gadgets and Goodies

The preceding topics cover the fancy photographic equipment, the big-ticket items. There are lot of small items that make the job a lot easier. While many are also considered photographic accessories and supplies, many are off-the-shelf products that are useful during the shoot.

Every wedding photographer develops a "Goody bag" over time. My standard items include gaffer's tape (more expensive than duct tape, but holds better and comes off with less risk of taking paint), power strips, extension cords, spare cables, a GigaView card reader/hard drive combo, spare gray cards, hair brush and combs, spare batteries for everything, pens, notebook, business cards and marketing handouts (somebody will catch the bouquet and garter!), walkie-talkies, and anything else that may be needed and are not at the site.

Cases

All that gear has to be securely packed and easily carried to the shoot. There is wide range of products, but remember that anything sold as "photographic equipment" is more expensive than similar items in the hardware or big-box store. Well-designed padded bags are a wise investment for fragile gear, like cameras, lenses strobes, and computers. A professional camera/computer backpack can haul all of your primary gear and leave your hands free to carry other bags. It's a good idea to make sure the bag will pass as airline carry-on luggage. If you have to check a bag for air travel for a remote shoot, a lockable hard-shell case like those from Pelican might be in order.

Light stands and umbrellas need a long narrow case; the fabric ones from Photogenic are lightweight and come with shoulder-strap handles. For cords, cables, tape, repair kit, and all the miscellaneous gadgets, large tackle boxes are a good choice.

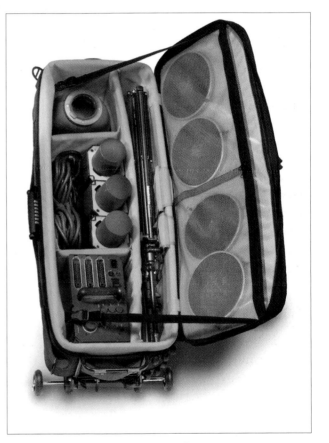

Figure 3.9 Cases come in variety of types and sizes. We tend to chose and pack ours to divide the contents by the type of gear they hold. Padded soft cases, like the one in this picture, are easier to transport than hard shells.

> ## Tip
>
> If you do check gear as luggage on a flight, make sure your insurance covers that kind of risk, and don't label the case with your studio name or mark it as photographic equipment—it's an invitation to thieves. I once heard of a photographer who marked his cases with labels for a fictitious mortuary supply company and never had a problem with theft!
>
> If a trip involves international travel, be sure to fill out a "customs declaration ownership" form for each major item before leaving the country. That avoids the risk of having to pay duty on the way back if you can't prove they were bought at home. The forms and a validating customs officer's signature are available at your departing airport.

Equipment List Summary

Filling in the names of specific products on the shopping list is a personal matter, based on the amount of money you are willing to spend (or have available), and may require trade-offs in quality and capability. In general, better gear will result in improved performance and reduced risk of frequent repairs. Primary lenses (one focal length rather than zoom) will cost less, but require more lens changes (and maybe missed shots). Less lighting equipment will mean more reliance on using available light. It's a rare photographer who says, "I have all the equipment I need (or want)." The important thing is to have the tools to capture the wedding with professional results. Here's a summary of our basic list in bulleted form with a few notes in review.

- **Camera Bodies:** At least two DSLRs with both automatic and complete manual controls, interchangeable lenses, removable memory and a sensor with ISO sensitivity ranging from 100-1600. The primary should be at least a 10mp model with a burst rate of 6-7 RAW images at 4 frames per second.

- **Lenses:** Professional quality with the ability to cover normal, wide-angle, and telephoto ranges from at least 28mm to 200mm in the 35mm format or about 20mm to 150mm on a digital senor with a 1.5x magnification ratio. Ideally, all the main lenses should have fixed maximum apertures of f/2.8. The appropriate lens shade and lens cap for each lens. A skylight or UV filter for each lens.

- **Lighting:** At least two flash units that take full advantage of any on-camera advanced metering and lighting-control features. The ideal kit will also include two or more high-powered strobes with well-constructed stands, and light modifiers like an umbrella or soft-box for group shots and adding additional light at the reception.

- **Light Meter:** An incident light/flash meter combination separate from the metering system built into the cameras.

- **Tripod and Brackets:** A sturdy tripod with quick release for use with group shots and long exposures. A flash bracket with quick-rotating and tripod-release features.

- **Memory and Batteries:** Adequate memory (with a fudge factor) to hold all the images shot during the entire wedding. Enough rechargeable battery capacity (with significant fudge factor) to power all cameras and strobes through the entire event.

- **Gadgets:** Exposure and color calibration targets, spares for critical composites (like cables, sync cords, and non-rechargeable batteries), gaffer's tape, extension cords and power strips, equipment manuals, repair kit, lens cloth, walkie-talkies, hair brush and comb to touch up the subject's appearance, and anything else that will make life easier and insure success.

- **Cases:** The right packaging to pack and protect all the equipment and provide an easy way to carry it all to and from the event.

Going Shopping

Just as with camera bodies and lenses, a photographer's shopping options vary in features and price. The trade-offs are price and service. You don't have to buy everything from one source, or even purchase everything new. The Internet has made camera shopping and feature-comparison easy. Visiting the vendors' websites or one of the photography websites in the Resource Guide will quickly produce a detailed features list and technical specifications, as well as a list with contact information for all the firms listed in this section. Having a plan can save time and money. Make a list, and know what the going rate is for any major items. For any new items from the big names like Canon and Nikon, make sure you are dealing with an authorized professional dealer, and make sure the item comes with a USA registration card. There are stores that get products from overseas and don't carry USA support or warranty coverage. This is called the Gray Market.

Don't buy Gray Market! You save about 10 percent, but lose technical support and have to go back to the store for repairs and service. That extra 10 percent is worth it the first time you need help a week before a wedding or on a holiday weekend. Consider, Nikon USA provides 24-hour-a-day telephone support and Nikon Professional Services offer expedited repairs—but not for Gray Market purchases.

Something Old, Something New

That old line applies to the savvy photographer's gear as well as the bride's outfit. Because of warranty issues, I wouldn't buy a used primary camera, but there are some great deals available on back-up camera bodies, used lenses, flash gear, meters, and photographic accessories. Look over your list and check the used equipment inventory before buying new. I've bought used lenses, a flash meter, and an external battery pack, as well as odds and ends. I've also sold some items as well.

If you plan to buy used, know the seller, and make sure there is an unconditional money-back guarantee. No "Restocking Fee," no "Return for Credit Only." The best-known name in used gear is KEH in Atlanta, founded in 1979. They send out a monthly catalogue and keep a list of their current offerings on their website, organized by category. They also have good prices on some new items, like memory cards. Virginia-based Used Camera Sales has been around since 2004, with similar polices. Both will ship an item and let you inspect or use it for several days and take it back "no questions asked."

Tip

A quick visit to the manufacturer's website may offer savings as well. Check for an online store and then look for refurbished items on your list. There may be demos, repairs that took too long, etc., for sale. I saved several hundred dollars on my 17mm-55mm Zoom Nikkor that way.

You can save money on new equipment too. There are some big-name camera stores that pass on their volume savings to the customer, like B&H Photo Video and Calumet Photographic. They offer both new and used products on their websites with a very good level of service. Remember what I said about Gray Market. Some of the big names offer both. Calumet also has its own line of excellent lighting gear, like reflectors, panels, stands, and booms.

Another caution, especially when shopping for the newest model, which may be in short supply, or trying for the lowest price, is to be sure to know the vendor and to read the fine print. There are sellers who promise items they don't have in stock, and then sit on your money. Another scam is the "camera kit." The sales clerk offers a real deal on the high-end body, but you have to get the "kit" with one or more cheap lenses and extras. In some cases the two games are played together. They sell you the combination deal, and the only thing that arrives is the "kit." Then they offer to sell you a different camera because the one you want is "back ordered." Once again, make sure you are buying from an authorized dealer.

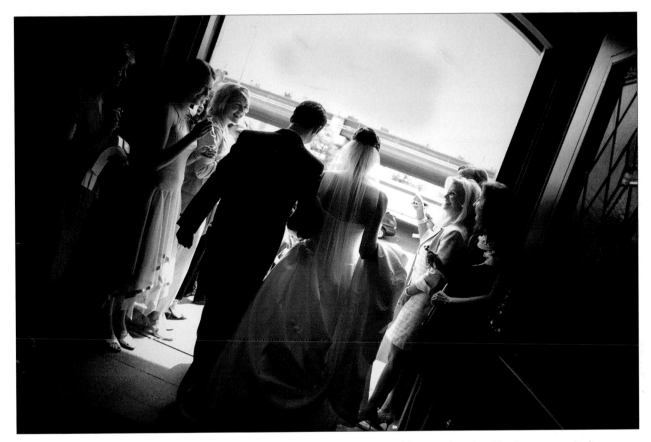

Figure 3.10 Well chosen and well organized equipment makes covering a wedding much easier. The fast pace and often changing environment makes having the right gear available at the right time very important. (TriCoast Photography image)

The highest level of service, but with a somewhat higher price tag, comes from specialty camera stores that cater to the professional trade. The really good ones have trained salesmen who know both their products and what the serious shooters tend to buy. My favorite is Showcase Photographic in Atlanta. I've known the owners for over 30 years, and their staff always comes through. Recently I was shopping for a camera backpack for an assignment in Europe, two days before the trip. The salesman asked what I was going to pack, then actually loaded prospective bags with matching gear, and then called me with the resulting product choices and prices. The bag arrived the next morning, a perfect fit.

Next Up

There may be a lot of computing power in a digital camera, but it won't process or print our images. Now we turn our attention to the hardware needed to finish the job.

Photograph by Mark Ridout

4

It Is *Digital* Photography— Computers and Software

Today's microcomputer and the programs it runs are just as important to the wedding photographer as the camera. At the event and back in the studio, computer technology plays a major part in the successful wedding assignment. Your website is a major marketing tool; contact programs keep track of clients, while photo editing and design software replace the darkroom. A fast Internet connection is the way proofs are delivered and how images get to the lab for printing. To be productive, we need machines that can help manage our business, make quick work of editing, and provide reliable results when sending jobs to the printer or photo lab.

Digital photography demands more from a computer than just about any other task (serious computer games are more graphics intensive). Many photographers spend more time at the computer than behind the camera; those who don't have the right combination of hardware and software spend more time there than needed. We manipulate large RAW images files with feature-rich applications using high-resolution displays. The good news is that today's PC or Mac can handle the task without breaking the bank, if we buy wisely.

This chapter shows you how to choose and configure a system with the right hardware and software. We'll start with the computer itself, then introduce the accessories, and finish with a tour of the major software applications. Those programs will be featured in later chapters, where we will see how they earn their keep managing files, editing images putting your proofs on the web, producing slideshows, and designing albums.

Desktop, Laptop, or Both? Mac or PC?

There is no "perfect" photographer's computer. Different users will need or want different features. Most of the software we use comes in both Mac and PC versions. (And the attitudes and debates surrounding which to own are just as fervent as the debate over the relative merits of Canon and Nikon.) We'll leave that argument aside and focus on features and configuration.

Desktop machines are still easier to configure and upgrade, and (if you compare based on equal performance) less expensive to purchase. Today's notebooks have the power to handle the work and the portability to work at a wedding, go on client consultations, and handle multimedia presentations at bridal shows.

Many photographers have both: a full-featured desktop for editing and website management, and a notebook for on-site duty. Wise shooters back up files on-site as a card fills up. With a DVD burner on the notebook machine, you can even create a "back-up back-up" (not an excessive practice) right away. No matter what approach you take, there are some basic features the machine must have.

Smart Shopping and Must-Have Features

The easiest way to define the requirements for any computer system is by providing a mission statement. Here it is. No matter the brand, operating system, processor type, or color of the keyboard (just kidding), a wedding photographer's computer has to handle three primary tasks—properly run the software, safely store files, and provide a fast connection to the Internet. If it can't handle those three tasks, it fails, and you suffer.

Unless you farm out all your editing, album design, bookkeeping, marketing, correspondence, file management, and website care, your computer will be host to a variety of programs. Make sure the machine has enough processing power and graphics display capability. A couple of hundred dollars spent on RAM and a fast display adapter will save hundreds of hours of editing and design time over the life of the computer

Parts Are Just Parts, but Not All Parts Are Created Equal

No matter the manufacturer, whether a Macintosh or a PC, desktop or laptop— all microcomputers are still just a collection of parts. The computer vendors buy these parts from chipmakers, graphics-adapter companies, hard drive manufacturers, and so on to make their products. There is a constant evolution in computer design, as designers improve performance and add features, seeking a competitive edge. Computers with the newest and fastest central processing units

(CPUs) and latest multimedia capabilities are billed as the most powerful and are the most expensive. As wedding photographers, we need high performance, but we don't necessarily need the fastest CPU or the most feature-rich display adapter.

CPU and Memory Considerations

When it comes to graphics-intensive operations, like editing digital photographs or creating a multimedia slideshow, the CPU is not the sole (or even the most important) performance factor. The amount of available RAM (random access memory), and the graphics adapter's performance (at the working display resolution) plays at the least, an equal role in overall computer execution speed.

Figure 4.1 An Intel Duo Core CPU.

The amount of RAM in the system is a critical factor in how fast a program operates. When the available RAM falls below the amount needed to perform an operation, the operating system has to swap portions of the files being worked on to and from the hard drive. That really slows down performance. In short, you should have at least the recommended (not minimum) amount of RAM in the computer listed for the most demanding program you use. In general, you can drop down on CPU speed by about 35 percent if you double the amount of RAM. The least amount of RAM for serious digital photography is 1.5GB, but 2-4GB is better.

If you have the money, load up on the RAM and then get a faster processor. The combination will extend the useful life of the computer. The multi-core technology developed by Intel does work, and CPUs that effectively use it can outperform lesser models with much faster clock speeds. A review of products and performance before shopping is a good investment of time that can save time *and* money later when you put the new computer to work.

Display Adapters

The display, or graphics, adapter is the card that processes and manages the picture displayed on the computer screen. Having a machine with a high performance graphics adapter (or even two) is very important. The better graphics cards have advanced processing technology and more self-contained high-speed memory dedicated solely to graphics operation. You do want a high-performance graphics card, but it does not need to be the fanciest card in the store. Some features,

like 3D rendering, are more important to gamers than to photographers. Look for faster memory in greater amounts, and 32-bit operation at higher resolutions than is offered on the standard machine.

Depending on the hardware configuration, it is often possible to actually use two display adapters with two monitors on a single machine. This setup makes it possible to dedicate one monitor to display the photograph being worked on, while the second monitor is used to display editing tools and the desktop. Depending on the operating system being used, it may only be possible to color-correct one of the monitors (more about that in a minute).

Monitors

There are a number of different ways to categorize monitors that are important to wedding photographers: big screen and small screen, basic and professional controls, flat panel and CRT. As a general rule, the better of each option is preferable for wedding photographers. For desktop computers, a 19-inch screen is about as small as you will probably use in a single monitor configuration. On my desktop, I use a CRT-style 24-inch monitor. Bigger is better when it comes to notebooks as well. My current model has a 17-inch wide-screen display. The big screen comes in very handy not only for editing, but also for giving demonstrations and DVD slideshows to clients.

More is better when it comes to controls. Less-expensive monitors generally only have basic controls like brightness and contrast to adjust the appearance of the display. Advanced professional controls are necessary for critical color calibration. That means gain and bias controls for each color gun on CRT monitors. Controls on flat panels will not be as extensive, and may be located deep within the adapter's Advanced settings. Figure 4.2 shows settings for an Intel-based notebook screen that provides gamma, contrast, brightness, and saturation adjustments. We'll look at why we need advanced monitor adjustments in the next section, "Color Calibration."

Figure 4.2 Typical advanced settings for notebook display/adapter configuration under Microsoft Windows.

Color Calibration

In the days of film, color management was easier for most photographers. There were daylight- and tungsten-balanced films, and fine tuning (such as it was) was done with color-correction filters over either the camera or the enlarger lens. With digital technology, color correction is a "bit more involved," and matching color throughout the photographic process—from camera to monitor to the final output device—is a major workflow consideration.

The human eye can't accurately calibrate monitors to output devices. The most effective solution is a hardware sensor coupled with software that uses precise targets. The program uses the results of the sensor's readings to fine-tune the colors sent to the monitor by the display card. The most precise monitor calibration requires the ability to tune the monitor, as well as the display-card settings. With current technology, professional-quality CRT monitors calibrate much better than flat-panel models. When shopping for monitors, find out which controls will work best with your chosen calibration.

If you do in-house printing, rather than sending the work out to a lab, a printer calibration device may be a good investment. These include densitometers that read a calibration target, produced by the printer, to match the monitor to the printer output.

Precise color calibration is important when printing wedding photos, especially for albums. Brides want images with pleasing skin tones, not to mention dress and flower colors that match what they remember. If a photographer can't be sure the print will look like the monitor, those results

Figure 4.3 The ColorVision Spyder2Pro is a popular and relatively low-cost calibration tool.

become either expensive or problematic—even with good lighting conditions from a single source. Getting acceptable color when you have variations from mixed lighting in a scene is even harder. If several images are next to each other in an album, imperfections will be obvious. We'll look at how to handle the workflow challenges later in the book.

Pointing Devices

Most of a photographer's computer time is spent working with graphics applications. That generally means making more clicks with a mouse than keystrokes. The simple mouse that comes with most new computers does not have the ergonomic design needed to be comfortable for extended use. An ergonomically designed wireless mouse that properly supports the hand and provides a comfortable angle

for the fingers is a good investment. Most office supply stores have a selection of mice and keyboards on display so you can try before you buy.

Digital management software and RAW editing programs generally don't call for specialized pointing devices; a mouse will work just fine. Detailed retouching, using pixel editors like Adobe Photoshop, require precise control over the cursor. For this kind of fine work, nothing beats a good graphics tablet. Models like Wacom Intous3 (seen in Figure 4.4) incorporate a pressure-sensitive stylus, exact one-to-one correlation between the stylus and the cursor's screen position, and some very handy function keys to speed up work.

It's a good idea to shop around for tablets. The vendor websites often offer tablets at refurbished prices, while many dealers offer deep discounts.

Figure 4.4 The Wacom Intous3 Graphics Tablet.

Storage and Backups

Image files tend to be large, and we shoot lots of images at a typical wedding. That means we need lots of disk space. To perform well, your computer's hard disks should always have at least 30 percent of their space available. This is easy if you buy a desktop with enough bays to add more drives or make use of external storage on both desktops and laptops.

Planning a storage solution (and paying for it) is easier if you design it in tiers. The first tier is the primary drive on the computer. This should be the fastest drive, either serial ATA (SATA) or SCSI. Here's where the operating system, programs, and the image files you are currently working on reside. On a desktop computer,

you can add additional high-speed drives inside the case that use the same technology. Another approach is to use a RAID; it incorporates both data redundancy and high-speed performance. Using external drives makes it easy to use files on more than one computer, or to move files between them, without clogging up a network.

It's imperative to have good backups of all your files. My personal backup plan is a set of external hard drives and DVD data disks. I use inexpensive high-capacity (>300GB) ATA drives that are mounted in third-party USB or FireWire enclosures. I can buy the external cases for about $35.00 over the Internet, and I've seen them at Wal-Mart for $45.00. Installing the drive is easy: just attach the data cable and power connection cable inside the desktop case, and then plug in the power cord and plug the unit into the host computer.

Pocket Backups at the Wedding

There are several products like Jobo's GigaVu Pro That combine a memory-card reader, a small display screen, and a hard drive in a package about 4 by 5 by 2 inches in size. Slip a memory card into the reader, press a couple of buttons, and you're making a backup. The GigaVu has a USB interface that can link to your computer, and voila! It's an external hard drive with your files on it. I use one to make backups as soon as a card exits the camera, without having to locate the laptop. (Still, bring the laptop; always have a second way to back up).

Figure 4.5 Jobo's GigaVu Pro Revolution makes easy work of backups during the wedding.

Active weddings are backed up to the external drives as soon as files are edited and saved. Completed weddings are archived using the same folder structure they had on the primary drive. That way, if I have to open them again in a program to recreate a slideshow or album collage, all I have to do is copy the folders back over to the C drive and fulfill the request.

I use a DVD burner to make two sets of backups of the original RAW files immediately after the wedding is shot, as well as backups of working files as edits are made, slideshows are developed, and albums are designed. I keep one set of backups in the studio, and the other is stored off site in case of fire or other catastrophic occurrence. We'll cover this aspect of workflow in more detail in Chapter 13.

Scanners, Yes or No?

If your operation is totally digital, you may not need a scanner. Flatbed scanners are handy for capturing digital copies of wedding invitations or similar artwork to include in an album. They can also serve as the input device for a computer-based fax system. Photographers who move to digital photography from film and still have an extensive negative collection may consider investing in a slide scanner as well as a flatbed.

Connectivity

The modern computer is a social beast. Consider before shopping how easy will it be to connect the new computer to existing and planned devices like (but not limited to) cameras, external drives, projectors, TV sets and a second monitor, a RAID, a tape drive, FireWire and USB devices, networks, the Internet, scanners, and printers. Most high-end notebooks come with a reasonable array of ports; desktops may come with fewer standard ports, but can be easily expanded to handle almost any connection.

My personal minimum for a laptop is at least 4 USB ports, standard VGA and DVI video ports, a FireWire connection, standard audio ports, and both WiFi and UTP network capability. Add to that some form of card reader and a PCMCIA slot for additional expandability. My desktop list is basically the same, but with two UTP network cards rather than the wireless/cable mix. The desktop's expansion slots eliminate the need for the PCMCIA compatibility.

Printers

Printing capability will vary greatly between wedding photographers. Photographers who plan on sending all their image printing out to a lab still need a device to handle invoices, brochures, and general correspondence. The best choice for this kind of work is a laser printer. Inexpensive lasers cost more initially than inkjets, but rapidly pay for themselves with a lower per-print cost.

If you plan on offering prints on-site at an event, consider a dye-sublimation printer. These have much faster throughput than inkjets. Inkjets are best suited for in-house printing of black and white images, as well as for large-format prints.

Before investing in expensive printers, do a cost comparison with labs that provide traditional silver prints. If you perform your own color calibration, and use the web for "as is" prints, an 8x10 unit can be as cheap as 85 cents each.

Power Considerations

Fully configured desktops for graphics—sporting a powerful CPU, loaded with disk drives, burners, interface cards, readers, USB devices, and maybe two display adapters (with monitors)—are energy hogs. Many PCs ship with an inexpensive power supply and minimal cooling capability to cut costs. Consider upgrading to a first-string high-capacity power supply, like those from PC Power and Cooling. The payoff is in a more reliable machine that is better able to handle the demanding requirements of serious photographic editing. Also make sure that there is good surge protection and, ideally, an uninterruptible power supply device attached to the machine.

The Modern Wedding Photographer's Software Library

Once upon a time—within the memory of some of us still shooting today—the complete wedding photographer's studio contained a film processing darkroom, a print darkroom, a toning room, and a retouching bench. There was also a library of negatives, a location for assembling albums, cutting mats, doing framing, and perhaps a consultation room for looking over proofs with clients. There were no computers, no printers, not even a modem.

Today, almost all of those functions have been replaced with a computer, software packages, and a website. The smart digital wedding photographer uses several applications to maximize productivity, the quality of the product, and profits. There are those who still rely almost solely on Adobe Photoshop, perhaps with the addition of a few plug-ins, to handle all of their image editing. They are barely one step removed from the darkroom.

Photoshop is an excellent pixel editor. For retouching, especially when combined with a graphics tablet and the right add-on filters, it is second to none for removing stray hairs, unwanted backgrounds, and giving a bright-eyed look to a group member who blinked. For culling images, RAW editing, batch operations, dodging and burning, color and exposure correction, and reducing noise and lens aberration—time has passed that venerable first-generation editor by and brought new solutions to the fore.

The rest of this chapter outlines the types of software available, presented in the same order as my standard workflow, and introduces at least one popular program in each group. The choices are based on the programs I know and use, and the comments are based on my personal workflow and experience.

Be aware that these categories are not precise labels, but rather an indication of what (for me) the program does best. Just as with photographic gear and shooting style, it's a good idea to keep an eye on the market and play with new ideas and toys. Software is much like optics, and a new program can extend your vision much like a new lens.

Many packages have a long list of features that cross several task areas. Evaluate and choose the mix of programs that enhances your style of photography and business practices. The less time and effort spent performing mundane tasks like renumbering images, renaming files, or mousing around menus, the more time available for being creative and finding new clients.

Note

The real features that distinguish programs can be tricky to discern. The digital photography market is very competitive. Vendors add new features, bundle with compatible products, and license limited editions to gain market share. All of the programs listed provide free trials on their websites. Try before you buy and see if the claims are real, as well as if the features really do the job the way you need it done. A little investigation can save lots of time and often some money.

Some photographers love working on computers and managing every aspect of the business. Others let someone else design albums, manage the website, and perform similar tasks. Even then, it is worth knowing what's involved and be able to take over if necessary.

So, let's start the introductions. We will return to many of these programs in following chapters to look more closely at them in a real work environment that will give you a better idea of how they operate and their benefits. For now, we will look at how they fit into the life of a wedding photographer and name the major players. I'll provide my personal impressions of the program on the way. Keep in mind that my workflow and experience may be different from yours.

Organizing the Work—Digital Asset Management Programs

Even a small modern wedding can generate a thousand images, even with a single shooter. Two photographers can double that; if you're at a large wedding with double coverage, all bets are off. Getting the resulting files culled, cropped, tweaked, resized and renumbered, then proofed and up onto the web quickly (within a couple of days), can significantly boost sales. So how do we do that without pulling all-nighters and cutting corners?

The same way we catalog, annotate, and create our backups—with DAM. Digital Asset Management programs have sophisticated tools for all those tasks and more. They can create web galleries, slideshows, basic DVD presentations, watermark images and more. Sure, many RAW editors offer some degree of DAM capability, but the volume of work in a busy wedding studio makes the $150-to-$250 price tag of the better programs worth the money. The DAM program is the first stop for wedding images on my computer.

Figure 4.6 ACDSee Pro is a popular DAM solution that is easy to learn and use.

There are some editing functions, including RAW camera support, built into in the full-featured DAM applications, but they are not as robust as dedicated image editing packages. It's worth repeating. The best way to evaluate their features and see which offers the best solution for your workflow style is by taking advantage of the free trial versions available on the vendor websites.

iView MediaPro and ACDSee are very similar in overall features. You can use tools like star ratings and color-coded tags to sort and select files. I use the color codes for two tasks. One set of colors denotes the category within the event. For example, one color for the pre-ceremony shots and walk down the aisle, another for altar shots. Then a third for the reception. That makes it easy to sort images, based on lighting for exposure and color balance adjustments. It also helps when it comes time to assemble groups of images for album design. The star rating system is handy for evaluating the quality of a shot compared to similar pictures. The higher the rating, the more likely it is to be included in the proofs and get additional retouching.

I found ACDSee easier to learn, and it offers a simpler user interface. iView has some really slick image comparison and database management tools that require a bit more practice to master, but offer payoffs that are worth the effort. (Microsoft recently bought iView, and as this book was written, was re-branding MediaPro as Microsoft Expressions Media, and making some changes to the user interface. The new edition was not available in time for screen shots, so we will work with MediaPro).

Figure 4.7 iView MediaPro provides solid database features and batch processing capabilities.

Processing the Images—RAW Editors and Capture Software

Once you have culled and made back-ups, it's time to process the images. This step is much like processing film. Developing film was a part of the photographic process that let photographers adjust the density and contrast of images, even push their ISO rating to compensate for low light levels. Now we do that with software. My personal workflow is to separate this step from retouching. That is the phase where detailed corrections are made to limited portions of an image before a final print is made. Right now we just want the best overall result for proofing—quickly.

Throughout this book, I champion the use of RAW images as the preferred file format. RAW provides the most control over the appearance of the final image, and the easiest way to correct problems of color balance and exposure that can happen all too easily in the changing environment of a wedding. It also lets us edit using some really excellent editors to quickly make batch corrections to the mass of images created during the nuptial event. There are programs that "do RAW," and there are those that are dedicated to RAW. RAW is not really a format in the sense that Photoshop PSD, TIFF, or JPEG are. RAW is simply the actual data recorded during the exposure. Some dedicated RAW programs don't even open other formats, but most offer the ability to edit TIFF and JPEGs. In most cases, once the RAW file is edited, it's converted into a more "portable" format and exported by the RAW editor. That's what the camera does if you specify TIFF or JPEG as a format in the camera. It creates the RAW fie, then processes it and writes out the new file with the selected options.

Since all my shots are in RAW, a RAW editor is the second stop for the image file. I then export a combination of JPEGs (for proofs and a DVD slideshow) and TIFFs of the images that are marked for additional enhancement or retouching, or inclusion in the album design.

Dedicated Camera Software

When considering RAW editors, check out the one made for your camera and sold by its maker. Since I'm a Nikon shooter, that's the brand I know and use, so that's the one profiled here. The other camera manufacturers sell programs tuned to their file format. That's the real advantage with proprietary software: they know both the sensor and the file structure better than anyone else. On the other side of the coin, they don't support other camera brands (you may only have one name on your cameras, but what about second shooters?), and often they don't have the advanced batch processing tools and plug-ins that after-market software includes to gain your business.

Nikon Capture NX and Camera Control Pro

Nikon believes in charging extra for a custom RAW editor and has teamed with Nik Multimedia (well-known and respected for their Photoshop filters) to provide a robust solution with Nikon Capture NX. The program provides the usual exposure and color management controls, along with the ability to reduce wide-angle distortion, recover lost highlight and shadow detail, and isolate portions of an image for selective correction, using control points at locations that let you fine-tune adjustments with sliders. Some features will only work with Nikon RAW files. Camera Control provides remote control of all camera functions and settings from a computer via either cable or wireless connection.

Figure 4.8 Nikon Capture NX is fine-tuned for NEF RAW files, and can edit TIFF and JPEG files.

Capture One Pro

Phase One's Capture One Pro is designed from the ground up to make quick work of image adjustments with RAW format editing tools that can be coupled with extensive batch file operations. Once you have a have a set of corrections for a given image (including color balance, exposure adjustments, and sharpening), the set can be applied to similar images with a few mouse clicks. Make fine-tuning adjustments and crop, then batch-rename and convert, and most images are just about ready for the printer. It isn't, however, a detail editor for retouching or working on portions of an image.

Bibble Pro

Bibble Pro offers the same types of batch processing and RAW editing tools found in Capture One Pro, plus some heavy-duty add-ins in a readily accessible interface. Figure 4.9 shows Bibble open with the Perfectly Clear plug-in panel visible. It uses technology originally developed for medical imaging to analyze and adjust a wide range of image attributes including contrast, color cast, clipping, and sharpness. The Noise Ninja plug-in offers precise tools, based on lens and camera profiles, to reduce or even eliminate noise. Getting the most out of this program requires some practice. The more powerful features lacked detailed documentation when this book was authored, so some experimentation is required.

Image editing and enhancement software is a hot market, and it pays to keep current with new products and upgrades. Many of the plug-ins and basic functions in programs like Bibble are also available in more potent stand-alone editions or versions for other products that don't automatically bundle them. Noise Ninja is a good example. You can buy a full license and get additional features in Bibble Pro (plus a Photoshop plug-in), and also a stand-alone version that does not require another editor. We will look closer at Bibble Pro in Chapter 14.

Figure 4.9 Bibble Pro shines with solid RAW editing and batch functions, coupled with third-party add-ins from Perfectly Clear and Noise Ninja.

DxO

DxO is a RAW editor that's best described as image enhancement software. The program has specific modules for the more popular camera and lens combinations. The modules provide both automated and user-controlled tools for the elimination of distortion, vignetting and lens softness, removing of camera noise and purple fringing, optimization of exposure and dynamic range, and RAW conversion.

To get the full benefit of DxO's capability, you have to be using one of the supported products when you take the picture. In many cases, DxO must also be the very first application you use to modify the image. If the EXIF data has been modified, DxO may not be able to use all of its correction tools.

This program can run on automatic and tune the entire wedding directory at once, or you can choose to fine-tune the results manually. As with other RAW editors, the program never actually modifies the original RAW file, but writes a control file as well as exporting the results in traditional formats, like TIFF, for use in other applications.

Adobe Lightroom

The best-known name in image processing isn't leaving the DAM/RAW editor market to the new guys on the block: enter Adobe Lightroom. It's not a replacement for Photoshop, but rather a competitor to the programs we've just examined. It was still under development as this book was written. The information below is based on working with a beta version and discussions with Adobe representatives.

Lightroom's main workspace is the Library, where the user sorts images and performs DAM tasks. Images are collected into a "Shoot" collection. A specific file can only be a member of a single shoot. Once you've culled and marked photos for manipulation, you can switch to other program functions using the Module Picker, located on the top right of the screen.

The Develop module has a bank of interactive tools for performing image adjustments; Slideshow makes quick work of (surprise) creating slideshows for onscreen/online viewing and exporting. The Print module offers an extensive set of output options, and Web is the place to create Flash or HTML web galleries.

Figure 4.10 Adobe Lightroom is a combination DAM and image editing application.

LightZone, a Third-Generation Editing Tool

LightZone is unique, so I've put it in a class by itself. In some ways, it is the first third-generation image editing tool. Notice the term *image editing.*.

LightZone edits are all non-destructive. Each tool works like an adjustment layer in Photoshop. Exposure and contrast are controlled with an interactive grayscale, using a reference image that shows precisely the tonal segments in the picture. Using vector-based regions to select areas of a picture, you can dodge and burn and selectively control all adjustments and enhancements. In this program you don't have to choose pixels. It can work with RAW, TIFF, and JPEG images. I use it to polish all the images that are sold as individual prints or included in the album.

LightZone offers sophisticated exposure, contrast, and color-correction tools which are incredibly easy to master. Its ToneMapper tool does an excellent job of "recovering" detail in shadows and highlights with a bit of practice. There is noise reduction and fine control over black-and-white conversions. I find that I can get results that would take hours in Photoshop in just a few minutes, without having to painstakingly create masks and resort to third-party filters.

You can perform batch corrections, but it lacks the automated file conversion and workflow tools of DAM software and programs like Bibble Pro and Capture One. I love this program for its ability to make creative adjustments in my images. We will cover what it does and how to use it in more detail Chapter 15.

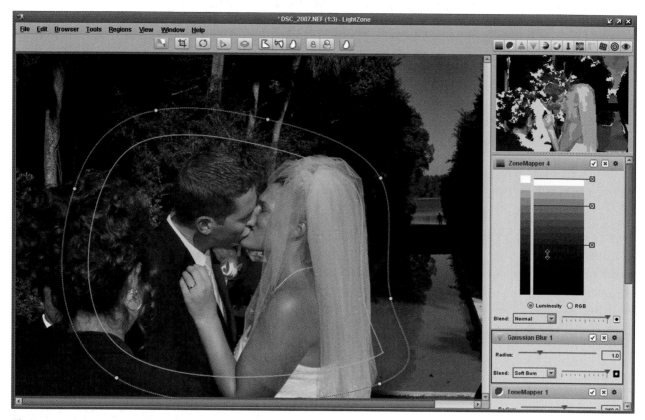

Figure 4.11 LightZone provides an incredibly fast and easy way to creatively manipulate pictures.

Pixel Perfect Results—Photoshop and Its Plug-Ins

In spite of the advantages of RAW editors and LightZone, there are some things that Photoshop (and its plug-ins and filters) still do best. I use it as the final retouching pass for images that need fine detail work. If you want to swap heads in a group shot, remove wrinkles and annoying elements in a picture—in short, traditional retouching, a pixel editor is still the weapon of choice. Programs like LightZone do have Spot and Clone tools, but the fine control of a Wacom Tablet, coupled with the brush settings in Photoshop, is hard to beat for a soft touch.

There are other uses, some of which require even more investment in software. Most of my work is sent to a lab for printing on "traditional" silver paper. The cost is less than in-house production, and my clients get "real" photographs, not ink-jet prints. The Picture Package option located in Photoshop's File menu makes quick work of grouping package prints combinations into 8x10 inch units. Two 5x7s, or four 4x5s, eight wallets—just tell the dialog box what you want, and it does the work of combining and resizing the images.

There are some really neat add-ons that extend the reach of Photoshop into artistic realms, as well as speed up the work. The full version of Noise Ninja includes a Photoshop plug-in, as well as making the program's full features available in Bibble Pro. Nik MultiMedia sells an incredible array of filters for everything from reducing difficult color cast and contrast problems to simulating random backgrounds and producing infrared effects in both color and black and white.

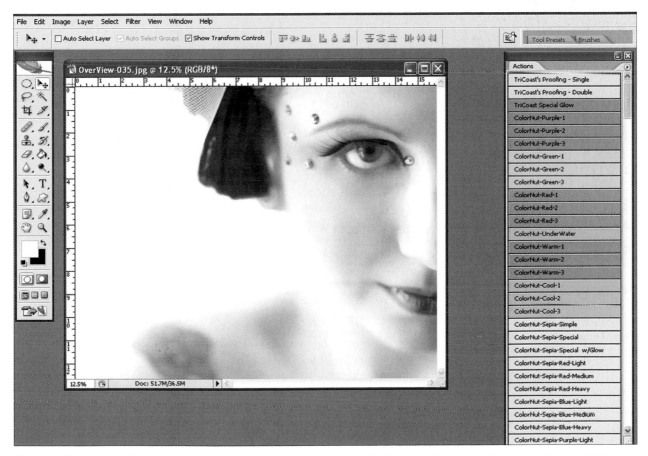

Figure 4.12 A host of third-party add-ons and enhancements work inside the venerable Adobe Photoshop. like the TriCoast Actions seen here on the right side of the work area.

Another firm worth checking out for Photoshop toys is Alien Skin. Two of my favorites are Exposure and Blow-Up. Exposure is a plug-in that can make an image look like it was shot on film, even specific film stocks. For example, you can make a black-and-white portrait with the grain and tonal range of Tri-X Pan pushed to ISO 800 for a grainy edge or get the saturated sky and colors of Kodachrome. It even handles the exotic results of cross-processing.

There are a number of photographers who also market inexpensive, yet powerful, Photoshop add-ons. The TriCoast Photography team has a great set of Actions (automated sets of adjustments) that can really streamline image enhancement.

Multimedia Production with Photodex Producer

Slideshows have become a regular part of the wedding photography business. Quickly added files can be displayed at the reception as a sales tool, and many studios use slideshows instead of paper proofs to avoid unauthorized duplication and reduce costs. Several of the programs we have already discussed offer slideshow production tools as part of their repertoire. For professional results, consider adding a dedicated application like Photodex Producer to your software library.

This program quickly became a favorite in our shop. Creating the basic show is simple: just drag and drop the slides, link to where the sound track files are, then tweak the transitions and add any desired motion effects and captions. All of the controls, thumbnails, icons for effects, etc., are contained in a very intuitive user interface. The music can be automatically or manually synced to the show and individual slides with 1/1000 of a second accuracy.

Once you have the show set up, you can output DVDs, VCDs, CDs, Autorun programs, and dual DVD or CD and PC versions with fancy menus. You can even make streaming video and Flash movies for the web. The standard product is a story-telling show with all the worthwhile images, which runs on both DVD players and personal computers. There are two editions, one without and one with image numbers, which appear after a short delay. The viewer can choose which one to watch from a professional-looking menu.

The discs are copy-protected and can be locked with a password and/or a time-limited functionally. We often give away 30-day editions that have a password. Clients can use them to choose prints. If they want to keep the show as a working copy, all they have to do is buy their password via our website. Many do, and we usually give one or more permanent versions as extras with a large order or a more expensive album package.

It takes about two hours to produce the complete show, and the program lets us burn multiple copies with ease. If there is time between a wedding and the reception, we can also create a simple show of the existing images by processing JPEGs in our DAM program, then using the default show options in Producer. The process takes about an hour. If you have two laptops, one photographer can be making back-ups while the other produces the slideshow.

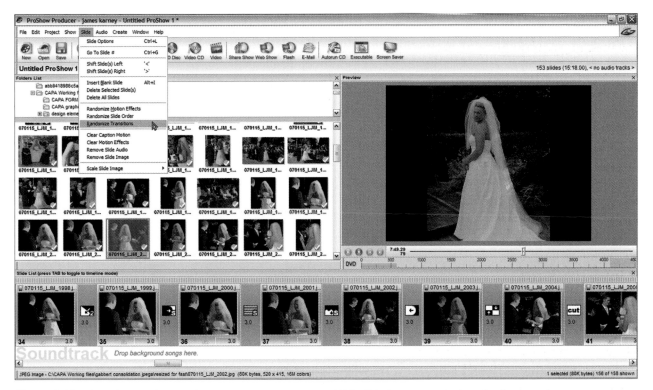

Figure 4.13 Photodex Producer makes it easy to create custom DVD slideshows, even in time for the reception.

FotoFusion—Albums Made Easy

The last step in our production workflow is designing the wedding album. I've often marveled at the people who do this chore in programs like Photoshop or limit the designs to standard templates. We have designed and had proofs at the lab on 45+ page albums, with custom designs of around 150 to 200 images, in about three days. The trick is in having the right software.

Our favorite is FotoFusion from LumaPix. You drag and drop images onto a canvas, then use the mouse and interactive tools to adjust size, placement, shadows, and special effects. One image is set as the background and the rest float over it.

The composite is rendered at output time from the source images, making it easy to adjust and retouch the pictures on a page at any time in the process. The professional version (there are three editions with increasing power and features) lets you have an unlimited number of pages with no size or resolution limits. The program produces TIFFs and JPEGs, which are automatically sharpened to match the desired new size of the final image. We match our settings to the lab and get prints that are ready to go to the album company for binding. More about that process in Chapter 18.

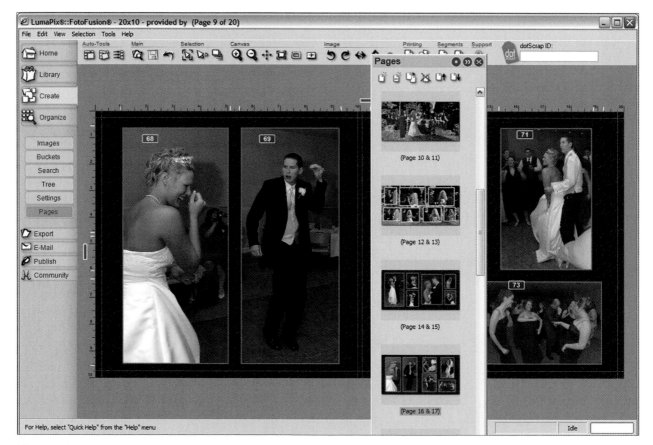

Figure 4.14 FotoFusion is where we design all of our wedding albums and coffee table books.

Next Up

With all the gear purchased, we turn our attention to the clients and the booking process. A wedding booking is a lot like a car deal. There is rarely a fixed price, because there are always options. It is a big ticket item (often one of the most expensive elements of the event), and the buyer is looking for high quality at the lowest price. Good booking skills make for bigger profits and happier clients.

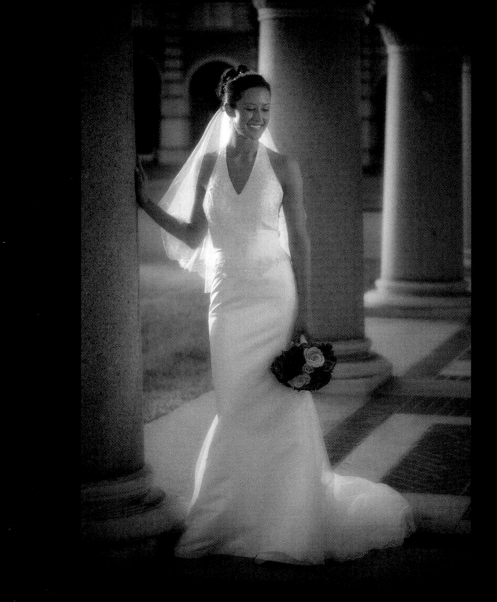

5

The Wedding Photographer and the Web

The Internet has become an essential marketing and customer service tool for any professional photographer. That goes double if you do weddings. If you are already a web doyen, have a killer site and keep up with the latest in Flash, streaming side shows and all that jazz, feel free to skip this chapter. If you would rather shoot than script code (even if you are a super geek), then this chapter will show you how to have a great website and still have time for photos and fun.

A Matter of Style

The Internet is a fact of life for modern photographers. Their websites are a showcase, contact point, sales tool, proofing solution, and sales room. Even those still shooting film (gasp) get business from a studio website. Some wedding photographers I know get all of their business via the web. Some are referred leads, but they still use the web to see the photographer's work; prospects call, knowing in advance what kind of pictures and philosophy the photographer has before the first meeting and consultation. For an example, see Figure 5.1.

It sounds wonderful. But all that technology requires know-how, updating, marketing skills, written copy, images, resizing the images, and keeping up with the latest fashion and styles of pages and pictures. Most of us don't have an in-house

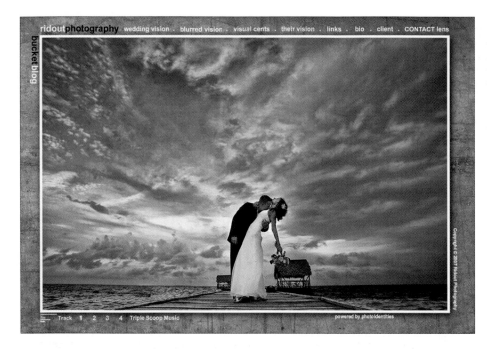

Figure 5.1 The wedding photographer's website is a powerful tool to attract and service clients—if it's well-designed and properly maintained, like Mark Ridout's. Almost all the pages on this website center on the images.

IT department. Even those photographers who have the skills would rather be shooting than writing code and proofing pages. Dated material and old technology has a negative impact on bookings. We are going to cover style, content, and management; along the way, we will look at several first-class sites and discuss what makes a site "work."

I'll have to make a confession. I know how to build and run a website; I have done it for several non-profits as a volunteer, and have the necessary software. Even so, I don't build my own websites from scratch anymore. It's not cost-effective, and it's too much work. I'm going to show you a quicker way to do things that anyone with the savvy to use a word processor and a digital camera should find easy. You can have a state-of-the-art site up in a day or so. It won't involve a pricy consultant, and you can update the content yourself. We'll also discuss some things that anyone with a website should know about content, and how to avoid some of the possible pitfalls in running a website.

If you want to do it all yourself, there are other books that can show you how to code xml, HTML, and Flash, as well as become an expert with DreamWeaver and other site-building tools. We are going to take the express lane, then after showing how to get the site on the net, we'll go into all the details of how and what to put on those pages to create interest and get clients to call. That's why we have a site in the first place.

What's in a Name and Getting an Address

A website is really just a collection of files on a computer network—an oversimplification, but accurate. When we use a browser and type in a domain name like www.courseptr.com (the Internet bookstore of this book's publisher), we are really making a database search. The browser and the Internet handle the technical details of connecting the local computer to the remote site, downloading the information, and displaying it on the screen.

Most websites, as well as their domain names, are rented. Internet Service Providers (called ISPs) provide a network server with a fast Internet connection. Clients load their web pages on the server and the ISP handles the details. It's a lot like the telephone industry. You have to get a number (that comes with the domain name), and have that linked to the web. Most ISPs do both, and it is possible to shop around for a good deal in both site hosting and domain name registration.

Choosing and Registering a Domain Name

Getting a domain name registered is easy. Just locate a company that handles registration, fill in an online form, pay the fee (some ISPs waive the fees if you host with them), and within 48 hours the name is ready for use. Choosing one that says something about you and your business—and that is available—is a bit harder. Virtually all ISPs offer a search page that helps you find an available name, and will then assist in registering it. Figure 5.2 shows the results asking if www.bigpicture.com is available. Nope, and all common .biz, .net, and similar variants of "bigpicture" are taken as well.

While there are people who will sell domain name registrations at full price, deals are far more common. And there is no set price for hosting fees. Sites like CNET.com have reviews of ISPs and their pricing for comparison shoppers.

It's a good idea to find the ISP before choosing a name if you want to try for a discount. Some vendors even charge for moving an existing domain. Many times the sales person will waive setup fees to get a new account.

Figure 5.2 Most ISPs offer easy domain name searches and registration. ReadyHosting.com provides a search page that will also report if any alternate names are free.

Another way to save money is by teaming up with someone else shopping for ISP services. See the Resellers tab on the ReadyHosting menu bar in Figure 5.2? The first account costs full price. All others are half price for resellers. That kind of discounting is a common practice.

Designing a name may be very simple if you have a studio name that works well as a web address and is unusual enough not to be already owned. Then there are variations on the name, and using a different domain type, like .net , .biz, or .us. Another option is to use a hyphen between words. All of those may be in use. Keep in mind that the harder a name is to type (or remember) the harder it will be for people to use. If it is easy to misspell, they may not bother after one or two attempts. Simple is best.

> ## Warning
>
> When registering a domain name and setting up an account, be sure to note the dates when both the ISP contract and domain name have to be renewed. Then make sure to take care of both tasks ahead of time. Many ISPs will automatically renew your contract and bill you. Most can do the same for the domain name as well. DON'T miss your domain name renewal! After 30 days it will be available to anyone who wants it, and it may be snapped up by a scammer the second it becomes free.
>
> I know of a professional (not a photographer) who used a contractor to build a site and never thought about renewal. Thirteen months later, his domain name was bought and pointed to a porn site. He was offered the name back for a $5,000 "fee" by the buyer. The seller lived in another county and made selling back names his regular business.

Setting Up Your Site

Once you have an ISP and a domain name, all that's needed are the pages, right? Yes and no. At its simplest, that's all a site is, documents on a computer that is connected to the Internet. But the way your site looks, how easy it is for users to find (and find the right information once they get there), how fast pages open, and how they look, are all important to success—both the site's and your business.

Everyone who surfs the net knows about slow sites, ones that are hard to navigate, and obviously outdated content. Those are the sins that can make a website work against its owner. So, if you are not a web expert and don't plan on a career change, how do you get a fancy site, and what should it contain? Let's take each of those points in order.

Three Options for Obtaining Expert Help

Hire a Consultant? Maybe, Maybe Not

Crafting web pages and managing websites has always required technical skill and familiarity with computers. Some photographers hire consultants to produce their websites. The cost generally ranges from $2,000 and up, plus the cost of hosting the site. Hire the right consultant, and they will do most of the work. You will still have to produce the pictures, provide text content, approve the design, wait for the results, and pay the bill(s).

While authoring this chapter, I actually was called twice by web designers offering their services. That's where the $2,000 number came from, but the actual cost would be a good bit more—especially after adding in the time the photographer has to spend crafting an online portfolio and marketing copy for the project.

There is an old country adage: "You can spend money or spend time." Most photographers would rather invest in a new lens than a consultant. And then there is the problem of finding a good one, one that knows the photography market and can work inside a reasonable budget. If you have the money and can find the right consultant, the professional webmaster may be the way to go. Most photographers don't have the time or expertise to craft a site totally on their own. There are alternatives. Let's explore.

Consider a Prefabricated, Do-It-Yourself Model

One option is to buy a bare-bones site designed by somebody else and finish the job yourself. Our first website used a template. This is a collection of pages that provides the basic structure of a site, and then you add the text and graphics. We used a design from Allwebco.com. They offer a large selection of templates, some designed specifically for photographers. There are basic models, Flash versions, and some that come with eCommerce shopping carts. Prices run from about $85 to $125 for the better templates. You can get a basic $25 version for free if you use them as your ISP. Just don't expect more than $25 worth of design.

We used one of the best and the project took about three or four weeks to get into full working order. The basic home and contact pages were up in a day. While there are good step-by-step directions with the templates, getting the site working well required a basic knowledge of webpage deign, a little bit of JavaScript coding, and the time to develop the content and craft the menus and navigation structure. The template had the basics, but was not a finished site.

Taking this approach will also require knowing (or learning) about setting up an e-mail server and addresses, configuring a contact form to automatically e-mail entries, and some degree of site management on a regular basis.

The other thing about templates is that they are designed to be easy to use for the novice webmaster. They lack the fancy features and latest enhancements found on custom sites. The good news is you don't have to pay a consultant. Most wedding photographers want (and desirable clients expect) websites with motion (Flash movies), sound, and slick effects. That's not easy to find and employ in a DIY web template.

To get the most juice out of a stock template still requires learning some HTML, a bit of work on setting metatags and such for getting your site seen by search engines, and a fair bit of site testing and debugging. Think fixing up a house with lots of character that needs "a bit of work."

The Best of Both Worlds?

About 6,000 wedding photographers have found an answer that blends the template with access to a design and support team. BluDomain caters to photographers, offering a slick set of templates that do have fancy animations, soundtracks, slick interfaces, and are really fast to set up. It costs more than a template, but is faster and a lot less expensive than a personal consultant is. We used them for our new website and know a lot of other wedding photographers who do the same. Mark Ridout took another approach with his website, a custom design crafted from scratch by Photo Identities (www.photoidentities.com). We'll come back to BluDomain in more detail shortly. And we will take a look at a new firm that is offering a bit more upscale approach to the idea for those who want more personal control. First, let's talk about the stuff that goes into all successful websites— no matter how they are created.

What's in a Site—Content Is the Key

No matter what approach you take in obtaining and building a site, the important thing is that it offers visitors the kind of experience that makes them want to do business with you, and makes it easy to do so. The technical aspects that deal with performance and content delivery are only important to us if they get in the way of our client relationship or become too expensive. For us, content is the real issue—words and pictures.

Most professional photographers are "picture people." We see the world around us in visual terms, and our websites need to impart our vision and sense of style to entice (and educate) potential customers. So we need to have galleries and maybe slideshows as a main part of our site, but there has to be more.

We also have to deal with words to explain and inform, forms to allow e-mail contact and feedback, and a clear user interface that is easy to navigate. The site also has to work with different browsers and operating systems, and (especially with all those images) load fast and reliably. Sounds like a tall order. Fortunately, web

technology and products have made it a lot easier to produce a website with real style over the last couple of years. In fact, if you have a website that is over a year old, it probably needs a makeover. Style is a moving target.

The Must-Haves

The quick list can sound daunting if you are not a writer by nature. Fortunately, websites don't require lots of words, just the right ones—placed on the appropriate page. Let's do a quick run-down of the primary pages that should be on every site, and what goes on each. We show some examples as we go through the list.

The Home Page

Think of the storefront of a retail business; that's the image of the home page. It has to invite customers in. It has to show in a glance what to expect on entry. The door has to be easy to find, and one shouldn't have to struggle to gain entry. Let's take each in turn, and see how TriCoast Photography in Houston, Texas presents their home page (shown in Figure 5.3). TriCoast hired a consultant to craft their new look and have a second site that explains their workshops, which is based on a template.

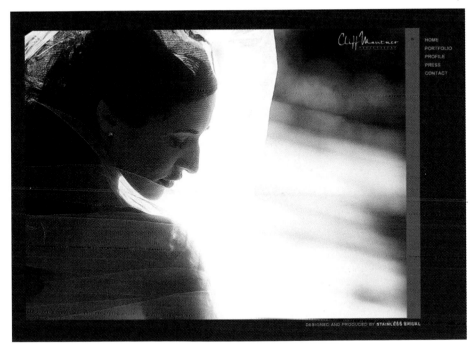

Figure 5.3 The home page is often the shopper's first impression of your photography and your business. (Website and image copyright Cliff Mautner)

No doubt, the picture is the main focus of this home page. The photographers at TriCoast chose an image that showed their style of shooting, as well as their willingness to craft the portrait to match the subject's personality. Both sites do something else; they run a slideshow of several images that keep the viewer interested. It increases the impact of the first impression without wasting space.

That slideshow does have a performance cost; last week a client called and wanted to talk about some of the pictures of her wedding that had just been posted. Her internet connection at work was fast, and usually so was the one at home. But the home connection was acting slowly that day. We had a pleasant conversation for two minutes while the Flash player and the 137-image gallery loaded. With a DSL or cable connection, the first image is usually up in under 10 seconds, and the rest load in the background while the first ones are shown. We'll look closer at designing and using galleries and slideshows later.

The story in the last paragraph underscores that website design is a business decision. It's important that the *intended* viewer can see and use it. That means knowing something about your clientele. Do the people you want to book tend to have newer computers with fast Internet access? If so, feel free to indulge them, and your design, with Flash movies, slideshows, fancy graphics, cascading style sheet designs, and fly-out menus. Appealing to those on a budget or less computer-enabled and savvy generally requires either a less-robust site or a dual high-performance and basic-model approach. There is not a "one size fits all" answer. If you want to impress the power user (and upscale clients) and still serve the novice, then a combination Flash-and-HTML site is required.

The Matters of Navigation and Communication

The World Wide Web is an amazing tool, and so is your studio website. Prospective clients can view your work, perhaps see if the date in your schedule is open for their wedding day, and get directions for their first appointment. Clients can see their proofs, order prints, send you an e-mail, and check out studio sessions for a family portrait, that is, if they can find the section of the site that has those features.

Several years ago, I was working on an article for *PC Magazine*. It was a product review of a new printer from a major manufacturer. My first stop was the product page on their website. The second was the contact page to locate a phone number and the city for the media contact so I'd know the time zone for the planned phone call. There was no page with that information, at least not one that I could find. There was an e-mail support request form. Not quite what was needed. When I did finally talk to the right PR person, she couldn't find the contact page either. Their site underwent a significant menu change two days later.

Figure 5.4 An easy-to-use interface and easy-to-find contact page are important parts of any website.

A website needs to have a navigation system that is obvious and easy to use, and a contact page should be very easy to find. The client may have found your site via a search engine and wonder if you are a local photographer. Figure 5.4 shows the contact page for CAPA Photographic Imagery, a combination wedding and portrait studio.

The site has a simple menu bar that runs across the top of every page. It could just as easily be on a side or the bottom, as long as it is visible and easy to understand and use. The menu buttons reveal submenus when a mouse cursor is placed over one. That keeps the page uncluttered and draws the viewer in an orderly manner through the site.

Let's look closer at the details of the contact page design. The left side provides the visitor with all the information needed to reach the photographer by phone, e-mail, or traditional mail. Some visitors may want to reach you right away with a booking request, or they might want to send a deposit and need the address. Your contact page should make those tasks easy.

The right side provides an online form that allows the user to send a message right from the page. Consider what you need to know and want to know. Our forms are designed to require a valid e-mail address. If the user hits the submit button without one, they are prompted to enter it. We can't respond to a request without an address. The box for the event date is optional. It is just as important not to frustrate users as to get the information. What if the question isn't about an event, or the date isn't firm?

Crafting the Information Pages

The pages in a wedding photographer's site could be combined under the term "information pages." Some may be mostly pictures, showing off the best work and the style of their creator. Others may have more text, like the ones that explain polices, show available shooting dates, offer a biographical backgrounder, etc. Some offer details, and even the ability to purchase prints. See Figure 5.5.

When planning a site, it's a good idea to visit other sites—and not just those of photographers. Study style and context. What do you like? What annoys you? Notice the navigation scheme, design elements, use of color and graphics, loading times, and if there are user interface items that work or that hinder use. What information works, what doesn't, what needs to be included, what should be left out?

The next step is to make a list of the things you want in your site. This is the time when you make basic decisions about what goes in the site and what pages are needed. The tour of other locations helps focus the attention, and perhaps sparks

Figure 5.5 Information comes in many forms. This page is part of a series of biographical sketches that explain both the background and style of the team.

ideas and alerts you to possible pitfalls. A good approach is to use a set of index cards and give each one a title. Then make a list of what should go with that title, like this:

Contact Page
How to contact us:
Name:
Address:
Phones:
Fax:
E-mail:

Form for user
Name:
E-mail:
Reason for contact:
Phone:

Organization and the Nesting Instinct

Each card represents a page on the new website. If one card has too much information, subdivide it. If one is too sparse, consider merging it with another. This exercise is handy no matter what approach is taken when it is time to build the actual site. If you hire a consultant, this will be a time- and money-saver, which gives you control over the process. If you are considering a template, the cards are important for choosing the right model and placing the content.

As the cards are made, place them in groups by topic. For example, contact information and a calendar, a news page and a blog, prices and policies, etc. The groups can be labeled, and the labels form the names for the buttons of the user interface. Nesting the cards is an easy way to set relationships and create a navigation structure. That can save a lot of development time. Even if you are using the template approach, which has a set structure, it can often be modified. If it can't, and your design really needs a certain number of menus or type of page, then a different template or provider may be in order.

Readability and Performance

It's called "design" for a reason, and the full scope of the topic is well beyond the scope of this chapter. There are some salient points to note and some basic advice that should suffice. Keep the focus on the viewer, while making sure the pages say and show what you want. The basics are discussed next.

Short and Simple Statements

Writers and new website owners share something in common: writer's block. The condition is a bit like that found when contemplating a jump into a cold body of water. The key to unlocking the words is knowing what to say. That was part of the reason for viewing other sites. While your site needs its own words, seeing the topics and categories helps focus the mind.

One approach for this kind of marketing copywriting is to get with a friend and let him "interview" you about your services. The questions and answers will be similar to those a visitor to your site will have. Now, craft short sentences. The definition varies: use enough text to answer the question, but not so much that the reader has to scroll, scroll, scroll down the page. Websites tend to use shorter blocks of text than books and other hard-copy media. Still, you don't want to force the reader to keep hitting the Next button to get the rest of the story.

Eye Control

This is one topic that an experienced photographer will find easy. The web is a visual medium. We want to draw the eye in and lead it to our message. That is done with color, fonts, layout, and—of course—pictures. No matter how the site is developed, you need to view (and have others view) it with a critical eye. Do the colors work, is the type legible and easy to read, do the pictures interest the eye and draw it into the page?

Bandwidth and Proper Loading

Photographs are graphics, and graphics take longer to load than text. Make sure that images are properly optimized and keep the number of pictures and their size to a workable level. Knowing how to scale JPEGs is a basic skill. The DAM and RAW editors we will use in later chapters all have sizing tools. Always check the image once it is on the site. Some JPEG compression works better than others, and local results vary.

Proof galleries can take a bit longer to load; people expect some delay when there are lots of images and will wait if they have a good reason—but not too long. The best approach is to use a set of thumbnails (smaller versions of the actual image) to show the collection. Then the viewer clicks the thumbnail to load the full-scale version. This is easy to do with modern software packages and proofing services. We'll go into the details in Chapter 16.

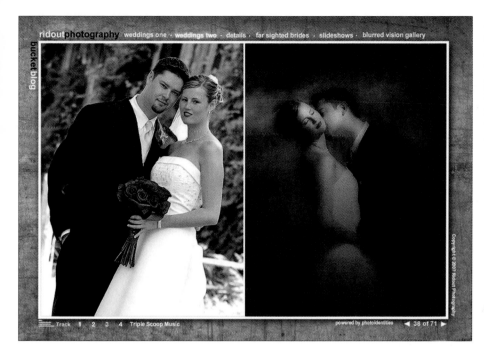

Figure 5.7 Mark Ridout showcases his portfolio in slideshow galleries for easy viewing. A good sample of your work on display is important. It's equally important that the images are optimized for fast loading in the visitor's browser.

Form Follows Function—Test, Test, Test

During design, and after, websites require testing. The design may work, but it may have flaws. There are typographical errors to find and wording to consider (your viewers are mostly instant critics).

The user interface is a tool that lets the visitor find the stuff they came to see, and which the design uses to make sure they see the stuff that sells. Does it do that? Pictures have to load, and do so quickly. Links, forms, and e-mail tools have to work. If there is music, it has to sound clear and enhance the experience. A volume control and/or a Mute button are necessities.

Watch Out for Rights

No matter the protection scheme, people can copy images from the web and use them, print them, and misuse them. That is one of the reasons many photographers use Flash-enabled sites—it's harder to steal images from a Flash movie. Another common practice is to watermark them. You also want to make sure that there is a copyright statement that covers the entire site and appears on every page.

Wise webmasters also respect the copyrights of others. Music and design elements are also creative products that carry copyrights and are worthy of respect (not to mention legal protection).

Don't Be a Stranger

Visit and improve the site on a regular basis once it's up and running. A website is a process as well as a destination. Styles change. Brides are shopping, and a stale look can cost bookings. If you have links to other sites, test them on your visits. They may not work. While you can't control the remote page, a broken link dates your content.

There is another aspect of not being a stranger with your site: using it to connect with both existing and potential clients. Wedding photographers often become more than just a one-time service provider. The website is also a way to keep in touch, and blogs are becoming a popular way to do that. Figure 5.7 shows a page from TriCoast Photography's blog.

You can see that the information has the personal touch that lets the visitor feel welcome and that they know the author. The site is also kept current with a variety of interesting and informative articles on shooting techniques and upcoming workshops.

Figure 5.7 Mike and Cody's blog let viewers learn more about both the photographers and their current activities in ways that go beyond the limits of a traditional business website.

TRICOAST PHOTOGRAPHY

TRICOAST BOASTS WORLDWIDE AND EDITORIAL FASHION WEDDING AND HIGHSCHOOL SENIOR PHOTOGRAPHERS WITH A VERY DIFFERENT APPROACH TO THEIR WORK. THEIR UNIQUE STYLE PROVIDES CLIENTS WITH A "ONE-OF-A-KIND" ATTITUDE THAT IS VERY APPARENT IN THEIR FINAL PRODUCT. FROM YOUR ENGAGEMENT SESSION, YOUR BRIDAL SESSION YOUR WEDDING AND EVEN A SPECIAL PORTRAIT SESSION, TRICOAST PHOTOGRAPHY CAN HANDLE ALL OF YOUR PHOTOGRAPHY NEEDS.

TUESDAY, MAY 01, 2007

Pittsburg Kansas - We made it baby!

Had a GREAT time at our main lab Miller's in Pittsburg, Kansas teaching their annual Wedding Workshop. With the class selling out in about 4 hours we were not sure what to expect when we got there. I must admit we had an AMAZING group of people with such an egar attitude to learn, share and just welcome a new and exciting method to wedding day photography. I would like to personally thank Ted, Lisa and the others at Miller's for taking a chance on some "non-traditional" wedding guys to respresent their amazing company!

LINKS

Beyond the Basics and Outsourcing

So far we have covered the basics of a website. The Internet can do a lot more than just showcase portfolios and let people find your phone number. It can show proofs, offer professional quality slideshows, handle marketing chores, and manage the complete post-wedding sales activity. Big companies have the servers, technical staff, and Internet bandwidth for those kinds of goodies.

Most of us don't. But all it takes to add a service to your site is a provider. The volume of weddings and the amount of money changing hands has produced a number of vendors that lets even the smallest studio look professional with virtually no web savvy. We will actually be looking at these topics in depth in Chapters 16 and 17, on working with labs, proofing, and creating slideshows, but I'll tease you a little bit now.

Basic Proofing for Free, or Almost

Most templates come with galleries that can be used to show a series of images. There are also proofing slideshows available that can automatically size and show a set of images, and flash the image number in a corner as the picture is loaded.

Figure 5.8 shows a proofing portal page. The client enters a password that calls up the images from a database. Some sites create and present a Flash movie. Some

Figure 5.8 The website can also be the proofing solution, making it easy for anyone to view images and buy prints.

photographers host their own shopping carts as well. We use a third-party provider to actually manage the shopping cart and let the viewer browse through the pictures and buy prints.

Proofing and Printing Are Us

There are several firms that can offer proofing and print sales (as well as album design, CD/DVD shows, contact sheets, and the like) together with an Internet shopping cart, and order tracking. They even can send your files right to a lab with the order; all you have to do is upload the images and pay the commissions and lab fees.

Actually, some offer basic service for a flat fee, and you can take payment with PayPal, credit card, or check. Some will even handle the credit card transaction and charge a percentage fee that is in line with the ones offered by banks.

Clients can be directed to their service either by a link from your website or go directly to the service's site and enter an account number. The fees and services vary. We have used ImageQuix for about three years. They offer both a basic service for a small listing fee or full service with labs and commissions. The market is getting competitive, so check out the features and services against the fees and how much time it saves or takes.

Figure 5.9 ImageQuix is one of several firms offering online proofing and printing services for wedding photographers.

Figure 5.9 shows a demo shopping cart from the ImageQuix website. The service is very easy to use. The photographer uploads images using her software program, which can number, watermark, size, and place the images on the remote server with fill-in-the-blank ease. Then all that is left is to set the prices and pay the fees. The speed, ease, and avoiding worry about the IT issues is well worth the price. If you handle the lab work and buy upload credits, the build-in cost for hosting a wedding is well under $15.

An Even Better Deal on Slideshows

If you want to show your clients really slick web slideshows, Photodex, the makers of ProShow, have a real deal. They offer free hosting, a plug-in, and unlimited playing of productions created using either their ProShow Gold or Producer software (making the shows is covered in Chapter 17). Owners of the basic version can pay a fee and host their masterpieces.

Mark Ridout uploads all his shows (and we are talking megabytes) to the Photodex server. Some have been viewed over 5,000 times. They track the numbers and will share the information. The positive PR and buzz of clients is a major part of Mark's marketing strategy. See Figure 5.10.

Figure 5.10 Photodex's Sharing site offers free slideshow hosting and promotion to owners of their ProShow Gold and Producer programs.

The Wedding Photographer's Website, Quick and Easy Times Two

Okay, no question, a website is a good idea, and a good website is well worth the effort. So let's look at two firms that are offering an easy path to webmaster status with templates *and* easy-to-use tools, which make short work of placing content, creating Flash movies and interfaces, setting up forms, and adding enhancements like slideshows and blogs. Now we are going to see how it's done and what you get for the money.

The cost is a good bit more than your garden-variety template. Prices for the better sites range from $600 to $1000, depending on the features and vendor. That's because the designs are more complex and are linked to slick control panels that all but totally automate sizing your images and getting things to fit. Depending on the vendor and your skills, it's possible to add your own pages, which extend the site past the standard template.

BluDomain was the first company to really focus on high-end Flash automation for photographers. They claim to have over 6,000 clients. That's not hard to believe. Most of the shooters I talked to for this book either have a BluDomain site or know about them. Figure 5.11 shows the BluDomain product page. No matter the vendor, the process is basically the same and starts with choosing a design. We'll walk through the steps and discuss not only working with this kind of site set-up, but look at the issues and solutions that apply to all website set-up and hosting.

Figure 5.11 BluDomain offers a variety of templates. Some offer both HTML and Flash pages, and the company will customize the design for an additional fee.

Choosing a Format and a Hosting Provider

There are several options when it comes to a site, even a ready-to-wear design. The majority of wedding photographers' sites offer some form of Flash. This is an Adobe product (they bought Macromedia), which is used to create animations that can be incorporated into a website and viewed using a browser plug-in. Almost all browsers have Flash support, and the technology is both stable and well-suited to fancy graphic layouts and presenting pictures.

The planning steps we discussed earlier make it easy to match up a template design with your desired features. If there are unfamiliar options, either check out the same sites shown by the vendor or browse other photographer's sites. The vendor blogs often have links to their more cutting-edge clients, so that is a good way to see features in action.

If you want to cater to low-bandwidth clients, consider a combination solution that offers both Flash and HTML versions. Some templates come with both and allow the viewer to choose which to surf from the home page. It is possible to code a home page to check the browser's ability to view Flash, make sure its plug-in is new enough for the site's features (technology always moves forward, right?), and automatically load the appropriate version.

Note

Adding special features takes extra effort and may require a bit of paid time to customize. Any special coding or cutting-edge extras carry the risk of compatibility problems. Flash is not new, and few users should have problems. Even so, it is possible to create very large shows that can clog a user's connection. Not all browsers are created equal and some may not fully support all enhancements. Be sure to test your creation during development, and ask others with different hardware, Internet connections, and browsers to visit the new pages and report as well.

Providers like BluDomain usually offer a combination of services that amounts to one-stop shopping. They will sell the template, host the site, provide technical support, and (for additional fees, often by the hour) customize the template and make modifications that are not available via the template's user interface.

The Interface Is the Big Difference

The real advantage to using a provider like BluDomain is their site production interface. It takes over many of the more technical aspects of design, content creation, and site management. A good interface is both easy to use and flexible. The best way to understand how it works is with a tour. Figure 5.12 shows the BluDomain start page for a typical template.

Figure 5.12 The start page for a BluDomain template with a blog and Flash Splash home page.

You can start editing a site even before you get a domain name and choose a hosting provider. The source files can be placed on the vendor's server and edited, then linked to your new site once all the details of name and hosting location are worked out. This is known as a local connection, and the pages are provided via the provider's network address, rather than via the (perhaps non-existent) domain address.

There is also a note about image sizes. Those who craft pages from scratch have to lay out images, code Flash timing, and optimize the pictures so that they load quickly. The real beauty of the automated template is that the work is mostly done for the user by the database and its supporting programs. With BluDomain's

technology, you just have to provide a JPEG file smaller than 2MB, and the picture is optimized. If the layout requires cropping, the user is presented with a dialog box that shows the new file and a cropping tool. Make your crop, hit OK, and the program does the rest.

The interface shown in Figure 5.13 is used to load the image and set the text for the link. All the user has to do is provide the image and enter the text, then click Update. All the code, layout, and optimization is the software's job. The same interface and process is repeated for the other two images and links.

Figure 5.13 Designing a Flash Splash page is little more than uploading files and filling in the blanks.

Crafting Page Contents and Finishing the Basic Design

The Splash page is a gateway, not a destination in itself. Some are static, others present a slideshow. If you offer one with an animation, be sure to provide a "skip intro" option on the page. Repeat visitors and those in a hurry will want to bypass this feature.

I won't walk you through all of the different menus and page configurations. All are managed very much the same, even if they vary in content and options, from template to template, page to page, and from vendor to vendor. Figure 5.14 shows

Figure 5.14 For most users, the entire website can be configured and maintained using the tools accessed via the primary BluDomain menu.

the master BluDomain interface. Click on an option, and a dialog box similar to the one used to upload the files in Figure 5.13 appears. The entering process requires little more effort than filling in the blanks. Of course, you still need to produce the images and decide on the words to place on the pages.

One of the reasons BluDomain has been so successful is the easy setup and updating; another is the design team that keeps adding new templates. Offering customization for a fee makes it easier to craft a site that looks the way you want, without the expense of a full-fledged webmaster.

Even with all the automatic features and the slick user interface, the wise photographer realizes that the more one understands about using the web as a business tool, the more that can be obtained from the investment. Figure 5.15 shows the BluDomain page used to set up metatags. This requires a bit of HTML skill, and the interface does not offer all the available tags. It is a lot easier than crafting the code yourself, and less expensive than buying a web authoring program or hiring a programmer. There are some sites listed in Appendix A, "Resource Guide," located on the companion website (www.courseptr.com/downloads) that lead you to some websites for background information on using metatags and getting noticed by search engines (the two topics are related).

Figure 5.15 Setting up metatags using the BluDomain interface.

A Matter of Control

BluDomain clients who buy the full web hosting option can add their own pages, build additional links and pages, or have someone else do it for them. They have a full-blown website, not just the template. It's also possible to have the template hosted on a third-party provider.

Either way, there should be some type of control panel that provides an interface, much like the template builder we just discussed, to set up and monitor the features and performance of the site. For the more adventurous (or web-knowledgeable), this is the way to get the most benefit from the investment. It's possible to manage customer e-mail accounts, upload additional pages, set up form handling (that's already done for template users), track visitor traffic, and broaden the site, while still using the template to handle the Flash component. It tends to be a good bit easier for most people to learn a little HTML than to design and execute Flash from scratch.

The array of icons in Figure 5.16 is the elements of the advanced BluDomain site Control Panel. The templates will work fine with almost no use of these tools, but they are there and add value. All users should use the Control Panel to set up at least one e-mail account for the contact page. I have run across some sites that don't have an active e-mail link or response form. It is a real oversight. One of the major reasons for having a site is to make it easy for clients to contact the owner. If the visitor has to do more than click on a link, she may take her business elsewhere.

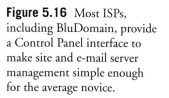

Figure 5.16 Most ISPs, including BluDomain, provide a Control Panel interface to make site and e-mail server management simple enough for the average novice.

First-time site owners may find the appearance of a web server Control Panel, with all its icons, a bit intimidating. The common functions, like setting up e-mail, usually come with instructions, and there is always technical support. Before making any major changes to a site or performing major control panel chores, it's a good idea to back up any important files and have a copy of settings that may need to be restored. That's a good practice on a regular basis anyway. Just like hard drive back-up, even the experts get lax. (It's impolite to ask if your dentist flosses, too).

The sidebar below shows the steps required to get e-mail addresses working using the BluDomain Cpanel. That's the name for the Control Panel interface. The steps are straightforward. Using most of the tools will present no real challenge to anyone who has used the System Configuration options with the Windows Control Panel. Some of the more arcane features will require more work. Some ISPs don't set up form handing, and that can require a bit of effort, depending on the operating system. Most vendors' tech support lines will take calls from prospective customers. It never hurts to check out possible issues—and that also lets the would-be client know how good the support staff is and how long it takes to reach them.

Setting Up and Accessing E-mail Accounts

HOW DO I SET UP MY E-MAIL?

1. Locate the e-mail that was sent to you with your Cpanel information titled "Hosting Information."

2. You can access your Cpanel by going to your website address and then typing /cpanel at the end of it. For example: www.yoursiteaddress.com/cpanel.

3. From here a password entry box will pop up where you will be required to input the username and password provided to you on your Hosting Information sheet.

4. The first icon entitled "mail" is the one you will go to to set up e-mail accounts. Click on the Mail icon, then select manage/add/remove accounts and click on it.

5. At the bottom of the screen, you will see that there is an Add Account button. Once you click on it, you will be able to create your new e-mail account

6. Once you enter the e-mail account, you will see that you can edit the password and the quota. Set your password to whatever you like and change the quota from 10 MB to 100 MB. We recommend that you give each account 50 MB.

7. Your e-mail accounts are now set up! Congratulations. (hehe)

WEB MAIL ACCESS

1. You can access your web mail from anywhere by entering your website address with /web mail at the end of it (for example: http://www.yoursiteaddress.com/ webmail). You will be prompted to enter a username. IMPORTANT: the username is your full e-mail address. The e-mail address is the one that you are checking and the corresponding password for that e-mail account. Once you have filled this information in, click on the Log In button. Once you enter the web mail interface, you will have a choice of two web mail programs (Horde or Squirrel Mail). Simply choose one; they all have similar functionality with different interface styles. From here you will be able to check e-mails and attachments. It is important that you do not let the web mail get too full, because storing e-mails will take up a lot of web space.

Figure 5.17 The Mail Manager Main Menu is used to set up and manage accounts, set up auto-forwarding, auto responders, and perform similar e-mail administrative tasks.

Not a Matter of If, but How

Only the most insular part-time photographer can compete in today's market without a web presence. Almost the first question during casual conversation with a new contact is, "Do you have a website where I can see your work?" They assume the response will be a domain name. There are some photographers who use services like Collages.net or ImageQuix to offer online proof and sales without a dedicated website. Some build a site and then leave it sitting without another thought. Both approaches miss the real value of the tool.

As our look at BluDomain shows, you don't need web savvy or a lot of time to build an interesting site that shows off your work. There are a variety of other vendors offering templates, as well as full-service web design firms that will do all the work for you. Of course, all that service and creative effort is more expensive. Chapters 16 and 17 on proofing and slideshows will look at additional ways you can use the Internet to offer your customers extra value and showcase your work.

The Internet and the photography business are both in constant and rapid development. To stay current in business means staying current with the tools that make for success. Most of us keep up with news about the camera we use, and seek out new tricks with the editing programs we use. Buying this book shows an interest

in improving your abilities as a wedding photographer and growing a business. Improving both your website and Internet skills are factors in both.

Next Up

So far we have focused on setting up the business. We have the forms, the gear, the website. Now attention turns in Chapter 6 to the client and booking the wedding. A wedding booking is a lot like a car deal. There is rarely a fixed price because there are always options. It is a big ticket item (often one of the most expensive elements of the event), and the buyer is often looking for high quality at the lowest price. Good booking skills make for bigger profits and happier clients.

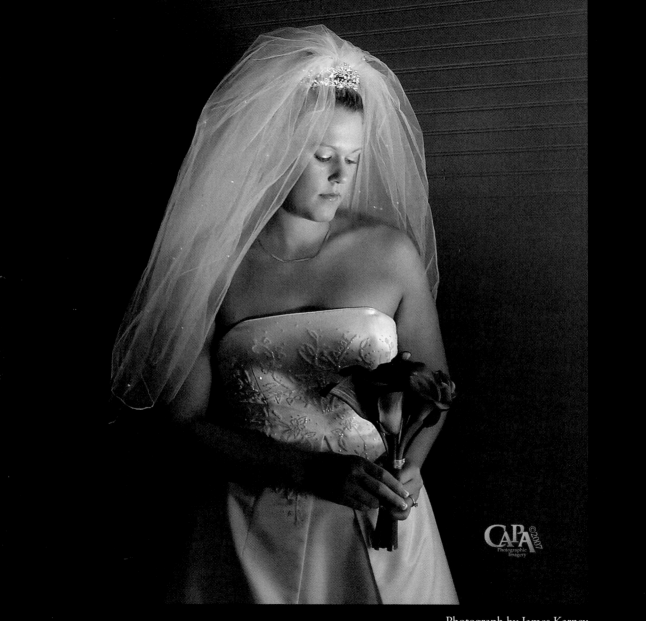

Photograph by James Karney

6

Preliminaries: Booking the Event

Booking a wedding assignment is a process. Photography is often one of the most expensive parts of the event. Clients are often hiring a professional for the first time. That means educating them, both on the benefits of hiring you and choosing the coverage and products that will meet their needs. Even for studios that only offer a fixed price, there are still negotiations to handle, like the length of coverage and the details of payment.

Before the contract is signed, everyone involved needs to understand exactly what services and products are being provided and when as well as who is paying. The education process starts with the first contact.

The Initial Contact

Most people shop for a wedding photographer using one or more of three approaches. They ask friends and other vendors, they call the listings in the phone book, and they check the Internet. The majority will have some idea of what they want—and what they are willing to pay—before you talk with them for the first time. How that conversation goes will determine if you get the booking. And you'll have some decisions to make as well. Let's break down an interaction with a typical first-time caller.

The normal conversation starts out with some variation of "Do you photograph weddings?" and then often right to "How much?" as soon as you say yes. We deflect the second question with a few of our own before discussing prices—and

take notes. Knowing some facts about the event and the client will help in framing your offer and deciding if you want to cover the wedding. (Sometimes getting the assignment turns out to be the bad news.)

Check the Date and Time

Our first response to the request is to ask for the date and time of the wedding, explaining that before talking about the details we want to make sure we are available. If not, we will offer to suggest another photographer. We also inquire about the full time of the event, from the bride's arrival to the end of the reception.

The length of time is an indication of how much effort the job will take, and the potential sale. Short ceremonies and limited receptions often point to a small wedding. That may mean no album and a desire to keep expenses down—but not always.

Gather Information about the Scope and Size of the Event

We then ask about the number of people in the wedding party and the number of guests. Are there a large number of family members coming from far away? Large wedding parties will mean more work handling the traditional formals. Is the reception at the site of the wedding? Will it follow right after? If both are together, the entire event may only last a few hours. A mid-day wedding with an evening dinner/dance reception makes for a long day. (Our record is 18 hours!)

Ask about the venue. Is it indoors or out? What arrangements have been made for an outdoor wedding in case of inclement weather? This is good information to have when planning your equipment list. An outdoor wedding in bright sun will need fill-flash, and a rainy day will mean figuring a way to protect the camera. See Figure 6.1.

Is the reception a dinner/dance, a buffet, or pot-luck? Is it indoors or out, day or night? The kinds of pictures and gear will again depend on the event. Big halls can be dark, so can late-night outdoor receptions. We had one wedding with late night hula-hoop and limbo contests outdoors. Full-flash was the only option. That meant insuring that we had fresh battery packs available after a full day of shooting.

People are generally more willing to pay top rates for an all-day event with lots of people in a fancy venue. Short weddings with catered barbeque usually indicates a more budget-minded approach on the part of the client. We take each in stride and look for other options to increase service and raise our profits.

Keep in mind that the importance of pictures varies with the client. In some cases, we have found the couple saves money on the reception to include more guests or to make the event feel less formal. They may use the savings to allow for a larger album and include gift prints for family members or the wedding party.

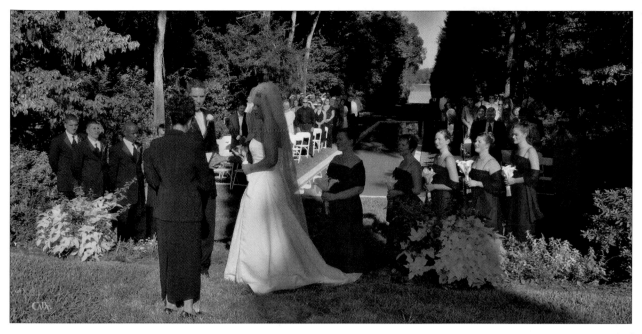

Figure 6.1 Knowing the size and the type of wedding is an important part of booking the event and planning the coverage. This large outdoor wedding challenged us with harsh light, deep shade, and mixed white balance. (Photograph by James Karney)

If there are family traveling to attend, the formals may generate a good number of print sales. We allow time at the reception to shoot any family groups the client approves. Note the last part of the sentence, emphasis on the word "client." Most clients are fine with the photographer offering to shoot more pictures, but not if it seems to impact on their coverage.

Ask about the Bride, Groom, and Attendants

We know the size of the party and the event, but we also want to know about their relationships. Is there a ring bearer and flower girl? Are there family members and long-time friends in the party? This may lead to a detailed discussion of the couple and their friends. We listen. It gives us a sense of the client and usually results in better coverage. It also engages the client and creates rapport.

If the members of the wedding party are close-knit, they may enjoy a special portrait that depicts the relationship and their personalities. Since these kinds of images often require advance planning, it's best to arrange them as part of the negotiation. Willingness to offer such personalized service adds to the value of hiring you and can be worked into an optional fee or additional print sales. See Figure 6.2.

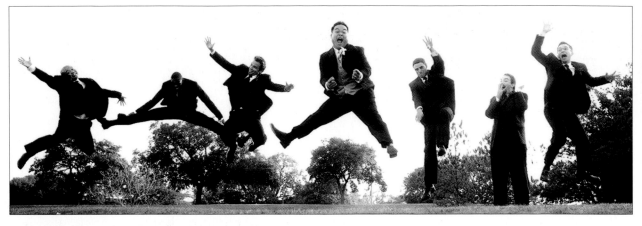

Figure 6.2 Creative wedding party portraits like this one, by TriCoast Photography, add zest and a unique touch to an assignment and to the photographer's portfolio.

Determine the Type of Coverage and Products Desired

We now know enough about the wedding and the people to move the conversation to what the clients want in the way of coverage. Do they want a traditional or a more "modern" style of photojournalistic approach? Are they considering an album or just loose prints? Will there be gift pictures for the attendants? What about companion albums for the couple's parents?

Ask about Any Special Considerations

By now, the client should be comfortable talking with you. If that seems the case, ask if there are any special considerations. These can range from a person in the pictures who may be in a wheelchair to difficult relationships. We had one client who wanted to make sure we didn't use a particular photographer as a second shooter. That individual was under a restraining order due to a history of stalking the bride!

Booking the Date

At this point we turn to their question: price. The offer is tailored to our understanding of their needs, blended with our pricing policies. If the event is taking place on a Saturday in the busy season, that's a factor. If it's a Sunday in February, and the request comes in January, the price may be lower. If they agree, we ask for the deposit to book the date.

Offer a Meeting and Samples

Whether they book on the date or not, we ask to set up a meeting. While assignments that involve travel may get booked without a meeting, we prefer to meet the couple (and the person paying for coverage) in person early in the process. Many times Mom or Dad handles the payment.

Warning

There are two types of scams to be very careful of when dealing with a new booking. The first is a "client" who wants to buy a big package and have you handle the contracts with a third party, like a caterer. The hook is the big contract. Then they ask you to advance part of their payment to the other party. Their check or credit card is a fake, and so is everything else involved—except you and your money.

The other threat is even more dangerous. A person books you to cover a wedding in a foreign country. They send a plane ticket and promise a wonderful time in exchange for your great pictures. The reality is a kidnapping, and they get your gear to cover the risk of the ticket if nobody pays their ransom demand.

The moral: if an offer seems too good to be true, there is a catch—and you may be the fish on the hook. Never forward payments, and be very careful when booking remote clients.

The Meeting

A wedding is often the client's first experience with booking a professional photographer (other than a mass-market portrait operation). The meeting serves several purposes for the photographer. We use it to show samples of different styles of images, sample albums and other products, and go over the details of the assignment. We also have a contract and other forms (more about these shortly) ready to be completed.

Our presentations start with a ProShow Producer slideshow with clips from several weddings, a collection of bridal and engagement portraits, and a set of album pages. This takes about 10 minutes and includes coffee, tea, and light refreshments. Then we turn to *their* wedding. We go over the proposed coverage, explain our packages and proofing system (with a quick demonstration), and confirm times and dates.

During the discussion, we gauge the way the couple responds to the slideshow and offer to tailor the way this wedding is covered to meet their desires. Some will want innovation; others have a large number of group shots in mind. In the days of film, adding pictures meant adding cost. Today, we don't worry about film and only detail or retouch images that are purchased. Knowing what the client wants to see in the proofs makes it easier to boost sales and please the buyer—a win-win situation.

If they have not yet made a deposit, we remind them that the date is only reserved with a payment. All our assignments are taken on a first-come, first-served basis. Once payment is made, we turn to the paperwork details and setting a time for the engagement and bridal portraits.

The Paperwork

Some photographers use a complicated contract with lots of legalese concerning "the client" this and "the photographer" that and clauses that detail every aspect of the wedding, the sale, and any acts of God that may occur. These documents run three to five pages and include witnesses. Others just take the check. We don't like either approach and take the middle ground.

The reason we dropped the detailed contract was that it seemed to intimidate clients. They wanted to take the document and study it. That delayed the booking, and sometimes may have been a reason for choosing a different photographer. Just taking the money offers no written form of the agreement to produce should there be misunderstandings later or if disaster strikes.

The Contract

Our contract is a simple, one-page document. It notes that we will come to the wedding, the times we are there, a brief description of the coverage, the price, a listing of what they get for their money, and how it is to be paid. There are signature blanks for the photographer and the client(s). They fill in the address and phone numbers they will use after the wedding, and we have already filled in our information. There is a clause about payment and refunds in the event of late cancellation or disaster.

Organizations like the Professional Photographers of America provide sample contracts that serve as good starting points for designing one that suits you. Keep in mind that contracts are legal documents, and only a lawyer can offer legal advice. The remarks here and sample forms from third parties are just starting points.

There is one element that we make sure is in any assignment agreement or contract: a copyright notice. This is a statement that all images are the sole property of the photographer, that we retain all copyright to them, and that only copies sanctioned by us are to be made. If the package includes client reproduction rights, that is noted as well.

Event and Vendor Form

We have another form that goes with the contract. The client provides the exact location and time information for the places where the bride gets ready, the wedding is held, and the reception. The times include both the actual beginning time and the projected end times for each part of the day.

We also have blanks for the usual collection of vendors. The list includes the minister, all of the venues, the florist, caterer, bridal shop, jeweler, florist, videographer, DJ, and any musicians. We ask for the name of the contact person, the address, and phone number. We have two reasons for collecting the information and want at least the contact name and phone number.

We may already know the vendor, or we may not. If we do, it makes it easier to plan. Some ministers don't want any flash during the entire event; some don't mind the extra light at all. The list helps in planning the coverage and working with the other providers. It also offers a chance to network and seek other business and referrals.

Almost all of the providers will be receptive to obtaining pictures of their work or services. The floral arrangements, the place settings for dinner, the cake, and the DJ at work are all likely to be the subjects of your camera. An extra print (free or at nominal cost) can be the opening a new business relationship with a vendor who may get frequent requests to suggest a wedding photographer. If they can show one of your prints during their meeting with a client—with logo—the odds of them mentioning your name go up. See Figure 6.3.

Figure 6.3 Vendor lists offer a ready set of contacts for marketing opportunities. What business wouldn't welcome a copy of an image that shows off their services, like this one by Mark Ridout, of fancy place settings ready for the guests at the reception?

Most couples don't actually fill in all the blanks, and we note that if they can provide just the name and phone number, we'll handle the rest. Some are willing (and organized enough) to complete the entire form. We note that the list makes it easier for us to coordinate our work with the other providers. For example, we like to know the florist so we can ask when their arrangements will be ready to shoot and the bride's bouquet available for bridal portraits.

Another good picture subject that can be shot before the big day is the rings. Figure 6.4 shows a beautiful arrangement photographed by Mark Ridout. His expertise as a commercial photographer shows in both the previous picture and this one. Imagine a picture of rings over a display of rings in the jeweler's shop, with your logo on the image and a set of cards or brochures nearby. They are ready to be used by couples looking for a ring and considering a photographer.

Figure 6.4 This picture of wedding rings shows what a trained eye, a creative mind, and a little extra time can achieve. The result can complement an album, a portfolio, and a marketing campaign. (Photograph by Mark Ridout)

Booking the Portrait Sessions

With the business details out of the way, it's time to focus on the photography. If possible, we try to arrange for engagement, bridal, and the groom's portraits before the wedding day. The engagement sessions are easiest, since they don't require special attire. The other sessions are often limited to a day or two before the wedding, since the bride will want her flowers; we need the gown, and the tuxedo.

The Engagement Session

Our packages all include a "free" engagement portrait for use in newspaper announcements. It's free for two reasons. If the booking is on short notice or the couple does not want the session, there is no discount on the price if it is omitted. The second is that we don't automatically provide prints to the couple from the sitting for bargain packages. They can buy prints, but we provide a JPEG directly to the newspaper for the announcement.

The engagement portrait is an important part of our coverage. It is often the only time we get to be alone with the couple together before the event. If there is a bridal session before the wedding, she often doesn't want the groom to see the gown.

Being able to work with both the bride and groom lets them get used to us with a camera in hand, and makes it much easier to get a relaxed session on the wedding day. It's harder to get good poses the first time with an audience watching. It also provides a second set of images that parents may purchase, and the newspaper usually provides a credit line with the studio name under the picture or a mention in the announcement. Be sure to note the exact spelling for credit in the submission. For example, Please credit this image with: "Photograph provided by [name]{city}." If we provide a print to the paper, the credit information is placed on the back. We also include a logo on the picture.

A Matter of Style

Usually the photographer can't choose the location for the wedding. (I have done so a couple of times, when the couple was coming from out of town and asked for advice.) We can almost always choose the site for sessions that take place before the wedding day. Asking the couple if they have suggestions both for the place and the manner of dress is an excellent practice. They may have a picture in mind or a favorite spot. We have a list of several possible places, based on the type of dress, the season of the year, and the style of pictures the couple wants.

Keep in mind that the primary role of the engagement session is the picture for the paper. The black-and-white image in Figure 6.5 by TriCoast Photography does the job well. Both faces are well displayed, and the pose is relaxed and shows the joy the pair takes in each other. The limited depth of field and matching dark clothing helps separate them from the setting.

Of course, we don't have to limit the session to one pose or one locality. We have a favorite park that offers a variety of "sets," from a playground, to a pond, to a woodland-bordered meadow. The nearby village sports several old shops, a railroad track, and several churches.

Variation is the order of the day in the poses as well. Figure 6.6 was taken by Mark Ridout, showing a much more intimate interaction between the couple. This may not be the first choice for the small-town editors, but it's one the couple may want to add to their print collection or frame for the new house. This image uses a rim of backlighting as well as a short depth of field to frame the couple. The black-and-white rendition and the soft expression of the bride show how well Mark has mastered his craft, and why he is sought after as both a photographer and a speaker.

Figure 6.5 The old style of static head-and-shoulders engagement portraits is giving way to a more creative expression that captures the connection between the couple, as in this image by TriCoast Photography.

Figure 6.6 Who says engagement portraits have to be staid? Mark Ridout uses all the tools of the master portrait photographer to create images that go well beyond the traditional news release "mug shot."

Bridal Portraits

Given the hectic pace of getting ready for the wedding, and the added sitting fees, many brides forgo a separate formal bridal portrait. If we know the venue does not offer a good location for one on the day of the event, we show samples and offer to provide a sitting either before or after the big day.

Keep in mind that a complete session requires planning and a number of props that may or may not be easy to arrange in time. The florist will have to provide flowers, or the bride will have to do without. The gown has to be ready, and she may worry about getting it soiled without enough time for cleaning. Her hair and makeup may also be limiting factors if she wants to look just as she will on her wedding day.

Still, the chance for really stunning pictures makes it worth the extra effort. Before the ceremony there is little time for formal portraits and limited settings. Later, she will be getting tired of posing after all the other posed pictures following the wedding.

That doesn't mean you can't get results. Figure 6.7 was taken on the morning of the wedding, just after the bride donned her veil. I used a single reflector to direct light from the only window in a hallway where we took the picture.

It's easy to fall into the trap of only seeing the bride in traditional terms during the bridal session, but the new freedom in styles (not to mention the broader tastes of today's clients) gives room for experimentation even in the bridal session.

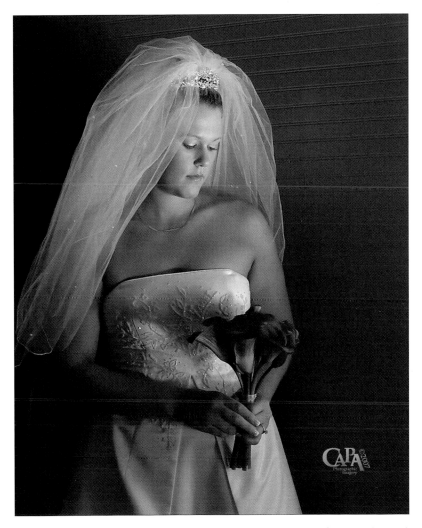

Figure 6.7 This quick study of the bride was taken just after she dressed on the morning of the wedding. (Photograph by James Karney)

Consider Figure 6.8 by Mark Ridout. This is not a billowing veil kind of picture! This lady is making a statement about who she is, and Mark is using his skill to blend color, light, and composition to make it a dramatic one, worthy of wall-hanging and the portfolio.

Here the red car, the fall color in the trees, and the raised skirt of the gown revealing cowboy boots create a memorable image, matched by the active pose and expression of the bride. The overcast day adds a natural saturation to the colors and the detail in the dress.

Another form of transportation was the major prop in the next portrait by TriCoast Photography. This picture graces the home page of their website. The lines of the motorcycle frame the bride, while the chrome and vibrant sunset accent the white of the gown. Once again, the focus is on the personality of the woman, not the wedding dress. It is an accent, not the focus. See Figure 6.9.

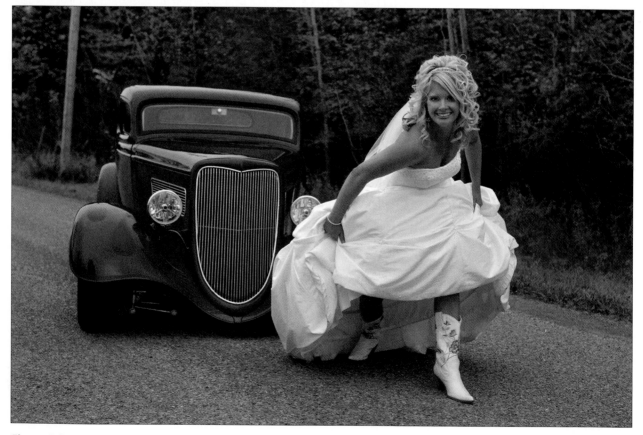

Figure 6.8 Who says you need a fancy backdrop and flowing veil to make a bridal portrait? Not Mark Ridout and this client!

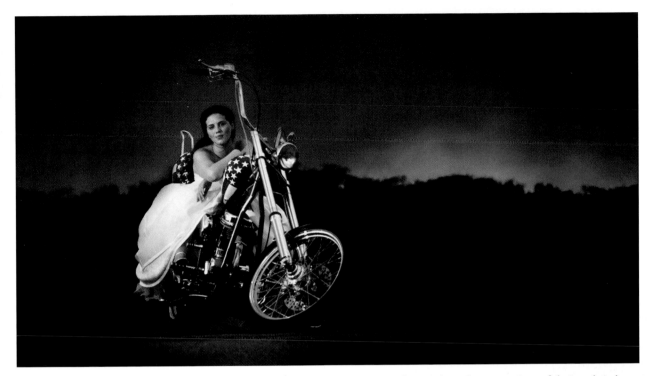

Figure 6.9 TriCoast Photography liked this non-traditional bridal pose enough to make it the centerpiece of their website's home page.

While it's fun to add *avante garde* images to a session, make sure you still get some images that are more traditional as well. The bride wants to be able to show her children how she looked as a bride. The gown, flowers, veil, and hairstyle are all a part of the picture.

Don't Forget the Groom and His Friends

The groom's party will usually pick up their tuxedos (if they are rented) one or two days before the ceremony. That provides a window for a special session. Just before the rehearsal dinner can be a convenient time to schedule one. The more formal pictures that can be taken before the wedding, the quicker the group shots will go after the ceremony. And the subjects will be more relaxed for that session, and also used to the camera on the big day.

All of the basic rules for masculine composition and posing usually apply to this type of portraiture. (Of course, rules are made to be broken—once you understand them.) TriCoast Photography has combined the stance of the groom, mixed with the pose and positioning of his companions, to create a composition that adds drama in keeping with the dark suit, white tie, and hat the groom is wearing. See Figure 6.10.

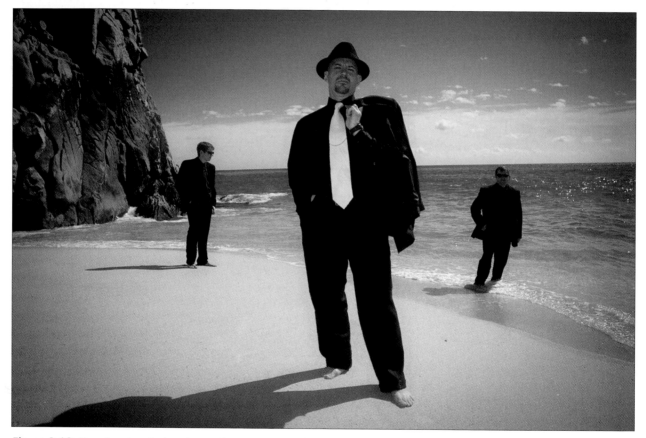

Figure 6.10 Pre-planning the location and pose increases the ability to produce a memorable portrait, like this seaside image by TriCoast Photography.

Mark Ridout uses a brooding sky and darker tone in Figure 6.11 to give a similar sense of drama. The fill on the faces, with the groom's the brightest, naturally draws the eye to him. The low shooting angle and the crossed arms of the groom and best man contrast subtly with the other members of the party.

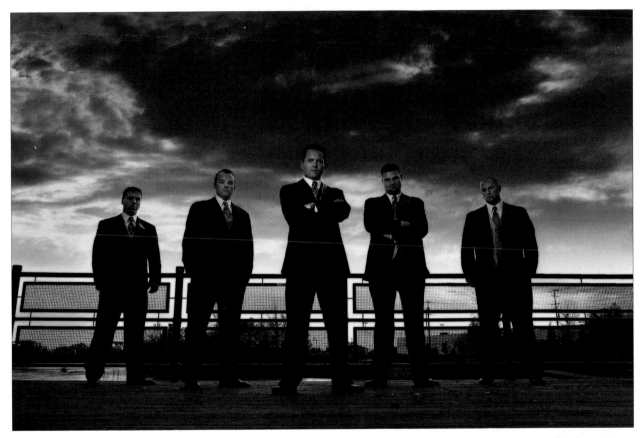

Figure 6.11 Who needs bright sky and smiles to create a wedding portrait? Not Mark Ridout, with his masterful sense of drama and composition!

Add a Bit of Whimsy

Just as with brides, the men's pictures don't have to follow a formula. And there is no harm in adding a personal or regional touch. We've already seen how a car and motorcycle spiced up the women. Scottish wedding photographer Nikki McLeod is used to men in kilts, and enjoys adding a little local flair to her images. Take the one in Figure 6.12. The Scots are noted for a love of golf and some of the most challenging courses in the world. She took her client and companion to the links to put a bit of perspective into her portrait.

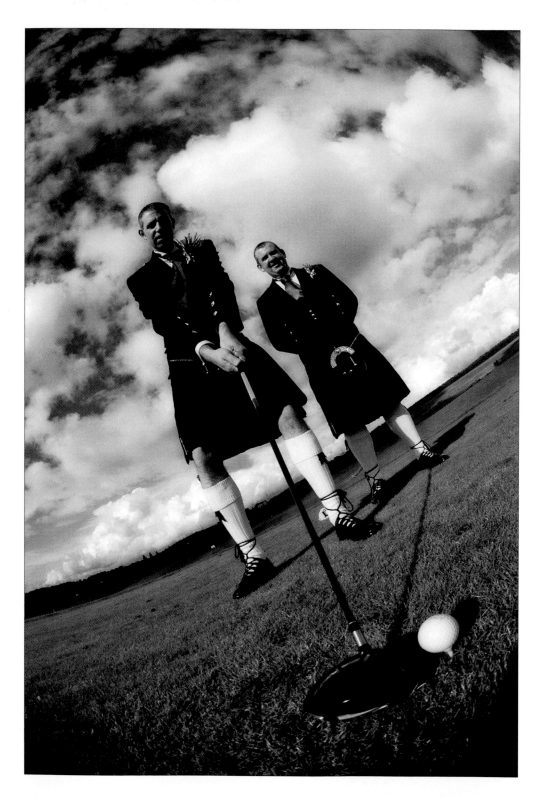

Figure 6.12 Nikki McLeod made good use of her wide-angle lens and Scottish traditions to create this interesting portrait of a groom on the golf course.

Her picture points out a basic skill of a good photographer: consider the angles, and experiment with the point of view. Then she used the wide-angle lens to add depth of field, while adjusting her position to keep the club, ball, and the men in focus. The contrasty black-and-white rendition of the cloudy day adds punch that would have been lost in a color picture, as does the judicious burning-in of the edges of the image.

Next Up

With a booking in hand and the preliminaries out of the way, it's time to start getting ready for handling the primary assignment. Wise wedding photographers never wait until the last minute to pack. Proper preparations make the day of the shoot a much more certain and enjoyable experience.

Photograph by TriCoast Photography

7

Getting Ready for the Big Day

Weddings are chaotic events. The wedding photographer has to be ready to get the images—no matter what happens. The key to success is proper planning for *that* specific wedding before the actual day of the ceremony. The obvious part is checking (and rechecking) the gear. We will cover that shortly, but first we have to actually decide what to take—and having the right gear is only part of the planning process. Getting ready isn't something that can be left until the night before. Using the time before the event wisely is just as important for you as for the bride and her family.

The Preparedness Process

We covered the basics of equipment selection in Chapter 3. Now it's time to look at how to choose what to take, organize it, and make sure the gear is ready to go to the party; your preparation proceeds in that same order. A very small outdoor wedding with a potluck lunch and a wedding party of four is a far different event from a big church wedding with a wedding party of 16 and a huge reception in a designer location. The first can be handled with a camera bag's worth of gear and a single shooter using fill-flash. The latter is best covered with two (or even more) shooters, several bags of gear, and an array of supplemental studio-style lighting.

Know Before You Go—Location, Location, Location

If all you know is the name of the couple, the date, and the address of the location, it's hard to know what to pack. Covering any wedding requires hardware. Properly covering a specific wedding—and with the right gear—requires understanding the details of the event before the bride starts getting ready. Every wedding is different, and success requires being in the right position at the right time, with the right equipment.

The more hands-on preparation you do, the easier the wedding day. No matter how much experience a photographer may have, every wedding is different. Just as with battle, knowing the ground where the event will happen, and the players involved, is as important as having the right gear.

Remember the Wedding Planner form in Chapter 5? Make sure it's filled out. Reviewing its key items is the first step in getting ready. And you should do that at least three weeks before the ceremony, just in case there are blanks that require contacting the client. Completed, it provides vital clues on what to pack, when to show up, and how to avoid common problems. Notice I said clues: the data on the form has to be turned into information that you can use.

The form gives the schedule and location for the entire production. Few weddings take place completely in one place. The bridal party often gets hair and make-up done earlier in the day at a salon or in a home. Then there is the location for the marriage ceremony, which may not be the same place as the reception. If there is a receiving line, it may take place right after the ceremony in the back of the church or as the guests arrive at the reception location. Knowing the addresses is just the first step.

The location's physical layout, lighting conditions, the expected number of people (bridal party, guests, important family members), and the "traffic flow" are all factors in choosing equipment, shooting time, and making the most profit from the wedding.

Smart photographers make sure they visit at least the places for the ceremony and the reception a week or so before the date. If possible, the visit should be at the same time of day to see the lighting conditions. Keep in mind that if the outside light is a factor, the weather may change. Packing a camera with your common lenses, some memory, a light meter, a gray card with a calibration target, and a notepad can be handy for making some test exposures.

Figure 7.1 Not the most glamorous picture from the wedding, but a very useful one. Shooting and saving test card exposures at the location under similar lighting conditions to the wedding is a good way to insure proper exposure and color balance.

If time allows, it's handy to check all the venues where pictures will be taken (including the bride's home, the beauty salon, etc.) and take time to call or meet the wedding planner, stylist, and the person leading the ceremony. All three, as well as people like the florist, are good business network contacts. The person leading the wedding may have real impact on the pictures you take.

Let me give you an example. There is one church in my area that was a favorite for weddings during the Second World War. It has charm and the perfect look for nostalgic-type portraits. It is also a photographer's nightmare for candid and photojournalist coverage. A few years ago a new minister took over there. He decided that the click of the shutter and the presence of the photographer during the actual ceremony distracted from the solemnity of the event. His solution: no photography in the church on that day until the couple left, not even from the choir loft in the back.

Needless to say, I have discouraged couples from using that location for weddings, even though we sometimes use the grounds for bridal and engagement portraits. Thankfully, most clergy are not so draconian. Some venues allow flash during the service, and some do not. Usually, I use a flash until the bride gets to the altar, then turn it off until the newlyweds come down the aisle.

If there are several locations for the wedding activities, you have several stops to make. I keep a separate set of notes for each, along with a master "shopping list" page that shows the items that need to be obtained, packed, and checked for the entire event.

As you look around the site, notice possible locations for both individual portraits and group shots. Pay attention to any possible visual obstructions, ceiling height for both bounced flash and studio strobe/umbrella use. Are there windows, glass, or mirrors that will help or hinder your lighting plans? Also, notice the location of power outlets for strobes and floodlights, and even back-up outlet locations. Make sure you have sufficient extension cords and three-prong adapters. Check to make sure the outlets work and the location of switches that control them. You don't want to plug in 15 minutes before the event and find there is no power where you need it, and no one to ask for help!

I often check the angle of view and coverage through my lenses during the visit. If the space is too close for a telephoto, I don't need to lug it around behind the altar, etc. If the wedding is outdoors, will fill-flash be needed or wanted? That may call for more batteries and a different lens selection.

Size Matters

Not all weddings are created equal. That's one of the major reasons for the planning form. You want to know how many bridesmaids and groomsmen will be in the party, if small children will be part of the altar party, and if there are special guests or some type of long-lost family reunion taking place at the reception. Why? Because these are all things that determine the number of group shots and the number of subjects in each. That will have a major impact on the time and space needed to handle the post-wedding photo agenda.

Use the information on the planning sheet to gauge the area needed for group shots and decide if you will need to arrange the subjects in rows. If the answer is yes, consider bringing a small ladder to allow shooting at a higher angle to give better depth of field. The higher location also means fewer problems with lost faces in back rows.

I've managed weddings with a very small church and 20+ people in one shot, and big churches where the largest group was eight. The size of the church and the number of guests has no bearing on the size of the wedding party—but it can impact the ease and speed with which you get the pictures taken between the ceremony and the reception. Weddings with 12 people plus the bride and groom and the bride's 6-year-old sister and nephew in the wedding party call for a lot more planning and arranging than a group of six.

So, how can the number of guests be a problem? If there is a receiving line at the back of the church and 250 people want to kiss the bride and wish the couple well, the picture may be delayed and the couple ready for a break before you start. In cases like this it may be wise to discuss alternatives beforehand—and to bring someone to help with posing and logistics.

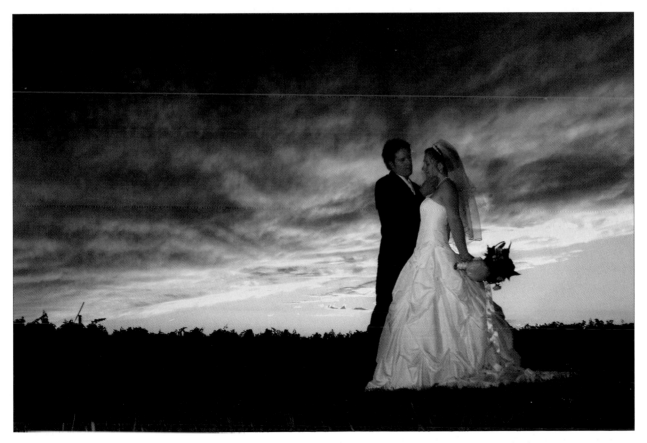

Figure 7.2 Outdoor weddings and formals offer both advantages and challenges that are best met with planning. Knowing the location and potential lighting issues helps get optimal results. This image by Mark Ridout is based on the time of day, and required carefully balanced flash to bring out detail in the couple without washing out the gown or the vibrant sunset

Outdoor weddings present other planning issues for large groups (and even small ones). Will there be shade to reduce harsh shadows if it's sunny or an alternate location if it rains? During the planning visit to an outdoor location, pack reflectors and come at the same time of day as the ceremony. Watch for backlight, glare, and bright reflections. I have even brought a couple of people along to be able to see exactly how things will work; one solution can be shooting the engagement portrait there.

Proper Packing Prevents Poor Performance

I keep all of the tools of the trade packed in cases, arranged by their use, and by how accessible they have to be during the event. The primary bag is a LowePro backpack that holds all the primary shooting gear, meters, memory, small strobes, and a 17" notebook computer with all its accessories. In the event of disaster, I could cover a wedding with just the contents of that bag. It gets triple-checked. The back-up camera is stored in a gadget bag with all its gear.

Light stands, umbrellas, and a soft box are in a long soft case. The wireless controls, power cords, gaffers tape, surge protection strips, and the like are in a large tackle box, and a custom soft case holds the studio strobes. Both bags have all the cables, snyc cords, and odds and ends to fire the strobes. All the gear will fit in the trunk of a car, but they usually ride secured in the back seat. (That area has tinted windows to reduce the risk of theft during stops on the way.)

What to Bring?

If you did your homework, selecting the right mix of gear should be relatively easy. Since some readers may not have as much experience as others, I'll share our studio's packing plan. It is designed to make the process as fool-proof as possible. You don't want to open a bag and find that a critical component (like a camera or a key lens) got left behind or that the power pack for a strobe is drained. In packing for a wedding, mild paranoia is a virtue.

Camera Bags

Our camera bags are designed as self-contained kits for a small wedding, containing all the gear for a single shooter. This design lets us use the same set-up for multiple photographer events. "The Bag" is kept packed with a basic configuration at all times. If any item needs repair or replacement after a wedding, it is handled right after the event.

The contents are all basically the same:

Primary camera body

Back-up camera body

Mid-range zoom lens, usually mounted on the primary camera body

Telephoto zoom lens

Wide-angle or fish-eye lens

Fast normal lens for low-light conditions

Two matching dedicated hot-shoe style strobes

External power pack for one strobe

Incident/flash light meter

Memory cards (enough for slightly more than the average event)

Back-up device (either a laptop computer or Jobo GigaVu Pro)

Required batteries for all powered gear for an all-day event

Cables, cords, batteries, a/c adapter and/or charger

Power strip(s) with surge suppression, 3-prong adapters

Gray card and color calibration targets

Lens cloth, small screwdrivers, pocket knife, pens, notepad, business cards, etc.

User manuals for camera, flashes, meters

MapQuest directions and maps to all event locations, and a list of relevant names and phone numbers added before the event.

Lighting Gear

For most weddings we bring a couple of studio strobes, translucent umbrellas, light stands, wireless triggering devices, and the cables, cords, gaffers tape (for securing cords), and several reflectors. This combination is used to light the larger group shots and boost the light levels in dark reception halls if needed. The entire ensemble fits into three cases.

For outdoor weddings and portraits, as well as large groups, we usually bring more reflectors. Calumet makes some really nice 4x8-foot collapsible panels that can be fitted with white, black, and translucent fabric. They sell legs, clamps, and other accessories that make these very handy gadgets both inside and outside. We bring them in the long bag with light stands and clamps to allow precise angles of reflection.

The 4x8 panels can do double duty and provide either soft lighting or cover very large areas. We have placed two panels together and shot through the translucent fabric. This produces an effect much like a large softbox, without the need for booms and heavy-duty light stands. (Don't try this technique in windy conditions.)

For larger events, or for locations where light conditions may be a problem, we bring extra equipment depending on the specific location. Strobes (sometimes with umbrellas) can be rigged to bounce light off the ceilings and walls. You may need a ladder and the cooperation of the facilities' staff at the location. Also be sure to check the color balance and get reference gray card images. The walls and ceiling, not to mention the regular room lighting, can play havoc with color casts.

Preparing the Kit

Well before the wedding day, it's important to inventory and test all the gear that will be required. Two weeks before the wedding, each item is taken out, assembled as needed, and tested to make sure all the parts are present, working, and properly charged. This bag is where these items live when they are not on a shoot. Why two weeks? That leaves time to locate, order, and receive any replacement items.

Figure 7.3 Brides and their attendants are not the only ones who need to carefully choose and pack gear for the big day. (TriCoast Photography)

Modern camera equipment is remarkably low-maintenance, but not totally care-free. Any sign of poor performance or strange sounds should be checked out as soon as possible. Professional gear gets a lot more exercise than an amateur's does. Several manufacturers recommend an annual inspection and cleaning by a trained technician.

Cleaning should *NOT* involve the actual surface of a lens except in an emergency. There is no cloth so soft that it won't make microscopic scratches in the glass (or plastic) or damage its exotic coatings. Even the finest scratch reduces the sharpness and contrast of the optical surface.

All of our lenses have either a UV or skylight filter placed on the front the first time it comes out of the box. If needed, that is cleaned with a mild solution of dishwashing soap and gently dried with a micro-fiber lens cloth. Never use a paper product to clean any optical surface! If the filter becomes scratched or dull (or damaged), it is replaced. The filters we use are high-quality editions and as thin as we can find to avoid the possibility of vignetting the image.

Don't forget the simple items. Check cables and connectors. Make sure any mounting plates (like those on tripods, light stands, and brackets) are in place and not missing any parts. Some brackets require a little lubrication with light oil. This is a good time to touch up details like that. A touch of silicon on bag zippers can keep them running free, and trimming off and sealing any frayed fabric strands can prevent the frustration of a jammed zipper.

Tip

Some manufacturers offer professionals special status, including expedited repairs, access to special websites, even loaner equipment. Nikon, for example, has Nikon Professional Services (NPS). To qualify you have to be a working professional and go through a verification process.

Members enjoy a variety of benefits, including a sticker to place on a package sent in for repairs. The work is done on an expedited basis and charged to a credit card on file, as long as the bill falls under a certain amount.

Two days before the event, we repeat the process, and all the batteries are tested and charged or replaced as need. Why test? It's too easy to assume something is there just by looking. One time it was a small screw that held the strobe in its stand, another time it was a light meter battery that had drained. All batteries have to be tested with enough time to recharge or replace them. I also power up each strobe and fire a few full-power discharges to form the capacitors. This insures peak performance at the wedding.

The day of the event, check the contents of bags against a check list. Are the cameras, lenses, memory cards, power sources, etc., all in place? Do any batteries need a charge? Why again? If one of the units was accidentally left on, it may have drained the power.

Some shooters also take the time to check each memory card for proper operation and reformat *inside the camera that will use it* the next day. Not a bad practice. Then make sure everything is topped up and placed back in its proper location.

The last thing before leaving the studio, and the first thing on unpacking at the location, is to assemble the camera rigs and make sure the settings are all in the proper configuration. That includes the capture mode (RAW for me), white balance, ISO setting, meter modes, flash sync, etc. That should become a habit with every change in location. It's a good idea to check the options periodically during the day and on each change of location.

All of this check and double-check may seem a bit excessive to the novice, until they get to a wedding (or are on the way) and wonder if the memory cards were put back in the case, or power-up a camera or battery pack and see the low battery warning come on. You can't re-shoot a wedding or ask them to wait while you run to the store. Covering a wedding is like an expedition: take everything you need and make sure what's needed works.

A Case Study

The wedding I shot the weekend this chapter was authored provides a good example of the planning process and how to take advantage of it on the wedding day—with the added advantage of hindsight. My role was second shooter, returning the favor to another photographer for her helping me the month before. The church was in her city about 40 miles from my studio.

This was a wedding party with a young bride and groom, three grown attendants for each, plus a young ring bearer and flower girl. As wedding parties go, this was about average. The ceremony was to be short and sweet, just an exchange of vows and rings. Should be an easy shoot, right? Maybe, maybe not. We did our homework and packed with the requisite bit of paranoia.

The Planning Visit

On the day of the preliminary visit (four days before the event), the sanctuary was undergoing renovation. The walls were primed for paint, there was no carpet, and the day was rainy. The only shooting locations would be in the aisle (which was non-existent on this visit) and on one side of the sanctuary with a narrow angle of view.

The church interior was narrow and located behind a busy highway with little more outside than the street and parking lot. The bride's grand entrance would be in very strong backlight, since she would be entering the back of church from the outside through a pair of open double-doors. Room to maneuver would be limited in the expected audience of 150 people.

The reception was slated for the Fellowship Hall next door. This was a Butler Building with no windows, but good overhead flood lighting. That was a real plus, since the room had a 21-foot ceiling, The food would be a light lunch, served from buffet tables in the center of the room. There were two stairways on either side of the room, providing a good set-up for both portraits and the bouquet toss.

There would be both a wedding and bachelor cake-cutting, toasts, and both bouquet and garter toss during the reception. The departure would be made in a stretch limo from just outside the hall.

The Shooting Solution

Over coffee after our site examination, we discussed how to handle the project. There is little a photographer can do about the layout of a church wedding. The angles are fixed by the layout of the room and the hidden vantage points in front available during the service. If there is more than one, you need an unobtrusive way to move between them. If there's a choir loft in back, be sure and arrange for the access to be open or get a key. This is where the site visit and talking to the minister can help.

With two shooters, it's a very good idea to divide up the work in advance, but stay flexible in case the situation changes. It usually does! We had neither hiding places nor an elevated view in the back. We decided to have the primary photographer start in the back in the beginning, move up as the first members of the wedding party entered, and then stay in the aisle around the third row with a medium zoom lens.

The second shooter would work from a location on the right side of the altar. The groom and his party planned to enter from the rooms behind the sanctuary. I would cover that, then concentrate on close-ups of the couple and minister during the ceremony, plus people pictures of family and friends among the guests during the service.

The likely problems during the actual wedding would be the backlighting as the party entered and the tight quarters due to the crowd. Precise readings and manual exposures with fill-flash would handle those exposure issues. We noticed that with the large windows in the church, the available light could change by two stops if the wedding day was sunny with moving clouds.

There was also the problem of color-cast inside the church. Mixed light from the painted windows and overhead lights tend to produce strange skin tones and uneven shades in the bridal gown. The reception looked easy, with lots of room and good lighting.

Sweeping vistas were out. There were limited options for taking bridal portraits or working large groups at the church. My colleague's studio had access to a local farm with a pair of decorative gazebos and a stone fountain. She arranged for access before the wedding for formal pictures of the bride and her attendants. We would shoot the groom's party in front of the church. (The forecast was for sunny weather.) The largest group anticipated was about 14 people, several of whom would be children. The area in front of the sanctuary would be large enough.

Don't limit planning to just who shoots what, when, and where if there is more than one photographer. Discussing equipment and technique is a very good idea. I use Nikon; she has Canon equipment. We both shoot RAW and use the same software, so the file format was not really an issue. We devised a common back-up scheme and could pool memory cards, but we could not share lenses, back-up bodies or dedicated flash, batteries, or cables. With our plans set, we arranged a meeting time and went off to our separate gear preparations.

The Day Arrives

The morning of the wedding started with a bright sunny sky and a few clouds. We made sure we arrived early, with gray card at the ready to get new reference readings, and to see how well the renovation had gone. The walls and floor had changed color with new carpet and paint. The church was packed with white folding chairs; there had not been enough time to get the new pews installed before the wedding. The aisle was narrow and the front row was about six feet from the edge of the sanctuary.

Overcoming Murphy's Law

The old adage "Hope for the best, prepare for the worst" is a good motto for those who are paid to take pictures at weddings. That corollary to Murphy's Law could serve as this chapter's subtitle. We benefited from following it. As the day progressed, we had to adjust our approach to suit conditions. The planning paid off by allowing us to anticipate challenges and have ready solutions.

The quality of light in the church was slightly warm, with a noticeable green cast from the florescent lighting and stained glass windows. It was obvious that the backlighting as the bride made her entry would be extreme, especially for the photographer shooting down the aisle.

We modified the plan slightly. In addition to the original pictures, I would photograph the seating of the parents and the arrival of the bridal party coming towards the sanctuary. That would provide insurance coverage. Timing the exposures so that the subjects were in between two of the windows took care of the backlighting problem. As luck would have it, the choice was perfect. During the processional, my colleague's flash cable failed, with no way to replace it in time to take pictures of the bride coming down the aisle. Having a second shooter paid off right there.

All of the other aspects of the event went pretty much as normal. Having two photographers let us move quickly through both the outside bridal portraits at the farm and the group shots after the ceremony. This was an important factor. Little kids don't like to wait around, and the bride had a contradictory dual agenda—perfect pictures of large groups, but without taking much time. We each took sets of small groups and doubled up on the big ones. One person posed the people, the other composed and took the exposures.

The sky had grown cloudy just after the service. The light inside the church varied as much as two stops between exposures as we managed the formals. While shooting the larger groups, the person doing the posing took an incident reading just before the shot to confirm the settings. That helped. We did have to take the time to take bracket exposures for insurance.

Next Up

The case study points out just how important proper exposure and shooting technique are in producing excellent pictures and pleasing the client. Covering a wedding requires the skills of a portrait photographer, a sports shooter, and a photojournalist. We have to manage a crowd, shoot moving subjects, and capture the emotions of the day. It calls for working fast, yet with a professional touch. We now turn our attention to the technical aspects of the craft: the camera and lighting techniques that apply to all weddings.

James Karney

8

Photographic Technique: The Gateway to Style

Feel free to skip this chapter if you are an experienced digital photographer used to demanding assignments with uncertain and often dim lighting conditions that defy light meters, fast-moving subjects, challenging locations, and the stress of having to get the picture the first time.

Watch experienced wedding photographers at work, and you notice they frequently adjust settings as conditions change—often without looking at the buttons. Their familiarity with their camera—its features, its ergonomics, and also its idiosyncrasies—requires regular practice. If you are new to professional photography, this chapter's short course will speed up your gaining that level of proficiency.

It provides practical exercises on estimating and adjusting exposures, dealing with white-balance problems, camera control, and advanced flash lighting techniques. Both skill and confidence need to be present before tackling a wedding assignment alone.

Since few people would venture into photographing weddings without a basic understanding of camera operations, the material assumes the reader understands basic photographic terms and principles. Readers wanting a quick review or basic introduction will find *Mastering Digital SLR Photography* by David D. Busch, also published by Thomson Course Technology, useful.

Some of the pictures studied in this chapter will reappear later in the book, as we look closely at the actual coverage of the wedding day. That way we can focus on skills needed to capture images now, and see them applied in context later.

The DSLR: Wonderful Technology and a False Sense of Security

The digital SLR is an amazing tool, with more computing power than the machines used to support the early space program, all in a box that can fit in your hand and take pictures without film. Its processing power seems to eliminate the need for any human intervention: auto-focus, auto-exposure, auto-flash. Automation is great, but it's dangerous to totally rely on it.

The camera doesn't see, so it can easily be fooled by the challenges presented at a wedding. Auto-focus can be fooled and track the wrong subject. Mixed lighting conditions (like sun and shade or flash and fluorescence) can fool its "sense" of color. Automatic exposure can't be depended upon to choose the right shutter speed to stop action, or the proper f/stop to keep the bride's face sharp while blurring the background. Sometimes we have to photograph subjects that are in deep shadow or harshly backlit. We start our exercises with the art of manual exposure.

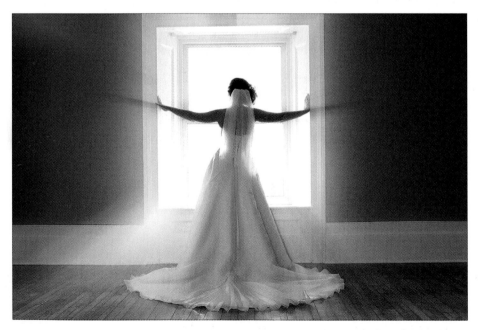

Figure 8.1 It's dangerous to rely totally on a camera's automatic settings when the scene contains extremes in tone, which must be preserved, and mixed lighting. In this example, Mark Ridout carefully and successfully dealt with a strong backlight to hold detail in the gown and maintain the rich colors in the room. Allowing the details in the window to totally wash out adds to the design.

Defining the "Perfect" Exposure

It's easy today to totally rely on a meter, and get "acceptable" results. Those in most professional cameras use sophisticated logic to measure the scene and offer a solution. But the meter has limitations and can itself fail. It can't choose the most important part of the scene, factor in difficult lighting conditions, or calculate the precise shutter speed needed to stop motion.

Don't get me wrong, the meter is a powerful tool. Both the in-camera and external incident/flash units are constant advisors as I cover a wedding. Truth be told, my settings almost always vary from the readings. Most of the time there is usually at least a minus 1/3-stop compensation to the matrix meter. Sometimes the camera is set to manual. Then I use a combination of intuition coupled with a regular check of the display and histogram.

That's because the "proper" exposure won't always serve our needs. A somewhat darker image will hold more detail in the highlights, and suits the way we process and retouch images for printing. The real "perfect" exposure is the one that lets the photographer get exactly the final result envisioned as the shutter is pressed. Most of the time, that is a well-balanced range of tones. There are exceptions.

Mike Fulton has provided us with examples of exposure and lighting drawn from the TriCoast workshop and DVD tutorial series. (Information on them is found in Appendix A, "Resource Guide," found on the companion website— www.courseptr.com/downloads). The picture in Figure 8.2 shows an original image, and 8.3 shows the result after RAW processing and enhancement in Photoshop. It shows how even when the meter reading is "right," another exposure is needed to obtain the desired final image and still preserve detail in important areas that the meter reading does not allow for.

Deliberate over- and underexposure are creative tools, and not just when we want a high-key or low-key effect. Figure 8.2 looks dark; examined in the camera's LED display, it probably looked almost unusable. But the photographer was visualizing how the final picture would look after processing.

He chose to let the fabric on the ceiling go *almost* totally dark to be able bring out as much detail in the highlights as possible after processing. The exposure still shows skin tone, and the flowers, gown, and wall have texture. The area just under the recessed lights on the left is slightly washed-out.

Let's look closely at what the "underexposure" allowed the photographer to do and how it was done. Compare the flowers and the open sky through the windows in both figures. Both have tone in Figure 8.2, but are close to washing out in Figure 8.3. The bride's skin tone in the processed version is right on the mark after processing, as are the walls and pillars.

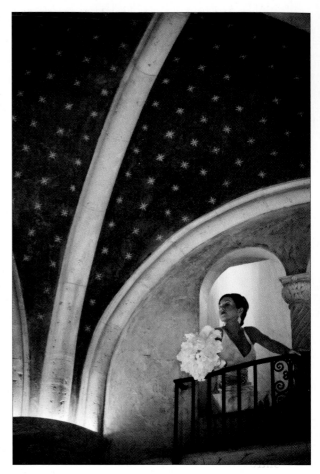

Figure 8.2 This image looks underexposed, and it certainly wasn't taken with the values offered by the camera's metering system. The photographer carefully chose the settings to hold highlight details for later processing.

Figure 8.3 After processing and enhancement, the dramatic results are very pleasing. The exposure is the starting point of the photographic process. The meter can only work with known values and the limits of its programmed logic to evaluate a scene. The photographer must consider the final use and determine the exposure settings needed to obtain the desired results. (Both images by TriCoast Photography)

Now consider the decorative fabric on the ceiling. The rich blue color was enhanced with a Photoshop action. Mike Fulton and his TriCoast partner Cody have developed scores of actions used to speed up their work, and many are based on techniques that require adjusting exposure to create a RAW image that can stand up to the level of adjustment required to produce the picture the photographer visualized at the moment of exposure. This level of skill requires an understanding of both exposure and processing techniques.

A Word about RAW versus JPEG

There are several aspects of digital photography that produce almost a religious fervor between adherents: Mac or PC, Canon or Nikon, and RAW versus JPEG. Professional DSLR cameras allow the user to save an image using the actual unprocessed (RAW) data or to let the camera process the image and only save a JPEG rendition. Some photographers would never consider covering a wedding in any other format than RAW, others hold that they do just fine with JPEG.

RAW files are large, so memory cards fill up much faster. On the other hand, JPEGs do not contain the original recorded data, which limits the photographer's ability to correct color and white-balance problems or to make extreme enhancements like those shown in Figure 8.3.

Mike, Cody, and I almost always have our cameras set to save images in RAW format. We like the extra control and security the format provides. Mark tends to work in JPEG mode. It is a matter of personal preference, but one that should be based on both ability and workflow.

Honing Exposure Skills with the Sweet Sixteen Formula

Okay, the first three figures show why being able to estimate exposure is valuable. Now let's work on the skill. We are going ignore all the fancy buttons and the sophisticated metering system to start; we'll just use our eyes and the basic exposure controls. Then we'll add features back in as our discussion progresses and the exercises become more advanced. If you are already skilled at setting manual exposures in daylight, skip ahead to the exercise on indoor available light.

In the days before meters, we relied on a tried-and-true formula for outdoor daylight photography that is still valuable today: the f/16 formula or "Sweet Sixteen" rule. We are going to use it to train our eyes and to calibrate the camera's meter to real-world references.

Once upon a time, before light meters, film speed ratings were determined by exposing the product at f/16 with a series of different shutter speeds. The test was made on a bright sunny cloudless day at noon. The reciprocal of the shutter speed that gave the best result was the rating.

So if 1/125 of a second gave the best image, the product was given a speed of 125. The system uses a table of defined sky conditions to adjust the exposure to compensate for cloud cover.

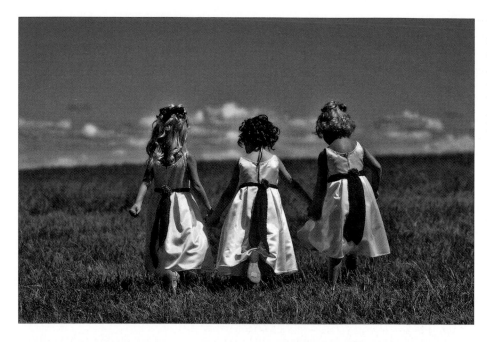

Figure 8.4 Bright sun, a few clouds, and an exposure of 1/4000 at f/2.8 used by Mark Ridout for this picture of three little bridesmaids is very close to the Sweet Sixteen rule of thumb for his ISO rating of 100.

The Sweet Sixteen Exposure Guide

Once, all boxes of film carried some variation on the following exposure recommendations. These settings still work well in this age of automation and can be used both to gauge the reliability of your light meter and to estimate a manual exposure.

Keep in mind that this list does not include consideration of the direction of the light or the colors and tones contained in the subject. Just as with light meters, the photographer must consider making allowances for specific conditions, subjects, and the desired final image.

Bright Sun on Sand or Snow: This is the brightest lighting condition on the scale, when the reflective nature of the ground cover requires less exposure than for a typical bright sunny day with no clouds, so we close down one stop or cut the shutter speed in half; Index Exposure is f/22@1/ISO

Bright Sun: This is the primary sky condition indexed to f/16 at the ISO rating of the media. It is a bright, sunny day with distinct shadows present, and there is no significant smog, fog, or other atmospheric interference. Index Exposure is f/16@1/ISO.

Cloudy Bright: A weak sun is easily seen through a thick haze or scattered cloud cover. Shadows are soft or indistinct. The exposure is increased one f/stop, or the shutter speed doubled, to adjust for the lower light intensity. Index Exposure is f/11@1/ISO.

Cloudy: The sky is covered with clouds and the sun is seen only as a bright area in the clouds. Shadows are not present. Contrast is low. The exposure is increased four times (two f/stops) more than the basic exposure. Index Exposure is f/8@1/ISO.

Cloudy Dark: The sky is dark with heavy clouds and no shadows can be seen, or the subject is in full shade. Photographs made under these conditions have low contrast. The exposure is increased eight times (three f/stops) over the basic setting. Index Exposure is f/5.6@1/ISO.

During the days or film and mechanical shutters, when I taught photography full-time, new students would always get the same first assignment. Use Sweet Sixteen to expose several rolls of film with slow, medium, and fast ISO ratings using the f/16 tables. This exercise, coupled with evaluation of the results, develops several important skills.

First is the ability to estimate exposure based solely on light intensity, no meter. Second, it develops an understanding of the relative range of tones the media can record without losing details in the highlights or shadows. Next, we can check the results we like against the meter's suggestions to determine if we should dial in an adjustment factor to suit personal taste.

Finally, working on basic exposure skills makes us more attentive to the quality of light in a scene, its direction in relation to the subject, and the overall contrast and tonal range that is recorded. We won't dwell on these topics in our discussion, since each reader will be taking different scenes with their own equipment. Keep in mind that seeing light, and how it models your images, is vital to real mastery of the art.

Exercise One: Determining Daylight Exposure without a Meter

As you can see in Figure 8.5, an open sun on a clear day is both a blessing and a curse. It provides plenty of a good thing, bright light. It also produces harsh shadows and deep shade. Even the best meters can be fooled under such conditions. When covering outdoor weddings and receptions, being able to judge and control extreme tonal ranges is an important skill.

The goal of this exercise is to become familiar and comfortable enough to use the f/16 system to set daylight exposures and make appropriate adjustments to the basic rules. You'll need your camera, a memory card, and the outdoors. If possible, use a lens that closes down to f/22.

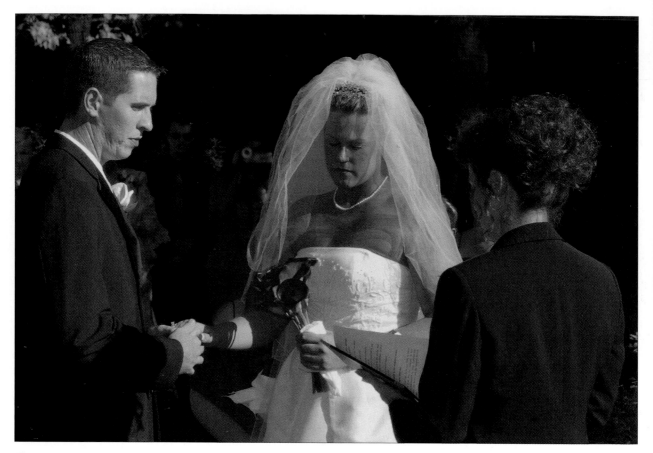

Figure 8.5 Bright sun, open shade, and a bright wedding gown all in the same picture; with such a wide tonal range, it's not a good combination to leave up to the camera. I underexposed (according to the matrix-meter reading) by two stops. While moving around during the outside ceremony, the direction of the light and the overall brightness of the scene had to be considered. Under these conditions, my practice is to routinely underexpose slightly, because it holds details in the highlights (like the fine work on this bride's gown). Look closely and you can see that the lighter areas on the groom's forehead were also close to washing out. A small amount of fill-flash was used to open up the shadows on the bride and the dark clothing of the groom and minister. (Photograph by James Karney)

An ideal setting is an open area that gets full sun, and which also has a range of tones from white to very dark. A person dressed in white is a plus. It's easiest to start learning on a bright sunny day. If your part of the world is cloudy, use the adjustment values given in the Sweet Sixteen sidebar.

Creating a Reference Set

We are going to start with a basic series of exposures to see how well the f/16 system works with the camera at three different ISO settings. Sensors vary, and so do the ways individual photographers determine cloud conditions. If manual exposure is a new adventure, it's a good idea to repeat this exercise under each of the

five sky conditions listed in the sidebar. Also, be aware that the direction of light and the height of the sun in the sky will change the apparent contrast in the scene on sunny days. The sun's direction can be ignored on dark days and when working under full shade.

Step One: Setting Up

Position yourself so that the sun is behind you and falling full on your subject, and place the meter in full manual mode. Set the camera to its lowest ISO value. Adjust the shutter speed to match the ISO (1/100 of a second for ISO 100, etc.) and the f/stop at f/22 if your lens permits

Step Two: Taking the Pictures

Now make a series of exposures of your scene at f/22, f/16, f/8, f/5.6, and f/4. If f/16 is the smallest aperture on the lens, then set the shutter speed to half the ISO and use the same series of f/stops. (Just remember in later discussions to consider the adjustment you made as we talk about results.) Now repeat the process with the camera adjusted to ISO values of 400 and 800.

Now take a set of metered exposures at each of the ISO speeds so that we can compare the meter to the f/16 formula.

Step Three: Examining the Results

Now we are going to examine the results. In theory, the exposure formula matching the sky conditions should produce the best result. Download the files to your computer, and leave the card in the camera. Look at the ISO 100 images in your editing program. Which one do you like best?

Examine the histogram displays for the finalists on both the editing program and your camera. Do they both look the same? Some cameras only use one color channel or a JPEG rather than the full RAW file for the histogram source data.

Repeat the examination for the each of the ISO values. Do they have the same quality? With the right light, signal noise should not be too great. It may be more noticeable at higher speeds in deep shade or in darker areas of the image.

Finally, pick the most personally pleasing of each manual ISO series and compare them to the metered images taken with the same ISO. Does it lead you to consider making use of exposure compensation to adjust for the exposure settings offered by the meter?

What has this experience taught you about judging light and exposure? Which combination of f/stop and shutter speed produced the best mix of depth of field and motion-stopping ability? Keep in mind that metering takes practice under different lighting conditions and with different subjects.

Step Four: Lessons Learned and to Be Continued

The exercise can be taken farther. Remember how Mike and I often underexpose pictures that show the bride and her gown? Take a set of average, under-, and over-exposed images and load them into your favorite editor. How far can you push the results? In the days of the darkroom, this kind of experimenting was a tedious process, with lots of processing steps. Now it's easy to play, compare, and push the results.

As a medical photographer, I carried a Leica IIIf 35mm rangefinder camera with a collapsible 50mm lens in a modified case on my belt. I picked up the trick from my boss, Norman Rabinovitz, who was W. Eugene Smith's assistant while Smith was creating his Pittsburgh essay. We would stroll the local university neighborhood during lunch looking for subjects to photograph.

Self-assignments should be a regular part of any professional photographer's routine. During self-assignments, estimate the exposure and test your intuition, then compare that to the results with the camera's metering systems. Varying the lighting conditions, shifting between subjects like landscapes, people pictures, and action-filled events helps to train the eye and the sense of timing. Figures 8.6 and 8.7 suggest how practice at a sporting event or street scenes on a rainy day can pay off on the next assignment.

Exercise Two: Meter-Free Available Lighting, Indoors and at Night

Training the eye for indoor exposure is similar to outdoors, except that we don't have as predictable a set of lighting conditions as sun and sky. Indoor lighting can come from a variety of sources, all of which may be of varying intensities. They can be shaded, reflected, even recessed in innovative ways that produce a variety of contrast and shadow conditions. Windows add daylight that blends with room lighting.

We tend to see picture possibilities more often when a camera is at hand. We examine light more closely when considering picture possibilities. I can still reliably walk into a room and judge the correct exposure for ISO 400 within a half-stop, and visualize how the scene will appear after processing. It's all a matter of regular practice.

Step One: Be Prepared

Most indoor settings are a good bit darker than even a cloudy day. The quickest way to develop a sense of indoor available light levels is to choose a single workable ISO level and find the matching exposure for an average room in your home. Use the meter once as a starting point, but then work on developing intuition.

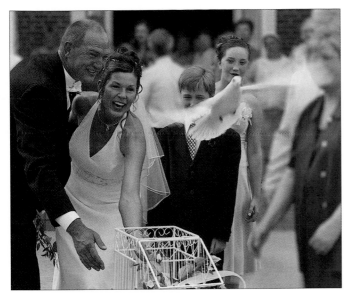

Figure 8.6 This is another example of when to bypass your meter. Catching the bird in flight and holding highlight detail were the critical factors in this exposure. I didn't want to totally freeze the dove's wings, and did want to blur the distracting background. Opting for a high shutter speed and relatively low ISO allowed opening up the lens to reduce the depth of field. The challenge here was not unlike that found during an active sporting event. A touch of underexposure provides highlight insurance. (Photograph by James Karney)

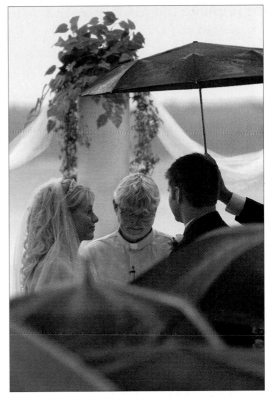

Figure 8.7 Not all weddings are filled with sunshine. Getting in practice sessions on rainy days offers the ability to learn how to work under adverse conditions, as well as to devise ways to keep your gear protected while still getting the pictures. The low-contrast conditions make for more saturated colors and a compressed tonal range—and little worry about washed-out highlight detail. (Photograph by Mark Ridout)

Keep that ISO setting, and move into rooms with different lighting conditions. Vary the f/stop and shutter speed—while leaving the ISO constant. Practice over a period of several days in a variety of settings and light conditions. Get to know the characteristics of that ISO and your camera. Watch how different types of illumination affect contrast and color in your images. Then add working outdoors at night under different lighting conditions.

Step Two: Test and Experiment

Photographing available light indoors and at night requires more exposure than daylight. We can boost the ISO setting, open the f/stop, or slow the shutter. Each has its limits. Faster ISOs produce more noise in the image. Wider f/stops narrow

depth of field, and slow shutter speeds increase the risk for blurring, from both subject and camera movement.

Play with all of the options. Find an interesting subject and take similar pictures with varied ISO, f/stop, and shutter-speed combinations that produce the same exposure values. How does the noise level at ISO 1200 compare to that of ISO 400? How do you like the effect in dim light? Would you prefer using a slower shutter speed and losing depth of field or a high ISO and loss of fine detail due to noise? This is the path to developing a personal style.

While experimenting, don't limit yourself to "ideal" lighting conditions or exposure combinations. Try variations of over- and underexposure, high-key and low-key renditions. Work both close to your subject and on scenes that take in the entire room. See how far the shadows and highlights can be pushed. Just as with daylight, the proof of an exposure setting is in the output. Work with the images in a favorite editor, and proof some examples to see how they look on paper and on the web.

So far, we have limited our attention to basic available light and exposure. I use the term basic because we have not been controlling the light and the way it works in the picture. Consider the lighting effects in Figures 8.8 and 8.9. Both are "available light" images. In both, the photographer carefully positioned the subjects so the light produced a precise effect. Both use a single light source. The results are dramatically different for one reason: the direction of the light.

In Figure 8.8, narrow illumination is almost directly overhead, forming deep shadows below and around the faces. Figure 8.9 has a broad light source, the sky, directly behind the couple. They are in full silhouette and the translucent stained glass is properly lit.

Exercise Three: Developing a Sense of Timing and a Steady Hand

So far, we've limited our discussion to seeing light and the importance of proper exposure in producing good images. The way we hold our cameras, and how and when we press the shutter, are just as important. They affect what is in the picture, and how sharp it is.

Step One: Choosing the Moment

If the subject is a tired little boy yawning during a ceremony, the impact is lost if his mouth has already closed. In Figure 8.7, the expressions of the bride and groom were as fleeting as the departing dove. Sports photographers develop a sense of when the peak of action will occur, and how to trip their shutter to capture it. We

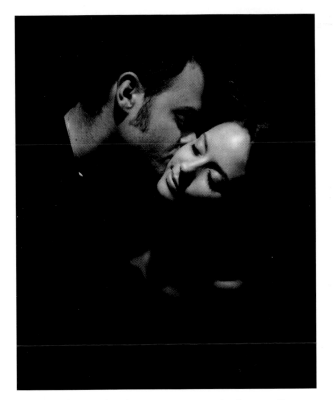

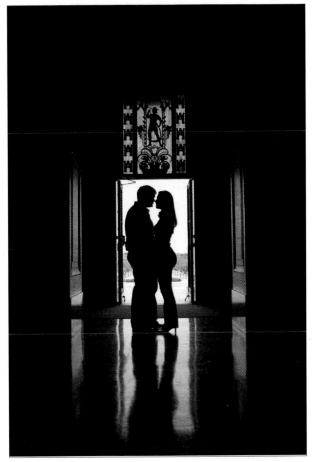

Figure 8.8 This low-key portrait uses a single, very direct light source to add drama and accentuate contrast. It is another example of conditions that challenge light meters, and thus empower the creative photographer. (Image by TriCoast Photography)

Figure 8.9 Here the exposure was based on the outdoor light, rather than the interior lighting conditions. The resulting picture holds color and detail in the stained glass windows and the reflections on the floor, and silhouettes the couple in the doorway. (Image by TriCoast Photography)

can make use of motor drives and fire exposure bursts. Even then, a finely honed sense of timing is better than brute force.

Another reason for developing timing is to reduce the effect of subject movement. When the action is faster than the shutter speed, the subject is blurred. Potentially, blur can be used for a creative touch, say as the bouquet is tossed to the waiting bridesmaids. If there is too much blur, and the flowers only appear as a streak of indistinguishable color, much of the effect is lost. But if, just as the bouquet starts to fall, it hangs in the air for a split second, and the shutter is pressed at just the right instant, the flowers are frozen or captured with just a slight blur.

This is one skill that can only be developed with moving subjects. Sporting events are one good place to find the appropriate material. Birds in flight and moving cars are other options if you don't want to search out a local team.

Track meets are great locations for working on catching the peak moment. Hurdlers can be stopped at the top of the leap, pole vaulters just as they release the pole, and jumpers as they hit the sand. No matter what your subject, work on first seeing the peak moment, then practice capturing just that instant.

Panning is another valuable motion-controlling technique. When the photographer keeps the camera moving in relation to a subject, the background will be blurred as seen in Figure 8.10. This can be a nice effect for images, such as dancers at the reception and the couple leaving under a shower of rice or birdseed.

The visual effects of panning will be greatest when the subject is moving perpendicular to the photographer, and smallest when moving either directly toward or away from the camera position. Choosing subjects moving at a variety of angles to you is a good way to work on panning and seeing how fast a shutter speed is required to freeze action.

While working, also keep looking for other images and practice evaluating the exposure. Keep honing all your skills. This kind of practice is also a chance to become more familiar with your camera's auto-focus and tracking capability. Just as with the other steps, examine the results and enhance the images in your editing program.

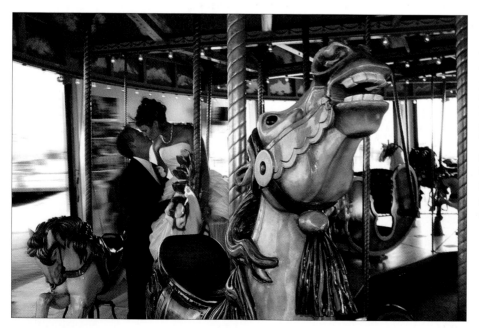

Figure 8.10 A fine sense of timing and a carefully considered exposure are key elements in the success of this picture. Mike Ridout used a slow shutter speed to blur the background and show the speed of the moving carousel. The kissing couple is nicely framed by the horse in the foreground. All three had to be timed just right as the wooden steeds bobbed up and down. (Photograph by Mike Ridout)

Sharp, Not Shaken

Camera shake is the enemy of sharp pictures at slow shutter speeds. The basic rule of thumb for motion-free hand-held exposures is to keep the shutter speed at least as fast as the focal length of the lens. The longer the lens, the faster the required exposure. So, for a 200mm lens, 1/200 of a second should overcome camera shake—if the photographer holds reasonably still and uses a smooth push on the button. In reality, the longer the lens, and the poorer its balance in the hand, the harder it is to hold still.

We can do two things to reduce camera shake, short of resorting to a tripod or monopod. The first is to practice holding the camera still and making the push of the shutter release as smooth as possible. The second is to brace either the base of the camera or the barrel of the lens.

> ### Tip
>
> A small bean bag is a handy tool that can be used as a rest that is both faster and smaller than a tripod. Set the bag on a stable surface, like a table or even the back of a pew, then use it to cradle the base of the camera or the barrel of the lens on the bag while taking the picture.

Let's use a practical example. The picture in Figure 8.11 was taken with a shutter speed far below ideal, 1/10 of a second with a 200mm lens. There is visible motion as the bride places the candle in its holder. The final picture is cropped to use only half of the original image area, increasing the visibility of camera motion. I used peak timing, a slow squeeze, and a brace.

Figure 8.11 This church may look brightly lit, but the wedding planner turned the lights very low. To make things even more difficult, I was standing 75 feet away in a doorway on the far side of the sanctuary, using a 200mm lens. The camera was braced against a door jamb to reduce camera shake. The exposure was 1/10 sec at f/2.8, with an ISO of 800. Subject movement was held down by timing the exposure to match the moment when the bride started to place the candle into the holder. (Photograph by James Karney)

First, the base of the camera was pushed against the door jamb of the small room I was hiding in during the ceremony. The other hand was placed under and toward the end of the lens barrel to improve stability. All of the slack in the shutter button was taken out, and then I waited. At the right moment, soft, smooth pressure was applied to make the exposure.

Step Two: Slow is Smooth, and Smooth is Fast

Gaining skill with holding a camera steady requires good habits and practice. In marksmanship there is an old saying, "Slow is smooth, and smooth is fast." In other words, don't rush, and keep the pressure on the trigger steady and smooth. That works in photography too. A constant pressure won't jar the camera the way that a fast push will.

Once again, the solution (at least within the limits of human ability) is practice. Short practice sessions on a regular basis are best for this skill. You are working on developing fine motor-muscle control. Here the goal is being able to evaluate your ability to stabilize the picture, so we will set up an exercise to maximize the problem.

Choose a long lens, or set a zoom lens at its maximum telephoto range. Find a subject and a background that have contrasting colors. Place the subject at the lens' closest focusing distance. Determine an exposure combination requiring a shutter speed that is one-fourth of the focal length. For example, use 1/50 of a second for a 200mm lens.

Press the shutter until all of the slack is removed, but don't take the picture right away. Work on holding the camera still so that the subject is not moving against the background. Then with an even, soft, pressure make the exposure. Slow steady breathing helps, with a short pause just as the picture is taken.

Keep practicing with both vertical and horizontal compositions. Notice which hand positions and grip are the most stable. Examine the images to evaluate your progress and see which arm positions are most efficient.

Flash: More than Available Light on the Subject

Available light lets us take pictures. Controlling light lets us create pictures. So far, we have limited the exercises to working with existing light conditions; now we are going to add and control the way light works in the picture. If you are already well versed in flash photography and the use of reflectors, feel free to skip to the remote flash and white-balance topics.

A full discussion of lighting is worthy of a library all its own and a series of workshops. This chapter focuses on lighting for wedding assignments. Most of the time that means flash, but not always. (We will limit the flash lighting discussion to compact units. Studio strobes, even portable ones, are beyond the scope of this book).

No Batteries: Scrims, Screens, and Reflectors

Before getting into power tools, let's mention and demonstrate a low-tech solution: light modifiers. Our studio's location gear includes two bags with collapsible reflectors, scrim (sheer fabric that is placed between a light source and the subject to soften the effect), and opaque panels, which can block all light coming from one direction to produce shadows.

Simple collapsible reflectors come with a variety of fabrics, including white, black, silver, and gold. They can be used to bounce light from a window, the sun, a strobe, or any other bright source. Metallic fabrics will produce a harder result than white material. Reflectors with translucent fabric will work as a scrim to soften a light falling directly onto the subject. Place an opaque cover on the device and you have a "flag" that can block light on one side to produce shadows. Properly used, reflectors can make one light look like two, or model a single light source to produce softbox-like effects.

Figure 8.12 is an image that was taken using one white reflector to bounce light from a small window, softening and broadening the effect. The reflected light is the only illumination falling on the subject. Most reflectors can be bent and twisted to "shape" the light and how it falls into the scene. In this case, my assistant canted the disk to almost an S shape to produce a more pronounced result on the bride's upper body, and to have the light fall straight onto her face from a low angle.

The reflective nature of the objects in a scene can also be used for lighting control. Here the wall was painted in a flat green paint, so it reflected little light. A bright white wall near a subject can be used to fill in shadows if the angle is set properly for the light source. When working with hand-held reflectors, it's easy to adjust them for the desired result. It's more difficult to employ walls and fixed objects, even if they provide the perfect amount of "bounce."

The key to mastering reflectors is observing how light changes as it bounces off (or shines through) different materials. The angle and distance between the light source, the reflector, and the subject modifies the amount and quality of

Figure 8.12 Reflectors are a simple form of light control. Here one is used as primary illumination, casting the light from a nearby window onto the subject at a precise angle. (Photograph by James Karney)

both the illumination and the shadows. The companies that make and sell reflectors offer a number of tutorials on using their products on their websites (some for free). See Appendix A, "Resource Guide," on the companion website (www.courseptr.com/downloads) for names of vendors.

Powering Up with Flash

Modern computer-managed compact flash units are amazing devices. The better ones come with automatic metering and built-in wireless remote control. Wireless operation has made it easy to combine multiple units at an event in ways that were once limited to studio settings. Flash units can be used as a main light, as a fill, and as an accent light. Let's briefly discuss different styles and techniques before actually working with the equipment.

Direct Flash

Direct flash is when the strobe is the principal light source for the picture. Many photographers shy away from this form of lighting because it tends to produce harsh shadows. This is because the light generated is much more powerful than any other light in the scene. (Think of the dark shadows produced by street lights late at night.)

We can reduce the shadows using a technique called "dragging the shutter," allowing the existing light to serve as a fill for the flash. The flash duration is very fast, so if you hold the camera still and use a slow enough shutter speed, the ambient light will add to the overall exposure.

This technique takes a bit of practice to learn to balance the dual light sources. The power of the strobe, the intensity of the other light sources, and the desired fill effect all have to be considered in choosing the right shutter speed (as well as your ability to reduce camera shake). Finally, mixed-light sources usually produce color casts, which may require white-balance compensation and/or retouching. That may sound daunting, but it's easy with a bit of practice. The results are well worth the effort.

There are several other things we can do to make direct flash pictures appear more natural-looking. One is to use a flash bracket that raises the strobe farther

Figure 8.13 This photograph was taken using direct flash. Notice how the bride's face and the gown are more brightly lit than the other people in the scene. Subjects closest to the strobe will get the most exposure, with significant fall-off of light as the distance from the light source increases. (Image by TriCoast Photography)

away from the lens. This both eliminates red-eye and shifts the shadow cast by the light so that it falls lower and behind the subject (and thus somewhat out of sight).

We can also use a coiled remote cord to attach the strobe to the camera (this is necessary with most professional brackets). Now we can position the strobe even farther way from the camera and control or even eliminate the visible shadows.

Bounced and Diffused Flash

It's not always necessary to point the flash directly at the subject. We can bounce the light off a wall, a white card, or the ceiling. As the light travels, the illuminated area broadens. The broader the source, the more diffuse the shadows—just as on a cloudy day or in fog with the sun. Another reason for having a coiled cord: we can quickly position the flash in relation to a reflector.

Another way to soften harsh light is by placing a diffuser over the bulb. Many camera-mount units come with small domes as part of the package, and third-party products range from simple cards to mini softboxes.

Fill-Flash

When there is enough light (actually when there is too much light), we can use flash to soften shadows. This is the opposite of dragging the shutter. I always have the flash on the camera in sunlight. In bright existing-light conditions, the trick is to not let the flash over-power the main light—it's the *fill*.

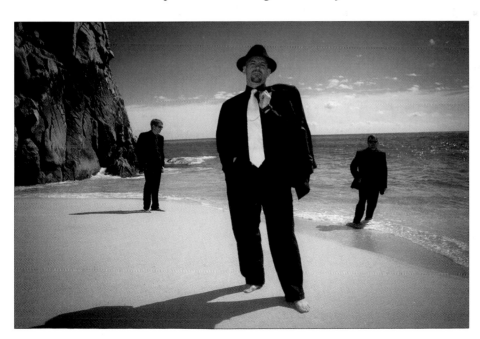

Figure 8.14 Bright day, beach, harsh shadows, yet the groom's face is well-lit, even with the sun over his shoulder—thanks to fill-flash. A little extra light is a good thing on bright days. (Notice how much darker the face of the man near the water is? He is standing in the same relative position to the sun.) Just be sure to balance the flash so that it does not overpower the main light source and look artificial. (Image by TriCoast Photography)

Today fill-flash is easy with most professional equipment. The units have a fill-flash mode that can be set to varying levels of compensation. As a general rule, I find that about one and one-third stop less than the main light source works well in bright sun.

Exercise Four: Learning the Ins and Outs of Single Flash Lighting

So, we have talked about several different ways to use a single flash. Now it's time to experiment. There are several skills that must be worked on to develop proficiency with single-strobe photography. One-camera direct flash is a good place to start, and in some ways, the best in most cases, except when more light is needed.

Working Indoors with a Single On-Camera Strobe

Step One: Still Life Near a Wall

The first series should be done indoors in average room illumination—not a brightly lit area, and no window light. Start with your subject (ideally a person) located near, but not next to, a wall. There should be other objects in the scene, and the wall should form the background of the picture. Consider having the person sit at a table with decorations. Use the default settings for your camera/flash combination and let the camera handle the exposure. Note that exposure setting.

Step Two: Into the Full Room

Next, position the person so that the full room becomes the background. Make another exposure, using the same settings as in the first image. Don't use the meter so that the main-subject exposure is the same. Compare the results. Note the way the flat lighting illuminates the person, how well exposed the wall is in the first picture, and how hard the person's shadow is cast onto it. Meters often have a difficult time holding highlights when direct on-camera flash is used, especially close to the subject.

The lighting on the person in the second picture will be much the same, but the room will be darker (unless it is a small room). This is due to the inverse-square

Figure 8.15 Here we have an example of how rules can be creatively broken. The harsh shadows created by the flash not only outline the bride and groom, but accent the vertical space in the church and fill in the composition. (Image by TriCoast Photography)

law: light moving from an open source scatters in all directions, so it quickly dissipates. This is the reason that subjects close to a single light source are so much brighter than the ones behind them.

Step Three: Finding the Right Combination(s)

Now turn the flash unit off and use just available light to make another image that has good tone and normal shadows. Note the exposure. Then, experiment with a mix of flash and different shutter speeds. Work with both metered and manual settings. You want to find a shutter-speed-and-flash combination that produces a pleasing result by dragging the shutter (explained above in "Direct Flash"). This simple set of pictures will show you the effect of direct-flash lighting.

Figure 8.16 Another " rule-breaker" in the collection produced by a TriCoast Photographer. The couple is fully illuminated by the strobe and the background is dark by comparison. Dragging the shutter would have given a more natural result, but this image was crafted to separate the bride and groom from their surroundings.

Step Four: Experimenting with Bounced-Flash

Now use the modification features of your equipment to produce images of the same subject with bounced-flash illumination. Since I can't tell what capacities your hardware offers, we will have to make general suggestions and means of evaluating, with you learning from the results.

Try rotating the flash head so that it points toward the ceiling. Place the subject near the wall, and then rotate the flash head so that the light strikes the wall first. If the unit has a diffusion dome or extendable white card, work with those tools as well.

When you have gotten a reasonable set of images, take the time to evaluate them in an editor, just as you did with the other exercises. Look at the results and

consider how each technique applies to covering a wedding. For example, what if you have a large group to pose in a church? Depending on the conditions, dragging the shutter may produce the most pleasing result—if the surroundings and the available space allow. If the backdrop is cluttered, maybe letting the rest of the room fade to black is a workable (albeit, not desirable) solution. Bounced-flash with a high ceiling and large group usually won't work very well.

Fill-Flash and Mixed Lighting Outdoors

Basic flash is a very versatile tool and one that most creative photographers constantly experiment with. Let's move outside, continue the discussion, and make our work with flash a little more challenging.

As we already discussed, basic daylight fill-flash is easy with most of today's professional strobe units. Just dial down the intensity a bit and all is well. Shadows are reduced, and the subject looks natural. The flash and the sun have basically the same color temperature, so white balance is not an issue—most of the time. We are going to edge into a mixed lighting exercise for this session. That makes for some interesting and challenging possibilities.

The picture in Figure 8.17 shows a masterful use of mixed lighting. The overall source is the open shade under the pillared walkway. Warm late afternoon sun is streaming through the veil and caressing the outline of the gown and the bride's hair. Fill-flash was used to open up the shadows and balance the overall lighting ratio so that both the shadows and highlights stayed within acceptable limits.

We are going to focus on balancing fill-flash in mixed lighting situations, then turn our attention to the challenges of working with mixed lighting and white balance.

Step Five: Setting Up Outside for Fill-Flash in Mixed Lighting Conditions

You'll need the camera, flash, a subject with some element of transparent clothing, like a scarf or veil, and a location with conditions similar to that in Figure 8.17. A manmade overhang is not required; the shade of a tree works just as well. To keep the discussion simple, I describe a scene like the one in the figure.

Figure 8.17 This picture looks easy; just place the bride in the shade with the sun streaming through her veil. That is the easy part. Getting the right mix of light and acceptable color often requires careful use of fill-flash, and even retouching, to deal with color casts. (Image by TriCoast Photography)

Positioning is a key element. The model has to be placed so that the sun is over one shoulder and striking the transparent item. The face should be turned toward the camera and the person standing almost completely in the shade. Now we come to the exposure challenge.

Remember the Sweet Sixteen formula? Because of the sunlight streaming into the area, you will have a three-to-four-stop difference between the sunlight and the shade. And that docs not allow for the "highlight burn" in the material in direct sun or the rim effect on light-colored clothing.

We are going to use fill-flash to reduce the difference in exposure values between the front-facing bride and the "hot" veil. The ideal exposure also takes into consideration the background. Here, it is also somewhat shaded, which is usually the situation late in the day.

Step Six: Shoot a Variety of Tests, Then Study Them

With practice (there is that word again), estimating the exposure is not difficult, but it does require some trial and error. Bracketing exposures never hurts in situations like these. Never completely trust the display or histogram. Start with the basic exposure; you can use the meter. Use fill-flash to increase the amount of light on the bride's face and gown. Bring the levels to where detail is just held in the veil.

As in the example in Figure 8.2, we can push the exposure to hold the highlights and let the overall image go dark—as long as we know our limits and what we can correct in processing. Here is where experience and experimentation pay off. That is really the goal of all the material in this chapter: learning to see both what is in front of the camera and what the image can become.

Make a variety of exposures. See how far you can push the exposure, the dynamic range between the highlights and shadows; vary the position of the model and the amount of light streaming through the veil. As you work, the sun is setting, and the white balance is shifting. We will deal with white balance next.

This is the last actual picture-taking exercise in the chapter. It has been designed to pull in many of the elements of the preceding material and leave most of the work up to you. Once again, take the results into an editor; have fun. Now we are going to look at a couple of white-balance solutions in dealing with uncertain and mixed lighting conditions, like the one we just worked with.

White Balance and Difficult Lighting Situations

Bridal portraits in late afternoon sun, like the example in Figure 8.17, have always been a personal favorite since I started doing weddings with color film. I'll never forget the first time I looked closely at the results of the first session after making

the move to digital—I was looking at the dreaded Blue Bridal Gown effect. (If you are not familiar with basic white-balance concepts and settings, refer to the accompanying sidebar.)

My camera had been set to auto white balance. The brightly lit veil had a pleasing warm color, like late afternoon sun. The portions of the gown exposed to a slightly strong fill-flash appeared properly white. The folds of the gown that were in shade had a glacier-blue tinge! The next hour or so was a real education in retouching color casts. It was a demanding lesson in just how much less forgiving digital sensors are, in mixed lighting, than film.

White Balance, Color Casts, and Degrees Kelvin

When it comes to color, not all light sources are created equal. Light on a cloudy day is far bluer than on a clear sunny day, which itself is bluer than the light from a tungsten bulb. While the human eye automatically compensates and makes "white" look "white," digital cameras do not. They must be set to match the color balance of a specific light source.

Take a picture with the wrong white-balance setting, and the image will have a noticeable color cast. Take a picture in sunlight with the white balance set to tungsten, and there will be a noticeable orange tinge to the image. Indoor pictures taken with a daylight setting will look blue.

The standard reference for color is a temperature scale determined by heating an idealized reference material, based on the work done by Lord Kelvin (hence the name). As the heat increases, the color of the material shifts in color from black to orange-red to ever-bluer shades and then to "pure" white. We can use the Kelvin scale to define the color of most light sources and how different a particular color is from another on the scale. Typical photographic light sources, with their corresponding Kelvin color temperatures, are listed in table 8.1.

Digital cameras offer various white-balance settings to match their color balance to the prevailing lighting conditions. In most cases, the standard settings will produce acceptable results. Fine-tuning can be managed during processing.

Typical options on professional cameras include daylight, tungsten, flash, florescent, shade, and cloudy (overcast sky). The auto-setting attempts match the brightest point in the scene to a white value. Many advanced cameras will also provide the ability to index a reference image taken of a photographic neutral gray card to set the white point. See your camera manual for details, since each vendor has its own procedures.

Table 8.1 Color Temperature of Common Light Sources

Light Source	Degrees Kelvin
Clear Blue Sky	10,000 to 15,000
Overcast Sky	6,000 to 8,000
Noon Bright Sun	6,500
Electronic Flash	5,400 to 6,500
200-watt Bulb	2,980*
100-watt Bulb	2,900 *
75-watt Bulb	2,820 *
60-watt Bulb	2,800 *
40-watt Bulb	2,650 *
Candle Flame	1,200 to 1,500

*denotes tungsten lights

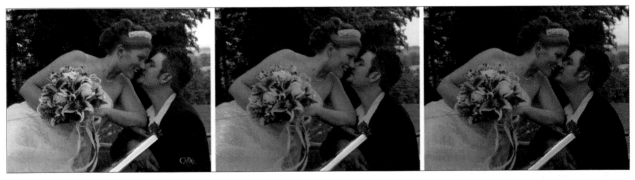

Figure 8.17a An example of the effect of different white-balance settings on image color and quality. The image on the left is correctly set for the sunny day with a bit of haze. The center version is set to tungsten; notice the blue color cast. The right is balanced for fluorescent and has a magenta tinge.

Dealing with the Challenge of Uncertain and Mixed Lighting

When a scene has only a single type of lighting present, or when a second light source's color will still look natural, setting white balance is easy. In fact, if we choose to capture images in RAW format, the white balance can be changed at any time in a RAW editor, just as if we had used that setting at the moment of exposure.

When a scene contains multiple types of light, there is no simple solution. We could go on for pages about the intricacies of color theory, but this is not a book on color technology. And in the end, we would still be faced with the fact that a digital camera can only be set to a single white-balance value.

If we want to take pictures in mixed lighting, we either have to define a practical solution or live with erratic color casts in our images. Wedding photography abounds with mixed lighting. There are all kinds of illumination in churches, reception halls, homes, and outside. We have people popping flashes on point-and-shoot cameras, videographers with their lights focusing on the happy couple, and candles at the altar.

A Practical Solution

In some cases, we can ignore isolated color casts. Take a room with open sun and a scattering of tungsten lights, for example. Most people don't find the warm glow of a lamp in sunlight unusual or unattractive. It is commonly seen on dark days and looks familiar. The same is true for candles, the glow of a fire, etc. As with mechanics, "if it isn't broken, don't fix it."

Some casts are not nearly as acceptable. Fluorescent, sodium, and other less-pre-dictable light sources can produce unflattering results. If this kind of illumination is the dominant light source, the solution is to index the white balance accordingly. Of course, your camera won't have a precise setting for the color tempera-ture. There is too wide a range of types of bulbs, each with its own color.

As mentioned, your camera may have a procedure for determining a custom white balance. Knowing how to do it is valuable knowledge. A more expensive approach is to purchase and use a color meter. There are two less-expensive alternatives.

The Quick and Dirty Approach

The first is simple—take a reference picture of an 18% gray card. Save it and use it to determine the actual value in your RAW editor during processing. (Always capture in RAW when working in difficult or mixed lighting.) I enhance mine with a Kodak Q-13 Color Separation and Gray Scale Target.

Purists, who consider such low-budget materials coarse, will recoil in horror. Such approaches are quite approximate, but they also meet the need and are easy to replace when worn or damaged. For most wedding work, the two important color issues are human skin tones and the color of the bride's gown. In most cases, the gray card/Q-13 works just fine for getting both looking the way they should.

A Bit of Technology, for a Price

Another solution is the Expodisc, shown in Figure 8.18. (Contact information is in Appendix A, "Resource Guide," on the companion website). This cool gadget looks like a white honeycomb filter and costs about $100. It works with any camera that can set a custom white balance via a reference exposure, which includes virtually all professional DSLRs and many pro-sumer models as well.

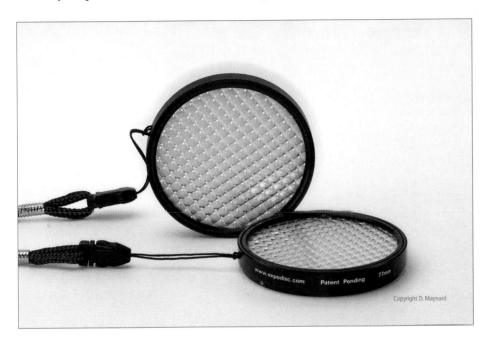

Figure 8.18 The Expodisc is an innovative solution for quickly setting custom white-balance values. (Image by Dave Maynard)

To use it, the photographer makes an exposure with the disc over the lens and the camera set to use the image as a white-balance index. That's it. The scene color is averaged and recorded. In my personal experience, the results are very clean whites and accurate color. The improvement over auto or preset values is often dramatic. Keep in mind that even with clear sky, the quality of light changes as the sun moves through the day. There is a second Expodisc version, tuned to yield a slightly warmer result for portraits. It's sort of like using an 81A filter over the lens.

Another plus to the product keeps it always in my camera bag. Place it over the lens, stand at your subject's position, and point it towards the main light source. Voila! Your camera now reads the exposure just like an incident meter.

There Is No Total Solution in the Camera

So, we have a working solution for usual lighting, but what about our mixed lighting and the Blue Bridal Gown? Mixed lighting is a special challenge. Remember that the camera can only index one color temperature in setting white balance. Anything beyond a certain range will still produce a color cast. These tools will work some of the time.

The most common problems will be color casts in the highlights, and/or sometimes in weak shadows. Fill-flash can help in shade. Sometimes we take an insurance picture with full-flash lighting. That usually overpowers the color cast.

Retouching will be required in really tough mixed lighting that produces unacceptable color. We'll look at a couple of tricks to clean up the problem when we cover the editing portion of processing.

Extra Credit: Remote and Multiple Flash Lighting

As long as we keep learning and expanding skills, photography will always present new challenges. The true professional never has to worry about being bored. In authoring this book, I've had the pleasure of talking shop and sharing techniques with excellent colleagues. Sharing ideas and working habits has more than once found me adding new items to the personal self-assignment notebook, and wishing for more hours in the day.

That brings us to our extra-credit topic, advanced flash lighting. During one conversation, I mentioned to Mike Fulton that my son and I had both been working with wireless and multiple-flash techniques. The major camera and strobe manufacturers offer products that allow the camera to manage banks of remote strobes without cables. This has become a really powerful and creative tool for the wedding photographer.

A Look behind the Scenes

Mike Fulton and his partner Cody Clinton have recently started offering "behind the scenes" workshops. The format is simple: they show, during working sessions, just how they use advanced remote lighting to produce outstanding results. They've provided us some examples, including Cody at work, to spark your imagination.

Look closely at the picture in Figure 8.19. The woman looks relaxed, the lighting is even and has a slightly pleasing warm tone. The overall impression is of a quick exposure as the photographer noticed the bride sitting still.

Figure 8.19 This bride looks very relaxed as she looks up at the photographer during what seems to be a quiet moment on her wedding day. The scene seems to be lit by available light, perhaps by a lamp near her chair—a simple candid with good posing. Appearances can be deceiving. (Image by TriCoast Photography)

There are some clues that there is more planning involved than that. See how the light wraps around her face? Notice how the train of her gown is positioned to exactly outline her head? The veil is carefully placed on her other shoulder. Now look at Figure 8.20.

Look closely at the strobe on Cody's camera in Figure 8.20. That flash didn't fire! That's because it is in Command Mode: when he pressed the shutter, it fired the flash his assistant is holding that is mounted on the monopod. The cord on that unit is connected to the external battery pack to reduce recycle time.

From the position of the camera, which took Figure 8.20, the scene looks cluttered. Just as on a movie set, a well-staged still image captures only what the photographer wants the viewer to see. An on-camera flash would not have produced the quality that this arrangement did. The result is much more like that found in a studio setting.

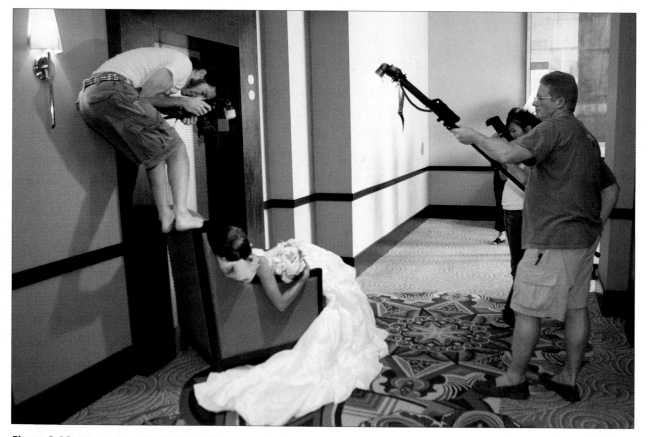

Figure 8.20 The reality of it all. Cody Clinton perched on the back of the chair, which was pulled into position to make use of window-light fill. The primary illumination was from the remote flash on the right. (TriCoast Photography)

Freed of Wires, the World Becomes a Studio

Let's look at two more examples. These are both taken outdoors and show just how versatile remote strobes can be. In the light of day, flash isn't just for fill anymore. We start with the completed rendition of the next example in Figure 8.21.

The sun is almost directly on the woman in the foreground. The photographer chose a position and lens combination to keep the man in the background in reasonable focus, while still providing separation between the two people in the composition. He waited for just the right moment to have the exposure take place just as a wave crested behind the man. The location had a tree just at the water's edge to enhance the size of the wave.

As we can see in the available-light picture of the set in Figure 8.22, the actual light on the beach was much less dramatic than the final composition. Part of that is due to Mike and Cody's collection of Photoshop Actions that selectively boost color—like adding blue to the sky.

Processing is part of the magic, but we should not overlook the importance of lighting in the crafting of the portrait. Here the strobe is not merely a fill light. It was used to add contrast to the image and add visual drama. This is one of the real advantages to off-camera flash. We can position the unit at any angle, and move it close enough to be a major factor even in bright light. Outdoor flash isn't just for fill anymore. It's an all-around tool.

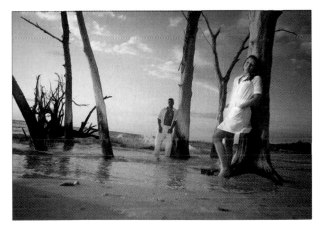

Figure 8.21 Engagement session on the beach, complete with driftwood, waves, soft light, blue sky, and careful use of remote flash.

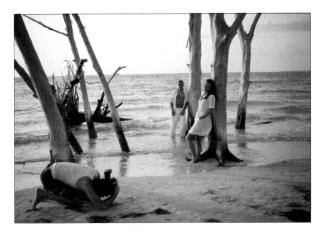

Figure 8.22 The basic scene looks a lot less dramatic than the polished rendition in Figure 8.21. Notice the assistant with the remote strobe behind the tree to the left.

Most units can be combined into several banks and controlled as if they were one unit. Indoors and out, we have flash capability that was once limited to cumbersome and expensive studio equipment. We often use a single Nikon SB-800 as a main light positioned off the camera location and use the one attached to the camera as a fill.

Let's look at our final example. It looks very much like the dark image we examined near the beginning of our discussion in Figure 8.2.

The TriCoast team used remote flash again to boost the light. This time the exposure was balanced to highlight the couple and almost match the skin tone to the deep glow of the sky. The single strobe was positioned to allow some shadow behind the woman's shoulder. The low camera angle leaves the section of beach between the photographer and the subjects in shadow and not affected by the reflection of the water underneath them.

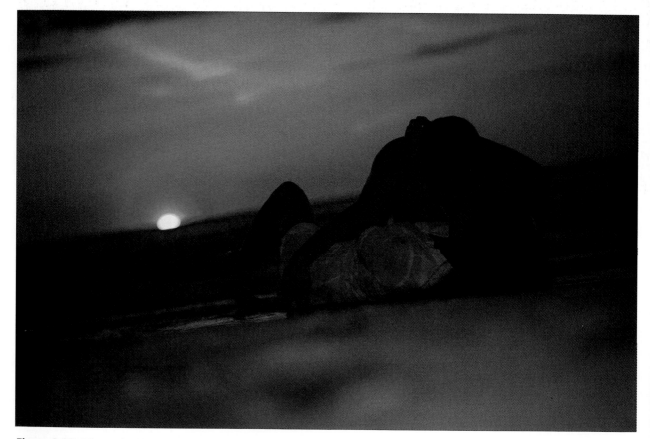

Figure 8.23 This is the "before" picture, taken without the flash to show the actual available light. The sun is just about to completely disappear. Our subjects are barely visible in the dim light

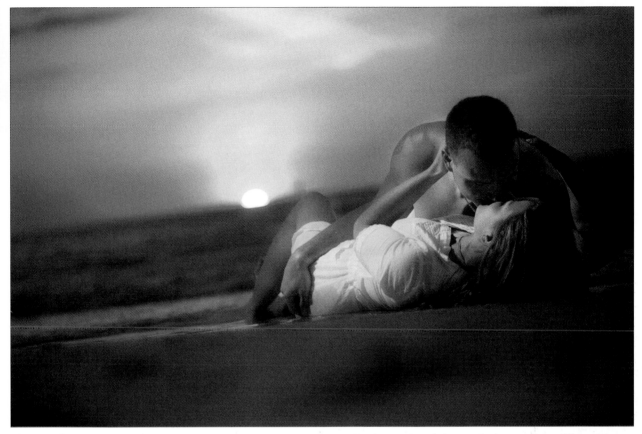

Figure 8.24 Careful balancing of existing light, the tones present in the sky, sand, and skin, with the intensity of the strobe are just as much a part of the composition as the placement of the couple and the setting sun. (Both images courtesy of TriCoast Photography)

Photographic technique is partly tools, partly the ability to use them to craft creative images. As the examples in this chapter illustrate, success requires both technical understanding and the ability to see the possibilities that the tools offer with the given subjects and locations.

Next Up

We have now covered business aspects, and getting gear and skills together; the practice session is over. It's time to move on to the main event. The next few chapters focus on covering the big day.

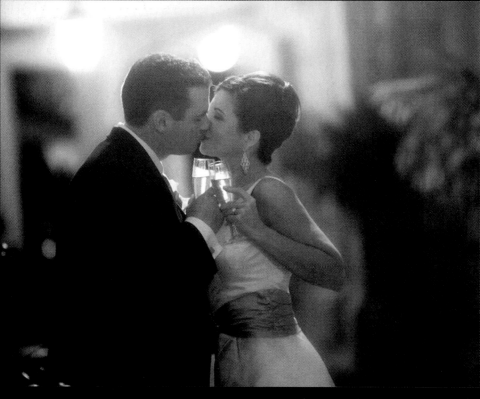

Part II
Photography

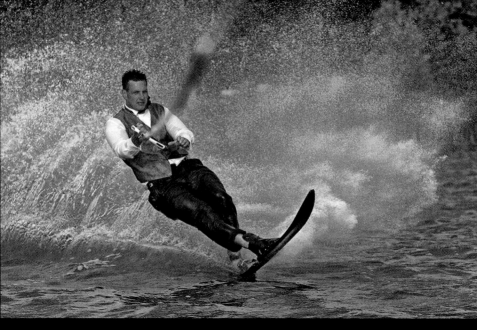

9

The Big Day: Photographing More Than Just a Wedding

While virtually all weddings include the same basic elements, no two couples, or their weddings, are really the same. The goal of the professional wedding photographer is to capture images that really convey the personalities of the couple and feeling of *this* wedding in a way that will please the client. The discussions in this and the following chapters are not a "cook-book" recipe; rather, they offer a look at how several experienced members of our profession approach their assignments, as well as a detailed examination of examples of their work.

This chapter covers the day up to the moment the bride is poised to take the walk down the aisle. There are two major objectives during this period: setting up the shoot and creating preparation and accent pictures. These include the bustle of the bridal party getting dressed, the church itself, and the reception settings, plus the little details that have been designed to add glamour to the site.

Shooting with Style and the Dreaded "Picture List"

Once upon a time (through the early 1940s), most wedding parties had formal pictures taken at their photographer's studio. The first "candid" weddings, starting about that time, were shot on 4x5 sheet film using the same Speed Graphic cameras used by newspaper photographers. Figure 9.1 is an example. The cost of

film, processing, and proofing limited the number of pictures most studios were willing to take, to an almost pre-defined list.

As medium-format roll-film, and then 35mm cameras, became viable options, the list was basically unchanged. The typical wedding required about 50 images, more if there were a lot of formals. Today, freed of film, the old list is sometimes derided. We can shoot all kinds of creative images, try unusual angles, and take pictures for the express purpose of manipulation in Adobe Photoshop or Corel Painter. The list still has a place, but it's a starting point—and open to creative interpretation. The modern wedding photographer can mix and match a variety of styles and weave them into a compelling and complete record.

Figure 9.1 That was then…. Early wedding "coverage" was limited to studio portraits of the couple and their attendants, like this tinted example from the 1920s, due to the fixed nature of existing professional cameras. (Picture courtesy of Avintagewedding.com)

There are pictures that have always been a part of the "candid" wedding style that are still "must haves," no matter how cutting-edge the shooter. Once the actual ceremony starts, we really become photojournalists. The event unfolds and we have to shoot what is presented. The couple wants a record of the event and the people who attended, not just creative pictures for art's sake.

During the actual ceremony, the focus should be on the action. That doesn't mean we can't use our artistic talents. But the bride walking down the aisle, the exchange of rings and vows, and the kiss, had better show up in the proofs. In the following chapters, we'll cover the "must haves." There is still a list, it's just more fluid and has room for lots of personal additions. This chapter centers on the couple getting ready and rounds out the coverage by using the freedom given by improved technology to go beyond simply recording the action.

The contrast of Mark's carousel portrait, in Figure 9.2, of the bride and groom with the 1920's studio picture illustrates the point well. It's not just color; it's not just the equipment. It's also the photographer's keen eye and the use of all the tools of the trade. Let's look more closely.

A wide-angle lens adds effective depth of field. The horse head in the foreground is tack-sharp and draws the viewer to the couple, who are still in acceptable focus. The blur in the background adds motion, and the use of color completes an outstanding composition.

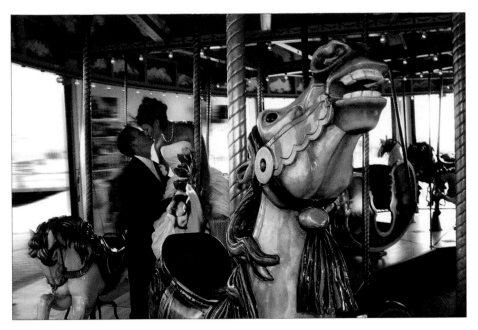

Figure 9.2 This is now…. Mark Ridout's portrait of the bride and groom is a great example of how much the style of wedding photography has changed. Only part of that is due to technology.

Start Big, but Pay Attention to the Details

It's a good idea to arrive at the site early enough to take a few practice shots and "warm up." Wide-angle views of the venue are a good starting point. That provides an opportunity to check camera settings, exposure, and white balance before actually having a person in the picture. The quiet time is great for exercising your creative eye and experimenting. When the bride arrives, things will get busy fast.

The way cinematographers use a mix of wide, medium, and close-up shots to tell the story in movies works well for a photojournalist's essay, like covering a wedding. Wide shots set the location and give the big picture. TriCoast Photography's infrared location shot in Figure 9.3 uses a common device in establishment shots, a low camera angle. Another option is a high-angle view, from a choir loft or balcony.

The unusual viewpoint makes the person seeing it take a moment to adjust and to consider the image. Just a shift in perspective is not the only design element used in the picture. See how the pattern of the stones, the angles of the chairs, and the framing tress all focus the eye on the center of the picture?

My personal warm-up often begins by working with a fish-eye lens, then shifting to a medium wide-angle. Checking the histogram and zooming in the preview display can show if there are hotspots, flare, or dark shadows in the scene that will have to be considered during the ceremony. Then I shift to a normal field of view and look around for opportunities.

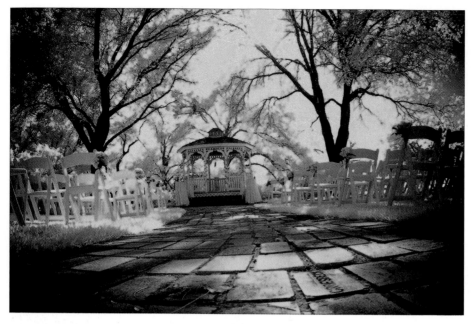

Figure 9.3 This infrared picture of an outdoor wedding setting by TriCoast Photography uses a low angle to add depth and a dark border to the composition.

The medium shot is usually taken with a "normal lens." The angle of view is basically the same as that of the human eye at standard viewing distances (not looking at a panoramic view or examining something closely). See TriCoast Photography's picture of the bride and dog in Figure 9.4.

Figure 9.4 Medium shots, like this one of bride with her four-legged friend, offer a perspective similar to that of normal human vision. (Photograph by TriCoast Photography)

This is the bread-and-butter range for most photo-journalists. As a newspaper photographer, my most-used lens was a fast 35mm, with the 55mm and 24mm the next-most used. This was on a 35mm body, so the 35mm was just a little wide (the true normal is the diagonal measurement of the frame, about 52mm on a traditional 35mm format). That provided room to crop and more depth of field than a shorter focal length.

In Figure 9.4, see how TriCoast used the dark objects in the background, coupled with a shallow depth of field, to separate the pair from their surroundings? That is a bit more difficult with digital cameras, which have sensors smaller than full-frame 35mm. The magnification produces a wider depth of field in these cameras than a 35 format at the same focal length. You can use a Gaussian Blur to diffuse areas of a picture that are too distracting.

TriCoast used a slightly different approach in Figure 9.5. Here the dress is still easily identified, as is the stained-glass window over the doorway and the rough-hewn walls of the room. Placing two shoes low in the frame makes sure the viewer won't ignore them. Taken as a whole, the picture coveys a sense of the time just before the bride starts getting dressed.

Getting Closer

Look for details that tell a visual story. They may not be evident to the casual observer, or the photographer in a hurry to get the next shot. The picture in Figure 9.6 by TriCoast Photography is a good example, showing how creative use of shadows and highlights can turn a simple device into a creative addition to the day's pictures. Careful focus and cropping add to the heart-shaped shadow of the ring and the cross-shaped highlight inside the band. "See how the diamond in the ring is a little off center?" Mike Fulton of TriCoast told me. "That was the only placement that produced the cross effect."

Often the organist or other musicians will be practicing as well. A quick self-introduction is in order, followed by a few exposures. It's difficult to get a good angle during the wedding; beforehand, we can move and pose to our heart's content. TriCoast Photography's close-up in Figure 9.7, like their preceding contribution, shows how effective getting close to a subject can be. The same shot during the

Figure 9.5 Selective focus and a little arranging are both useful tools that don't take up any room in your gear bag. (Photograph by TriCoast Photography)

Figure 9.6 This macro shot of a ring on a Bible by TriCoast Photography is an excellent example of how a skilled photographer can add artistic accents to his coverage.

Figure 9.7 This picture of the organist getting ready, also by TriCoast Photography, is another example of using close-ups and camera angles to add detail and interest to your coverage.

wedding would be very difficult, if not impossible. Asking the performer to hold a note can reduce blur when shooting in dim light with a slow shutter speed.

The way we see and use light is a major factor in getting professional results. A bit of extra time spent setting up lighting during the time before the event can really make these pictures sing. One of the really great technical innovations in photography is the wireless intelligent flash head. Both Nikon and Canon have small units that can be remotely placed and controlled from the camera position. These can be used to control and add fill light, just as in the studio. I keep two in my carry bag, both set to remote, and another on the camera bracket as the command module. A quick placement, and I have a new fill or key light.

One of the standard "list shots" is a picture of the couple's hands overlapping each other to show off their new rings. Mark Ridout uses his skills as a commercial photographer to produce creative images of the rings, which look like they were taken for a high-end jewelry magazine or catalogue. Figures 9.8 and 9.9 show two different takes on the same theme.

Figure 9.8 A close-up combination of rings and beaded gown photographed by Mark Ridout. (1/15th of a sec at f/2.8)

Figure 9.9 This unusual composition, the juxtaposition of wedding rings and sink, works well as a "getting ready" image. The close focus on the wedding bands works well with the soft tones of the faucet and water taps. (Photograph by Mark Ridout)

As the photojournalistic style of wedding coverage has become more popular, the old list is being augmented by new "standard images." Masters of the craft don't rely on standard shots and aren't afraid to use a mix of traditional and experimental images.

The macro photo in Figure 9.8 shows both wedding bands placed on the beadwork of the wedding gown, with folds of fabric from the dress forming a soft backdrop. The very shallow focus lets the pattern of the rings stand out sharply.

The image in Figure 9.9, framed by the basin and ornate fixture on the sink, speaks of the wedding to come. Even though both use the same muted color pattern and softened backgrounds, they have very a different feel from each other.

Figure 9.10 A similar approach was used in this study of the bride's shoes against a blurred red backdrop. Here the colors are combined with the vertical lines of the shoes and leaves. A short exposure, 1/500th of a second, allowed Mark Ridout to open up to f/3.2 with a 200mm telephoto to get a shallow depth of field.

Here Comes the Bride

Pictures of the bride getting ready and interacting with the members of her entourage are on the must-have list. The "true" photojournalist is sometimes said to be strictly an observer, waiting for the moment. In my years as a newspaper photojournalist, I did spend a lot of time waiting for the right moment, but I also directed and positioned my subjects, when possible, if that would produce a better picture. The same habits serve the wedding photojournalist well, too.

I also look for distracting objects in the frame, things out of place, and move to find the best camera angle before pressing the shutter. Even if you can remove a problem in Photoshop, it's easier to not have to; looking for problems first results in better compositions.

That said, always be on the lookout for the action shot that tells a story, like the one by Mark in Figure 9.11. He used a slow shutter speed (1/15 of a sec.) to capture the woman running up the stairs. Notice the flowers in the mirror and the wrapped wedding gift on the bench in front of the stairway.

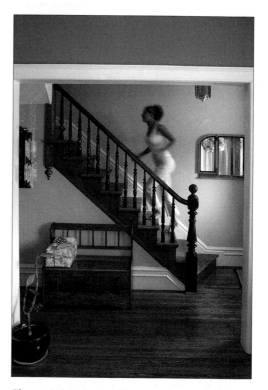

Figure 9.11 A slow shutter speed conveys the sense of hurried movement as this woman gets ready for the wedding to come in this image by Mark Ridout.

We always ask the bride if there are any special elements to her wedding outfit. Some brides have mementoes or a family heirloom that they will wear as part of a family tradition. These are always worth taking time to feature in a photograph.

Another set of standard pictures are those of the bride dressing and putting on makeup. The former will depend on the type of gown and how comfortable the bride is with the photographer and the idea of images of her getting dressed.

Figure 9.12 shows the bride fixing her make-up in a mirror. Posed pictures of the "bride in the mirror shot" are considered hackneyed by some photojournalist "purists." We take the middle ground on this one. The bride is going to use the mirror, and we take the picture. It isn't posed, and we don't offer her a heart-shaped hand mirror to use.

The picture in Figure 9.12 was shot using a 20mm f/2.8 lens stopped down to f/5. The primary point of focus was the bride's eyes. That left the reflection of the veil in focus, while softening the actual fabric on the right side of the picture.

TriCoast Photography used a 70-200mm zoom set to 200mm at f/2.8 to get the close-up of the bride being made up in Figure 9.13. The long lens kept the focus tightly centered on the bride's face, and kept the make-up artist's hands from being distorted, as they might have been if a wide-angle was used.

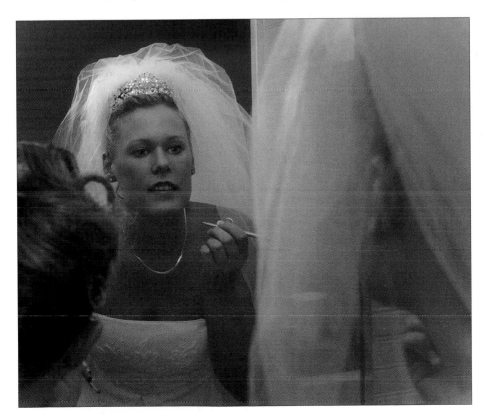

Figure 9.12 This image by James Karney of the bride putting the finishing touches on her make-up was shot over her shoulder. A bare-bulb flash, used to boost the available light, was placed close to the ceiling on her left side. The result was soft lighting bounced through the mirror onto her face, with highlights on the veil adding an accent.

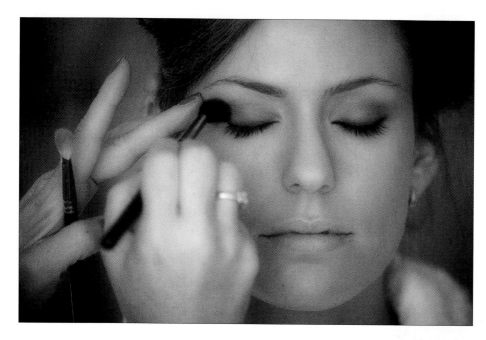

Figure 9.13 The serene look of the bride as her make-up is applied is accentuated by the soft tones of this black-and-white image by TriCoast Photography.

Brides and their attendants getting ready provide all kinds of photo opportunities. Among the more common sources are attendants helping the bride into her gown and making sure that all the details of the party's outfits are adjusted properly.

Keep an eye out for interactions and activities that are unique to this wedding and that show the relationships between the people. For example, there are often last-minute adjustments to the gown, finishing touches to accessories, placing the garter, pinning corsages on the father of the bride and the ring bearer, and the mother making sure the bride looks perfect.

Fill-flash is a great tool, but pay attention to the available light and use it as well. Mark did that for the image shown in Figure 9.14. The light falling on the bride models her skin, hair, and the veil perfectly. He used a 35mm lens and angled the plane of focus to keep her head and the shoes in focus. That required an exposure of 1/8th of a second at f/4 for his ISO 100 setting.

Be willing to change your focal length as well. In Figure 9.15 Mark used a 200mm lens and boosted the ISO to 400 so he could shoot at 1/80th of a second at f /2.8. Notice the tight focus on the tips of the fingers and the dominance of white in the image.

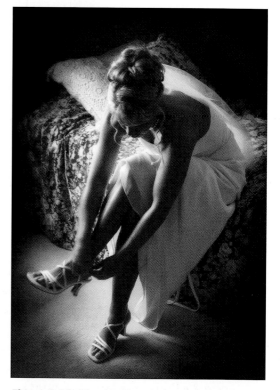

Figure 9.14 This low-key study of the bride fastening her shoe was made using available light by Mark Ridout.

Figure 9.15 Tight focus on the hands makes for a dramatic portrait of the bride donning her gloves. (Photograph by Mark Ridout)

Details of the Day

Notice how many of the pictures in this chapter have focused on details and how the photographer uses them to create a visual record of the event. While working, consider the type of products that your client has requested, what you may want to offer, and images for your portfolio and website. These are the details that are important to you.

We take time to look for subjects that can be used in our albums and slideshows. These include decorations, beadwork and decorative items on the bridal gown, a panoramic view of the church, or anything that strikes our fancy. Albums and slideshows are not just print collections, they are designs in their own right. That panorama may become a black-and-white background that has been rendered out of focus, as can a floral arrangement, or a series of lighted candles in the sanctuary. They can also serve as accents, when placed with other images.

It's always a good idea to take several different pictures of the bouquets. Not only are they a part of the wedding, but a print provided to the florist may lead to a business relationship and referrals. It's easy to imagine how an 8x10 print (complete with studio logo) will look. See Figure 9.16.

Figure 9.16 A still life of the bride's bouquet, like this one by Mark Ridout, offers a quiet change of pace from the bustle of the bridal party's preparations.

The picture in Figure 9.17 also centers on flowers and adds a human touch by getting the bridesmaids to hold their arrangements. TriCoast Photography used an exposure of 1/400th of a second at f/2.8 to make sure there was no camera shake due to the 160mm lens they used.

Figure 9.17 This gorgeous shot of twin bouquets by TriCoast Photography uses focus effectively to heighten the composition.

Notice how the attention is centered on the close-up in the right third of the frame, letting the arrangement in the background fall out of focus.

And Some Little Ones

There is usually at least one child hanging around during the preparations, perhaps a ring-bearer or flower girl. I make a habit of spending a bit of time taking their picture, and playing around a little bit. That puts them at ease, relaxes the adults watching the interaction (if the kids aren't afraid of the camera, why should they be shy), and usually results in a salable picture. See Figure 9.18.

There is a quiet (sometimes not really *quiet*) bit of waiting time before most ceremonies. It offers a chance to portray the participants' emotions as they consider the event about to occur. Consider Mark's image in Figure 9.19 of the bridesmaids sitting with their legs crossed. One can almost feel their desire to be told to form up for the procession to the altar.

Figure 9.18 Don't overlook the smaller participants. Most are more than happy to pose, as was this young man with his shades for Mark Ridout.

Figure 9.19 Mark has a real flair for capturing the feel of the moment in pictures. This image of the waiting bridesmaids is no exception.

A Slightly More Formal Tone

If possible, make time for a few bridal portraits as soon as she finishes getting ready. Her make-up, hair, and level of energy will be at their peak now. You and the wedding party will usually be hurried by the rush to get from the wedding to the reception after the ceremony, limiting your ability to fuss over bridal portraits.

We try to get a mix of both formal and informal poses but make sure that we don't take too long—or make the bride feel rushed by our demands. Some brides take a bit of quiet time after getting dressed. Pensive portraits like the one by Mark in Figure 9.20 show her mood and the setting just before the ceremony. He used a mild telephoto (88mm) and available light, with an exposure of 1/20th of a second at f/2.8 and an ISO of 400.

Churches and fancy wedding venues usually offer several settings for more formal pictures of the bride and her attendants. Just keep an eye on the time and the mood of your subjects. Many are happy to have the distraction during the wait and know they look good in their finery.

The portrait of the bride by TriCoast Photography in Figure 9.21 is a classic example of posing and the use of light and visual elements in the scene. The bride is positioned with her face in a "rule of thirds" sweet spot in the upper-left-hand portion of the frame. They used a 70mm lens (24-70mm zoom) wide open for an exposure of f/2.8 and a 1/125th of second shutter speed at ISO 200.

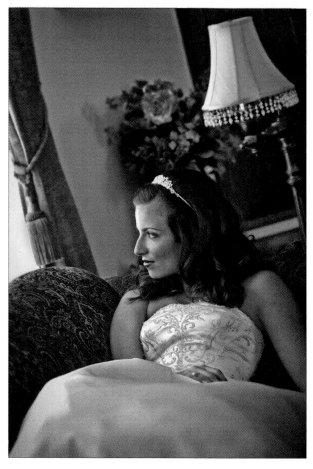

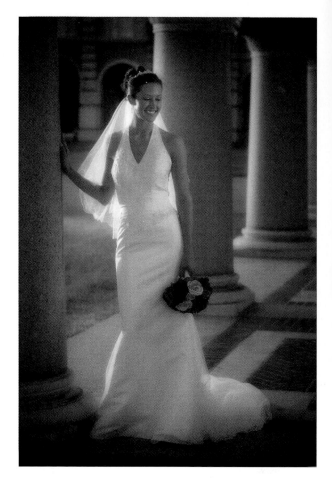

Figure 9.20 The moments after the preparations are done are often an excellent time to capture a reflective mood in a casual bridal portrait, like this one by Mark Ridout.

Figure 9.21 This more formal portrait combines a lovely bride and setting with well-placed backlight and careful posing. (Photograph by TriCoast Photography)

The backlight from the late afternoon sun added definition and pleasing illumination to the veil and the outline of the wedding gown. Burning in the outer edges of the final image heightened the effect. I often use a bit of fill-flash on this kind of portrait. That helps hold the highlights, which can blow out if the exposure is not properly adjusted. An incident meter and careful examination of the preview display and histogram is a good practice in these circumstances.

And Then There's the Groom

One can't forget the groom, waiting in the wings. With a single photographer, it can be hard to spend any time photographing the groom before the ceremony, especially if the bridal party is dressing at her home or another remote location. When we have two shooters, one of us usually is sent to cover the bride, the other the groom.

That arrangement often allows sufficient time to get the formals of the groom and his party, as well as candid shots of them getting ready, adding to the image collection and saving time after the ceremony as well. If you are covering the wedding alone, there will still be time as he waits for the bride, just before she starts down the aisle. Don't cut it too close; the grand arrival and procession with her escort is a must-have picture.

The standard pictures of the groom and his men include the usual donning of tuxedos, adjusting ties, and interacting. We don't need to show them here, they are easy to understand and obtain. Let's look at a few examples of images that capture more of the special elements of the day and the personality of *this* groom.

Mark Ridout's example in Figure 9.22 shows how willingness to spend some extra time on the part of the photographer and the groom can push the creative envelope and produce an eye-catching result. Does he have a hobby or special interest? Then add a bit of planning and thought. To get the water-skiing just right,

Figure 9.22 It's not a pre-wedding candid, but Mark's picture of the groom on water-skis was a dramatic image that just had to be included in this chapter.

Mark used a very fast shutter speed, 1/8000 of a second, and waited for the visual elements to come together during the shot.

See how the spray of water frames the action, with the series of vertical crescent-shaped plumes? The rope is canted to draw the eye into the shot. Completing the image is the cant of the groom with his focused gaze, coupled with the incongruous tuxedo vest and the open-collared dress shirt. A real show-stopper!

In Figure 9.23, TriCoast Photography used another unusual setting for this picture of the groom—using mass transit to get to the wedding. The casual smile, the careful use of wide-angle distortion, and the use of available light work well together. Once again, the result is a signature portrait that pleases both the client and the casual viewer.

So, what can you do if the groom doesn't water-ski or sky-dive, the local town lacks a subway, and you only have a few minutes at the wedding site as a location? Well, there are the old standbys, but why settle, when a little vision can go a long way?

Our final two images, both by TriCoast Photography, show what a skilled eye and careful composition can do with limited time and resources.

The first image, Figure 9.24, almost looks like a black and white. The exposure was chosen to produce a high-key effect, while preserving detail in the groom's shirt and featuring the effect of the bright window light to wrap around him. The only color visible in the image is the slight beige above the window and his hand and ears.

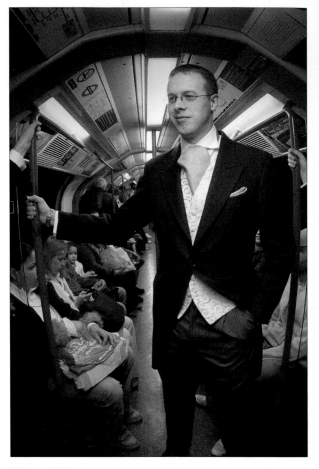

Figure 9.23 While not as dramatic as the water-skier, this picture by TriCoast Photography of the groom using public transit offers another interesting set of visual juxtapositions for a candid study of the groom.

The last picture underscored the point that the subject's face isn't a necessary element of every picture in an essay, like the one produced for a wedding. Our final image, Figure 9.25, shows show empty space can help tell the story. The expanse of the large room and vaulted ceiling is emphasized by the use of a 15mm wide-angle lens. By using only available light, TriCoast Photography was able to hold the warm tones and soft feel of the moment.

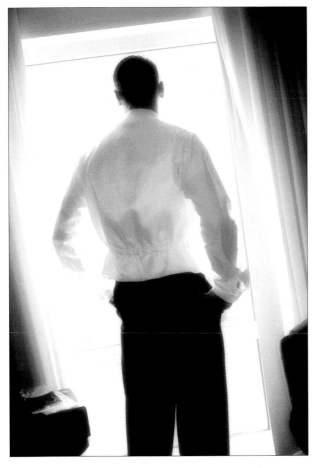

Figure 9.24 This almost monochromatic study of the waiting groom shows how a good eye and careful exposure can transform a simple pose into a well-executed photograph. (Photograph by TriCoast Photography)

Figure 9.25 Warm and dark tones dominate this TriCoast Photography environmental portrait of the waiting groom.

Next Up

Everyone is ready (or should be). We now turn our attention to the ceremony. This is the time we have the least control over, and it's usually the shortest part of the day—even if it doesn't seem that way at the time!

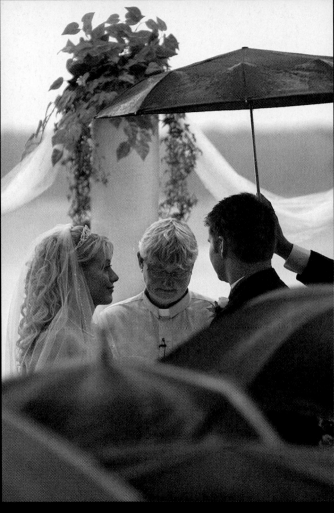

10

Photographing the Main Event

The bride is ready, the church is set up—are you? No matter the logistics of the ceremony, the photographer needs to be properly set up before the bride starts her walk down the aisle. There is more to do than just take pictures. The time spent setting up before the wedding is critical to success. If the photographer does not use it, the needed pictures may never make it to the computer.

Once the shooting starts, the whole focus should be on the images, so we get the busy work out of the way first. That includes checking out the site and making sure all the gear is ready. Let's go over that now, and then discuss the picture possibilities, the must-haves, and the event itself.

Be Prepared, Be Very Prepared

Surprises are the order of the day, and the bigger the wedding the more things (and people) to manage. While the bride and groom may have more intense feelings on their wedding day, most photographers also get started with a sense of anticipation of the coming hunt and a need to double-check the equipment. There are also things that need to be done at the site before the shooting starts. We allow time for that as part of the pre-event preparations. Figure 10.1 shows how not to do things.

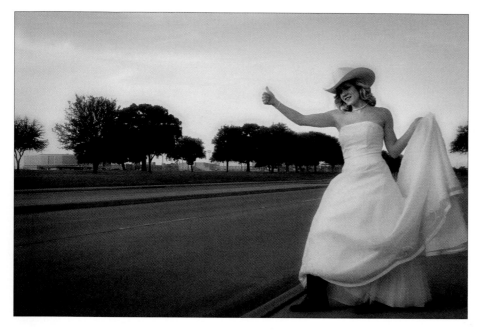

Figure 10.1 Like the bride, make sure to leave plenty of time to get to the ceremony site in time to be ready when the shooting starts. (Photo by TriCoast Photography)

Scene Survey

On arrival at the site, the first step is to perform a Scene Survey. This is a term borrowed from firefighting. The first thing that firemen do on arrival at a scene is to check the area for hazards, and then assess the overall situation. The wedding photographer can put out potential "fires" the same way.

Even if you visited the location before, make sure that you can gain access to the viewpoints needed for your pictures. Are needed doors unlocked? What is the lighting like? Check for mixed lighting and color balance issues.

Once we arrived at a church to find that the wedding planner had lowered the normal bright lighting inside the church to that more in keeping with a candle-lit restaurant. The dimmed floods reddened the color balance significantly and required major adjustments to ISO and exposure settings from the test exposures made earlier in the week.

Access and Ground Rules

Find the custodian. This person often knows where the bride, groom, and attendants will arrive, where they will be waiting, and if the flowers and decorations have been placed. They can also tell you where to find the minister.

We always check with the site manager and the person conducting the ceremony, as well as the wedding couple, for any special considerations as to use of lights, flash, and movement during the ceremony. Asking often leads to good suggestions

about shooting locations with good fields of view. Even if a door is unlocked, you may not have permission to use it. Always check first.

There is one church in our area that does not allow ANY photography during the ceremony (now that's a fact to learn as soon as possible)! Needless to say, they don't get our referrals. When we have to shoot there, the couple is told that we will have to get all pictures as posed shots later. That has led to clients booking another church more than once.

It's also important to know which guests the client particularly wants to have in the photographic record. Often there are family members from far away, college roommates, and other people who have played an important role in the lives of the couple and warrant extra attention. Ask the couple (before the wedding day) to have someone who knows the important attendees available at the wedding, as well as during the formals, to point them out and even introduce you to them.

Many clients (or their parents) want certain pictures, including ones from the "traditional" wedding album list. Such images are automatic must-haves.

Gear Cache and Security

Many photographers bring a good bit of gear to a wedding. There are tripods, strobes for lighting the formals and the reception hall, spare camera bodies, and a laptop for on-site back-ups. Unless you have an assistant who can be dedicated to gear management, equipment security has to be considered. Unattended gadget bags and laptops are easy targets for thieves.

We usually ask for access to a room that can be locked, place gear near someone known who can keep an eye on it, or use our vehicle to secure valuable items. The car's back windows have been tinted so that the contents are not visible to a passer-by.

It's a good idea to keep all of the memory cards on your person during the entire shoot, rather than leaving them in a gear bag. That is an extra level of insurance. If the back-up device is lost, fails, or is stolen, the original files are still safe on the cards. There are small belt holsters that can carry six CF cards. We keep empty cards on our right side, and have an empty holster, ready for the cards as they are filled, on the left. That makes it easy to reload the camera and avoids the need to check the card's back-up status.

Good hidden vantage points to pre-position a tripod are near to the place where the couple will exchange vows or in the back of the church (like a choir loft). Most pictures taken during the service are made using available light, generally with a wide-open lens and a slow shutter speed.

Figure 10.2 While setting up, consider taking pictures of the wedding location before the scene is littered with bird seed and rice. (Photo by TriCoast Photography.)

Figure 10.2a A few images of the empty church are not only a good addition to the picture collection, but can be used to verify exposure and check for hotspots and color casts. (Photo by TriCoast Photography)

Tip

Professional tripods and camera brackets come with quick-release mounts. Buying extras for each camera body really saves time when swapping out hardware. We keep one body with a telephoto zoom and another with a wide angle, and can change out in less than ten seconds when and if the need arises.

Equipment Check and Load

Check cameras and flashes to make sure that they are at your desired settings (and that the settings match the needs of the location). Make sure any required sync cords and cables are attached and working. We usually make a few test shots of both the target card and the scene to verify both the exposure and that the gear is functioning properly.

We always check the power charges on all battery-powered devices—and each spare power pack. That allows time to replace and recharge if one was drained.

Carry a spare battery with you. In the days of manual shutters, a dead battery was an inconvenience. Today it can mean a disabled body. That's true even with spares. What if you need ALL the juice to get through a long reception?

The Waiting and the Walk Down the Aisle

With most weddings, the ceremony begins with the procession of the bridal party to the altar and the grand entrance of the bride. Waiting at the altar are the groom and his attendants. All are part of the story, as are the guests. While people are arriving, consider taking pictures of them signing the guest book, dropping off presents, and interacting. If the bride has children in her party, they are also good candidates for pictures, both by themselves and with the bride or groom.

The traditional list includes pictures of the couple's mother and grandmother being escorted to their seats, the procession, and the groom waiting at the altar. These points in the event often offer good opportunities for pictures of the participants, which show their feelings, as well as the details of the day.

When we have two photographers present, one stays back with the bride and the other is free to roam the location looking for pictures. Just before the procession starts, that shooter moves into the aisle and gets ready to photograph the procession.

Lighting Considerations

Plan for issues with lighting and exposure, and be ready for change. For indoor weddings, many photographers will use fill-flash (or even full flash) as needed, right up to the point at which the bride is presented to the groom at the altar. From that point until the first kiss, the flash is turned off and only available light is used. That is often the rule imposed by the minister, and is a good practice anyway. The flash can be very distracting during the service.

For outdoor weddings, especially on sunny days, fill-flash is vital to avoid harsh shadows. There we use a flash intensity about one-and-a-half-stops less than the ambient light level, to retain some shadows and a natural look.

Figure 10.3 During the wait, watch for picture opportunities of the bride and her attendants. (Photograph by TriCoast Photography)

This is a good time to look for detail shots of the people, the place, and things that make this wedding special. Two of the images in this chapter by Mark Ridout illustrate the point: the bride's bouquet held as she waits for the wedding march (in Figure 10.4), and the old woman's hand holding the Rosary (Figure 10.5). Watch for candles being lit by groomsmen, children trying to see what's going on, parents talking quietly as they wait.

Figure 10.4 While every one else is waiting, the photographer pays attention to the details and watches for pictures, like this quiet pose of the bride holding her bouquet as she waits to walk down the aisle. Notice the excellent blending of the primary exposure with the back-lighted rim of light on the bride's arm and torso. (Photo by Mark Ridout)

Figure 10.5 Hands can tell stories, like this image of a grandparent holding a Rosary. (Photograph by Mark Ridout)

Shifting Gears

When the first member of the bride's entourage starts moving, the tempo (and the style of shooting) shifts. From this point until the newlyweds leave the church, the photographer is focused on the event as it unfolds. For the processional, I still use a trick from the days of film and manual-focus lenses.

It works like this. Pick a point part-way down the aisle where you will be able to frame the entire figures of the bride and her escort as they are just inside the door-way (that's if the event is taking place inside), and focus. When the first person starts to walk in, back up and take a couple of frames. Quickly check the result. Then repeat the process for the other women.

By the time the bride is ready, the rhythm of moving and shooting should be perfect, letting you get a solid series of shots as they enter. The bride usually walks more slowly than her attendants do. This is one of the must-have shots. Quite often, there will be visible emotion on her face, and it may intensify as she gets closer to the altar.

When there are two photographers, one can be positioned either in the back of the church or toward the front, allowing pictures that include the groom's perspective. That's the technique Mike and Cody used in Figures 10.6 and 10.7. They have lots of practice working as a team, and know how to plan coverage and stay out of each other's frames.

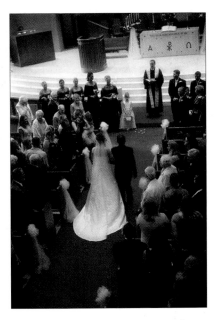

Figure 10.6 The grand entrance of the bride is a must-have shot, no matter what the wedding tradition, the ceremony, or the style of the photographer. (Image by TriCoast Photography)

Figure 10.7 Adding the groom to the picture of the entrance produces a completely different perspective. (Image by TriCoast Photography)

Figure 10.07a High-angle shots from the back of the church are an effective way to show both the procession and the bridal party. (Photograph by TriCoast Photography)

Notice how the photographer had to carefully watch his exposure and the flash output in Figure 10.7. Any time there is a subject significantly closer than the main point the values are set for, there is a risk of washing out detail due to the proximity of the strobe. Depending on the ambient light conditions, the color balance may require some fine-tuning during processing as well.

Photographing the Ceremony

Expect the Unexpected

In the early days of "candid wedding photography," it was easy to work wedding coverage. There were few variations in the ceremony within a given religious tradition. Today there are many variations in the way the couple exchanges vows and in the order of service. Many couples write their own ceremonies. One we photographed this summer took less than three minutes! Another had over 20 minutes of music. Of course, you should have found all this out in your meetings before the day of the wedding, but be prepared and ready to take pictures quickly of anything that looks important or interesting.

A very common, and photogenic, part of many modern weddings is the lighting of a unity candle. Sometimes the parents of the bride and groom will light a candle for each family, and then the couple will light the primary taper. Sometimes two candles will already be lit. There are other variations. No matter, be ready. The most important shot will be when they are lighting the new candle together. See Figure 10.8.

The ceremony is the most challenging part of the assignment. We have no control over the situation except our visual position and exposure. We can't ask the participants to slow down or repeat an action. So we have to be in position and ready. Lighting conditions can vary, and there may be distractions in a shot that are unavoidable. Watch for changes in light intensity, even indoors (on a day with fast-moving clouds and lots of windows, exposures can shift by over a stop).

Figures 10.8 and 10.9 show how the same part of the ceremony was handled in two different weddings, based on the circumstances at hand. Both of us were dealing with moving subjects under low light conditions. The high angle of a choir loft is a great place to capture an overall picture of the wedding, and any activity where the participants are turned toward each other (allowing a profile shot) or the guests.

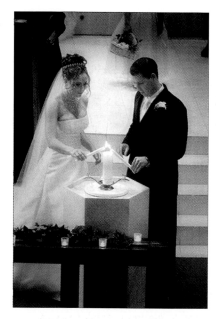

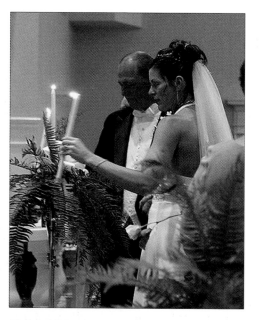

Figure 10.8 The high vantage point for this image of the couple lighting their Unity Candle was taken using available light at 1/160th of a second at f/4 an ISO speed of 1600 and a long lens. (Photo by TriCoast Photography)

Figure 10.9 This picture of the candle lighting was hand-held from a small room off to the side, with a very narrow angle of view. Many churches offer no access to the back of the sanctuary, and poor access from the sides, a good reason to make an early planning visit. (Photograph by James Karney)

Not all churches and very few commercial venues provide such views. When taking the picture in Figure 10.9, I had to shoot from a small room on the side of the church, using a 300mm lens with an exposure of f 2.8 at 1/20th of a second and an ISO of 800. There was no room for a tripod, so the camera was braced against the wall. The shutter was pressed just as the bride lit the candle so there would be minimal movement of her hand.

Time Your Shots and Notice Conditions

There are two reasons to be precise when pressing the shutter release during the ceremony. You want the peak of the action, and available light means a slow shutter speed. Both of the candle pictures in Figures 10.8 and 10.9 were timed for that fraction of a second when the subjects were still as the candle was being lit.

That's not always possible. Watch for emotions, and be ready to take a quick series of shots. If you are using a camera with a limited memory buffer or a slow memory card, be sure to save some capacity for a fleeting moment. See Figure 10.10.

I used fill flash and kept a finger ready on the exposure-compensation control to adjust the variations for the wedding shown in Figure 10.10. Fast-moving clouds obscured the sun, and then would pass just as quickly as the emotion on the bride's face.

Figure 10.10 Watch for emotions and changing lighting conditions. Both were considerations in this picture as the couple exchanged vows. Clouds kept moving in front of the sun, and her emotions showed as she said her vows. (Photograph by James Karney)

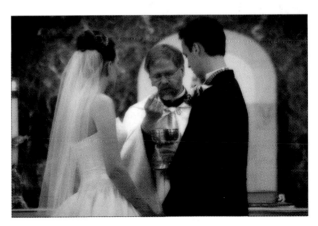

Figure 10.10a There are special religious ceremonies and traditions that are part of many weddings, like the Catholic Nuptial Mass shown here, or the groom breaking a glass during a Jewish service. It's important to know about these elements of the event beforehand to be able to produce meaningful images. (Photograph by TriCoast Photography)

The flash was set to one stop less than the available light exposure, and that was set a bit below the meter reading. This is the kind of situation where knowing the camera, its file characteristics, and your processing software is very important. I shot in RAW format and knew that the highlight recovery tools in Bibble Raw and LightZone would allow holding highlight detail under these lighting conditions.

Don't Forget the People

It's easy to focus on the couple and their actions during the ceremony. Even if you are the only photographer at work, keep an eye open for good images of the members of the wedding party and the guests during the service. The couple has invited the people who are important to them, and they will only know how the audience responded through your pictures—at the time they are too focused to watch anything but each other and the minister!

We usually make sure to get shots of special guests (find out who they are before the event) and the parents. If possible, we find a location where the bride or groom is visible in the picture as well. The children present are another good set of subjects, as they watch and sometimes interact with others.

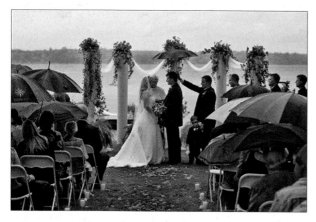

Figure 10.10b Be ready for changes in the weather and the pictures that come with them. In this case, the bride and minister got wet, while the umbrella-armed Best Man took care of his charge. (Photograph by Mark Ridout)

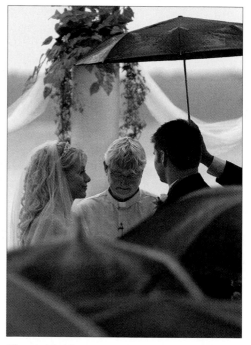

Figure 10.10c One wonders what the bride and the minister thought as the rain ran off of the umbrella, and they kept getting wetter. This is the kind of image that becomes a family keepsake. (Photograph by Mark Ridout)

Figure 10.11 Keep an eye on the flower girls and ring bearers. They offer the chance to show a view of the wedding from a child's perspective, and are usually important to the couple. (Photograph by James Karney)

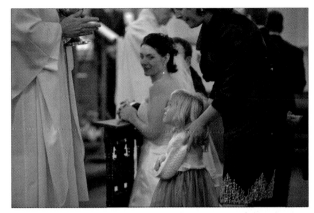

Figure 10.12 The interaction of the children present with the adults and their expressions uncover details of the day that add depth to the photographic coverage. Getting this type of image requires being very observant and waiting for just the right moment. (Photo by TriCoast Photography)

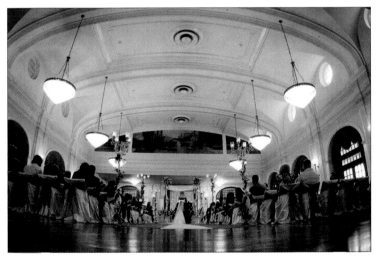

Figure 10.12a The wide-angle shot from the back of the church during the main ceremony is a standard image that has been on the must-have list since the days of sheet-film coverage in the 1940s and 50s. It's still a client-pleaser. (Photograph by TriCoast Photography)

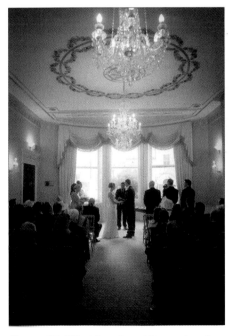

Figure 10.12b Not all weddings take place in ornate churches with a large wedding party and lots of guests. This picture shows both the setting and the intimate nature of the event. (Photograph by TriCoast Photography)

The Ring Exchange and Kiss

The two most important items on the must-have list are the couple giving each other their rings and the kiss. Sometimes the layout of the location lets us get great images of these critical moments. In many cases, these portions of the wedding happen under adverse lighting conditions, and when the photographer has a limited field of view.

It's a good practice to get whatever is available, and if there are two photographers, both should strive to get the best images possible under the circumstances. I've always made sure of the shots by making the couple and the minister reenact the exchanges right after the wedding, before the formal pictures are taken. Let the couple and the person performing the ceremony be aware of your plans beforehand. Ministers who have been hired just for the marriage have been known to leave right after the couple leaves the altar!

Be sure to take the staged shots with everyone in the same positions as in the real event, and don't dress up the lighting too much, maybe use a fill-flash to allow a lower ISO and better shutter speed. If the images look too different from the available-light pictures, the results will look artificial in the album or slideshow. Also get a mix of close-up and medium shots to round out the portfolio.

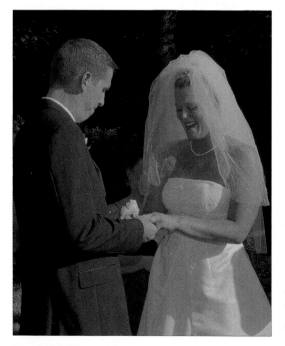

Figure 10.13 Visible emotions during the exchange of rings are fleeting, and important to capture, even if the only available position is usually limited to the point of view of the bride or groom and the ring. (Photography by James Karney)

Figure 10.14 Once the ceremony is completed, the exchange of rings (shown here) and the first kiss can be re-enacted to get close-up views. (Photograph by TriCoast Photography)

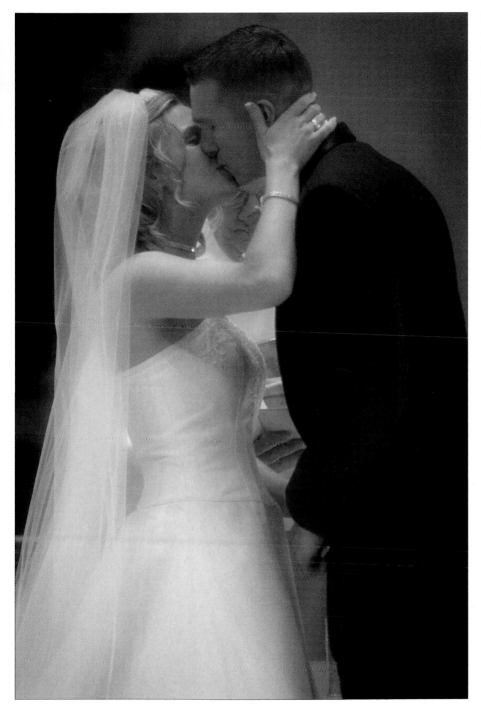

Figure 10.15 The kiss is one of the most important images on the must-have list. The couple will usually hold the pose long enough for several exposures—and have no problem repeating the task for a posed picture after the ceremony. (Photograph by TriCoast Photography)

The Presentation and Leaving the Church

Just after the couple kisses, the person conducting the wedding formally presents them to the guests and introduces them as man and wife. Be ready. Until now, the bride and groom have been focused on the wedding. Now they can unwind. Many couples are so relieved it's over that they rush back down the aisle. The couple will often hug people on the way out, and on occasion give a high-five or two as they pass by.

I turn on the flash unit right after I take the pictures of the kiss. The center of the church is usually darker than the sanctuary, and the extra light will be needed to get pictures that are not blurred as the couple hurries past. While less common now, there may be a formal receiving line, and many times there are special extras (like the release of doves) arranged by a wedding planner.

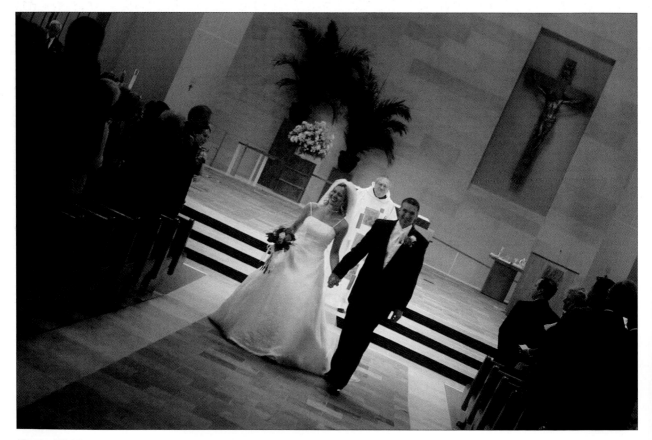

Figure 10.16 Be ready as the couple turns just after the ceremony. They will usually pause as the person conducting the service presents them as man and wife to the guests. (TriCoast Photography)

Checking exposure is critical as the couple moves outside from an indoor wedding. Photographers who shoot RAW-format images don't have to worry about white-balance issues; those who shoot JPEGs do. Usually, we can also set up fill flash and lower the ISO setting to improve picture quality. Typically, we still leave it a bit high, around ISO 400. That allows for a faster shutter speed, which makes it easier to process with computer motion.

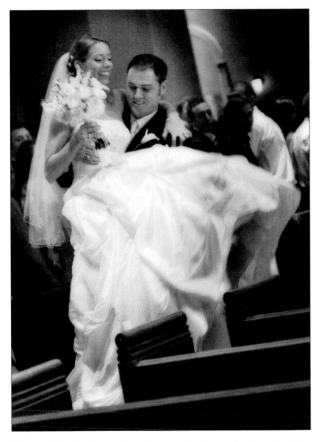

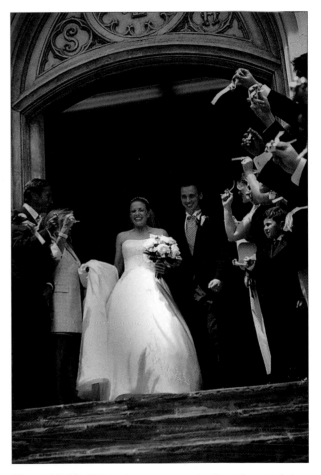

Figure 10.17 Be ready as the couple leaves the church. The most stressful part of their day is over, and the relief and joy is usually very obvious and makes a good picture, like this image of the groom actually carrying the bride back down the aisle. (TriCoast Photography)

Figure 10.18 If there is a separate reception, the couple is often greeted with rice or bird seed as they exit the church. Don't forget to adjust your exposure as you go outside. (Photograph by TriCoast Photography)

Wedding planners don't always let the photographer know the complete set of events for the day, and even hide some from the bride. That was the case with the next picture. I was shooting near the groom as the crowd left the church, about 175 people. I heard the planner say "Here, open this," to the bride. As I turned, I saw the birds in the cage! My habit of adjusting the exposure for speed paid off. In less than 20 seconds, the birds took wing.

The first shot caught the second dove with wings raised in a V-shape over its head, the second shot is shown in Figure 10.19. A second or two later would have meant missing both pictures.

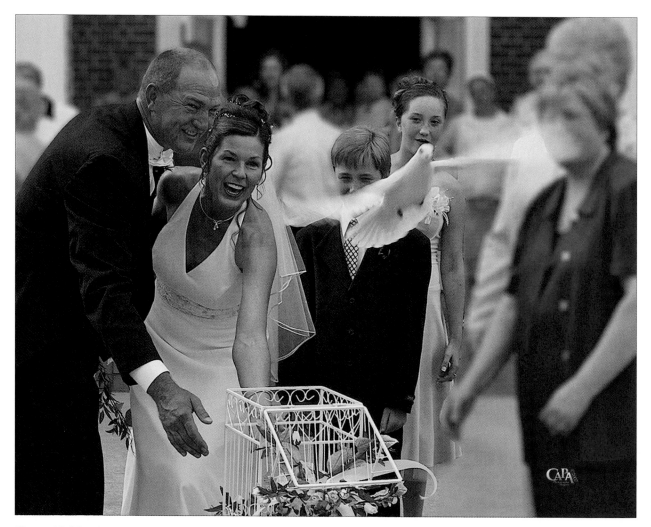

Figure 10.19 The activities right after the ceremony, like this release of doves, can happen fast. Paying attention to the couple and what they are doing is imperative. (Photograph by James Karney)

Next Up

The couple is married, but for most wedding assignments, that only means the photographer is at best half through taking pictures. We turn our attention, and that of our clients, to the formal pictures that need to be finished so we can move on to the reception.

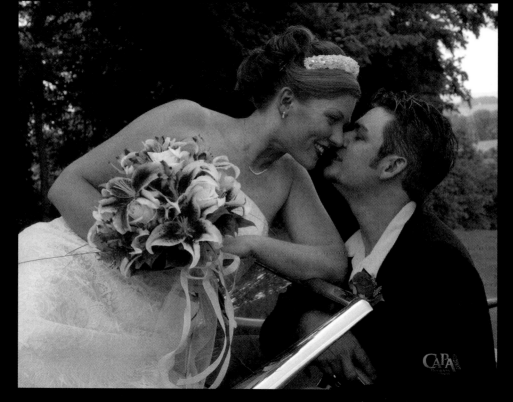

Photograph by James Karney

11

Making the Formals Creative and Fun

The time between the ceremony and the reception is often the only time available to get pictures of the couple with their family, wedding party, and important guests. Unless the client books a bridal session, it's the only chance to get formal poses of her as well. We also use it to re-enact the ring exchange and kiss, taking images with full control of lighting and camera angles.

It can be a real challenge to manage the group and get their cooperation. The wedding entourage has already had a full day just getting through the preparations and the service. The reception may be starting shortly, and you may only have the church sanctuary as a setting.

With many location weddings (and when the photographer is lucky), the couple will schedule a block of time on another day just for creative poses. Let's look at both options and how to use the time wisely to create outstanding images. See Figure 11.1.

Planning Pays Off

The sooner the formals are planned the better. In fact, if the couple is willing, get their pictures BEFORE the service. We also make every effort to get pictures of the groom and his attendants, the bride and bridesmaids, and the bride and groom with their parents then, as well.

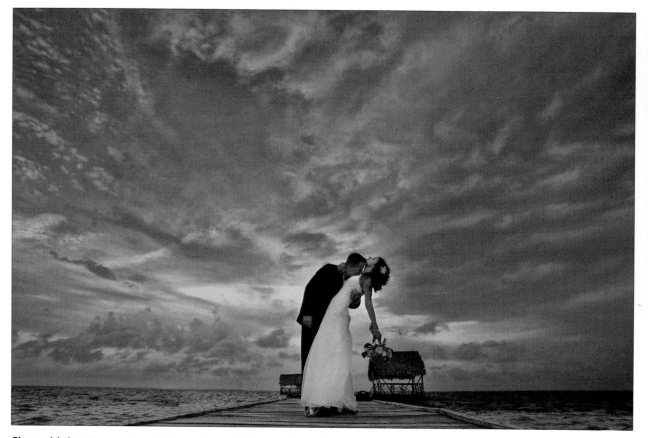

Figure 11.1 Who says formals have to be staid images of people lined up in rows? Not Mark Ridout, who took this great portrait of his clients during a wedding on location in the Caribbean.

If not, planning is still the order of the day. Before the bride is ready to walk down the aisle, the photographer should know where the formals will be taken and have the needed gear readily available for set-up right after the ceremony. Make sure the bride, groom, the wedding party, and the person conducting the ceremony are in on the plan. Ministers have been known to leave as soon as the couple exits the back of the sanctuary.

If you need additional light (and that's usually the case), find out if the existing lighting can be increased. Many times the lights in the venue are on dimmers, or some banks are turned off for weddings. When the location is still too dark, we position a set of strobes, light stands, and translucent umbrellas nearby before the ceremony. An assistant brings them out as soon as the guests start to leave.

Right after the Service

Crowd management is a big part of getting through the traditional formals and re-enactment shots quickly. It's a good idea to ask the client to have someone to identify the people to be in the pictures and to help find them. The goal is to have as few people tied up with the session (and milling about) as possible. Think outside the box if the wedding is indoors, you have large groups to manage, and the weather cooperates.

Our typical post-service session works like this:

Ceremony Shots

We start shooting the re-enactment shots while the assistant is setting up the gear for the formals, and we have the person designated by the client rounding up the folks who will be in the first set of group shots. The wedding party takes their places and the couple goes through the vows, ring exchange, and kiss while we shoot both medium and close-up pictures. Watch the camera angles. Pictures with an empty church or that have bystanders watching won't work.

Large Groups

In most cases, it's best to get any large groups done as soon as possible. That reduces the number of people in the room to distract the subjects. Consider the people who need to be in the pictures as you plan and have the "runner" get them for you. I often start with the larger groups, like the bride's extended family, then the groom's.

If you have a very large group (at some smaller weddings the bride has asked all the guests to pose for a picture), consider taking the picture right after the service, outside. There are no fixed rules, and each wedding varies in time, the number of people, and the images required by the client.

Small Groups

Next we shoot the images of the parents and any grandparents and siblings (both in sets and then individually) with the couple. Then it's time to photograph any special people the couple wants in formal pictures. Weddings are often ad hoc reunions. While these formal poses are generally not the most artistic, they often sell multiple copies.

With those choices out of the way, the photographer can concentrate on the wedding party and the bride and groom. Just how much time you have depends on the time available before the reception. If they are set close, then the options are

Figure 11.2 Even with the ring shot, Mark Ridout shows that he can bend the rules and still produce a compelling image.

Figure 11.2a Close-ups of must-have pictures like the kiss can be posed during the re-enactment with full control over exposure, position, and timing. (Picture by TriCoast Photography)

Figure 11.2b It's possible to use creative lighting effects when re-enacting the ceremony in ways that would be disruptive during the actual service. (Photo by TriCoast Photography)

limited. The best pictures often happen when you have a significant break between the wedding and the reception and have a beautiful venue, allowing more time for a creative approach. Many times, you only have a half-hour or so.

The Wedding Party

Depending on the client, and the available time, we work to offer more than the tried-and-true group shots in front of the altar. The composition also varies, with shots combining different members if the party is large enough. The ceremony provides enough images of the site, so consider the outside of the building, local parks, or even cityscapes.

Knowing your clients helps in choosing an approach to the group shots. Some will want a traditional arrangement, and it's always a good idea to take a few of those—even if just to please the mother of the bride. More adventurous, and even humorous, pictures can be fun for all and good sellers—provided you understand the clients' tastes. See Figure 11.3.

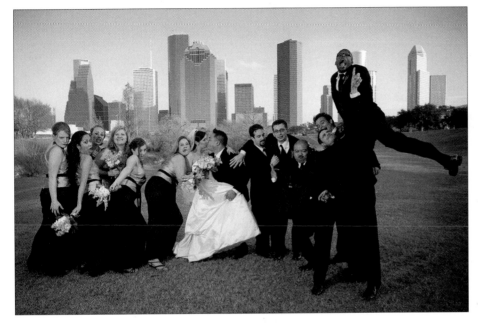

Figure 11.3 Some wedding parties are more than wiling to make the session—and the images—fun, as the faces in this photo, shot by TriCoast Photography, show. No need to say "smile" with this group!

Varying the members of the group is a common practice. Unless the party is small, we take images with the bride and her attendants, the groom and his, the entire ensemble, the groom with the ladies, and the bride with the men. If there are any special relationships, consider getting pictures of just those individuals with the bride and/or groom as well. Also, watch for them interacting during the reception.

The local environment, the wedding attire, and the personalities of the subject are materials at hand that the photographer can use to produce unique pictures. All show the interaction of the people, even if they are not looking at each other or at the camera. See Figure 11.5.

Also, consider Mark Ridout's work in Figure 11.6. The group is broken up much as in the standard pose, women on one side, men on the other, and the bride and groom are next to each other. But the poses and direction break up the composition so that it is dynamic. Add to that the bride and groom kissing and the reflections in the water. Mark also used exposure and color saturation to enhance the mood.

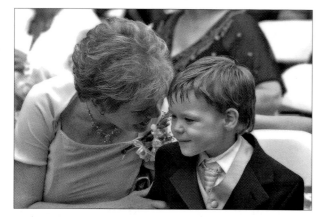

Figure 11.4 Don't forget to keep looking for good people pictures throughout the day, including while taking the formals. (Photo by Mark Ridout)

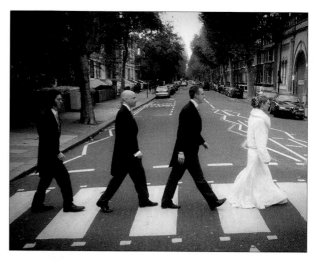

Figure 11.5 Another example of an inventive approach taken by TriCoast Photography. The incongruity of the procession, the city street, and echoes of an album cover all work together.

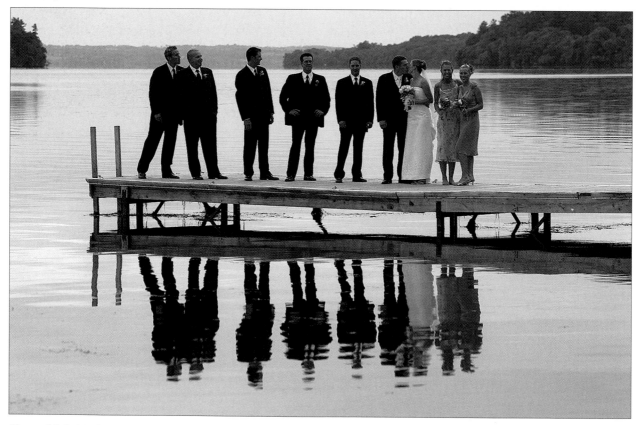

Figure 11.6 Traditional arrangements can be varied with creative poses and the environment. (Photograph by Mark Ridout)

Let's examine another of Mark Ridout's images and compare techniques. Figure 11.7 is an indoor shot, taken at a high camera angle. The bridesmaids are all grouped around the bride, with the plane of focus aligned so that everyone is in focus. (I used the same method to keep the faces sharp in Figure 11.4.) Both of those images are close and intimate. Both pictures are rich with bright colors.

The image in Figure 11.6 uses the open space of the lake, the mist, dark tones, and the natural enhanced saturation of an overcast day to create a mood. The other two pictures use tight grouping to show closeness. Figure 11.6 uses the repeating lines of the trees, the people, the dock, and the reflection to build a balanced composition.

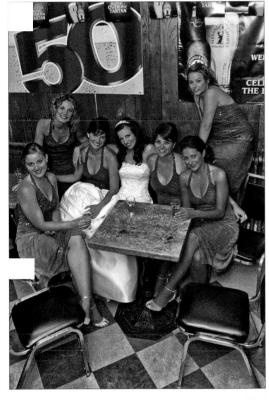

Figure 11.7 The pose, a high camera angle, and tight horizontal framing are all used to show the close friendship of the bride and her attendants. (Photography by Mark Ridout)

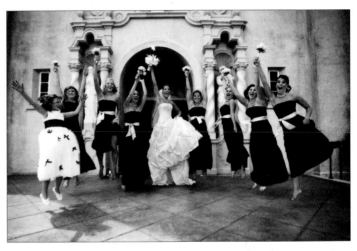

Figure 11.7a Exuberance is the order of the day for this bride and her entourage in this picture by TriCoast Photography. Active participation, with your subjects being at ease in front of the camera, is the easiest way to obtain good expressions and a pleasant shooting session (not to mention, better referrals).

Portraits of the Bride and Groom

The most important people at the wedding are, of course, the bride and groom. If at all possible, we try to get a full session with them before the ceremony—even before the day of wedding. That is not always an option, and with that there are details to manage, such as having access to the gown, tuxedo, and bouquet.

The couple in Figure 11.8 weren't worried about the groom seeing the bride before the service, and we had an hour after she dressed for formals. The groom designs custom cars, and we had arranged to have several on location that afternoon. Available light, with a boost from a sliver reflector, was used with a telephoto lens to help blur the background.

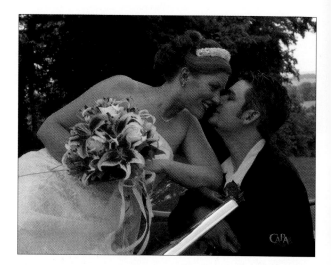

Figure 11.8 All dressed up and somewhere to go. This image was taken before the ceremony, so both the couple and the photographer were fresh. (Photograph by James Karney)

Vary the Point of View

The most important tools at any session are imagination and the ability to see the picture possibilities. The standard full-length poses that show off the gown and the happy couple can be varied with tighter images like the one in Figure 11.8 and with wider views like the one in Figure 11.9. In this image, Mark wrapped his subjects in the "background" of a field and then used the contrast between the color of the grain and clothing, as well as placement, to create a picture worthy of a large frame and a prominent place on the wall.

The rounded-out portion of the wheat and the posing of the couple make this an intimate study, and the placement of the bouquet and flow of the gown visually balance the composition.

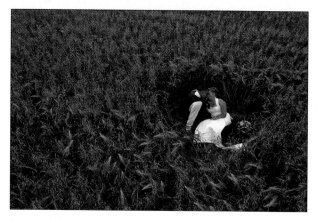

Figure 11.9 Mark Ridout proves that people don't have to dominate the picture in this compelling image, which has an Old Master's feel in its use of space and color.

...And Consider the Place

Locations for weddings run the gamut from outdoor vistas and gothic cathedrals to backyards and small chapels. The venue is part of the story and reflects the personalities and tastes of the couple. When setting up a formal pose, work with the location and the elements of the scene.

Consider the differences in the poses between Mark's picture in the field and the one in the great hall shown in Figure 11.10. He chose a vertical composition in the latter to show the size of the room and include the lighting and balcony. The

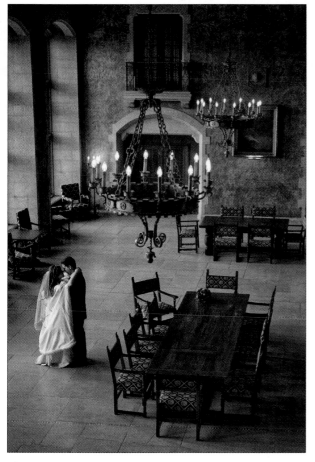

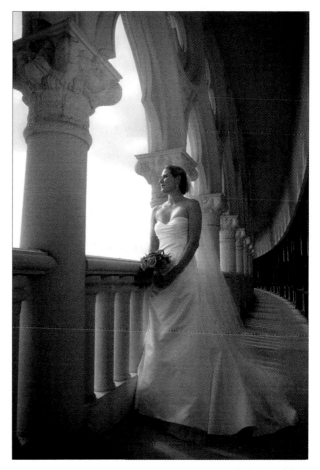

Figure 11.10 If the venue offers a sweeping view, take advantage of it. (Photography by Mark Ridout)

Figure 11.10a Looking for interesting architecture and good light is a part of photographing any wedding. Not all venues offer sweeping lines and long corridors. Enjoy the ones that do; having the available light in a perfect position helps, too. (Photograph by TriCoast Photography)

horizontal arrangement in the preceding picture allowed for better placement of the couple, while keeping the detail in the plants sharp.

Of course, placement and setting are only part of the design in a well-executed formal. Lighting, pose, and the proper use of visual lines are all important. The picture in Figure 11.11 illustrates the point. The bride's gown is the brightest object, and the reflection on the floor is about a stop darker. Just bright enough to carry the design without distraction. The balance of light and dark in the picture is enhanced by the flow of curved lines, which are bordered on the right of the bride by the vertical line of the banister. The texture of the wall and the deep tone of the carpet reinforce the theme.

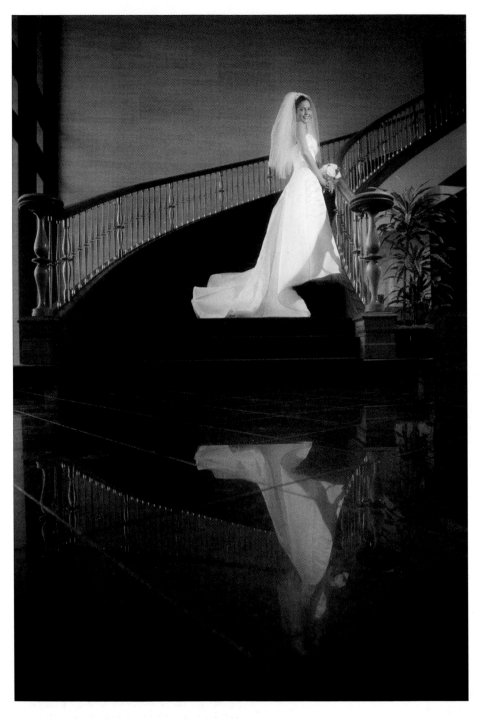

Figure 11.11 Negative space does not have to be empty. The reflective quality of the marble floor helps draw the eye to the bride just as much as the curve of the staircase. (Photography by TriCoast Photography)

Being sensitive to the setting, local traditions, and the client can lead to interesting picture possibilities. Take the example of Figure 11.12. Horses are a part of the culture of the American West, and when the venue for this wedding combined the bride and a horse, so did the photographer.

Don't Forget Simple and Fun

Of course, many weddings don't take place in fancy venues or offer all kinds of wonderful settings. The real subjects of the photographer are the people and events of the day. Close-ups, the use of simple backgrounds, and good use of light and composition work well no matter how exotic or plain the location. See Figure 11.13.

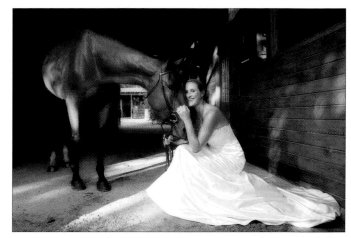

Figure 11.12 Formals don't have to be all that formal if the venue offers a casual setting with good picture possibilities. (Photography by TriCoast Photography)

Mark shows another technique for getting good portraits that don't require fancy settings in Figure 11.14, getting close. Here he uses a high-key exposure and a soft background to produce a picture that matches the soft expression on the bride's face.

Another tool we have to get great images is a sense of play, both in the subjects and the photographer. Many weddings in the home will be near a pet or a location that has special meaning for the bride or groom. If you know this, work it into the pictures. Asking the client during the consultations, or their parents, is a useful technique. We once learned that the bride was licensed to drive a horse-drawn carriage—just like the one in use at the reception. She brought a pair of white cowboy boots for the occasion.

If the subjects are willing, consider suggesting something unique. Many times the subjects may offer suggestions of their own. Of course, it's important to keep in mind a certain level of sensitivity and professional decorum. All rules in art and composition can be broken (within the limits of common sense).

We'll close with a fun image that shows a daring sense of humor. One hopes there were towels and warm drinks available for the bride and groom after they pretended to try to catch the water taxi—which had already left the pier!

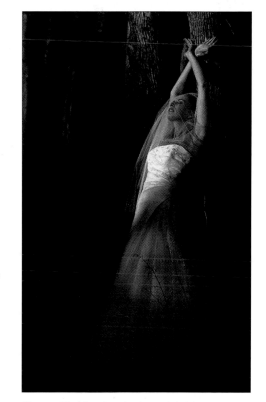

Figure 11.13 This dramatic bridal portrait "required nothing more" than a few trees, good lighting, an attractive subject, and a knowledgeable photographer to put them all together. (Picture by Mark Ridout)

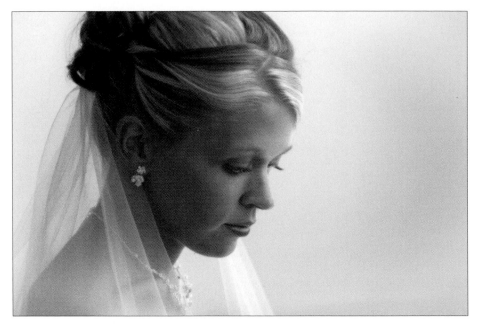

Figure 11.14 A soft expression is enhanced by the close camera position and high-key exposure. (Image by Mark Ridout)

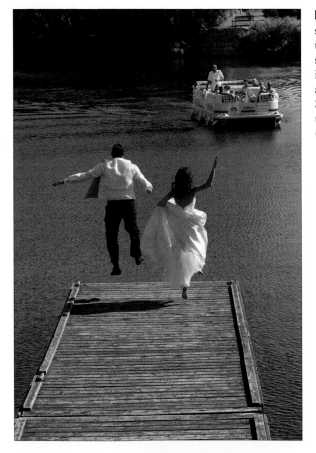

Figure 11.15 Never forget a sense of fun and being willing to play with your clients in the sprit of getting a wonderful image. Just remember to keep a sense of perspective as well. Some subjects are more willing to experiment than others. (Photo by Mark Ridout)

Next Up

Once all the formals are completed, it's time to quickly pack up and move to the reception location. The party is about to begin, with lots of picture possibilities.

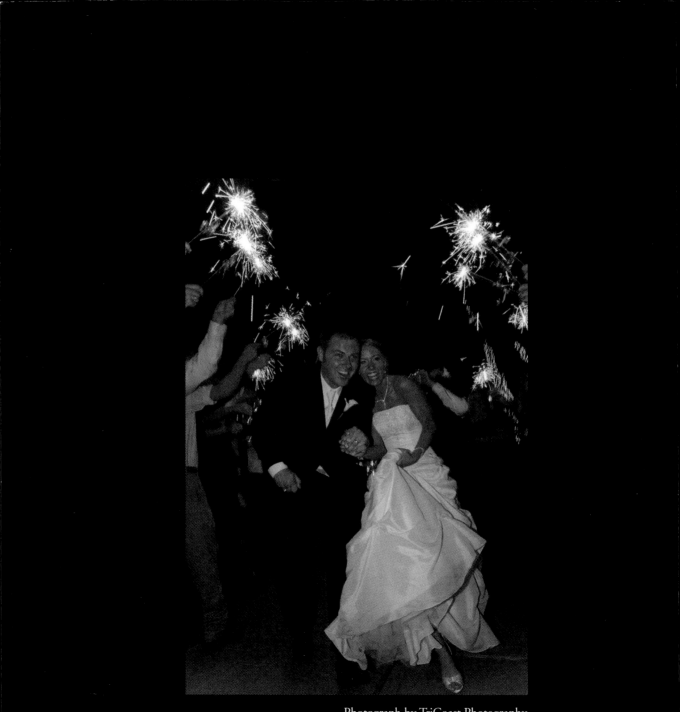

Photograph by TriCoast Photography

12

The Other Wedding Party—Covering the Reception

During the formals, we focused on the wedding party. At the reception, the operative word is *party*. The serious part of the day for the couple is over and their goal is to share the joy they are feeling with the guests. The photographer's primary objective is unchanged: to take wonderful images that convey both the look and feel of the festivities.

There are wide variations in the scope of the reception, based on budget, local conditions, and cultural traditions. Big receptions can last for hours: cocktail hour, sit-down dinner, dancing, and entertainment. Some receptions are little more than a receiving line with light refreshments.

Receptions can offer challenges both similar to and different from the ceremony and formals. Lighting is difficult when receptions take place in large rooms with dim lights. People will be more active, requiring a fast shutter speed to avoid blurred images. Good backgrounds can be hard to find, with lots of dining clutter on tables.

On the plus side, the photographer is free to move to get the best angle, flash lighting (and often even supplemental off-camera strobe) is permissible, and the happy people present are generally cooperative for your work. There are also marketing opportunities at the reception for the well prepared.

Preparation: There's That Word Again...

There are more variables in covering receptions than ceremonies and formal group shots. Just as with the ceremony, the lights and decorations may have been adjusted just for this event. Be ready to adapt as needed.

Lighting Issues

Lighting techniques for pictures at the reception depend on the nature of the available light. Many venues allow for a mix of available light mixed with fill-flash. In some cases the existing light levels will be so low that direct flash is required. Bracket-mounted flashes reduce objectionable shadows and the risk of red-eye that results from having the strobe head too close to the lens.

Some photographers arrange to set up studio strobe and umbrellas to bounce additional light into the scene, or they have an assistant carry and position a pole-mounted flash triggered and controlled by the primary photographer's camera or a wireless command module. If you plan on using one of these methods for improving the lighting, practice, and plan—then test and check your results in the display and histogram before taking any critical images.

What's in Store

Know before the party starts what the couple plans for activities, and be ready at the appropriate time to take the necessary pictures. Cakes—just the wedding cake, or a bachelor's cake as well? Are they planning formal toasts? Will there be dancing, and if so, using a DJ or band? Are they going to toss the bouquet and blue garter, and if so, when during the reception? Is a meal to be served? Will it be a sit-down version or a buffet? Is it catered or potluck?

The answers to those questions will keep you from being surprised and can lead to better pictures. It's often easy to suggest a good location for the tosses, rather than let the bride just stand in the middle of the room. The cakes might be in a corner with a distracting background, but there may be a good angle available for the moment when they feed each other.

If there is a potluck meal, who helped organized it? That person will most likely be busy in the kitchen and worthy of a picture to record such valuable dedication. If there are special items laid out on the table for the couple to use, look for an interesting still life.

Table Pictures or Not

Some photographers make a point of getting pictures of the people sitting at each table at receptions with a formal dinner, some do not. Our studio only does them if the client specifically requests them. Over the years, our experience has been that there are very few prints ordered, and so it is not a part of our regular package.

If table pictures are on your menu, take them before the dinner mess clutters the table. Another good idea is grouping the subjects on one side, to improve the pose and tighten the composition. This makes the flash exposure more uniform as well.

Exit Plans

Will there be a "grand exit" in honeymoon clothes, and if so are there any special send-off embellishments, like sparklers? It's best to know early and plan the pictures. (It's also a good idea to check with the Best Man and Maid of Honor to see if they plan surprises for the bride and groom.)

There is also the matter of the photographer's own exit plan, in accordance with the contract. If there was an agreement on a set number of hours, what happens if the event runs late?

Clean Up Pictures

The reception is usually the last item on the day's agenda. If there are any pictures that you or the client want that have not been taken, this is the last chance.

Multimedia and Marketing

The reception provides an excellent showcase for the photographer's work, and an opportunity to market both print sales of the wedding and plant the seed for possible new customers among the bridal party and guests. With enough planning (and possibly the help of an assistant), it's possible to provide a slideshow of images from the earlier events of the day, as well as retouched slides from any engagement and bridal portrait sessions already processed. This will require permission from the client and coordination with the manager of the facility hosting the reception.

We provide "Thank You" cards as part of our packages, placed either with the guest book or on the tables at the reception. These are 4x6 prints with a picture of the bride and groom, with the message "Thank You for Sharing the Day with Us." It also includes the web address of the couple's proof gallery, studio contact information, and notice of when the images will be ready for viewing. See Figure 12.1.

Figure 12.1 The wedding's guest book may make a good picture, and a good location to show off your work. With the addition of a portrait by you of the couple, and cards that explain how to view the proofs, it becomes a marketing tool as well. (Image by TriCoast Photography)

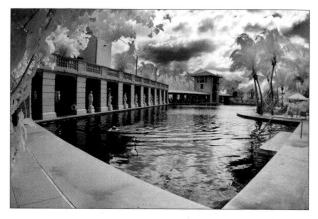

Figure 12.1a Fancy reception venues are often worthy of a picture, either as an accent or for use as a background image in the album, as in this black and white infrared image by TriCoast Photography.

Ready, but Not Waiting

During the first part of the reception, guests will be filtering in and the couple may be taking a short break. Some weddings allow travel time (even several hours) between the ceremony and the reception. Others have both in the same location and time may be limited.

This is a good time to double-check gear and take pictures of the cake and table decorations before they are disturbed by the arriving guests and the coming party. The location of the cakes, and the tables for the wedding party are already fixed, so the photographer will usually have little control over the backgrounds for those portions of the party. If the couple is planning to include tossing the bouquet and the garter, you may be able to choose locations to allow for good pictures.

If the band or DJ is already present, it's a good time to get some pictures and introduce yourself. DJs generally have a schedule for important events like toasts, father/daughter and mother/son dances, as well as the first one with the newlyweds. They can be an ally in making sure that there is enough time for you to get into position for pictures if they are asked to help.

Figure 12.2 Cakes are best photographed as early as possible to get "uncut" images. We often take a mix of the cake, alone and with people stopping to examine it. Take advantage of any design elements, like the candles in this picture. (Image by TriCoast Photography)

Some clients may hire limousines, or a horse-drawn carriage, and then ask the guests to line the curb awaiting the arrival of the wedding party. If this is the case, and you have more than one photographer, ask about riding with the couple and taking pictures en route to the reception.

At the reception, look around for still-life pictures, and keep an eye open for the entrance of the newlyweds. They may make a grand entrance, accompanied by the applause of their guests. If this is part of the plan, consider setting up a picture to provide a good background and dramatic effect in keeping with the occasion. See Figure 12.4.

Figure12.3 Close-ups of the decorations, presents, and table settings are all good material for pictures and possible inclusion in an album. (Image by TriCoast Photography)

Figure12.4 If the party travels by limousine, try to make arrangements to get pictures either before they depart or on the way if there are two photographers, so one can go on to the reception. (Image by TriCoast Photography)

There may be an entryway with a sweeping staircase, a balcony that overlooks the hall, or some other formal entrance that can serve as a pleasing backdrop. As the couple approaches, be ready and make several exposures. The technique is similar to the one used when the bride came down the aisle for the ceremony. Choose the point for the first shot to allow for a clean background, good focus, and room to back up and take additional pictures. Be careful. There will be people around you. If there is a staircase, it may not be possible to negotiate the steps safely. See Figures 12.5 and 12.5a.

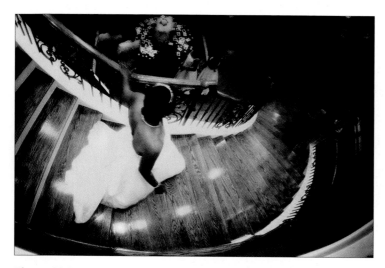

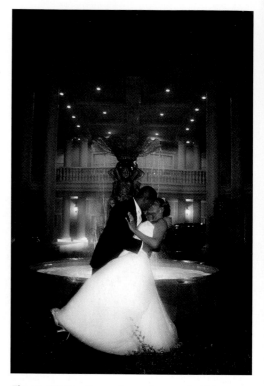

Figure 12.5 Creative use of camera angle and careful composition are obvious in this TriCoast Photography picture of the bride entering the reception. Note the cake at the foot of the stairs and how the lights glow on the polished wood; these kinds of pictures rarely happen by chance, but are the stock in trade of the wedding photographers who plan ahead.

Figure 12.5a Receptions often are held in locations that offer dramatic backdrops for impromptu (or pre-planned) portraits of the newlyweds. It is often a good idea to shoot these pictures as they arrive. Once the party starts, getting them posed will be more difficult. (Photo by TriCoast Photography)

Going with the Flow

It's a good idea to check with the clients once they arrive and see if they have any special requests for pictures. Double-check on the timing for taking pictures of the bridal bouquet and garter toss. Some couples are more interested in relaxing after a very busy day and want to minimize the agenda; others want to jump right in and dance the night away. If the tosses happen late, there are fewer people in the group making the catch, which makes for a less dynamic picture.

Remember the person who was tagged with the job of finding people for you? That's someone who can be handy now as well. We pay special attention to finding out if any guests are very old friends, or family members who traveled far to attend the wedding. Pictures that include them can have special meaning.

The children present are also good subjects, especially if they are interacting with the bride or groom or doing something cute that relates to the current activity. Opportunities to watch for include a child being held and dancing with an adult, two children together, a little girl trying to catch the bouquet, or one getting ready to throw rice or bird seed when the couple departs. See Figure 12.6.

Figure12.6 Keep on the lookout for cute pictures of children at the reception, especially those who are favorites of the bride and groom. (Picture by TriCoast Photography)

Targets of Opportunity

If the reception takes place in a fancy hall, beautiful outdoor location, or other interesting setting, consider taking some casual portraits of the bride, the couple, and the wedding party. These can be much less formal than those just after the ceremony. The subjects are often more relaxed, now that the "business" part of the event is over. See Figure 12.7 and 12.7a.

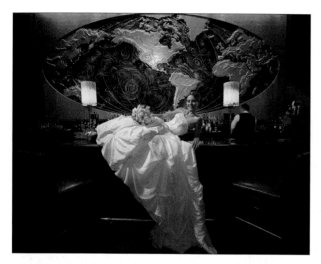

Figure 12.7 Reception venues often offer interesting settings for impromptu portraits, like this one by TriCoast Photography. The indirect light, the warm wood tones of the bar and chairs, and the soft folds of the gown all work well with the large map on the wall and the relaxed pose of the bride.

Figure 12.7a Another TriCoast Photography location picture, this time with a more candid pose that is in keeping with the simpler setting and the bride's cowboy boots and hat.

When not busy with a major event (like the first dance or cake cutting), the photographer is free to look for interesting pictures of people interacting and perhaps pose a few. Watch for humorous images that show the personalities of the people. At one wedding the two groomsmen changed into shorts right after the cake cutting. Another reception included a friend who changed from high heels into furry slippers! All made it into their respective wedding albums.

Tip

Reception halls often present difficult mixed-lighting conditions. Sometimes it is due to dimmers that are used on some lamps and not on others. Social halls may have sodium or fluorescent lights for overall illumination and tungsten spots for accent. Reflections off the walls may add a less than pleasing color cast to light-colored objects in the picture (like the wedding dress and a grandparent's white hair).

We use RAW format, which lets us shift the white balance easily. Two other useful tools are to make an exposure with full flash lighting, and to use Nik Multimedia filters in Photoshop to fine-tune the problem areas. One reception took place in a hall that had sodium lights, coupled with green walls and ceiling. The bride's lap had a faint pea-green cast. A bit of brush work with Nik's Pro Contrast and Remove Color Cast filters took care of the problem.

Look Closely—It's Not Always the Big Picture That's Important

It's easy to get focused on the people and the action during the reception. That is the main focus but be sure to take time to find the little details that are part of this wedding. Wedding planners, family members, and the couple may have included elements as part of decorations or rituals that have special significance and should be recorded.

We have photographed several weddings wherein a parent or friend who recently died was honored with a place setting, lighted candle, or remembrance table. Pictures with these items, and any ceremonies (like lighting the candle or the placing of flowers) should be part of the "must have" coverage.

Don't forget the DJ, band, or other performers, as well as the serving of the food. These are a part of the story as well. A mix of close-ups and wider pictures are always worth the effort. These images round out the story when mixed with pictures of the guests dancing and enjoying the party. See Figure 12.8.

It's important to keep an eye on light levels and quality during the reception, just as during the ceremony—even if you can use flash. Experienced photographers work to avoid making flash pictures look like flash. If the strobe dominates the

Figure 12.8 This close-up of an entertainer with his instrument uses selective focus and a wide aperture to separate him from the background, while the angle of the bow and the violin draw the eye to his face. (Picture by TriCoast Photography)

ambient lighting, the background will be dark (and often have a color cast), and the subject will be too harshly lit.

If the ceiling is not too high, consider bouncing the flash when shooting indoors. Another option is to "drag the shutter." This means slowing down the shutter speed to allow more available light to register in the picture. The result is a more-balanced-overall lighting effect and a brighter background. When the reception is outdoors in daylight, use fill-flash to reduce shadows without overpowering the existing light. We use a flash that is 1.5 to 2.3 stops less than the available light exposure reading.

Of course, there are trade-offs. If the shutter speed is too slow and the subject is moving, the result will be a blur. That can be a problem or a creative choice. If the photographer moves with the primary subject the blur will be reduced on the primary focus, while the background will be even more blurred. That can be a dramatic way to capture the bride and groom dancing. See Figure 12.9.

Figure 12.9 Slow shutter speed, a primary flash exposure, and moving with the dancing couple let the photographer blur the lights in the background for dramatic effect in this reception picture. (Photograph by TriCoast Photography)

Don't Forget the Fun and Watch for Tender Moments

The reception may have its formal aspects, but the focus is on fun and the joy of the couple. The pictures need to record both the details and the mood. If there is dancing, there will be a first dance as man and wife and usually a session with the bride and her father and the groom and his mother on the floor. For most couples, these are must-haves in the proof collection.

I usually move with the couples for these pictures and vary the angle of view and the focal length of the lens. Wide shots can show the sweep of the room and the attentive guests. Close-ups can capture tender moments like a soft smile, gentle touch, or even a tear. See Figure 12.10.

Figure 12.10 The first dance is a key moment in many receptions. Using a second off-camera flash for these pictures can add highlights and separate the couple from the background. Notice how this image by TriCoast Photography holds detail in the highlights by carefully balancing exposure levels between the strobe and the available light, while creating a rim effect that outlines the groom.

Photographers with an assistant often arrange to have a second strobe carried that is aimed from behind and to the side to highlight the bridal veil and perhaps create a rim effect. This can be tricky if the exposure and triggering device are not properly set. It's a good idea to both practice and take some insurance shots as well. If the flash is too bright, the highlights may be too light to record detail, and the rim effect may look artificial.

Another thing that experienced photographers use to improve their photographs is taking the time to vary their camera angles and choose viewpoints that enhance their images. Notice the difference in viewpoint between Figures 12.10 and 12.11.

Both are TriCoast images; both of the newlyweds are dancing. Figure 12.10 is taken at an average viewing level, rendering both the couple and the subjects in the background in normal perspective.

In Figure 12.11, the photographer dropped his viewpoint closer to the ground. Now the couple dominates the scene, as the onlookers appear smaller in stature. The photographer has also used the lighting to convey the same emphasis, making the bride's gown and the couple's faces brighter than most of the rest of the composition.

We pack a short stepladder and rest it in the corner during the reception. It gets us above the crowd on the dance floor. Another trick is a fish-eye lens held at arm's length overhead. It gives a similar overhead view, and is easier than the ladder for moving among the guests on the dance floor, but it does introduce some distortion.

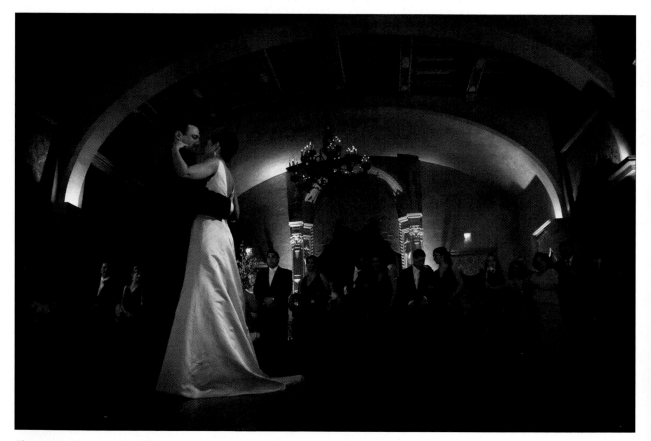

Figure 12.11 Consider different angles of view to enhance your images. Lowering the camera's viewpoint increases the prominence of the couple in their surroundings in this TriCoast Photography picture.

The Cake and the Toasts

One of the most common reception traditions is cutting the wedding cake and having the couple feed each other the first servings. Basic coverage includes both a close-up of the formal cutting and the couple eating. Some clients are more playful with this part of the event than others, almost to the point of gagging the new mate with a large slice. Be ready for the interaction of the couple and the guests.

The cake is often placed in a corner, with little room for the couple, let alone a creative pose. If that is the case, you can get a better set of photographs by posing the exchange using a more pleasing background. The key is to work with the couple before the time of the cutting.

We often shoot the close-up of the cut first, because the chances of moving the table at all, let alone safely, are remote. The hands will look the same, and so will the cake and the knife, no matter where they are taken. Then we take their portions on a plate—and bring napkins—to the desired location for the pictures of them feeding each other.

The same is true for the toasts, and we can bring the glasses to a new location with ease. See Figure 12.12. Some religions don't approve of alcohol consumption, but the toasts may still be on the agenda—just with a less potent beverage. The traditional pose is with the arms intertwined. We look for innovative poses, but still take one of the tried-and-true, since many couples expect it.

That's true for most of our coverage. Parents and grandparents often want us to take the same set of pictures they had for their wedding. This may seem old-fashioned, and it is. But if it makes for a happy client, we go by their list. We still take the pictures we want and make sure that both sets of images are properly represented in the proofs.

Keep in mind that very close subjects will result in a limited depth of field and may call for small lens apertures. We keep a table-top tripod and a bean bag in our gear box for the reception. These are handy tools for close-ups even when there is enough light for an average exposure. The combination of low light and macro focusing calls for an extra level of stability to avoid a blurry image due to camera movement. See Figure 12.12a.

Small reflectors are also handy for adding and directing light onto close subjects like table settings and decorations where a flash would cause harsh highlights or reflections.

Figure 12.12 This lovely portrait of the bride and groom toasting each other shows how a creative photographer can transform a standard "must have" into something exceptional. Note how the TriCoast photographer placed the couple in front of the light so it created a backlighting effect and filtered through the raised glasses. The slight flare around the couple enhances the effect.

Figure 12.12a Getting close and a bit of selective focus make for an interesting still life of the goblets and cake in this TriCoast Photography image. The exposure was balanced between the room light and the fill from the open window. A shallow depth of field and the reflection of the candles add to the design.

Figure 12.12b The real fun (and good pictures) with the cake are usually not during the cutting, but as the couple attempt to feed (or gag) each other with the ceremonial dessert. (TriCoast Photography)

The Challenge of the Tosses

Usually toward the end of the reception comes the time when the bride tosses her bouquet to the assembled unmarried women. Often the groom then removes the blue garter from his wife's leg and tosses it to the bachelors. These rituals are both good picture possibilities and challenges, especially for photographers working alone.

The challenges come in several ways. First is exposure. The group waiting to catch will be 10 to 20 feet from the person making the toss. This is a good bit of distance for a single flash to cover, and the unit will have to recycle quickly if you plan on getting off more than one or two shots.

Second, the object and the people will be moving. That calls for a fast shutter speed or allowing the object and anyone moving fast to blur. Finally, there is composition. The distance will make both focusing, and the relative size of the person in the foreground and the group in the back, harder to control.

Single photographers have limited options. Often the only way to handle the shot is using direct flash at a relatively fast shutter speed (125th to 250th of a second) and as small an f/stop as possible to improve depth of field. That will call for a fast ISO.

A single flash can cause harsh shadows, unless the photographer can raise the flash high and to one side using a remote cable or wireless trigger. (Consider asking a bystander to hold a second strobe aimed at those making the catch. Make sure your assistant doesn't cover any sensors and that the unit is aimed properly.)

Another option is to have a fast-cycling flash or use available light and make several exposures. Our primary units are all equipped with external battery packs that cut recycle times in half. The first picture is taken as the person gets ready to toss, the next at the peak of the toss while the person is almost stopped, and then the catch. Then we move to get the interaction of the winner and the rest of the group. See Figure 12.13.

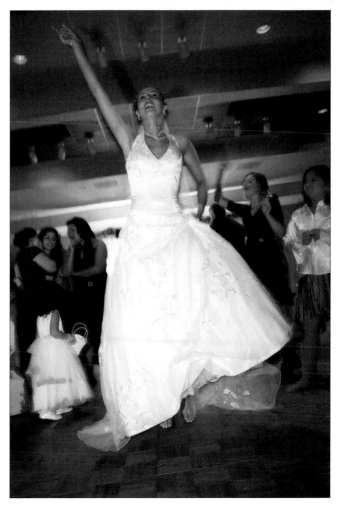

Figure 12.13 This bouquet toss was caught at the peak of the bride's jump, allowing the TriCoast photographer to record her in action, but without blurring.

With two photographers, one can handle the person making the toss, the other the group of would-be catchers. This is a part of the reception that takes a bit of practice and good equipment. Slow lenses, tired batteries, and poor lighting conditions can really take a toll on image quality, so first-class equipment is a must for professional results. If the client is willing, sometimes the event can be repeated to get another set of images.

Be ready for surprises. The bride in Figure 12.14 at first looked like she was going to toss the bouquet over her shoulder, then spun around and low-pitched to her sister. The second frame of the quick burst of three shots captured the flowers in mid-air.

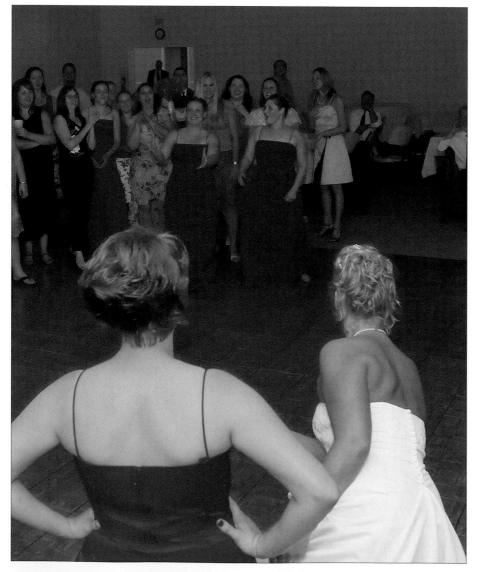

Figure 12.14 Bouquet tosses happen fast. Here the second exposure caught the flowers just before the lucky bridesmaid did. (Photograph by James Karney)

Something Blue

The garter toss has two parts: the groom removing it and the throw. This is a part of the festivities where it helps to understand the couple. Some grooms will carefully remove the garter while barely lifting the gown, others will (often with encouragement) pull the garter off with their teeth. Keep an eye on the facial expressions of both the bride and the groom; and be sensitive to the way they handle this mini-ceremony to get the type of pictures that reflect their personalities. See Figure 12.15.

Some grooms will just toss the garter over a shoulder, others will shoot it into the air much like a rubber band. Once again, a well-timed, quick burst of images can capture the throw, the garter in flight, and the catch. The interaction of the men vying for the prize offers additional picture possibilities. See Figure 12.15a.

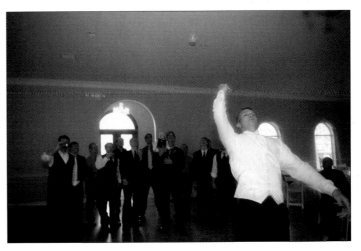

Figure 12.15a The groom tossing the garter offers the same challenges as the bride with the bouquet. Be ready to take several quick exposures to capture the action and the reaction. (Photograph by TriCoast Photography)

Figure 12.15 The way the blue garter is removed will vary depending on the personalities of the bride and groom. The photographer needs to be sensitive to the way the couple interacts, and capture pictures that suit the mood of the couple. (Photograph by TriCoast Photography)

Taking Leave

The Couple...

Some receptions end quietly, as the crowd thins. Others include a finale with rice, bird seed, even fireworks as the couple enter a limo or carriage as the party carries on. Once again, planning and knowing what to expect is important.

If the couple is leaving by car, check to see if their friends are "decorating" it. Pictures of the people adding adornments and painting words on the windows are worth a shot, and we often take a portrait of the couple in or by the vehicle.

Figure 12.16 Keep an eye open for items that show the details of a formal leave-taking by the couple. Often there are decorative elements like bags of bird seed, sparklers, or little wedding bells, like the ones shown in this TriCoast Photography image.

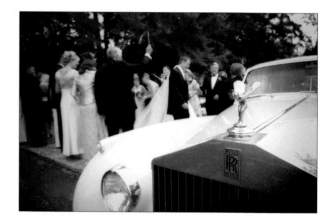

Figure 12.17 Here small red banners and a Rolls Royce are part of the grand send-off. (TriCoast Photography)

...And the Photographer

The photographer's exit almost always comes after the couple departs. If possible, we let a principal family member know we are leaving. We also make sure that all the desired pictures have been taken before making certain all the equipment is properly packed and loaded.

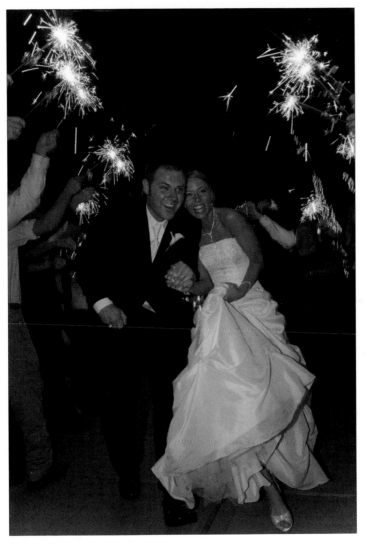

Figure 12.18 It's a good idea to plan your location and set up before the couple starts to leave, if there is a special send-off planned. Notice how the TriCoast photographer chose a low-angle viewpoint and captured the couple with a good number of the lighted sparklers in the background.

Next Up

The pictures are taken, so our attention turns to managing the files and creating a complete back-up copy of all images as soon as possible. We often do this right at the wedding, then move the files onto a separate device at the studio. No memory cards are erased until two known good copies of the entire array have been verified.

Given the number of pictures taken at the average wedding, keeping track of the files and having a good workflow for processing them is a necessity. Busy wedding photographers (and wise novices) make use of a dedicated DAM program.

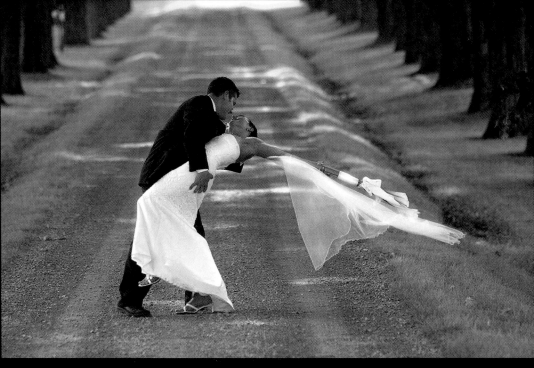

Part III
Production

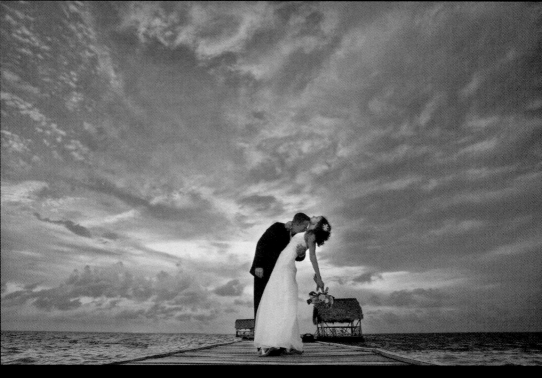

13

After the Wedding— All Those Pictures!

The rice and bird seed are thrown, the doves have flown home, and the bride and groom are safely off on the honeymoon. You may have over a thousand (or even several thousand) images to process and proof. In short, you still have work to do. With the right workflow and software, the images can be proofed and ready for sale on the Internet in a couple of days.

The first task for film photographers after a shoot is developing the images. Then they cull out the undesirable shots and proof the "keepers." Organizing and archiving the negatives may be weeks away. The digital process reverses the order. The first phase involves archiving, culling, and organizing the files; processing is the second phase. We'll focus on image management in this chapter, and take up editing in the next.

We will use a well-known program, iView MediaPro, for this task, also called Digital Asset Management (DAM). Microsoft recently bought iView, and as this book was written, was re-branding MediaPro as Microsoft Expressions Media and making some changes to the user interface. The new edition was not available in time for screen shots, so we will work with MediaPro.

I chose MediaPro for its range of professional features at a reasonable cost, and I know it well. Other programs may work better under different operating systems, may support more users, or be optimized for specific equipment. Adobe offers Lightroom, which is well-integrated with newer editions of Photoshop. As with all software purchases, the right choice is based on your budget, the desired features on your "must-have" list, and personal preference. The basic tasks are the

same, no matter which program you choose. The better the tool, the easier the work, and the more pleasing the final result.

Let's start by introducing the realm of digital asset management. Don't forget that you can download a trial version of MediaPro and follow along, practicing with your own files. If you do, you'll see that digital asset management programs offer some RAW image editing tools, just as most image editing programs provide some DAM-related features. A little experience will show that product labels mean something, in that each performs its primary function much better than any secondary ones. Figure 13.1 shows the MediaPro user interface.

Figure 13.1 iView MediaPro offers DAM features well suited to the needs of wedding photographers and small studios.

DAM—Digital Asset Management Is a Must

"File overload" can be a major problem for wedding photographers, and it's not just because of lots of pictures. Digital media includes pictures, music, slideshows, videos, and graphics—and we work with them all, often in multiple formats. The images are often shot in RAW format, edited as TIFFs, and then printed from JPEGs by a lab. A complete wedding project can generate all of the above, and even several editions of all of the above! We may need to find them several years after the event for repeat orders or to use in a mailing or marketing campaign. Unlike film photographers, we can't go looking for the case or folder with the negatives. The image files can reside on a local hard drive, a DVD, an MP3 player, an external drive, an archived back-up, or the Internet.

Sounds like a real problem. Where there is a well-defined problem, there is a market for a solution. The buzz-word for this situation is "workflow." The goal is more

"flow" and less "work," and the solution is digital asset management, and DAM software. My personal workflow is very straightforward. I shoot everything in RAW format, then use DAM to track the work as it progresses and to manage the library. I do most editing quickly in a RAW editor, and selected images get additional attention in LightZone and retouching in Photoshop. Almost all proofing is done via DVD slideshows and the Internet. But it all starts with DAM, just as we are explaining here.

Software Options

The occasional wedding photographer, or those who simply shoot the files and give them to someone else, may be able to get by with careful file management and good record-keeping. If you are just getting started and don't have a large volume of clients, you may be able to avoid buying a dedicated DAM product.

The majority of image editing programs, including the leading RAW editors, Lightroom, and Photoshop, all include some basic DAM features, such as the ability to sort and tag images, edit metadata (more on that shortly), and perform batch operations.

On the other hand, good DAM software is a lot more than just a file browser and organizer. It is a full-fledged database environment for managing your files. Don't worry about the database part. Good DAM packages automate the complicated aspects. They can speed up your workflow and get your work out the door faster. That can generate more sales, and maybe even a day off. While we don't have the time or space for comparative reviews of DAM programs, a quick listing of the key benefits will show why a dedicated program can be a bargain and suggest what to look for when shopping.

Robust Importing, Collecting, and Cataloging Capability

Working with a wedding project often means finding, organizing, viewing, editing, and exporting a variety of file formats—and not just image formats. Full-featured DAM packages collect and inventory scores of file formats, including major RAW camera files; Adobe DNG and Photoshop files; TIFF, JPEG, JPEG 2000, and GIF images, audio, video, fonts, illustrations, PDF, and HTML files.

Media Display and Editing

DAM programs make it easy to review, compare, organize, and even do some editing of their supported digital media via a single interface. They may not have all your favorite editing tools, but they can usually be integrated with external programs (like your favorite RAW editor) for serious manipulation. That's a lot faster than having to switch between several programs to select and get things together for a project.

Efficient Sorting and Locating

The better programs create a database inventory with previews and thumbnails. That means saving the time needed to load large image files for previews and sorting. Then they let you use tools like star ratings, color coding, and annotations to sort and organize the images into groups. Being able to use a remote copy of the database (where only the previews and file information have to be available) lets you easily locate files, even those that have been backed up and are not on the computer you may be using.

MediaPro lets you use many types of labels, including user-defined keywords and descriptions, the ratings system, etc., to sort and tag files. They can then be adjusted, moved, annotated, and even turned over to an external program for editing.

You can also do all of your file management with the program. I pull all of the files into MediaPro, create the subfolders in one of the program's panels, then sort and move the files without ever having to use any other tools—including the operating system's.

Metadata Editing Functions

"Metadata" is a fancy word for a formal annotation, following standard rules, that describes properties or contents of a media file. There are several industry-standard types of metadata, as well as custom forms that are program-specific. DAM applications have editors and batch commands for viewing and modifying metadata.

One familiar class of metadata to most photographers is the EXIF (Exchangeable Image File format) set of image properties, including file format, size, and camera/exposure settings, which are recorded and added to an image file automatically by most digital cameras. These non-editable annotations can be used to locate, sort, and organize images.

DAM applications let you add user-defined editable metadata, such as the location, name of the client, star ratings, keywords, client names, etc. In fact, you can usually combine batch and annotation features to sort, group, label, and even perform edits by group.

Figure 13.2 shows just how easy it is. Directly adding or modifying most metadata elements just requires selecting the image(s), double-clicking the desired field, and typing the tag. Here I am adding a category tag, denoting a part of the wedding, to several images. Now I can quickly select images using that tag and perform virtually any operation the program offers. The tags can be added from a drop-down box, so you only have to type them once.

Figure 13.2 It's easy to add and edit metadata tags in DAM applications, directly or in batch mode. The cursor shows where I am creating a new metadata tag, "Outside after ceremony."

Streamline Workflow Using Batch Processing

Annotating, renaming, moving, watermarking, resizing, and converting a large number of files can be a real chore. DAM programs let us automate repetitive tasks with tools like version control, automatic folder watching, batch commands (with easy-to-use dialog boxes), and scripting support (for the more technically proficient).

Archiving and Retrieval Tools

Some DAM packages can create portable visual databases (catalogs), allowing previews and annotations of a collection to be browsed and searched without the original files being on the same disk. These can be used in-house to locate and preview archived files, or to provide a catalog or portfolio to clients or prospects.

Simplified Export Options

Once you have organized and edited a project, DAM software (depending on its features and supported file formats) can be used to create and output contact sheets, proofs, slideshows, videos, DVDs, PDF composites, and web galleries.

Image Management *Is* Workflow Management

Okay, it's obvious that full-featured DAM packages are real organizing powerhouses, so how do we put them to work? The most effective way (assuming you have a real DAM application and not just a beefed-up browser) is to make it the hub of your entire workflow. That way it can track your files from the time they are downloaded onto your computer and right through to the last archiving, when they are retired to long-term storage.

The files for a given wedding usually don't have to stay on the primary workstation for more than a few months. Once the orders are filled, we can archive the event. The really nice thing about DAM software is that the program can manage file-naming systems and automate renaming, as files are imported or moved. MediaPro lets you keep a copy of the primary catalog file (including thumbnails) by itself, without all the images. This results in smaller catalog sizes. A catalog with all images included could easily be several gigabytes; most of mine without the full image files are under 10 megabytes.

I keep a copy of the primary catalog file in a folder on my primary computer and one with each back-up or archive of the entire wedding. That simplifies both the file system and the method I use for naming all the files and folders for each event.

The Naming of Names

A name is a powerful tool that we use in social settings without thinking about the concept as a technology, unless we get in a situation where there are several people with the same name. Then we have to come up with nicknames, Junior and Senior, Pope John XXIII, and such to keep things straight. Having a defined naming system for your wedding-related files and folders can make life a lot easier.

Needless to say, there are already thoughts on the matter; it may seem as if there are as many naming and file-management schemes as there are DAM experts. One approach is to set a global file- and folder-naming convention that is completely independent of the client or event. In fact, the principles used for naming a file-structure system can be very much like setting up the structure of a database, which can get complicated; fortunately, in our case, it doesn't have to be.

Weddings are discrete events and we don't have to worry much about confusing them. Even if we have two people who marry, divorce, and remarry, and they hire us for both weddings, the events will take place on different dates. We can use the date in the file and folder name to both identify the event and to make it easy to locate. That is a trick used in legal systems all the time. Including the clients' names in our event name, even just initials, should produce a unique name—that's our first goal. In the very unlikely event of two weddings with brides and grooms having identical names, we could add an ID number.

The naming convention I use looks like this:

> 980511_jmd

The 98 is the last two numbers of the year, the next two numbers are the month, then next two the day. The first letter after the underscore is the bride's first initial, followed by the groom's, and finally the couple's last name initial. This is the short form, and is used for file names. Longer forms using full names can be used for folders and catalog labels.

The highest-level folder has this label, followed by the last name and the word "wedding," like so:

980511_John and Mary Doe wedding

Either way, if you know the system, it's easy to find and recognize files and folders. John and Mary Doe married on May 11, 1998. For the RAW files I use the same basic even name format, followed by the four-digit image sequence number:

980511_jmd_ 0001.nef.

Edited files, like those created by LightZone or Photoshop, use the same name with the appropriate file extension, like 980511_jmd_ 0001.psd. You can add custom tags to JPEGs of the files to denote both the file use and also the resolution, e.g., 980511_jmd_ 0001_300dpi.jpg. That may look like work, but the software does most of the typing—and it's easy to find a file and know exactly who it was for and what its use is.

I set up a master folder using that naming convention just before the initial download of the RAW files. Then, once they are safely backed up and verified—*before I reformat the memory cards*—I move them into appropriate subfolders by category. Let's look at downloading and backing up the files before discussing subfolders and metadata strategies.

Caution

If more than one photographer is working at the wedding, it's important to make sure that no duplicate file names exist before beginning a download. Otherwise files could be overwritten! Most professional and prosumer digital cameras have a provision for setting naming conventions and numbering files. It's a good idea to coordinate a method for all shooters before the wedding starts. Another tip—synchronizing the time on all cameras involved will make it easier to sort the images based on the time of their creation, once they are downloaded onto the computer.

MediaPro can actually fix most problems with both file naming and time stamping. It has a very sophisticated renaming feature that can search and replace, renumber, reorder, resequence, and even run a routine much like a mail merge, using a template and an external text file list to assign new names.

There is also a dialog box for shifting the metadata time stamp associated with images. We used it this year when one of our cameras was accidentally switched from 24-hour to 12-hour time. We covered an afternoon wedding, and all of one camera's files jammed at the head of the list. It was showing a 4:xx time; the other

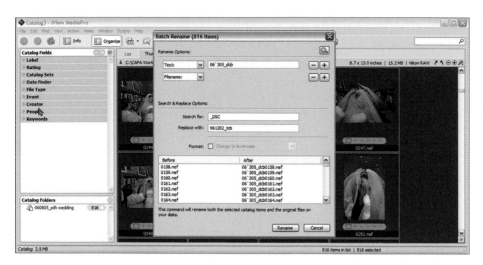

Figure 13.3 The best place to rename and organize images is in a robust digital asset manager. Here I have set MediaPro to rename a batch of 816 files according to my date- and client identifiers.

files were stamped with 16:xx. We used the program's "Sort" feature to tag and select the errant files, then added 12 hours to the clock. It's a neat trick (but not advisable for images to be used in court!).

Uploading and Cataloging Your Images

You may create a set of back-ups at the wedding; I do. That's an excellent practice. It's kept intact and untouched until I'm sure all the original source files are safely downloaded and that *two* back-up copies have been successfully created and stored.

All the original files are copied (not moved) into the root folder for the event, using the naming format just described. Most RAW editors are non-destructive and never actually modify your original source files. In spite of that, I try to always leave one set of RAW files unedited—just in case. I usually do it right away, as part of the uploading, and automate some of the metadata tagging as the files are imported. I also rename the files as described above as the files are copied.

Some programs, like MediaPro, offer several ways of importing files. All involve bringing them onto your computer. The simplest is to drag and drop the images from the camera or a card reader into a folder on the desired hard drive. Most DAM applications also have media readers that will detect when a new external device is connected.

Understanding iView MediaPro Catalogs

At its heart, MediaPro is a very sophisticated, and pretty much automatic, database. All files maintained in MediaPro are contained in catalogs. The catalog is actually a database that lets you organize media files, perform searches, and manipulate your data. You can create catalogs either before or after importing your images.

The catalog contains information about each file and metadata tags that are used to organize, classify, and search for files. The catalog also contains the complete path location for the original file. The catalog doesn't have to actually be in the source directory with the files. I actually keep multiple copies of the catalog. One stays in my master catalog folder with the rest of my documents. Another is kept with each complete back-up copy of the event.

Each file placed in the catalog is represented either as a thumbnail (usually created by the digital camera), a thumbnail created by MediaPro, or a generic icon for the media type. You can also have the program create full-screen high-resolution JPEGs for previewing images and to use in slideshows. The ones made in the camera can be pretty poor in appearance.

Figure 13.4 shows the program being set up to import images from a memory card in Windows. The process is the same (with minor operating system differences) on a MAC. The dialog box on the left is the one used to set up the downloading. There are several options. I often make the master folder, and enable Folder Watching with Auto-Update. I also have MediaPro create larger thumbnails than the ones produced by the camera. The Folder Watching Auto-Update feature means that MediaPro will add any files created within that folder to the catalog. That saves work. As you edit and add files, MediaPro will be able to search, annotate, and manage the new arrivals.

Figure 13.4 Using a DAM program's Download function can save steps and simplify workflow by creating directories and annotating metadata as the files are transferred.

The dialog box on the right hand side of Figure 13.4 lets you append metadata to image files as they are placed in the folder and catalog. You can make master templates with standard information, like your studio name and contact information, copyright, details of the event (like the couple's name), and even the master file location of the primary permanent archive. That lets you quickly locate a file for a reprint from a digital proof a client brings in—even years later, just with the information embedded in the image file.

Verify! Don't Trust the Thumbnails!

As soon as the files have been placed in the new destination, verify the transfer. Don't rely on just seeing the thumbnails in the new location. The thumbnails are not the actual image. The little JPEG may have made the trip all right, but the actual image file could be corrupted. Some programs do have a verification feature. If not, you'll need to bring the files into an application that actually verifies that they were properly copied. Files that won't open will need to be recopied.

Warning

Don't use any form of Move Files command to transfer original images from a camera or card reader to your computer. Always use Copy. Always verify!

If the system loses power or fails to write a file properly, images can be lost forever.

Archive the Unedited Files Immediately

As soon as my files are copied to the primary hard drive and verified, I create two copies of the entire folder before doing anything else. These are designated as the master archives. They are kept in a pristine condition in case I ever need an original version of the RAW image. They will never be directly manipulated. One copy is kept on a hard drive in the studio, the other off-site in a safe deposit box.

Two other copies are made and used as working back-ups. One is kept on an external hard drive on my workstation. The other is moved to a remote location. One of these will be updated at important points during the day as the project proceeds. At the end of the day, the second working back-up is updated. Once all the work is completed, one set of back-ups is kept on a storage server's hard drive, and a second set is burned onto DVDs and moved off-site. This system ensures that no valuable work will be lost, and copies of the intact originals are safe.

Note

You don't have to use a digital asset management program, whatever it is, to handle file transfers or perform archiving and back-ups. I use a third-party solution that offers more choices in back-up media. Don't be afraid to experiment with different methods and features when working with DAM and developing a workflow. Just make sure you have your master archive and back-ups firmly in place before you do! Most of these programs are very flexible, and workflow is very much a matter of individual style.

Creating a Subfolder System

After verifying and safely storing the archives, it's time to sort the images into more manageable sets. I start by creating subfolders named for portions of the event. This system is designed to keep pictures taken under similar lighting conditions in the same folder, making it easier to adjust color balance and exposure. It also simplifies selecting and placing images during the album design.

The Pre-Ceremony subfolder contains all the images taken from the time we arrive and start shooting until the bride is at the altar and has been presented to the groom. At that point, I usually stop using flash for indoor weddings. And many of the pictures will be candids, mixed with detail shots (the bride's ring, for example) and put into the album.

In the Ceremony subfolder are pictures taken during the actual ceremony, ending when the couple starts the walk back down the aisle. I may add also add retakes of the ring exchange, kiss, etc., that are taken before the formal shots. This is another well-defined section in the album, and the images are usually taken at a high ISO, hand-held, and using available light. The retakes and formal poses generally will need a different color balance, noise reduction, and sharpening from the other pictures taken at the event.

The Formals subfolder contains all of the group shots, as well as portrait-style images of the bride and groom. Once again, they will have generally the same lighting and need similar retouching.

The Reception subfolder holds just what you would expect—all of the post-wedding activities until the couple leaves the scene: the cake-cutting, bouquet toss, garter toss, the toasts, the dances, and scores of candid people shots; again, here I use similar lighting, and the album sequence from this point on is easier to predict.

As additional edits are made in various stages of the workflow, new subfolders are created. For images selected for individual prints and the album, I create high-resolution TIFF files in Bibble Pro, LightZone, or Photoshop as I edit. As they are generated, they are placed in a subfolder under the one where the RAW file is located.

Slideshow images are generally JPEGs that are batch-created by the RAW editor after the primary processing. Sometimes a troublesome file, or one that is worthy of immediate retouching, may be creatively tweaked in LightZone or get advanced optical corrections in DxO Optics Pro. No matter the program, the results are always placed in the Slideshow subfolder.

Supporting images are in a Resource subfolder and sometimes in another subfolder under that (for example, music files for the slideshow and web page, the logo, the copy of the wedding invitation, etc.) Figure 13.5 is a screenshot that shows my catalog with subfolders, and the thumbnails in MediaPro, before my culling and sorting started.

Figure 13.5 A well-designed folder system can be a valuable asset for a wedding photographer.

Culling and Sorting Images

A photographer who always gets a perfect exposure, creates excellent compositions, and has clients who always look wonderful, would still have to cull (i.e., discard) unnecessary images. (By the way, if you know that photographer, I'm hiring). Clients should be given a manageable number of pictures to choose from for their order or album design. I give them proofs as a DVD slideshow and an eCommerce website address (more about that in a later chapter). Most of the slideshows have about 200 images, only a fraction of the ones we shoot. That makes a 20-minute show and has enough pictures to tell the typical wedding story.

There are always multiple pictures shot of each group, and the ones wherein someone blinked, was talking, telling the person who was talking to stop, or making funny faces are dropped. The variations on a theme that are as good as the one I really like are cut out, and so are those that just don't interest me the way they did when I clicked the shutter.

Just as with metadata, DAM software provides tools that make the culling and sorting process easier—rating tools. In fact, some of the rating categories may be appended to an image as metadata, which can then be used in the RAW editor to tag files.

An Iterative Process

I find it easiest to do my culling and sorting in a series of passes. The first pass focuses on eliminating the obvious discards and getting a sense of the scope of coverage. Any deleted files are still available on the master archive, so I can afford to be somewhat "ruthless" during this phase.

One example is with large group shots. Even with a group of 15 to 20 people, I usually don't give the client two or three selections of a given pose. For very large groups I may have made 15 exposures, so 12 are cut. There are also usually several variations of most candids. I usually remove the less interesting ones during this first pass.

With Stars

The first pass is also a good time to give initial ratings, while removing the obvious cut-outs. Virtually all DAM software, as do most of the image browsers, offers both star and color-coding systems for tagging files. I use MediaPro's five-star system to indicate my overall impression of each picture. My rating system is much like the one used for hotels. It's easy to change star ratings if you change your mind during a subsequent pass, so going with a first impression here is OK.

A single star means the picture will probably only be used as a last resort. (Think, it's late at night, and I'm on the road. And it's a long way to the next good hotel, so I would make do at a single-star hotel.) This is usually something like a group shot wherein one person blinked or had an unflattering expression. Most of the time a single star means the picture won't even be proofed.

The images that get two stars have good exposure, reasonable composition, and may make the final cut. In short, they have no problems, but are not likely to end up in the permanent portfolio. Two stars are a bit like a good budget motel. You wouldn't mind sleeping there, but a nicer place at a good price would win out.

The three star pictures are definite keepers. Think full-service lodging. Most of these will become proofs and appear in the slideshow. The final decision will depend on whether several other images have similar content, and it will be made later in the process.

Just as with hotels, the difference between a three-star and four-star rating is hard to define. In my system, four stars indicate a picture that sparks enough interest to be worth the extra effort of individual retouching in a program like LightZone or Photoshop. Three-star images are generally limited to processing in the RAW editor without additional detail work, such as fixing hair and touching up distracting elements.

Five-star ratings are reserved for pictures that stand out right away. These images are going to go into the portfolio, be featured in the album, and are contenders for the cover of the album.

You can assign star ratings by clicking on the row of stars below the image using a hot key or the right-click context-sensitive menu. A good shortcut is to select all the images and assign them three stars, then click to add or remove the appropriate number. A no-stars rating in my system is the same as being deleted, since I choose and move images in part based on the stars they earn. See Figure 13.6.

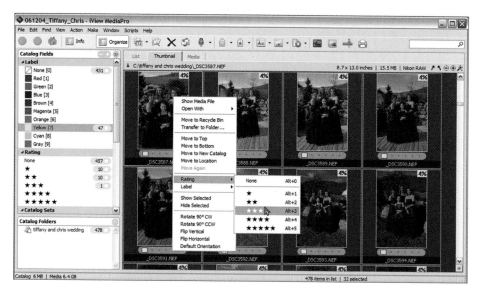

Figure 13.6 Tagging images with star ratings is an effective way to denote the relative quality of your pictures during the culling process.

A Little Bit of Color

Most DAM programs also offer color coding as a way to tag images. I use this marker to denote the likely editing processes needed. Since I shoot in RAW format and leave the camera's white balance on Auto, color coding lets me denote obvious conditions. For example, I use yellow for sun, blue for shade, and green for florescent or mixed lighting. Then I bring all the images with one color tag into Bibble Pro at the same time and batch-correct white balance, color adjustments, and exposure (more on that later).

Sometimes I color code on the first pass, sometimes on the second. The second pass has fewer images to deal with, thanks to the culling that is the primary focus of the first run-through. I save the catalog at the end of each pass.

And Then There Are Categories, Keywords, and Descriptions

There are also custom tags I use on a regular basis. Categories are handy for grouping images by where they occur within the order of the event. An easy way to do this is to first select all the appropriate images, for example, the portion of the wedding where the couple are at the altar for the actual ceremony. All these images are placed in the Ceremony category. That makes it easy to select a specific set of images and move them into a folder, then search on the category to locate them when designing the album, etc. I also use the Slideshow category for every image that will be included on the DVD and with the proofs on the website.

Keywords are handy tools for more specific annotations. I evolve a regular list of keywords, just as above, using portions of the event within in the ceremony, which makes it easy to identify images for special handling or consideration. Let's say I have a wedding with an unusual feature or interesting series of images, such as the releasing of doves just after the ceremony or an interaction with a special guest. I can use keywords so I know later that these images are grouped together and should be considered for inclusion as a series within the album or slideshow.

The final annotation I use on a regular basis are descriptions. These are like freeform text in the database. It lets me describe editing issues, special handling, or any notes that don't fit easily into any specific category.

Most DAM software makes it easy to do this kind of editing and add custom annotations. In MediaPro, a panel to the left of the thumbnails lets you view and edit all metadata elements. The cursor in Figure 13.7 shows the editor as an annotation, "Outside after ceremony," is being made. It's as easy as opening that section, double-clicking an image, and filling in the data for that image. You can select a series of images using existing metatag annotations, or keyboard shortcuts, and apply the same tag to all of those files at once.

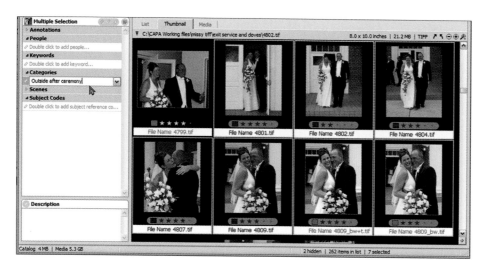

Figure 13.7 Using custom annotation features like categories and descriptions is time well spent, so that later you can quickly find and use images based on individual attributes.

Folder Placement and Backing Up

Once the images have been culled and annotated, it's time to move them into their subfolders. They've all been categorized with tags that match the name of the appropriate subfolder (for example, Reception). All we have to do is select the images with each appropriate tag and tell the program to transfer them into the appropriate folder. Once all the folders have been populated, we double-click the remaining images (none of which should be tagged with a star) to make sure we really want to delete them. Once those have been deleted or redesignated, it's time to back up again. As before, we make two copies and one is stored off-site.

Next Up

For large weddings, the complete cataloging process can take the better part of the day. The time spent is well worth the effort. We now have a good idea of what images we have from the shoot, and it will be much easier to perform editing and proofing. Now it's time to fire up our image editor and make the images ready to show our client.

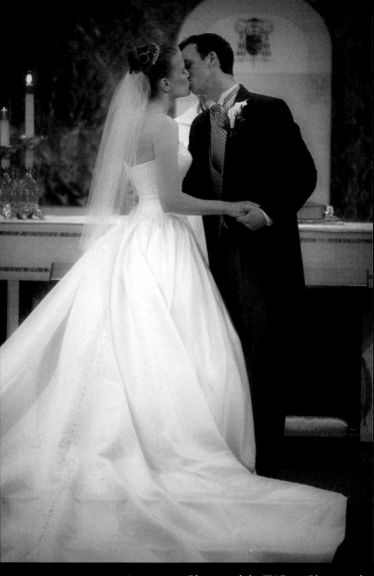

14

Images into Pictures— The Art of Image Processing

Order has prevailed over chaos. We have our images safe and sorted. Now it's time to transform them from files into pictures, and we have the need for speed. Faster proofs mean more sales, more time for other things, and there are a lot of images to adjust. The wise wedding photographer does not spend a lot of time fussing with image corrections. Good camera technique, proper exposure, and well-designed software do the bulk of the work.

Digital cameras always capture RAW files. RAW files are like digital negatives, they contain all of the data recorded about the color detail and tonal range of the original scene. We could let the camera do the processing automatically and provide a JPEG image. Doing so results in permanent data loss and image compression. We may need the RAW data to correct color casts or to bring out maximum detail and quality. Professional RAW editing tools offer features that we would only dream of in the days of the darkroom. To demonstrate the point, we'll take an image with extreme shadows and highlights, underexposure in main areas of interest, sensor noise, and lens distortion and vignetting, and produce a presentable photograph quickly, without choosing any individual pixels or doing any masking.

This chapter is not designed to make someone a RAW wizard overnight. It will demonstrate the benefits of working with RAW and provide a good foundation for developing your own workflow. While different RAW editors vary somewhat in features and design, they all perform the same basic tasks in the same way. We

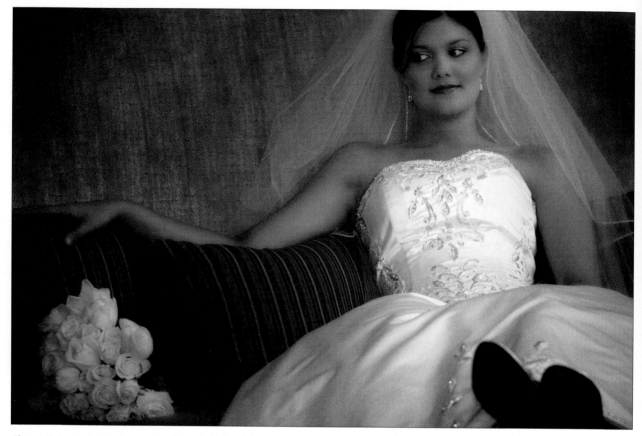

Figure 14.1 The bride may be able to relax after the wedding, but getting the images processed is a priority for the photographer. Good workflow and the right software are the key to success. (Photograph by TriCoast Photography)

will focus on Bibble Pro, the editor our studio uses. Feel free to follow along with the trial version (available for free at Bibblelabs.com) and the image found on the companion website at www.courseptr.com/downloads. When you get to the book's site, the file is named _DSC1336.NEF. Or, you can use your own image.

The Processing Workflow Sequence

In our studio, we divide the processing portion of our workflow into stages, based on the amount of attention a picture needs. The sheer volume of images shot at a wedding makes it impossible to give all of them detailed individual attention in an editing program in a reasonable amount of time.

We start by sorting the photos based on the lighting conditions when the image was taken. For example, all of the images taken in the church with available light are in one round, the ones taken outdoors before the reception in another. Then we choose a representative picture and make corrections for white balance, color

casts, exposure, etc. The overall adjustments are then copied to pictures shot under the same conditions. Then we check each image, make individual adjustments, and crop as needed.

Once the processing is done, the program generates the files used for retouching, proofing, printing, slideshows, and the web. That may sound like a long list, but with Bibble batch (a batch is a set of automated commands) it's quick and easy. With good camera technique at the event, most images only need a tune-up and cropping to be ready to use. Pictures of a bridesmaid walking into the church or an aunt hugging the groom during the receiving line don't need fancy retouching, just basic exposure, color balance, and sharpening adjustments. If the picture was shot using a high ISO setting, a bit of noise reduction is in order. That's how I handle the pictures that have been marked with three stars or less in the DAM program. RAW editors can do those kinds of corrections in batch mode on hundreds of images at the same time.

Making corrections to images sight unseen may seem risky. Not to worry. Most RAW editors never actually modify the source file. A companion file contains a list of instructions that are used to display the modified pictures as you work and create a new TIFF or JPEG for use in other programs or to make a print.

While they are real speed demons when it comes to correcting the entire image, most RAW editors are not really designed to fine-tune portions of a picture or handle retouching details. The images marked with four and five stars in MediaPro, pictures used in the album, and any to be printed over 8x10 inches get special attention in our studio, using programs like LightZone and Photoshop.

Pixel editing programs like Photoshop may offer RAW support, but their primary use is retouching and graphic design, not processing. Most RAW editors don't have sophisticated tools (like magic wands, marquees, paint brushes, and buckets) for manipulating individual pixels in an image. While they may offer limited spot and cloning features, they are designed to make overall corrections quickly. Most provide advanced batch file manipulation that really speeds up processing.

Once the RAW processing is completed, I use LightZone or Photoshop to retouch and manipulate portions of the picture and similar tasks that are beyond the ability of the RAW editor. We'll cover that phase of the workflow in Chapter 15.

Color Calibration

When sorting, we didn't have to worry about things like color balance and exposure. Before actually manipulating the images, it's a good idea to calibrate the system's monitor and display card. If you do your printing in-house, calibration will save frustration and money. If you send images to a lab, your printing bills can drop from 15 to 30 percent. That's if you send calibrated files for them to process

"as-is" and they don't have to do color balance to get clean whites and skin tones. That's money you can keep or pass on to offer more competitive prices. The turn-around for as-is is faster, too.

Clients expect pleasing skin tones, good contrast, and clean whites. They also expect those attributes to look the same when two images are viewed side by side in an album or folder. (We'll look at how to handle that when we work on an album.) Keep in mind that "reasonable" is in the eye of the beholder, and there is no such thing as a perfectly calibrated workflow from end to end.

Note

Not all labs are really set up for customer-managed color calibration. Those that are should be willing to let you send several images for a check before starting to send paying jobs. The lab support staff may also have a special target image and sample prints so everyone is working to the same standard.

Even if you don't plan on doing your printing in-house or sending work to a lab as-is, calibration is a good idea. Photographers that rely totally on the lab to get images looking right lose a lot of creative control and the understanding of your camera and exposure that comes with being involved at every point in the imaging process.

The exact settings, and how they are adjusted, vary with different monitor controls, operating systems, and calibration devices. Your display doesn't need to per-fectly match colors to a printer, as it would for critical pre-press of scientific applications. The idea is to make sure that the system is properly adjusted, is free of color casts, and that the brightness and contrast are within acceptable limits.

We adjust our monitors about every two weeks. First, we use DisplayMate. This software program projects a series of test patterns on the screen, along with step-by-step instructions for correctly adjusting the brightness, contrast, and overall quality of the picture. Then we use a sensor like the ColorVision Spyder2Pro. It reads a set of color targets and produces a calibration profile that is loaded each time the computer is started.

Figure 14.2 Devices like the ColorVision Spyder2Pro are popular tools for calibrating monitors.

The printer has to be properly tuned as well. We use an outside lab, so that's their job. Outside labs will give you settings for the resolution and color space they need. Appendix B, "Color Calibration," (found on the companion website, www.courseptr.com/downloads) and the DisplayMate website offer suggestions on how to handle printer calibration if you do your work in-house.

It's easy to see that a complete discussion of color display and calibration technology is beyond the scope of this chapter. Appendix B provides a good background on the topic, information on additional tips and tools, and comparisons of the suitability of various types of displays for critical work.

The Color-Correct Workspace

The computer is not the only issue when it comes to calibration. Human vision is a very subjective sense, especially with color. We still need a carefully lighted workspace, even if there is no need for a darkroom safe light. When editing, it's best to work in an environment without bright light or glare falling directly on the monitor screen. Soft indirect lighting is best, and lights close to the same color temperature as the monitor are a plus. Our workstations have monitors balanced to 6500 degrees Kelvin, and the area illumination comes from a matching lamp that is adjusted so no light falls directly on the monitor.

Most flat-panel displays don't show the same levels of brightness and contrast at all viewing angles. Find the screen position that gives the best picture—and part of the picture quality is the fidelity of the image to your final output.

Color calibration is not a one-time event. You should repeat the process at least every month or so if you have a high-quality new monitor, more often on an older model. I usually run mine every two weeks and right before any big editing job.

Finally, make sure that the display system, all editors, and output devices use a compatible color space. Some programs, like LightZone, handle all the details internally. Others, like Bibble Pro and Photoshop, suggest you set a specific color space (like sRGB or Adobe sRGB) in the program's Preferences.

Color calibration can be intimidating to the novice. Getting accurate color does take some effort. The payoff is in getting quality results the first time—no repeat jobs, no wasted ink or photo paper, and happy clients.

There are some things to be aware of when working with any calibration system:

■ Make sure the monitor has warmed up for at least an hour before doing any color-critical work.

■ Make sure Adobe Gamma is not running on a computer that is using any other calibration process. Adobe Photoshop (and some other Adobe applications) automatically install it during the program set-up.

- Be aware that bargain monitors and graphics adapters do not have the same level of quality or advanced controls to fully calibrate to the level needed for critical work.
- Monitors age with time and lose the ability to make fine adjustments.
- Most flat-panel monitors will not calibrate to the same level of quality as a quality CRT device.
- Color management is an ongoing process, and you have to be the one to decide what is good enough for your style of work
- The old country adage applies: you can spend money or you can spend time.

The Joy of RAW

Some photographers are intimidated by RAW. The different file types, the large image size, and the need for an "extra" processing step can seem overwhelming. It's not. Each camera type does have its own file format. That's because a RAW file is nothing more than the actual light intensity and color values, along with the camera settings, recorded by the sensor at the instant of exposure. As long as your RAW editor supports your camera, no problem.

Using the camera techniques and exposure methods shown in Chapter 8 should give you the kind of RAW images that will be easy to adjust, proof, and print. The batch capabilities and advanced processing tools in the leading RAW programs streamline workflow. We will be using them in this chapter. First, we are going to see how working in RAW can be an insurance policy when the lighting gets difficult or an important shot was made with the wrong camera setting.

File size varies with the camera, and some can be large: the more megapixels in the sensor, the larger the RAW file. Memory cards keep getting bigger and less expensive as sensor megapixel counts go up. The increase in editing speed and control and the quality of results are worth to a professional the little bit of extra cost in memory.

RAW Processing Demystified

That "extra" step of RAW processing isn't really extra. All digital cameras shoot RAW for every exposure. If you use settings that produce a JPEG or a TIFF file, the camera is doing the processing on autopilot. You have the equivalent of a digital Polaroid. The result may be acceptable, but never as refined as custom processing. This is why the RAW format is often compared to film negatives and JPEGs to slides.

With digital cameras, we can shift ISO speed and color balance at will. For example, my shots at the altar are generally "pushed" to a higher ISO than the formals

or the candids, where I can use flash. High ISO generates noise, and the two sets of images generally have a different white balance, and so need different corrections.

Coupling the original data with good RAW processing offers an amazing array of tools for adjusting almost every aspect of our pictures. You can make major adjustments in exposure and color balance with little or no loss in image quality. It's possible to reduce noise from high ISO settings, "recover" lost highlight and shadow detail, and correct defects due to lens distortion. And they can do it so well, it looks as if we got the settings exactly the way we wanted when the picture was shot.

There is no mandatory order of processing with many RAW processors. The program will arrange the order in which tools are applied to achieve the most effective result. It's still a good idea to follow a basic set of steps that adjusts the appearance of the picture in the most efficient manner to minimize having to readjust a setting and to be able to see what other corrections need to be made.

For example, if you tweak exposure or color saturation before removing any color casts, it's likely you will have to revisit the first two edits, because the color cast influenced your actions. My personal approach is to deal with color casts, tune overall exposure, correct contrast, and then deal with any problem areas. Sharpening and cropping are left for last.

Note

When choosing a RAW editor, *check out the trial version first.* Yes, I say that with all software, but I emphasize it here. Why? Because you need to make *sure* the program properly supports your camera and has the features you need. Also, the RAW market is one of the fastest changing areas in digital photography. Companies update features and support and get bought by competitors. New cameras may only have support during their first weeks in the programs sold by their manufacturer. Many RAW editors will open and adjust JPEGs, some also can work with TIFF files. They may not offer full support for either, and don't expect the same output quality as obtained with RAW formats.

Figure 14.3 shows Bibble Pro, the RAW editor we'll be using in this chapter. There are several others on the market; some of them are included in Appendix A on the companion website (www.courseptr.com/downloads). I chose Bibble Pro as a representative because of its features, the range of cameras supported, and its ease of use. We will start with basic editing, then progress into batch file handling.

If you have never used a full-fledged RAW editor before, you're in for a treat. The best way to learn RAW is by doing. You'll need to learn a few new habits. Don't worry. It's a lot easier than picking out pixels. First off, the process is almost always non-destructive. We don't really alter the source file, just apply different settings.

The editor shows us what the results look like, and we can then keep them or try something new. The output is a TIFF or JPEG "copy" with all our edits in place. We can save the edits as well, return later to make more modifications, or undo those we don't want.

Bibble Pro's interface is simple to use, and not much different from its competitors (see Figure 14.3). You can see the Browser panel on the left. When you choose a folder, its files are shown as thumbnails in the next panel over. Grouping pictures into subfolders based on lighting and exposure conditions makes it easy to select and apply adjustments. See the Queue tabs in the Browser pane to the left of the thumbnails? We'll look closer at them shortly. They are used to group files and apply a set of adjustments with background processing.

The large panel in the center of Figure 14.3 shows the currently selected file, and the rightmost one has the editing controls. Icons on the top provide shortcuts to many tools and functions. The tabs at the top of the rightmost pane divide the editing tools into sets. Virtually the entire interface can be customized to suit personal work habits. We'll just use the program's defaults, and walk though an editing session. I'm going to focus on the process, not the program. The goal isn't to make you an instant expert with this specific product, but to learn effective workflow and the power of RAW editing techniques. Along the way, I'll show some of my basic techniques and favorite shortcuts.

Figure 14.3 Bibble Pro is an excellent example of a full-featured RAW editor and the one we will use in this chapter.

Note

While the material in the rest of this chapter uses Bibble Pro for editing, there are a number of other RAW editors on the market. Choose the one that meets your needs and supports your camera the best. All offer some form of trial version, and the discussion is designed to make it easy to follow along and work with your own files.

Working with most RAW editors, Bibble Pro included, is very straightforward. Most controls use some form of slider or WYSIWYG interface to manipulate the current image. Results are shown in real time. If you don't like the result, either Undo or Reset the control.

Most of the time I follow a basic series of steps to produce a complete set of files (proof, print, web, and slideshow versions) for a wedding in a single session. They are exported in the appropriate file format at the correct resolution for each use, with custom file renaming, and with a single mouse click!

Before starting the editor we cull and sort our files, as we did in the preceding chapter. Those with common exposure and lighting are in the same folder. We work on one folder at a time, and start by selecting one image that is representative of that group. It is checked for noise and adjusted for white balance, color cast, exposure, contrast, and lighting refinement (highlight and shadow recovery) as needed. Then we make any adjustments for noise and apply sharpening. These settings are saved, and then applied to all the similar files in the folder.

Next, we evaluate each image, fine-tune the edits as needed, and crop the image. A set of Batch commands is used to output the JPEGs and TIFFs of the files for use in other applications. We repeat the process with each folder. We'll walk through the process so you can see how it works. As we start working in Bibble Pro, I'll show you an image that needs an extreme make-over. It was shot under difficult lighting conditions and will demonstrate both how the program works and why I recommend shooting RAW.

Individual images can be opened via the File menu, but the best approach is to use the Browser panel to navigate to the desired directory and select it. Then all the images selected are presented in the Thumbnails panel. Clicking on a thumbnail opens the image in the main window for editing.

We always start by checking (and adjusting if needed) white balance and color casts. If the image was taken without white balance calibration at the event, it has to be properly set now.

The picture loaded into Bibble Pro (see Figure 14.4) is a close-up of an assistant holding a standard gray card with a Kodak Q-13 target. It's the same card recommended as an inexpensive color reference tool in Chapter 8. Now we'll use it to adjust white balance and start exploring the Bibble Pro user interface. Don't worry about the image's slight green cast. That's the way it's supposed to look for now.

Figure 14.4 A reference target is a quick way to get accurate white balance values in your images when working in RAW.

Correcting White Balance and Removing Color Casts

Most digital cameras set to Auto white balance use the brightest area in a scene as the white color temperature reference. That may give a workable result. If the scene illumination is all from one type of light source, it's possible to simply set that as the value with the White Balance tool. When there is mixed lighting from several sources, things get more interesting.

In this example, we knew the light was an issue when we walked into the church. Fluorescent lighting in colored cylindrical lamps was blending with daylight filtering in through large green and beige stained-glass windows. Wedding locations are often a challenge when it comes to color casts and getting clean whites (as on the gown). That's one reason we shoot only RAW.

Coupling RAW with a known reference shot under the exact lighting conditions, let's make short work of this problem during processing—and without loss of image quality. It's very much like calibrating the monitor. The gray card is a known neutral 18-percent value. We made reference images like this at each location during the day and left the camera's white balance in auto mode. (Our normal practice is to make these reference pictures during a first visit, before the wedding when possible.)

The cursor in Figure 14.4 is the Color Picker common to almost all image editing software. It's located right over the tall white patch in the Kodak Q-13 target

taped on the gray card. I could have used the gray card area as well. The trick is to use a known neutral gray value taken under the exact lighting conditions of the image you want to correct (in this case, all the other pictures taken at the same time).

Since our card has a white patch, we can use the Color Picker to identify it. The program will set the color temperature to make that the new white point. Just choose the Click White option in the White Balance section of the tools and move the mouse over the desired location. Click and the green cast should vanish. Figure 14.5 shows the same image, before and after setting the new value.

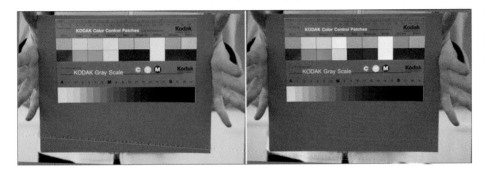

Figure 14.5 The reference target before and after white-balance calibration, with hands showing skin tone changes.

These show how dramatically that single click changed the image. It's also obvious that the picture's highlights and contrast improved. You can tell that from the improvement in the grayscale and the color patches. That's why I hold off on those corrections until any color cast is removed. Skin tones now won't look like the subject needs treatment for jaundice.

We can now save this setting and apply it to other images that need the same or similar corrections. We can also use it as a starting point for fine-tuning. I often warm up an image slightly from pure white. That improves skin tones. Too much can add a color cast. I'll show you some tricks for getting the perfect glow a little later.

Don't Have a Target? There Are Options

What do you when there is a color cast and no reference target? Remember how your camera works and adapt. When set to Auto white balance, the camera finds the brightest object and calls that white. We can look for something that should be—or is close to—true white, gray, or even almost black in the image, then use the same Pick White tool as a starting point.

Results will vary. It's tempting to use the bridal gown; that often works, but there may be a bit of a color cast. Many gowns have a slight color, often crème. Others use "whitening agent" that increases UV transmission to make the gown appear

pure white. I usually click around a bit and see what works best. Then I adjust the Tint and Temp sliders to get good skin tones and whites. A little shadow or highlight can confuse the Picker, and a spot next to where it puts the slider may be just right.

Figure 14.6 shows the reference card sample, after correction using the white patch, next to a sample that was balanced by clicking on the assistant's white blouse. The color temperature and tint values are different, but both work as a good starting point.

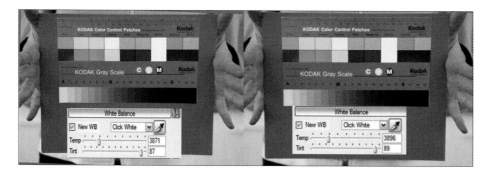

Figure 14.6 Choosing a white or relatively neutral item in an image will serve as a starting point if a reference target is not available.

Option Three: Using a Known Lighting Source

Bibble Pro's adjustments for the reference card and the Color Picker are very close to the ones obtained using the white shirt. It's not always that easy, and some pictures don't have a subject with a good neutral target. In that situation, my solution is to use a custom white-balance setting and work to get pleasing skin tones with no obvious color casts. First, I set the color temperature with the Temp slider (blue-yellow axis); then the Tint slider controls any green-magenta cast.

Making Image Adjustments

Once the white balance is set, it's time to evaluate the image and start editing. Properly exposed pictures taken in good lighting conditions may only need a little sharpening and to be cropped. Poor lighting, high ISO, wide dynamic range, deep shadows, and lens distortions call for more aggressive editing. The neat thing about RAW and the latest processing software is just how easy it is to "save" many images that would have been considered unusable three or four years ago. (Better camera technology, higher resolution, and more pixels help, too.) Our normal processing goes something like this (there is no set rule):

1. Set proper white balance and correct color casts.

2. Turn on and off any automatic processing and see how well it works (results vary).

3. Check for noise (hold off on actually adding noise correction to improve program performance).

4. Adjust exposure and contrast.

5. Use Highlight Recovery and Fill Light to recover detail in very light or dark areas.

6. Evaluate lens aberrations and use beneficial tools.

7. Recheck overall exposure and contrast.

8. Sharpen the picture.

9. Crop and save the file.

Because most RAW editors don't actually change the image, we can reopen the file and adjust a crop or make a second rendition with special effects. If the image would look good as a black and white, we might do a quick "save as" grayscale version. Bibble Pro offers a slick plug-in for this task. Our favorite black-and-white tool is one we designed that works with LightZone. We'll show exactly how it works in the next chapter.

The best way to see just how much can be gained by working with RAW with a full-featured editor is by adjusting an image that pushes its limits. The image we'll use was designed to do just that. The location is the medieval cathedral in Cologne, Germany, known as the Dom. It has a very tall ceiling, and the light is filtered through high-placed stained glass windows.

In short, it's much the same kind of lighting challenge we face when shooting a wedding in any big church with the lights dimmed. The day was overcast and the interior of the church was dark. The exposure was selected to hold detail in the windows, leaving the interior of the church very underexposed.

Figure 14.7 shows images of the file before (left) and after (right) a quick editing session in Bibble Pro. To the left of the pictures are before (above) and after histograms. On the right are enlarged areas without (above) and with Noise Ninja enabled. These improvements only took a couple of minutes to obtain and are just a rough edit. We will improve the results in the final image as we walk through the process. Remember that you can move back and forth with settings to fine-tune your work without degrading the final result.

The camera settings for the shot were 1/20th of a second at f/2.8, using an ISO of 500. The lens was a Nikkor 17-55mm zoom at 17mm on a Nikon D200. The actual readings for the different areas in the interior of the Dom varied from 1/8th for the area near the windows to over one second for the side chapels sitting in the shadows.

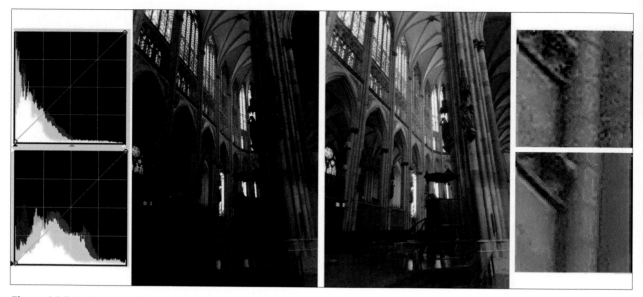

Figure 14.7 Before and after versions of the Cologne, Germany cathedral's interior showing the power of editing images in RAW.

While an ISO 500 setting does not produce extreme noise in good lighting with the D200, in this shadowy environment the noise is quite noticeable in the dark areas of the picture due to the relative underexposure in those portions of the image. The wide-open aperture, coupled with a wide-angle zoom setting, produced a variety of optical artifacts, even with a high-quality lens.

I chose this picture as our example because the actual ceremony of many weddings is often shot under adverse available light conditions like the one inside the Dom (even if not as severe). Knowing and using RAW techniques produced a result that can be used to make large prints or cropped to use small areas of the picture.

There are trade-offs with almost every editing adjustment when working with an image. That was true in the world of film, and it has only increased with the new tools available in digital photography. Wedding photographers are after a look and feel that expresses their style, which shows the mood and tells the story.

When working with an image, keep that in mind. Sometimes a "correct" adjustment doesn't look right to the eye. The warm tone in this picture was not the way the Dom looked that day under an overcast sky in the early morning. The "real" colors were more like the diffused blue of foggy twilight. I made edits to bring out the colors and warmth of a late afternoon on a sunny day. (I've been known to do the same thing with a bridal portrait.) The real goal is a pleased client and a happy photographer.

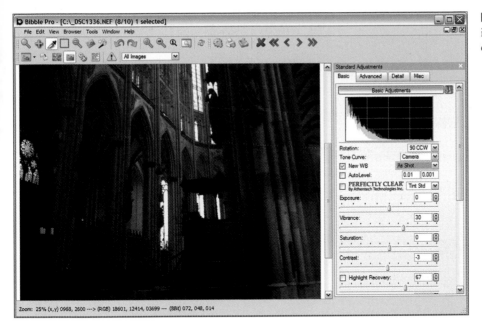

Figure 14.8 The original image in the Bibble Pro work environment.

Setting Up the Editing Work Environment

Figure 14.8 shows our image in Bibble Pro with a portion of our picture visible in the editing window and the Tool Stack in the work area. Let's take a quick tour of the general interface before making edits. Most RAW editors use a similar system. The array of controls may seem daunting to the novice. Images that need little correction can be adjusted using just the tools on the Basic tab.

The icons above the work area provide quick access to operating modes, let you add and subtract panes in the view (like folders, Queues, and camera data), and invoke interactive tools like those used for cropping, rotating, and zooming in on portions of the image in the work area.

See the four tabs above the Tool Stack? They separate the editing controls based on function and complexity. Most tools use sliders to set values; some also allow entering them from the keyboard and selecting from a drop-down list. The check boxes are used to turn on and off a tool or effect. The tabs also contain histogram readout, curves adjustment interface, and the Focus window. This is an extremely enlarged section which makes it easier to see adjustments as they are made.

Figure 14.9 shows the tabs in the Tool Stack using the default settings and adjustments from screen shots as I edited the picture of the Dom. Keep in mind that RAW editing in programs like Bibble Pro is a non-destructive process. You can experiment with settings and change the editing sequence to suit your style and the image at hand. With good exposures, there is little work to be done and the process is very quick.

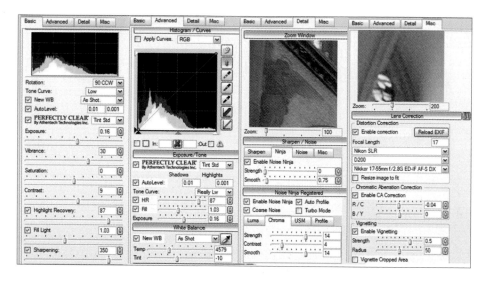

Figure 14.9 The panels of the Bibble Pro Tool Stack.

You can rearrange the order of items in the Tool Stack by picking up the name bar and moving it to a new location. Tools can also be "undocked" to use in free-standing mode. In short, users can design a custom interface to suit the way they like to work. Here's a quick run-down of the tabs:

- The **Basic tab** has all the tools needed to adjust most well-exposed files for controlling white balance, curve presets, and a general range of tools from exposure to highlight recovery and on to sharpening, allow simple adjustments with sliders. You can also turn on and off the Perfectly Clear technology, and enable the Auto Level function. Auto Level will adjust the image's levels in the histogram to make the best use of the available tonal range. (You can still fine-tune manually if you don't agree with the program's opinion.)

- As you might expect, the **Advanced tab** provides additional adjustments for (mostly) the same tools, sort of like the fine-tuning controls offered in a lower-level dialog box in some programs.

- The **Detail tab** has crop, rotate, spot healing, and advanced noise controls. There is a zoom window at the top of the list that lets you examine small portions of the image at 100 to 400 percent of actual size. Noise Ninja can be installed as a plug-in as well as a basic feature. If you purchase a full license of Ninja, you get a full set of options and camera/lens profiles right on this tab. (A full copy of Noise Ninja also gives you a stand-alone version and a matching Adobe Photoshop plug-in).

- You'll find the **Misc(ellaneous) tab** home to lens correction tools that reduce aberrations and vignetting, color management settings, and a dialog box that can set custom output resolutions.

I sometimes change the interface as the processing progresses through a job. You can close individual tools so they just show their title, as well as rearrange their order in the Stack, shift the location, and adjust the size of each pane. There are zoom windows and other aids that are opened as desired and closed when they get in the way.

Adjusting Exposure and Contrast

A good first step after setting the white balance is adjusting exposure and contrast. With an image needing a lot of adjustment in either the shadows or highlights, consider turning on the Perfectly Clear check box. Perfectly Clear is a technology originally developed for enhancing medical and scientific images. It is available via both the Basic and Advanced tabs in Bibble Pro. In many cases, it offers a quick way to tune a problem picture. If you don't like the result, simply disable it. I used Perfectly Clear in this initial edit (as shown in Figure 14.10), along with a half-stop increase in exposure and a boost in the Vibrance setting. The white balance was changed from As Shot to Sunny.

Figure 14.10 The original image (left) and the results of Perfectly Clear and a simple exposure increase in Bibble Pro.

Also notice the Auto Level and Tone Curve drop-down menus on both the Basic and Advanced tabs. They provide a quick first step when working on getting the most detail in the final print.

The new settings produced a warmer image (thanks to the new White Balance setting) and better detail (as a result of the increased exposure). Vibrance is a tool that boosts color intensity by using luminance. I use it often with skin tones instead of modifying the Saturation Control's settings, which often make colors look artificial. The modest boost in exposure opens up the shadows without losing detail in the stained glass. (Keep in mind that I am editing for a photographic print. Some of my observations may be lost in the conversion to the printed page.)

Note

Turning on Perfectly Clear invokes a series of automatic adjustments to the picture's exposure, contrast, and color. If an image needs a good bit of adjustment, it can be a good staring point. It also can be combined with manual settings. Sometime the results look a little too "processed" to me. I often click it on and off to consider the effect.

The basic adjustments so far are okay, but it's possible to do a lot more. It takes a bit of practice to get used to seeing the image in RAW editing terms if you are used to pixel editors and have never printed in a darkroom. The best way to learn is by using mages that are less than perfect and playing with the tools. I'll outline some of the tools I tried on this image during a five-minute session.

While working with this image I used both the Highlight Recovery and Fill Light sliders to tune the detail in the stained glass and shadows. The noise in the shadows was quite noticeable, so I used the Noise Ninja tools next, followed by sharpening.

Since the pictures were shot at the zoom's wide-open aperture and the widest focal length, there was also vignetting and some color fringing. I turned on the correction options in the Misc tab. That shifted the color, so the sliders in the Advanced tab's Color tool were tweaked to get the warm glow back.

For most pictures, the controls available in the Basic tab will offer all the adjustment tools. You can tune the white balance, tweak the exposure and contrast, add fill light (this boosts the exposure only in the darker areas of the image), and recover blown highlights (reducing exposure in the brighter areas). Working with one tool may shift values in another tonal range within the image, and a second modification may be needed to get things exactly the way you want. A little practice makes the process intuitive. The slider interface makes the process quick.

Figure 14.11 shows a portion of the original image to the left of an edited and cropped rendition. The mosaics that decorate the arches are clean and clear, thanks in part to Noise Ninja and to removing the blue color cast. Highlight and shadow recovery have revealed details in the stonework beneath the stained glass windows that were muddy to the point of obscurity in the original. The overall impression of the Dom's interior is light and open, compared to the dark and dank mood of the original lighting.

All of these corrections took less than four minutes, and the settings can be saved for use on pictures taken under similar conditions. My copy of Bibble Pro has a

Figure 14.11 Before and after enlargements showing the changes after editing.

library of settings with names that denote the lighting and exposure issue they correct. Once I had this image looking the way I wanted, I copied the settings and pasted them to another picture taken inside the Dom. This image had a slightly different exposure under similar lighting conditions.

> **Tip**
>
> It can be useful to copy some settings, even if they don't exactly match the needs of the target image. Let's say we want to make a set of 8x10 edits of several images. While the exact crop is not likely to be the same on all the files, the area is. So pasting the basic area saves steps; all we have to do is move the crop mask on the new file (another advantage of non-destructive editing).

The zoom window enlarges the area of an open file under the Zoom Cursor, which is a golden square outline that can be moved with the mouse. The selected area can be shown in magnifications ranging from the actual pixels to 400 percent. Figure 14.12 includes a zoomed view of a tiny portion of the center stained glass.

The close-up makes it easy to see noise in that specific area and the results of different Noise Ninja settings. I also used it to observe changes when turning on and off lens corrections and Perfectly Clear. Figure 14.12 shows the interface while working with the zoom window and Noise Ninja undocked.

Figure 14.12 Adjusting a second image using the zoom window with Noise Ninja and the Color tool.

Batch Processing and Power Output Options

As just mentioned, Bibble Pro makes it easy to tune an image and then map those settings to other files. This can be done on an individual basis, or to generate batch jobs that can output files for a variety of purposes at the same time. I usually use the Copy and Paste Settings function to adjust a similar set of files just before fine-tuning and cropping them individually.

Using the Copy and Paste Settings Feature

Quickly copying all the current settings is as easy as holding down the Control+C keys, then selecting the desired target files and pasting the settings using the Control+V combination. You can also choose to copy selected settings. That lets you eliminate settings like crop or rotation that you may not want to apply to the other picture. The entire range of Copy and Paste commands is available on the Edit menu. Figure 14.13 shows the Copy Selected Settings dialog box open in the work area over the image.

As you can see in Figure 14.13, Bibble Pro lets you save and apply all or just some of the settings and use them to process similar images. We save settings for a "master image" in each folder. If there are major variations due to lighting or exposure conditions in that file, we save more than one. Each is given a name that explains its use (the reception with sodium overhead lighting, fill flash outdoors, etc.). Then we can reuse the settings as needed.

Figure 14.13 Copying and pasting selected tool settings is a real time-saver when editing weddings or any job with a lot of images that need similar corrections.

That simple copy and paste approach is a great time saver, but only hints at the real power of using batch with Bibble Pro's Queues and Batch features. We adjust a representative file (sometimes more) for each subdirectory created during the DAM portion of the workflow, and then use batch processing to do all the repetitive chores: image adjustments, basic cropping, renaming, resizing, and producing all the output needed for proofs, slideshows, albums and print orders. Here's how…

Mind the Queue: True Workflow Automation

"Mind the queue" is a British phrase used to (sometimes politely) tell someone there is a line and not to simply cut in front. In Bibble Pro, Queues are powerful processing tools that let us group files using tags, simple selection, or even another Queue. Files in Queues can be manipulated using batch processing. Before showing how we use Batch commands to automate almost all of our processing and back-up chores, we need to explain Bibble Pro's Queue features. Let's start by explaining what Queues are, and how they are used. Then we can see how they are set up and their practical applications in wedding workflow.

There are two basic types of Queues in Bibble Pro. *Work Queues* are virtual holding locations. Placing a file in one does not move it or perform any actions. It's sort of like getting your name on a seating list when you enter a restaurant. It's a way to group files easily, no matter their location or relationship. *Batch Queues* are sort of like when your name is called to be seated by the restaurant's hostess. They are actually a series of pre-set actions that are carried out when files are added to them.

Work Queues can be combined with the DAM directories, created in the previous chapter, to make a matrix structure of "dual sorts" of images by where they are in the timeline of the event (handy for album and slideshow design) and workflow/product orders (album images and prints for the wedding couple of the mother of the bride). During the first editing pass, images are grouped to allow easy tagging and then processing using the saved settings we just discussed.

On the second pass, each image is inspected, modified as needed, cropped and placed into the appropriate Work Queue's final output and back-up. The Queues can be given names that denote the planned use of the content. For example, any images to be output for later editing in Photoshop or LightZone can be placed in a Work Queue called something like "Retouching." A set labeled "5x7 and 8x10" might contain copies of the same file, if that image is to be printed in both sizes. I use that system to place the output files into separate folders for transmittal to the lab. It saves a lot of time (and possible confusion) when uploading a job.

Once all the files are adjusted and placed in Work Queues, the Work Queues are sent to the Batch Queues that will actually create (and number) the output files and place them in new folders as needed.

Bibble Pro's Default Queues

The program offers a set of default queues that can be added to or modified easily. It's easy to make new Queues, and even combine their functions. Here is the run down of pre-defined Queues contained in tabs in the Folder View Panel:

- **Work Queues:** *Hold, Keepers,* and *To Process.* Placing files in these queues just adds them to the virtual folder for later action. Work Queues can be used to organize images that are stored in different directories (even if they have the same file names). A Work Queue enables you to view, edit, and process images from these directories simultaneously. You can create a Work Queue, associate a hot key with the Queue, and then select images and add them to the Work Queue by pressing the hot key on your keyboard. This is an easy way to arrange and tag images for processing, printing, or file output.

- **Batch Queues:** *16-Bit TIFF, 8-Bit TIFF, Download, JPEG Full, JPEG Proof,* and *Web Gallery.* Files or folders placed in these Queues are processed immediately using the current settings (we cover how to set up Queues next). The TIFF and JPEG Queues are set up to quickly output files in those formats. The Web Gallery option creates a complete set of files for web display (HTML pages, full-size, and thumbnails) and can resize and rename the new files automatically.

- **Print Queues:** *5x7 (2), 8x10,* are used to send output directly to a printer and can create picture packages with several images of different sizes on the same sheet (depending on the page size).

Custom Queues and Multitasking

Now that we have cropped and placed our images into Work Queues, we can let Bibble Pro's Batch features do all the work of renaming and generating the files, creating web galleries, and making back-ups. Our workflow calls for TIFFs of four- and five-star images for retouching, and two sets of JPEGs for all images for slideshows and web galleries. We use specific renaming conventions so we can tell the variations apart, and each set is placed in separate folders. There is also a back-up made of the master files and an EXIF data report generated.

That may sound like a lot of work. Thanks to Work Queues and Bibble Pro's ability to combine and run batch jobs together, there is very little to do at this point but tell Bibble to get started. Figure 14.14 shows the dialog box that was used to create the master Batch Queue. Notice the five tabs at the top of the right hand column of the dialog box (with the tabs labeled File, File, Gallery, Copy, and EXIF). Each tab indicates a separate job with its own set of output options, which will be run on all the files in any directory or Work Queue sent to this batch. Available output options include the file naming format, file type, output directory, and image size settings.

All you have to do to add a new tab (think, job title) to a Batch Queue is click on the little box with the arrows in the upper right-hand corner of the dialog box. This opens the drop-down menu shown in Figure 14.14. Then choose the type of job you want to run, and a new tab is added. Click on the tab and you can set the options.

Figure 14.14 Batch processing lets us combine jobs. Here a single batch includes TIFF output for retouching, JPEGs for a slideshow, a complete web gallery including images and HTML pages, a back-up set, and an EXIF file for use in a DAM database.

Our master Batch Queue has at least one of each of Bibble's types of four types of Batch tab. Let's look at each and see what they do, and then explore some of the advanced features available in Bibble Pro's batch processing technology.

File Tabs

The first two tabs shown in Figure 14.14 are labeled File. In our workflow, each produces a different JPEG file. The one open in the figure is used for our proofing slideshows. Each File tab can have its own output options that will control the file type, naming conventions, image size, and destination directories. For example, a single Batch Queue with multiple File tabs can create a full-size final output file in TIFF format and JPEG proofs in the same processing pass.

We have two tabs in one complete batch that do just that. The high-resolution TIFF is for retouching in LightZone or Photoshop, and the smaller JPEG is used for proofs. We have a separate Batch Queue that outputs just JPEGS for files that don't get retouching. The JPEGs are renumbered with a file name that includes the resolution and all are placed in new directories under the master wedding folder name to show the purpose of the files (like Web Proof or Retouch).

Gallery Tabs

The Gallery Batch produces a complete web gallery with both full-size and thumbnail JPEGs and all the necessary HTML, CSS, and JavaScript files to display and navigate them on the web. The number of pages will vary based on the number of images being processed. The standard thumbnail layouts include columns, single row, and grids. If you do edit the files, make back-ups in another location. Every time the Gallery Batch Queue is run, the existing files are overwritten. Figure 14.15 below shows the Gallery Setup dialog box.

They have both mouse and keyboard navigation features and can display either the IPTC Image Name and Caption (if defined) or the regular file name. It is also possible to show the basic EXIF shooting information at the bottom of the page when the full-sized image is presented in its own window.

One feature we find especially useful is the ability to set the full-size and thumbnail images' resolution to set values based on the largest side's dimension. We use it to create images both for the web and slideshow file sets.

Figure 14.15 The Gallery tab dialog box lets you customize the way the generated web pages and related images will look and operate.

Copy Tabs

Copy Batches can be used to automate making back-up copies of the source files or (if the Delete after Copy option is selected) moving files. We use this as part of the master batch process to create our duplicate files.

EXIF Tabs

Those photographers who are really interested in tracking the details of their shooting style and image details can use the EXIF commands to create a text file containing the exported EXIF data for processed files.

What's in a Name?

We use Bibble Pro's ability to both rename and place files in new locations during our batch processing. The new locations are named to make it easy to match the right set of files to their role in the workflow and to client orders.

The files are labeled with appropriate elements that serve much the same purpose. It can be confusing to have several JPEGs with the same name, even if they are in different locations. Bibble has renaming features that rival advanced DAM programs. Here's a brief rundown.

Bibble's Basic Naming Formats

The program uses a combination of macros and user-defined data strings to create new names as files are generated. We won't go into all the possibilities; that's better served by the program's documentation. The user can use a default macro or build a custom one in the renaming options for the Batch tab. You can also save the naming convention to use in the future. An example should make the process clear.

Let's say we are outputting a batch job that makes both TIFF and JPEG versions of a Nikon RAW file named _DSC1212.nef. We want the copies to have the same name as the standard .tif and .jpg extensions. Bibble uses macros enclosed in square brackets for this task:

[oname][ext] where [oname] is original name and [ext] is file extension. The resulting two files will be _DSC1212.tif and _DSC1212.jpg. If we wanted to add the last name of a couple named Smith to each file, all we have to do is add the name as text. So Smith [oname][ext] will produce Smith _DSC1212.tif.

Variable Sequences

Fixed-entry macros and text are okay for basic tasks, but Bibble offers something better: job name and sequence variables. These prompt you for the job name and a counting sequence for the job as the process starts. That makes it possible to use one Batch Queue to process images for several jobs simultaneously.

For example, suppose you are processing images for the following two jobs: *Smith Wedding* and *Doe Wedding*. You can use these renaming variables to process images for both jobs: [jobname][jobseq][ext]. As the batch starts to run, the program prompts for a job name. The [jobseq] number is a counter that counts the processed images associated with the job name, starting with the number 0.

There is a whole page of variables in the Bibble Pro manual for use in renaming files. We use several and have them named by task. We also use variables to denote the lab used for a job, as well as the client or order number. It all depends on what works best to keep the workflow well organized.

Print Queues

Photographers who send their work to outside labs, or use additional software to retouch files generated by a RAW processor, may never use the Print Queue feature. Those who do print directly will love it. Just as with Batch Queues, they let you automate your output workflow and still maintain control. The basic settings let you name and manage the printer that will handle the job, the print size, etc.

The program also lets us specify layouts with combinations of multiple prints of the same or multiple images. Figure 14.16 shows the Print Queue dialog box being configured to process a series of 5x7 prints.

- **Custom:** Defines custom print layouts that include page layout templates for images of any size you specify.

- **Fixed Size:** Defines print layouts for images of standard print sizes such as 3x5, 4x6, 5x7, 8x10, or any custom proportion.

- **N-up:** Defines a table-style layout for images where you specify the number of rows and columns (and the spacing between images).

- **Contact Sheet:** Defines a table-style layout for images that includes text fields for captions

Figure 14.16 Print Queues can be used to simply send jobs to the printer or to create and use custom layouts to produce sophisticated print packages.

Next Up

Now that we have the majority of our images processed, it's time to turn our attention to those worthy of special attention and detailed retouching. Using tools like LightZone and Photoshop, we'll clean up the fine points and add crowd-pleasers like black-and-white conversions and split-toning to our product line for extra profits.

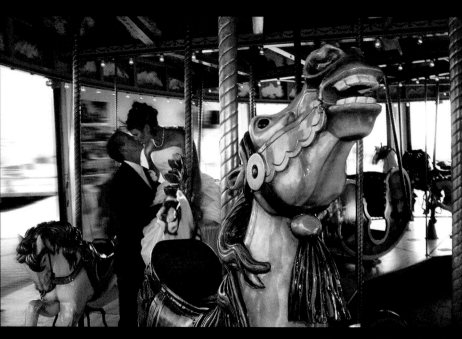

15

Crafting the Image

There are two points in covering a wedding that really get my creative juices flowing: shooting the pictures, and then working with the best images to make the finished print match my vision at the moment of exposure. The processing done, now we turn out attention to the pictures that warrant special attention.

Polishing a picture is an iterative process. We analyze the image and add impact by adjusting its visual elements. We may tune relative contrast and exposure, crop, sharpen, blur, and tweak color. We can also add special effects, like toning or partial black-and-white conversion. We look closely for flaws and distractions, pruning unwanted elements and making cosmetic corrections.

There are two primary tools our studio uses in this phase of our workflow, LightZone and Photoshop. I can hear some readers thinking, "More software?" Yes. There were days when we just used Photoshop for everything from processing to album production. Adding new software tools to our production has improved both the quality of our product and the turn-around time.

The goal of this chapter is not to covert readers to a specific program or method. It's designed to introduce new skills and share useful techniques. Workflow and editing develops just like artistic style. As photographers, we are always looking for new ways to engage our viewers and satisfy out clients.

It's also a business necessity. Experimenting with new software is just as much a part of digital photography as buying a new lens. Professional results require professional tools, and that target is moving. As point-and-shoot cameras offer more megapixels and ship with easy editing tools, we professionals have to add real value and hone our edge to continue to charge profitable—yet affordable—prices. New tools that improve productivity and let us add value to our products are worth the investment.

We are going to start this chapter with LightZone, an incredibly fast and intuitive photo editor. It's easy to learn and offers the same kind of control we enjoyed in the darkroom when making enlargements—the ability to easily see and adjust the relationships in tone, contrast, and exposure in the picture to draw the viewer's eye and focus the attention.

I'll use LightZone to show you how we analyze and tune images for visual impact. Some of the techniques are adapted from traditional darkroom enlarging skills. Then we turn to the venerable Photoshop (and some add-on products) to do what they do best, detailed retouching at the pixel level. Both programs are available in trial versions, if you want to follow along with the examples using your own images.

Note

This chapter assumes the reader has a basic knowledge of digital editing, common tools (like Sharpen and Gaussian Blur), and basic terms. Rather than a detailed step-by-step guide, it shares a look into how one studio uses advanced editing to fine-tune selected images as part of a complete workflow.

LightZone: Total Tonal Control

LightZone provides a really unique set of editing tools, ones that let us work on the picture, not the pixels. Instead of curves and levels found in other editors, LightZone lets us visually manipulate exposure and contrast directly as tonal values, correlated directly to a grayscale.

It's easiest to understand with an example. Figure 15.1 shows a picture open in LightZone and the ZoneFinder (top) and the ZoneMapper (bottom) tools in the pane to the right. I'm going to start by introducing LightZone's primary concepts and tools, and then use them with several images to show both how the program works, and how we use it to analyze and polish our images.

Mapping Exposure and Contrast

The ZoneFinder and ZoneMapper are the heart of LightZone's powerful and novel approach to image editing. Based on the well-known Zone System developed by Ansel Adams and Frank Meyers, they provide a systematic method for visualizing and controlling the tonal range and contrast of a photograph.

The ZoneFinder is an "interactive grayscale image analyzer." This is an incredibly powerful tool. It's like having an advanced densitometer in a darkroom—without having to learn any sensitometry. All of the power and none of the math! Moving

Figure 15.1 Together the ZoneMapper and ZoneFinder tools (located to the right of the image being edited) offer exceptional control over an image's tonal range and exposure.

the mouse cursor over a segment of the ZoneMapper's right grayscale turns the corresponding area of the ZoneFinder image (in that 1/2-stop range) yellow, as shown in Figure 15.1.

Notice the two vertical grayscales on the ZoneMapper, a narrow reference scale (left), and a wider active scale (right). Each contains 16 steps or segments. Each step represents 1/2 Exposure Value (equals 1/2 f/stop difference) from the one above or below it. Together these tools provide precise control over an eight f/stop range, covering the effective dynamic range of any digital image device (cameras and scanners), and they are well matched to the tonal range of output devices like monitors, printers, and projectors.

The ZoneMapper does more than just reveal tonal contours in an image. ZoneMapper and ZoneFinder work hand in hand to analyze and fine-tune exposure and contrast. The grayscale is a traditional photographic tool used to represent the range of tones and their relationship within an image. It is a much more intuitive and visual approach than a dialog box and has an 8-bit range of numbers from zero to 255. With the ZoneMapper you can adjust the tonal range of all or a portion of the image visually—no curves, no levels, no numbers. The actual tonal range of the image is displayed on the image as you work.

The grayscale on the right side of the ZoneMapper can be adjusted using the handles (called locks) shown by the little box with the X inside. Placing three locks lets us limit the changes to just a portion of the tonal range. Pull the handle down, and the tones in that section in the picture get darker, pull up and they get lighter. As zone segments are compressed, the contrast in those tones is reduced. Expand the segments, and the contrast increases.

Every file opened in LightZone is imported into a 16-bit linear editing space, taking maximum advantage of the program's advanced features. Digital cameras and scanners record images in a linear form, but that's not the way most bit-map editing programs work with images. A non-linear approach limits the tonal range available in the darker portions of an image and increases the risk of posterization and artifacts when adjusting exposure and contrast. Figure 15.2 shows why it does this and how linear mapping works more effectively for working with digital images.

Computer graphics use numbers to denote the number of shades that can be represented between total black and pure white. The total number in the range depends on the bit space. Most DSLRs use a 12-bit sensor, with 4,096 steps in the resulting 12-bit color space. Sounds like a lot, since the eye can only discern about 256 shades of gray in an image. In a linear world, a 12-bit space for capture is enough to produce realistic images with good tonal range and color.

Figure 15.2 The advantage of working in a non-linear editing space—the tonal range is evenly distributed across the entire range. In a non-linear space the "clumping" of pixels in the highlights results in less detail in shadow areas.

The problem is the way the steps are distributed in non-linear style editing programs (read, most editing programs). They use half the total number—whatever it is—for the first f/stop in the range. Then the second stop uses half of what's left; and the next, half of the remainder, and so on. For DSLRs, that means eight stops down there are a paltry 16 bits left to show detail in the shadows.

LightZone maps an image into a linear space—just like your camera's sensor—so the numbers are evenly spread out over the entire dynamic range of the image (within the limits of the quality of the original file). Thus when you use a ZoneMapper, you have the ability to make finer levels of correction in the darker tone ranges; and the dynamic range is reset with a fresh scale when you place a new tool on the stack, reallocating the available space to accommodate the new tool. This ensures that LightZone's editing power and response remains consistent throughout an entire session.

Local Control with Regions

Unlike Photoshop, LightZone doesn't offer any tools for picking out individual pixels. Instead, LightZone's Regions use the same sophisticated shape technology found in advanced draw programs to create interactive outlines around an image; those areas (Regions) restrict the effect of a tool to the desired area. Each click of the mouse over the image sets a control point (the white dots around the Regions outline), and LightZone draws lines between each pair, forming the Region's outer boundary. You can add new points, delete existing ones, drag, and stretch or compress the Region's shape, and use the active tool's slider to vary the intensity of the effect.

An inner zone, the Feather Area, bordered with a second line, matches the Region's outline, smoothly blending the effect from 100 percent to 0 percent. You can adjust the size of the Feather Area at any time. Figure 15.2 shows a Region with an extreme color cast to make it easy to see both the outline and the Feather Area.

Regions and the ZoneMapper can be combined to obtain very precise exposure and contrast adjustments. We'll see that shortly. Regions can be used with all of LightZone's tools, and you can reverse the area and the Feather effect to work on the entire image except the inner circle.

LightZone offers an array of other editing and image enhancement tools (like the ToneMapper, Sharpening, and Blurring, Blends, and Noise Reduction) as well as batch-processing capability. I'll introduce them after showing you the program's user interface.

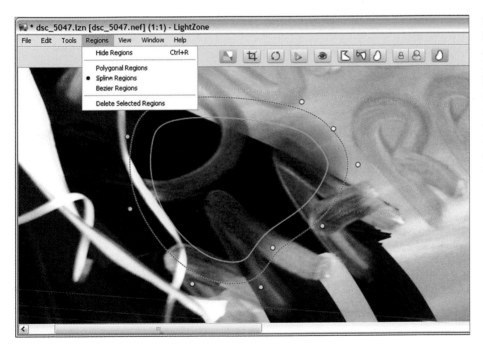

Figure 15.3 Regions are interactive vector masks that contain the effects of LightZone tools. The blue area in the picture shows the center of the Region. The effects of a tool are feathered between the two white lines that outline the Region's area. The white dots are the control points that are dragged to shape the outline.

Some Interface Basics

LightZone's offers three operating modes: Standard, Browser, and Editor. The Browser mode is used to locate and sort files; we won't use it in this session. The Standard view (shown in Figure 15.3), provides immediate access to all areas of the program. The upper left-hand pane contains a Browser for navigating to all available local and network drives and directories. The lower left pane has sections that provide all the available metadata for the currently selected image.

The center of the interface also has two panes. The top section is a combination preview and editing area. Thumbnails of the images in the currently selected directory are displayed in the lower pane. Selecting a single thumbnail displays a larger version of the image in the upper section. If you select more than one image, they all preview in the upper area. Double-clicking on an image loads it into the editing workspace.

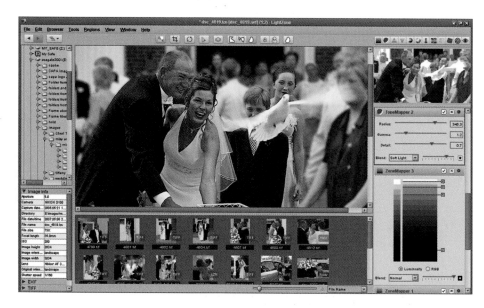

Figure 15.4 LightZone user interface in Standard view. The Tool Stack is on the right of the editing area.

The right-most panel in all modes is the domain of the Tool Stack The top portion contains one of three Image Information tools: a ZoneMapper, a Histogram, or a Sampler. Right-click on the currently displayed tool, and you get a popup menu, allowing you to specify which one of the three to display. The lower portion of the Tool Stack holds the actual editing tools.

When a tool is first used, it is placed at the top of the Stack, and its settings are applied to the open image. Each one is, in effect, a new adjustment layer.

Adjustments change the image in real time. No OK buttons, no need to fill in nested dialog boxes or calculate settings. Almost all tools work directly with slider bars. You can change a tool's position in the Stack order by dragging it up or down by its title bar. Tool effects are applied from the bottom of the Stack upward.

All the tools are available via icons placed in bars located above the panes, via the Tool menu, and with hot keys. Figure 15.5 shows all three

Figure 15.5 LightZone toolbars.

toolbars. The Browser tools (the left-most set) are similar to the ones we use for navigating our computer storage and the Internet.

The second set is located above the center pane, containing icons that enlarge and reduce the selected image, rotate and crop it, and the Regions icon, for masking sections of the image for corrections. We can also toggle modes to see the edited and unedited versions of the image and show and hide the masked areas (Regions). Rather than picking out sets of pixels, LightZone lets us simply draw a shape around the areas to be focused on or excluded. Tool effects can be limited to the area within a Region or set to affect all the image outside the Region.

The third row of buttons (located on the top of the right pane) hosts the primary image adjustment tools. Clicking on a tool adds a new dialog box to the Tool Stack and creates a new adjustment layer. As we said, LightZone calculates tool effects from the bottom of the stack up. A check box turns a tool on and off, letting you see the effect or create alternate versions.

Dragging a tool by its title bar to a new location in the Stack changes the processing order. That can be very handy if you want to experiment with early sharpening (a task normally left for last) or add noise reduction after all of the editing is done. Not to worry, just move the tool. Now that we have the basics of the interface introduced, its time to load an image and do some editing.

Basic Image Editing with the LightZone System

Before delving into a full-fledged editing session, let's start with a simple example so you can see how the tools operate. Then we can get fancy.

Our first picture was taken during the formal portrait session following a wedding. See Figure 15.6. There are several things that need attention, just because of the conditions at the time. The scene was in open shade in mid-afternoon, with fill-flash, so there is a bit of a cold cast. Hand-holding the camera and working fast to arrange the group (there were over 25 people involved in the various formals) produced an image that isn't exactly straight. The Crop and Rotate tools (the second and third icons on the toolbar over the Editing window) have been added to the top of the Tool Stack.

Notice how the Crop and Rotate icons are blue, showing they are active, just like the Preview button on the very left. Once we have made the corrections, I'll click the icons and hide them to make the Stack smaller. The grid over the image makes it easier to get things straight, using either the sliders on the Rotate tool or an interactive angle cursor directly on the image in the window.

The next steps in the process involved the ZoneMapper and ZoneFinder. The overall appearance was fine, the pose fun, and the expressions happy. We want a good tonal range, with slightly warm colors to produce pleasing skin tones, clean

Figure 15.6 Cropping the picture.

whites, and a rich black in the groom's jacket. Add a little careful contrast rather than sharpening to keep the ladies' skin looking soft, and you have the basic formula for a pleased client.

With pixel editors, determining the darkest and lightest points in the image is a guessing game. We name a value somewhere in the 0-255 range to keep the whites and blacks from blowing out and losing all detail. LightZone's ZoneFinder shows us exactly where the points are, so we can adjust the ZoneMapper to set the values.

Fixing the black point was the first step. Placing the ZoneMapper over the lower portion of the scale, I watched to see when the tux turned yellow in the ZoneFinder image. A click of the mouse placed a lock (think handle) there. That was used to pull the zone down to extend the range in that portion of the scale.

Adjusting the locks in the upper region (again using the ZoneFinder to see the target and watching the Editor window to see the real-time results) made quick work of opening up the faces and getting a nice sheen on the groom's vest, without losing detail in the flowers the ladies held.

A few adjustments with the White Balance tool warmed up the scene. The reference point here was the sunny area in the back of the picture on the right. That canceled the blue of the shade, but left a little bit of green cast from the surroundings. A nudge of the slider while keeping an eye on the white shirt and the flowers was the guide.

The final step was a adding a ToneMapper. See Figure 15.7. This tool adjusts contrast in a way that mimics human vision, balancing overall contrast, while increasing it in the "softer" areas of the image. The three sliders let you fine-tune the effect automatically generated at first by ToneMapper. The fine control over both global and local contrast makes it much easier to put in a bit of "snap," without blocking up the darker regions or blowing out the highlights.

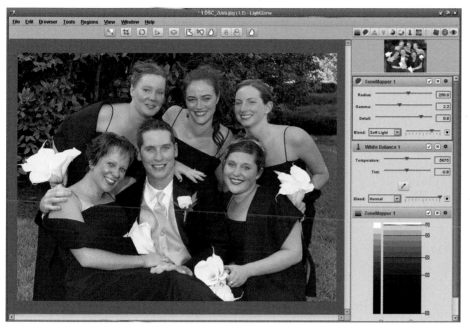

Figure 15.7 The finished image.

Adding Impact and Bringing Out the Details

Now that we have the interface introductions aside, we can get into a serious editing session with two pictures. The first was used as the final image in an album. It was shot just before the couple left the wedding as they sat in the "decorated" car. Figure 15.8 shows a marked-up copy of the original, unedited picture detailing the areas that will get special attention.

We are going to use Regions to fix specific areas. With a little practice, LightZone becomes very intuitive. That is especially true if you have ever done any darkroom printing; Regions work just like dodging and burning.

The picture was taken during the late afternoon in the shade of the church, producing a slightly warm color balance and low contrast. The depth of field from the wide-angle lens and small f/stop rendered the entire scene in focus. Part of the dark appearance of the RAW image is due to the normal sensor filtering. LightZone has custom tools that are added automatically when a supported RAW image is loaded into the program.

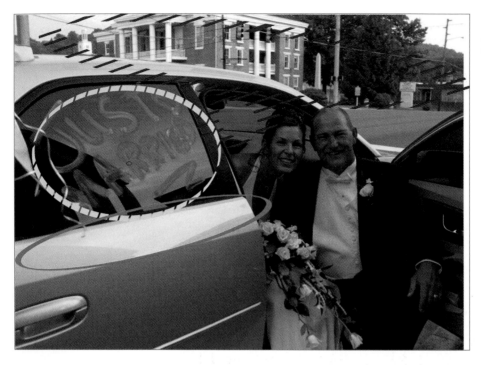

The automatic processing improved the contrast and lightened the picture, but not enough to suit us. We added a ToneMapper and then examined the result. Some judicious dodging and burning, along with adjusting the sharpness of different Regions will help draw the viewer's attention to the primary focus. Here is a run-down of the planned adjustments (over and above the normal processing), referencing the color outlines shown in Figure 15.8.

- There are two focus points in the picture, the newly married couple and the words "Just Married" soaped onto the passenger window by friends. We'll use LightZone's ability to adjust the relative brightness and contrast of specific sections of the tonal curve, and then limit the areas with Regions to make these two areas more prominent in the composition.

- The yellow circle outlines where we can brighten just the white color of the words Just Married, without lightening the underlying tinted area. The color will be modified to a warmer cast and accentuate the reflection of the late afternoon sky.

- The background is nice and sharp—too sharp. Adding a Gaussian Blur will diffuse its appearance and reduce the distraction of the buildings across the street. We'll balance the view through the windshield the same way to produce a matching effect.

- The reflection of the roofline and sky in the accent panel underneath the rear window on the side car will be given an even color and sheen.

- We want to slightly burn (darken) the outside portions of the picture and lighten the bride and groom a bit to make the couple the center of attention.

Adjusting the Exposure and Blurring the Background

Figure 15.9 shows two tools expanded in the Tool Stack on the right and a closer view of the image being edited. The ZoneMapper on the bottom boosts the overall exposure. I have set three Zone locks. The one on the bottom is pulled down to set the black point, using the technique mentioned earlier. The slight lift at the top lightens the mid-range, and the very top lock limits the shift in the lightest values to hold detail in the whitest objects in the scene.

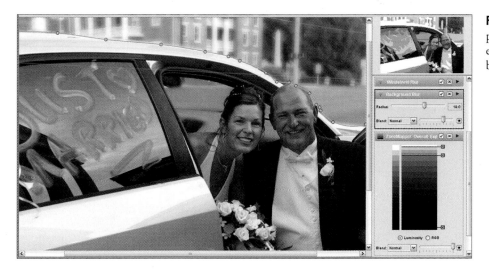

Figure 15.9 The work in progress with the overall exposure correction and the background blurred.

The Gaussian Blur tool located above the ZoneMapper in the Tool Stack is controlled by a Region that limits its effect to the area behind the car. You can see the outline of the Region as a series of dots on a line running along the top of the car and around the top of the groom's head. The Feather Area has been pulled right on top of the outline, since we don't need or want to feather this Region.

See how the title bar (with the name) on the Gaussian Blur tool is blue and the all the other tools are gray? That indicates it is the currently selected tool. At the bottom of the tool are a drop-down menu, a slider, and a little box with a dot in the center. The drop-down menu offers a selection of 14 Blend modes that can be used to create different effects.

The slider is used to adjust the intensity of the tool's effect. Clicking on the box to its right toggles the area controlled by any Region linked to that tool. In this case, the area inside the line is active; if we clicked the box, the background would become clear and the rest of the picture would be blurred.

Each tool opens with a title bar bearing its proper name. Double-clicking on the name within the bar makes the name editable, so the user can assign meaningful names. Here I have named most of them to explain what they do or the area of the region they manipulate.

Opening Up the window

It's amazing how easy it is to select and make the words "Just Married" stand out, and then manipulate the color in the reflection. The masking would have been very complicated if we had had to pick out pixels; instead, a single Region was drawn over the major portion of the window with a slight feather. See Figure 15.10.

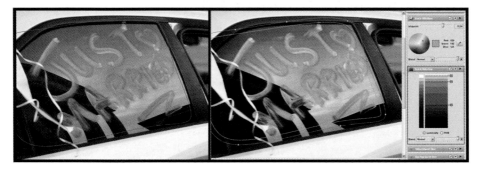

Figure 15.10 Before and after versions of the back window with the Tool Stack.

LightZone can copy and paste a Region for use in multiple tools. You can choose a simple Copy and Paste or Copy Linked. That's what I did here. Adjusting the outline feather of a linked copy will ripple the edits on every copy. Unlinked Regions can be independently adjusted.

Working with Regions

When setting up a Region, first choose or add the desired tool to the Stack, then click on the appropriate Region Type button as shown in Figure 15.9. Visualize the basic shape of the Region and place the cursor at the point where you want to start, and then click to place the first control point. Don't worry about getting an exact fit when placing control points. One of the great things about Regions is how easy they are to adjust and modify. All you need is an approximate outline.

The Adjustment Cursor lets you add or remove control points and move them to change the Region's shape. Move the cursor to another point and click again. (A line will pull from the first point, following the cursor). Now each click will set the line and add another point. Repeat the process until you draw the desired shape, then double-click to set the final point and enclose the Region.

Dragging the inner line adjusts the width of the Feather Area. Deleting control points is done using a context-sensitive menu obtained by right-clicking on the Region's boundary line. Pressing the Escape key cancels the Create Region command.

You can create multiple Regions for a single tool, but they will all perform exactly the same operations (whatever the tool actions perform) because they reside on the same layer in the Stack. This feature makes quick work of making uniform adjustments to several areas on an image. The following list provides a summary of working with LightZone Regions:

- To select an existing Region, double-click on its outline (the outer line will be visible when a tool with the Region is active and the Show/Hide button is set to Show Regions).

- Adjust the shape of a Region by dragging a control point to a new location; the outline will adjust based on the type of Region (for example, a polygon line will always be a straight line between two control points, but can change angle and length).

- To increase or decrease the Feather Area, drag on the inner line. The closer the lines, the faster the Feather effect takes place. Bringing the lines together forces a sharp transition.

- Click on the outer line to add a control point.

- Right-click on the outer line and use the pop-up menu to delete a control point.

- Use the Escape key to cancel placing a Region while setting points on an image.

- Use the Edit menu to delete, cut, copy, and paste Regions between tools.

- Use the Edit menu's Paste Linked command to share a Region with two or more tools. This method sets the properties so that changing the shape, Feather Area, etc., on one tool will change it on all the layers.

- Invert the Masking effect of a Region by selecting the Region, then clicking the Invert Mask box, and using the Blend and Slider to modify the type of effect and Opacity, as shown in Figure 15.10.

- Adjust the intensity of the effect by using the Opacity slider and/or changing the Blend mode of the tool associated with a Region.

Two tools were used, a ZoneMapper and Color Balance. Both were named Back Window. The icons make it easy to tell which is which when they are collapsed to show just their title bars. The ZoneMapper was used to lighten the letters and increase the contrast, while the Color Balance slightly spread the appearance of the late afternoon sky.

Clicking a point on the Color Balance wheel sets the color, and the midpoint slider just under the title bar determines where in the tonal range (think grayscales, again) where the effect will be strongest. The best way to understand how this works is to experiment. The Color Balance tool is mostly used to correct any color cast. As you can see, there is also an eye-dropper tool for selecting and setting points. Here we actually used it to enhance a color cast.

Once the window was adjusted, a new ZoneMapper was added and a Region drawn around the unwanted reflection in the metal just below the words "Just Married." A quick pull on a couple of Zone locks tamed the glare.

Note

While the number of tools and Regions may look like this session took a while, in reality the entire process was under five minutes (not counting the time to make the marked-up copy and screen shots for the book.)

Time to Burn

The Region placed with the open ZoneMapper centered over the couple in Figure 15.11 is inverted. See the blacked-out appearance of the little box in the tool's lower-right corner? The Zone locks are coupled with a wide feathering area to make the couple slightly lighter and a bit more contrasty than the rest of the image, without losing detail in the highlights or the groom's tuxedo. Notice that the Region extends outside the actual image area. This is an approach I use all the time in LightZone.

Some smaller regions were placed to fine-tune the darkening effect. Once they were all in place, another overall assessment was in order. The shape of the region in 15.10 made the left side of the "Just Married" letters darker than I wanted. Easy to fix in LightZone. It just required revisiting the tools used to adjust them and increasing the settings a bit. I could have also experimented with an additional Region. Once that was done, a Sharpening tool was added to the Stack and a TIFF file exported for retouching in Photoshop. The entire process took less than five minutes. Just the masking would have taken that long in a pixel-based editor. Figure 15.12 shows the finished version.

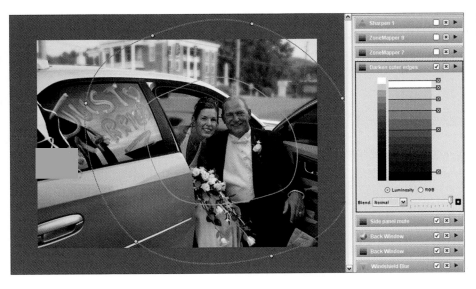

Figure 15.11 Fine-tuning with a Regional approach.

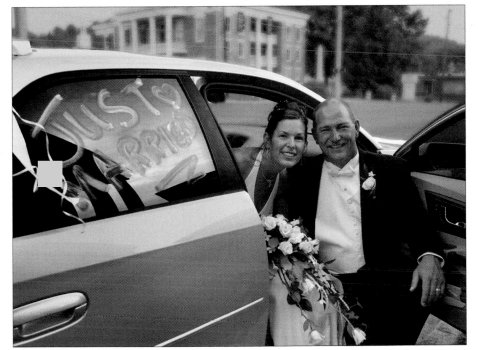

Figure 15.12 The final LightZone version.

Just a Splash of Color

Black-and-white prints are a popular wedding-market product, especially for portraits of the bride and the wedding couple. Many of our clients like to use black-and-white images as an insert on the cover of their wedding album. Variations and special effects can increase their appeal and showcase a photographer's creativity. We'll continue exploring LightZone and use it to transform a simple bridal study into an accented portrait, shown in Figure 15.13.

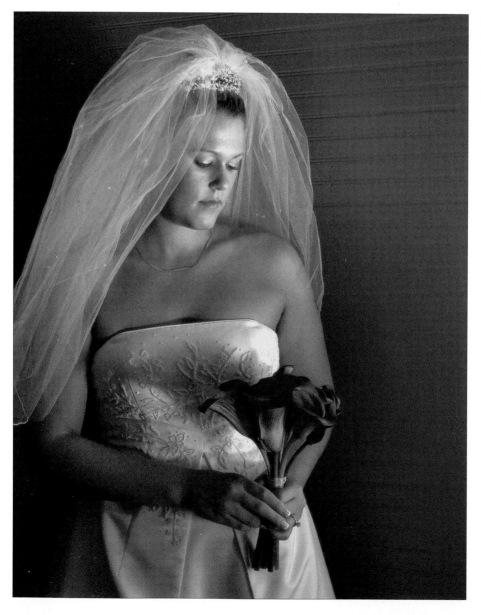

Figure 15.13 This black-and-white portrait, leaving the bouquet in color, was used as the signature image for the wedding's slideshow and proof book.

Setting the Scene

The ceremony took place in a state park in Florida that is a popular wedding location. The women started getting ready at 9 AM, using the rooms in the gardener's cottage near the reflecting pool that was near the site of the actual ceremony. This quick bridal study was taken just after the bride had dressed. The set was a small hallway next to a large window that was flooding the room with early morning light.

A single round white reflector was used as a key light to focus a bit more light on the bride's face and veil. An incident-light meter gave a reading of f/4.5 at an 80th of a second, which was the exposure used with a Nikkor 20-35mm zoom set to 28mm on a Nikon D100 camera, and captured in RAW format. The field of view is the same as a 40mm lens used with a 35mm camera.

The final result was always intended for a black-and-white or a toned print. During the editing, the bride's bouquet was masked to allow the colors to come through, producing the final design. Later, Photoshop was used to add text and the studio logo and the result became the DVD album cover. We'll share some tricks on that process later in the chapter.

The editing started using a ZoneMapper and adjusting the white and black points on the image in color, then applying a ToneMapper to hold more detail in the veil and the bodice of the wedding gown. ToneMappers work much like a contrast mask in film photography. It reduces the overall contrast slightly and boosts local contrast.

Don't expect to see massive changes in the appearance of the picture; the results are subtle. In this case the changes are slight and limited to the intended areas. LightZone's ToneMapper controls (shown over the image on the right side in Figure 15.14) have three sliders. The top adjusts the global contrast, the bottom one increases or decreases the local effects. The middle slider, as listed, adjusts the gamma.

The actual mask, rather than the effect, can be seen by setting the Blend mode (via the drop-down menu on the lower left of the dialog box) to Normal mode. (If you like the foggy effect, the Normal mode does work.) Most of the time a setting of Soft Light produces the best working result with ToneMappers. The quickest way to gain a working understanding of this tool is to use it on an image with several areas of strong contrast variations, like a darkened room with bright windows. Then shift to Normal blend and adjust the sliders.

In practice, I generally use the ToneMapper early in the editing cycle, then adjust the picture's exposure and contrast. Remember that you can shift the processing order of tools in LightZone by simply moving their position in the Tool Stack. I often adjust a previous tool to fine-tune the overall effect. It's as easy as moving a slider, since all tools are active unless disabled.

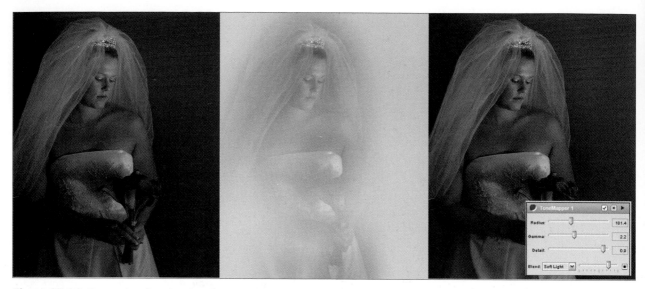

Figure 15.14 Recovering fine detail with a ToneMapper. The original image is on the left, the mask generated by the ToneMapper in the center, and the result on the right. The dialog box shows the settings.

Making the Change to Black and White

There are several ways to convert a digital color image into a grayscale rendition. Our favorite is to use a LightZone Channel Mixer with the blend set to Normal mode. Then the individual sliders are adjusted to tune the results. Each picture varies somewhat, based on the subject, the color balance, and type of lighting, and the desired effect.

The open image in Figure 15.15 has been converted using that method—after we masked the bride's bouquet and then reversed the effective area of the tool so it kept the color inside the Region. You can see the Region outline around the flowers.

> **Note**
>
> LightZone developers were in the process of revising the Chanel Mixer tool while this book was being written. The proposed changes may change the name of the tool and the interface, but not remove the basic functionality. The same techniques for applying toning effects and working with templates will be available in newer versions of the program.

Then we added both a ZoneMapper and a Hue Saturation tool with linked copies of the same Region. This time we set the effect to occur *inside* the Region. We wanted to boost the color and lighten the exposure to boost the color in relation to the black-and-white portions.

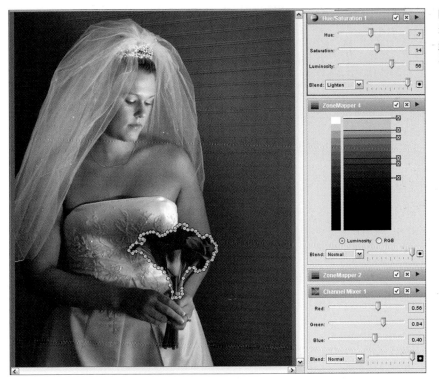

Figure 15.15 Masking the flowers and converting to grayscale with the Channel Mixer.

Each channel will shift both exposure and contrast, based on the relative amount of that color in the original image. Fine-tuning the conversion is a matter of moving the sliders for the best visual result. The bride's right arm is a bit dark. A ZoneMapper confined to that area with a Region was added, as well as a sharpening tool to perk up the detail.

Then Toning, Templates, and the Power of the Tool Stack

I've always enjoyed toning black-and-white images. With digital editing, it's now possible to simulate toning and replicate the appearance of almost any photographic paper ever made. Combine that with today's fancy inkjet surfaces, and you have something special to offer clients.

The versions of the image have been toned in Figure 15.16. The version on the left is a sepia and the one on the right a cold tone. Both effects were created using a LightZone Template. So far we have been crafting Tool Stacks manually, one tool at a time. A Template is a Tool Stack that has been saved, which can be loaded at any time from the File menu.

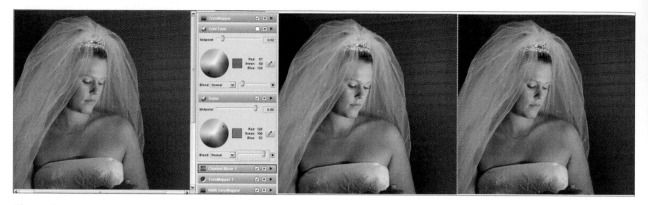

Figure 15.16 Sepia Toned image, the Toner Tool Stack, Cold Tone version, and the Split-Toned edition.

The six tools in the center of Figure 15.16 are the standard ones I like for toning. All I have to do to add them to an editing session is to open the File menu and use the Apply Template command. I have one saved called Sepia that is set just the way I want to create a sepia effect for a portrait. I used another, named Split-Tone. It adds a second Channel Mixer tool. A quick click on the menu and toning is done, save for a quick slider adjustment. The result, from a properly exposed image, can be hitting the printer in under a minute!

Here is what each of my Toner Template tools do:

- Sepia can make blown whites more noticeable, and may block up the shadows. A ZoneMapper is in place to tune the highlights and shadows. I start by setting the black point, and then tweak the highlights.

- The Channel Mixer performs the grayscale conversion. Tweaking each channel can improve the overall appearance of the image, especially when combined with the ZoneMapper and ZoneFinder.

- The first Color Balance tool (named Sepia) sits above the Channel Mixer. It is set to a deep coffee color, and the opacity slider at the bottom of the tool is used to adjust the amount of tone. The midpoint slider is normally set toward the right side so the sepia color affects the highlights

- The second Color Balance tool (named Cold Tone) sits above the first Channel Mixer. It is set to a deep blue color and the opacity slider is used to adjust the amount of tone. The midpoint slider is normally set towards the left side so the cold tone affects the shadows.

- The ToneMapper adds punch. With the default settings, a ToneMapper adds about the same boost as going up just about a paper grade using variable-contrast print paper in the darkroom.

All toning is done after the Channel Mixer conversion process. Either or both of the Color Balance tools can be made active to create sepia, cold, or split-tone effects. Sometimes I shift the midpoint or even pick a new color to vary the tone to suit the image. The cold (or blue) tone on the left has a richness in the blacks that the straight grayscale lacks. The sepia has a brown tone in the darkest areas. The split-tone version has a sepia effect, but gains from the blacker background imparted by the cold second tone.

The Art and Science of Retouching and Special Effects

We've reached the final stage of the editing process, taking care of the little things. The most common tasks involve removing the unwanted. The bride may have a pimple on her cheek; perhaps the groom has a bit of icing from the cake on his jacket. It could be a person who walked behind the couple with a funny expression, just as the shutter was pressed during a special moment.

We could also want to add something. It might be text, a logo tucked into the corner, or maybe a special effect that lies beyond the scope of the tools we have been using. The most popular professional retouching program is the venerable Adobe Photoshop.

If you don't need all of its graphics features (or want to pay the full $649 price), then Adobe Photoshop Elements may do the trick. It has the Healing Brush we'll be using and supports some third-party filters. There are also other pixel editors, like Corel Photo-Paint, on the market that are popular as retouching tools. We started with the first version of Photoshop on the Mac and have continued with it on the PC. Photoshop CS3 is what we will use here. It has a wide range of features, but our discussion will focus on retouching and some special effects. There are many heavy tomes on mastering Photoshop (David Busch's *Adobe Photoshop CS3 Photographers' Guide* from Course Technology, for example) if you want to continue exploring the program.

Basic retouching is more art than science. In some cases, the goal is obvious, like removing a wart on the nose. Many times, it is more a matter of looking at a picture to see things that will make the image look better by their absence. The simplest approach is to view the image against a plain background. Whenever possible, we set the operating system desktop and program background areas to a dark neutral gray. This not only eliminates visual distractions, but also aids in getting accurate color balance.

Cleaning Up the Car

Most of our retouching in Photoshop involves two tools, the Healing Brush and the Clone tool. There are similar tools in Photoshop Elements and other pixel editors. Bibble Pro and LightZone also have such tools, but they are not as precise and (as this is written) do not provide full support for pressure-sensitive tablets. Tablets like the Wacom Intuos 3 make precision pixel-level edits much easier and faster to perform. Before showing you the results on an editing session, here is a run-down of how the tools work and how we use them.

Both tools allow you to set the size of the tool. The wider the tool, the bigger the effective source and target area. When working on large regions with relatively even texture and lighting, a larger tool makes the work go faster. In areas with a lot of variations in any of those aspects, a small tool will limit the possibility of getting unwanted tone, texture, or detail in the new location. Getting some "contamination" is not really a problem, it just wastes time. The Undo function will bring back the image to the same appearance as the last time you started using the tool—based on the point at which the left mouse button was pressed and released.

Working with the Clone Tool

The Clone tool makes an exact copy of whatever is set as the source, and then paints a duplicate copy—pixel for pixel—in the target location, replacing whatever was there before. In Photoshop, the user first selects the tool and then holds the Alt key down and clicks with the left mouse button to set the source point. Now the tool cursor is moved over the target area while pressing the left mouse button.

If you get a pleasing result, move on to the next area. Remember that it will be an exact replication and that the distance between the source area and the target is fixed. It's like making a copy and pasting over the target. We make new source selections in areas or the image with the same lighting, contrast, color, and texture we want in the new location.

The Clone tool works especially well in areas with broad areas of flat color and even lighting.

Variations on a Theme with the Healing Brush

The Healing Brush blends the source and target areas. It is great when you are working to remove blemishes, smooth wrinkles in skin or fabric, etc. When a target or source borders an area of radically different color, you may get unexpected results.

The Healing Brush really shines with a pressure-sensitive tablet, since the user can vary the effect with a lighter or more forceful push. We usually set the diameter of the brush to about 1/3rd of the area to be "cleansed" when removing blemishes. A little practice, and most users are able to get very pleasing results.

Marked for Change

Let's look at an example of both tools and how each tool was used to clean up an image before the picture was sent to the lab. Two pictures are worth a thousand words—in this case the two versions of the same image shown in Figure 15.17. We'll use a familiar image that has a few areas that need attention.

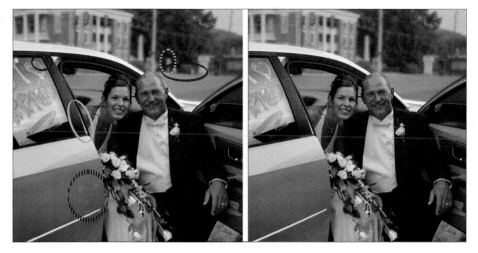

Figure 15.17 Before (with marked areas for attention) and after views.

Eye-Catching Is Not Always a Good Thing

The secret to be a good photographic retoucher is a sense of distraction. Tools like the Healing Brush make it easy to fix things, but they don't tell you what needs attention. Some should be obvious, like a skin blemish. The bride wants her pictured face to look perfect in the years to come. I also look for shirts that are a bit untucked, clothing labels (and sometimes a portion of the body) that has slipped out, stray hairs—in short, anything that is out of place. Then you have to choose a technique and weigh the amount of distraction against the amount of effort required.

For example, you might have an unwanted person in the background. You could replace the entire background. But what if the person is partially behind the flowing bridal veil? Much harder to fix, perhaps a Gaussian Blur might work better. There is no hard and fast rule. It's all in the eye of the beholder(s). Plus, the client will also have an opinion when the prints are delivered.

One bride loved the pictures, but called three days later (after the prints were on the way to be made into an album). She noticed a highlight on her hair in one portrait that made it look like she had a z-shaped part in her hair. The image was reprinted, the album company put the job on hold, and I learned to watch out for something new.

One pre-digital era retoucher showed me a trick in seeing what to work on. Start by turning the picture upside down. That makes the shapes unfamiliar. Another approach is to focus on shapes and color rather than the subject. Then do a close inspection at full magnification. Here is the critic's commentary explaining the marked areas and the corrections made from Figure 15.17.

The Case at Hand

The first thing that caught my eye during the evaluation was the bright flash of silver color bordered by black on the car's passenger door post, next to the bride, that is circled in blue. It's a normal part of the car, but it draws the eye from the couple.

This is a natural target for the Clone tool. We selected a brush size as wide as the narrow upper part of the offending area, then cloned a section of the black post to its left. We varied the source as we worked down, so that the result would have the same general texture and darkness without looking exactly the same. The Clone tool tends to make too good a copy if you are not careful. Exact copies next to each other can look artificial. So can lighting that comes from a slightly wrong angle.

Next was the historical marker to the right of the groom's head (outlined in blue). While Clone would have done the job, I opted for the Blend tool. It produced a more random effect that worked well with the existing blur in that area.

A mix of Clone and the Blend tools was used to eliminate the orange caution barrels (outlined in red) across the street in front of the courthouse. The same combination of strokes was applied to the reflections of the flowers and a panel light (marked in red) on the side of the car. More work for the Clone tool is the black line circled in red in the upper corner of the window above the words Just Married.

Then I switched to Photoshop's Eraser and made one adjustment that won't show up in the print. It's one performed on almost every portrait. A very small circle is erased in each eye, at the same location in each. It enhances (or creates) the catch-light in the eye. A clean edge gives the print the appearance of being in crisp focus. It's a trick learned from my mentor as a studio apprentice. We often soften the skin on the face, and that can soften the eye. The white dot gives it a sharp twinkle.

The Special Effects Locker

We do use Photoshop for more than just simple retouching. It is very handy for adding text over a picture when making titles for slideshows, and we have created a special brush that makes quick work of watermarking pictures with the studio logo. Photoshop has also become our special-effects locker, the place we go to produce posterization, to mimic film grain, and to emulate infrared, black-and-white, and color films.

Crafting those effects can be complicated, and that has created a market of add-ons. Photoshop plug-ins automate a wide range of special effects and image enhancements. We have two sets that are on our studio's must-have list.

The Nik Color Efex Pro 2.0 Complete Edition has 75 traditional and stylizing photographic filters. When you load one, it opens a new window that shows the image modified with the default settings. Then the user can adjust the controls for precise adjustments. The effect can be globally applied to the entire photo, or painted to convert just desired portions. Figure 15.18 shows one of the filters in use in Photoshop.

We use effects filters like Pastel and Midnight to quickly create mood-style versions of pictures. Others, like Pro Contrast, are really valuable time savers (and in some cases picture savers) when it comes to removing color casts that only occur in part of an image. We reach for it when the bride's gown is part in sun and part

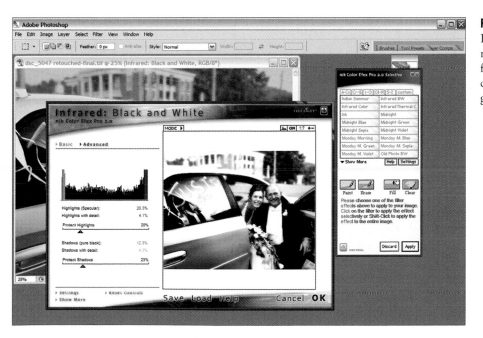

Figure 15.18 Nik Color Efex Pro provides an incredible range of tools as Photoshop filters that make quick work of complex special effects and gnarly corrections.

in shade. That can render parts of the dress a glacier blue. Once we had "must have" images where one light placed a green cast in the white areas (hair of a guest and bride's dress). Nik to the rescue.

Another favorite is Alien Skin's Exposure, shown in Figure 15.19. While we can vary the ISO and white balance settings of our DSLRs with the push of a button, the sensor stays the same. There are times when I want the grainy look of Tri-X pushed two stops, or the rich saturation of FujiChrome to boost the colors in a shot. Alien Skin offers a library of modern and classic film stock effects, right down to the grain. Then you can adjust the response curve, shadow and highlight involvements, and just about every other aspect of the effect. It's like having your own chemical company in a dialog box.

There's one more third-party add-on to mention before we move on to the next chapter. Throughout the book, we have been treated to TriCoast images that Mike Fulton and Cody Clinton enhanced using custom actions they designed for Photoshop. Actions are recorded adjustment steps that can be replayed on other images, and TriCoast has an extensive set that really speeds polishing a picture. They have created a kit with all of the actions along with a training DVD of their techniques. For more information, check the listing in Appendix A, "Resource Guide," on the companion website (www.courseptr.com/downloads).

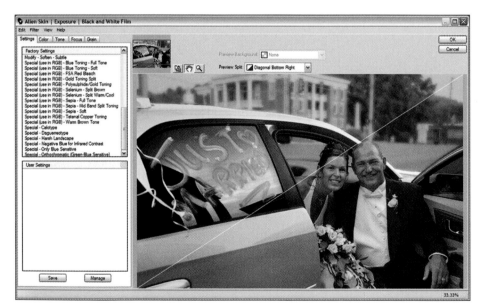

Figure 15.19 Exposure from Alien Skin can duplicate almost any film stock and grain pattern inside Photoshop, producing pictures that look like traditional photos.

Next Up

Some photographers still provide paper proofs, but there are better ways. Chapter 16 covers how to handle paper proofing with relative ease, and then in Chapter 17, see how to use a combination of online and DVD slideshows to cut costs, protect against image theft, and produce more profits.

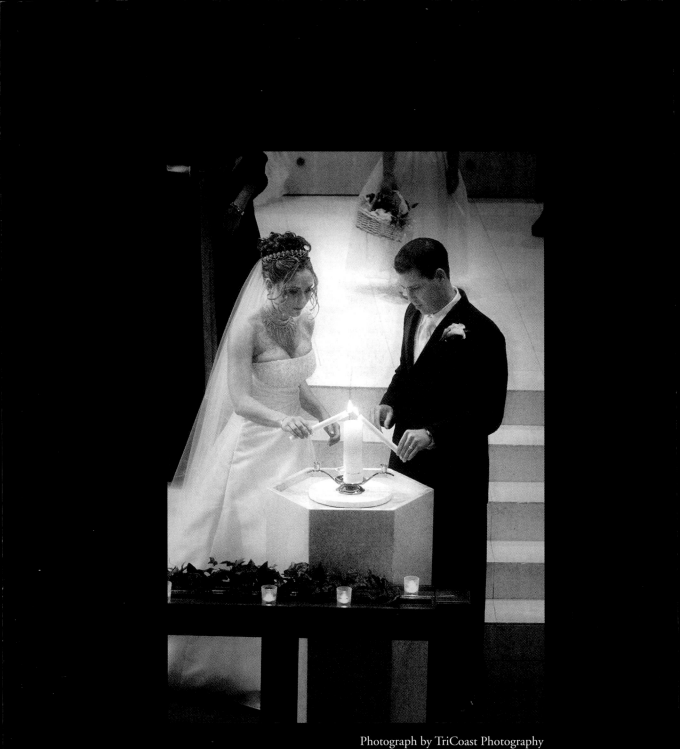

16

Proofing, Selling, and Printing

It seemed so simple in the days of film. Provide the proofs and wait for orders. When they came in, produce the prints. That was before low-cost ink-jets, inexpensive scanners, and easy-to-use editing software. It was also before Internet sales, multimedia slideshows, and DVDs. Some photographers have quit offering paper proofs. Others sell the images and let the client print their own. There are still ways to offer proofs and make use of the easy automation tools provided by the Internet (most people today have computers with photographic-quality displays). There are also ways to make proofing a profit center—without paper.

Tip

Many photographers give the couple a "gift" of Thank You cards with a copy of the engagement photo, the date and location of the event, the couple's new name, and the location of the proofing website. It is not uncommon for our first sale for a wedding to come via the site from a guest who lives several states away.

In our studio, proofs are provided in two forms within a few days of the wedding. First, there is a custom DVD produced with both numbered and unnumbered slideshows that display every image to music. It will run in both DVD players and on a PC with a DVD drive. The disc is time-limited and can be locked after a certain number of plays or after a set period of time. It can also be copy-protected.

We'll cover the proof show production and multimedia products next, in Chapter 17, then follow that with album design. Right now, let's focus on proofing, producing, and selling individual print orders.

Online proofing has become a service industry. Most photographers outsource individual print sales, leaving the technical details to a webmaster. Several firms offer turn-key Internet sales systems that work seamlessly with the photographer's own website. Most offer thumbnail galleries of the processed pictures, along with larger versions viewed via a pop-up window. Pages are designed to prevent visitors from copying printable files. For example, images are watermarked and they disappear anytime the mouse cursor is placed over the picture. The site includes a shopping cart for easy ordering, the ability to mark favorites, compare two images, and see them in color, black-and-white, and sepia-toned versions.

Figure 16.1 shows the Client Proofing Welcome Page on Mark Ridout's website.

Figure 16.1 Online proofing saves costs, limits piracy, and lets the photographer reach a wider audience.

Sound like a lot of work? Not at all, now; previously, it was so for our business, when we managed webpage viewing and our Internet shopping cart in-house, but now we outsource almost the entire process. You can do it yourself, but it is much more cost-effective to use a professional service. Vendors like Imagequix.com, Collages.net, Pictage.com, and the like provide the web server, client software, and all the tools needed by both photographers and buyers. If you provide cards at the reception and have the images on the Internet, casual sales will usually increase far more than the fees or commissions the sites charge.

All these firms offer similar services, with varying levels of elegance, cost, and support. Satisfaction levels and ease of use vary, and working with one of these firms is a business relationship. Shop around, compare prices, and ask other photographers about their experiences with a vendor. One good place to do that is online

at the Digital Wedding Forum (www.digitalweddingforum.com). Our studio uses ImageQuix and we show its operation in this chapter.

When shopping, look at the entire range of services and the partner labs. The original shopping cart has expanded. Vendors now offer CD proofing and slideshows, album proofing, album design and binding services, specialty prints (like 16x20 composites), and photographer's websites. If your existing lab isn't on the provider list, then a new relationship will have to be established for full-service ordering. Many vendors will let you use PayPal for credit card and debit orders; some require using their credit processing service for a fee.

Many clients want—even demand—a traditional proof book. Mother is arranging for the photographer. She had one, and her daughter will have one—how much? If that is part of the package, then price it that way. We sell a set of prints for the same price as a finished album. If the package includes an album and at least one smaller companion copy, the proofs are free.

Here's why. Some clients order a set of proofs or 4x5s, and then copy the images and make their own prints. Some even tell you they plan to do that. If they have already placed a good order, and they have access to the prints, we can't stop them. We do let them know about copyrights, the benefits of "real" photographic paper over ink jet, and the pride we take in our work. Even with proof books, we still set up the proof-and-print website.

That's because prints still make money, and people want to be able to hold pictures and show them around. Then there are albums. The fancy leather-bound flush-mounts with real photographs are still a good seller. While there is encroachment from short-run printing-press versions, the elegance of the custom design keeps sales going. That means ordering 10x10 and 10x20 prints. For studios that outsource printing, both individual and album sales means working with a lab.

The really good news is that the software and support for online proofing, shopping, ordering, and printing can be free for the photographer. We still have to pay fees or commissions to the site provider, and pay for the actual prints—so the money is still collected for those products, but the tab for each wedding is known and can be factored into our prices. It also makes it easy to keep an eye on the market and shop for the best deal. We'll look at the workflow process in a minute; first let's consider the business option.

The Matter of Money

If you have a website, it is possible to set up your own online shopping section and handle the entire process, but that is a lot more work than just posting images; and if you get a lot of traffic, the extra bandwidth charges incurred may eat into the profits. The technology and skills required for setting up a custom shopping

cart system, credit card accounts, coding and populating web galleries, and managing the site are well beyond the scope of this book.

We recommend a third-party shopping cart, either a prepaid or a commission-based solution. The online proofing companies offer them as part of their packages. Both can be linked to your website, and you can still host a sample gallery there to entice visitors to go shopping. Our site uses this approach, and we hand out cards with our web address that way, rather than promoting the vendor's shopping cart address.

Our client gallery Welcome Page showcases an image from our most recently posted wedding and offers a direct link to the shopping cart. If the visitor chooses to see the images in our gallery, they are shown a slideshow that flashes the image number superimposed over each picture in the top-left corner as the slide is displayed.

Pay as You Go

The most inexpensive way to add Internet proofing is a pay-as-you-go system. This allows you to upload images, provide previews, make sales, and track orders for a set fee per event or upload. ImageQuix provides this service using a custom credit system. Credits are purchased in advance, and then collected when you set up an event. The amount per credit varies, with discounts for large purchases. See Figure 16.2.

With this approach, you get an e-mail when an order is made, and then you have to handle the tasks of producing the print and getting it to the buyer. The e-mail order notifications include a list of the photos, plus thumbnails, the client contact information, method of payment, and any additional comments the buyer made using the order form. The system also can send our confirmation notice to the buyer that the transaction was sent to the studio.

For photographers who print in-house, this makes the most sense. It is also the best solution for those who would rather keep more money, and don't mind the

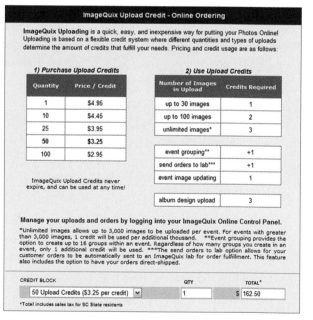

Figure 16.2 ImageQuix offers discounts for volume credit purchases, which are used for a variety of online proofing and sales services.

effort of dealing with a lab and the extra time in transit. We use an outside lab for most of our printing. When an order is received, the image is opened in an editor and reviewed for any needed retouching (we don't retouch most images unless an order is made). After any adjustments, the file is cropped, output as a

high-quality JPEG, and we use the lab's online order system to transmit the job for printing. To save work and reduce shipping costs, we bundle orders and send them once a week. (Customers in a hurry can pay an extra fee for rush shipping, or we may print a small order in-house on our dye-sublimation system.)

Full-Service Solution

Photographers who would rather shoot than handle orders, and don't mind paying more, opt for full service. In this case, full service means that the provider is linked to a lab and they work together to handle the printing process without bothering the photographer. You upload high-resolution files when the event is posted for viewing. The vendor takes care of getting the order to the lab, and the finished prints are sent directly to you for review and forwarding to the client.

The charges vary. Some vendors charge a monthly fee to host your work. There are also commissions, credit card fees, and sometimes a per-order transaction fee. ImageQuix does not have a monthly fee, but does take a 12 percent commission, three percent credit card fee, and a 30-cent processing fee per order. That would work out like this:

Example: An order is placed for $50.00 with $5.00 shipping and 6% sales tax totaling $58.00.

Fees include:

$6.00 commission fee (12% x $ 50.00)

$1.74 credit card processing (3% x $58.00)

$0.30 transaction fee

$8.04 total fees

$49.96 minus your lab bill is remitted back to your studio

Then the lab adds their shipping and handling charges, plus the cost of the prints.

Doing the Math

Full service or a la carte? As with most purchases, the choice involves a balancing of cost and features. We have considered full service, but tend use to the pay-as-you-go model. The bride and groom usually work with us on an album/print/DVD package. Online sales are usually small orders, so shipping from the lab and to the client is better controlled if we combine orders. In total, the commissions, fees, credits (they still apply to full-service postings), and shipping can boost the cost of an order by over 25 percent. In our market, that will cut into the size of sales.

Photographers who don't take the time to craft a package, or find that their time is better spent just shooting, may like the streamlined workflow that full service provides. Just how hassle-free that solution is depends on how good the lab is. If they know your style and take the time to make sure the job is done right the first time, great. If an order has to be reprinted to get the right look or fix flaws, then maybe it would be better to take more control and save the money.

If a vendor charges a monthly fee (no recurring hosting fees is a major reason we chose ImageQuix), that has to be factored into the total cost of an order. Getting the real cost of doing online business requires looking at the sales for each wedding and over time for all Internet sales. We do that at the end of the year.

When calculating costs, don't forget to compare the costs and profits between paper proofs to online sales. The traditional proofs can be sold or placed in an album and used to defray printing costs, but that may kill more lucrative individual print sales. Also, the proofs are just that—proofs. To make them look like professional prints that reflect quality takes more time. Labs generally charge less for proofs than "finished" prints—and take less care with color balancing and quality control in the process.

The best solution is a combination of the one which makes the client happy, with the least effort and the most money for you. Since paper proofing is a matter for the photographer and a lab, we won't take time to detail the obvious. Let's turn our attention to online sales and fulfillment.

The Basics of Proofing Workflow—The Online Version

There's that workflow word again, and DAM isn't far behind. No matter how you handle proofs—unless you just give the whole job to the client as files on a disc—DAM is required to know what prints go with what images, and which orders go with which client. If you used the DAM techniques suggested earlier in Chapter 13, the images are already arranged and numbered using a system that makes it easy to find a file even years later. If not, well…we can still use basic DAM to get things in some semblance of order.

Vendors have their own software and specific workflow. A little planning makes it easy to integrate theirs with yours. Most follow a common form, so the following procedures will provide a solid introduction to both the process and the features to expect. You prepare the images and convert them into a supported file format. Then their software is used to set up an event, create a price sheet, upload the files, and build the pages. Most of the work is done automatically. Some

providers make you send the client to their homepage and then locate your proofing page and the event. ImageQuix builds pages and uses your website interface to wrap the proof pages so they look like they are yours.

Figure 16.3 shows the Windows version of the ImageQuix software, which runs our website on the left; and on the right is their online control panel hosted on the ImageQuix site inside Internet Explorer. Between them, they offer all the controls needed for managing the entire proofing and sales workflow. Let's follow along through posting an event to see how it works. Then we can follow that with placing an order to a professional lab to complete the a la carte process.

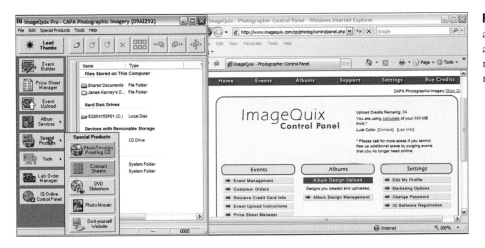

Figure 16.3 ImageQuix offers a variety of online proofing and sales services coupled with robust software and online management tools.

Setting Up an Event with ImageQuix

Setting up a proofing site is done on the photographer's computer, using the features in the software on the left of Figure 16.3. The buttons in the left column provide access to the fill-in-the-blank event set-up forms and special services. The actual file manipulation (creating thumbnails and compressed versions of the proof files, renumbering, and uploading) are all background tasks. A price sheet is either loaded from an existing version or created, and then the program automatically generates and sizes both proof and thumbnail versions of the image files for web use, then uploads the entire collection. The ImageQuix site produces the pages and the shopping cart.

Once a site is set up, the online manager located on the ImageQuix website is used to track orders, handle accounts, and get information about visitors. You can obtain credit card information and obtain the e-mail addresses of visitors to use in marketing or follow-up orders.

Creating a Price Sheet

Generating the prices and product list for the shopping cart is a good starting point in the event set-up process. It is really a form that tells the shopping cart what products are available and sets the cost structure (including tax and shipping). The photographer can use a single price sheet for all events or create a custom version for specific clients.

There are two types of price sheets. Both provide order tracking and sales collection using credit and debit cards, etc. The Full Control sheet can contain any products that the photographer wants to offer, because the photographer is responsible for getting the orders filled. Only the proof images are uploaded when the event is posted on the site. When a sale is made, the system sends an announcement containing buyer and order details, and leaves everything else up to the seller.

Full Service price sheets are linked to one of ImageQuix's partner labs. High-resolution images are stored on the ImageQuix server. When a purchase is made, the order notification is sent to the seller, and the order and the related files are transmitted to the lab. The products that can be listed on the price sheet are limited to those provided by the designated lab. To use Full Service, a photographer must have a designated lab. You can change the lab if you wish. Depending on the event, the photographer's mood, or the profit margin, the type of price sheet is up to the seller. We tend towards the Full Control model, but have designated Luck Color Lab in Chattanooga for Full Service jobs. That offers the freedom to use either price or fee system.

The Price Sheet Manager is easy to use. See Figure 16.4. Click on the button and the form used to generate or modify forms opens. If you have a designated lab, their products will be available in the drop-down menu at the top of the column on the right side of the box. If the Full Service Price Sheet box is checked, those will be the only products that can be entered on the sheet. The photographer can create custom products in Full Control mode.

It is possible to open an existing price sheet and modify it, then give it a new name. Price sheets are stored *ONLY* on the client's machine. The data from the selected sheet is loaded into the eCommerce shopping cart database when the files are uploaded. If you change machines or lose the ImageQuix program folder, the sheets (but not the data loaded on the remote server) will be lost. You can back up the file that holds the price sheet, and that's a good idea. It is located in the program files\imagequix\iqdata directory. Back up the entire set of files, just in case.

We name our price sheets by the type of work, since we have different rates for weddings, portraits, and non-profit organization jobs. It is possible to have a separate price sheet for a separate client. Keep in mind that if your lab does not offer a product promised for a job, that offering (or the event) will have to be set up on a Full Control basis.

Figure 16.4 Defining or selecting a price sheet is generally the first step in setting up an ImageQuix event (once the images have been edited).

What's in a Name and the Magic of Numbers

The real purpose of DAM is to make sense of the thousands of images that a busy wedding photography business generates each year. Some shooters don't worry about it and store each job separately. Others use complicated schemes and databases to track the entire workflow and the orders. We take the middle road, with a set file number format and a simpler version for proofs. All we use inside ImageQuix is the four-digit sequence number. We know the event, so we don't need to use a complete wedding identifier.

The format we used in Chapter 13 on DAM (to refresh your memory) is the date in reverse order, the initials of the couple, and the file sequence number generated by the camera. That's the method we set up with iView Media Pro. Think "full name." We can use the "nickname" with clients for proofing, since we will know the date of the event and the couple for the order. If you don't want to fuss with DAM—and don't plan on being easily confused or care how long it takes to find a file—then the short form or nickname is all you ever need for the file.

We actually make a set of JPEGs that are renumbered with just the sequence number when we set up ImageQuix and multimedia proofs, no matter what method we use. Then that number is used for both the DVD and the online proofing system. Both the DAM software and ImageQuix can strip everything but the last four numbers, and even add new file name components—like the last name of the new couple (for example: smith-0022). The main thing, just as with DAM, is to have a number that lets the photographer, the lab, and the buyer be sure everyone is talking about the same image file, and that *that* image file is the same picture the client wants to have printed.

If you already have a naming and file system that makes sure that two images won't be confused, the files are ready for proofing. If not, either you or the software used to handle the proofs has to take care of that step. ImageQuix, the vendor we use in this chapter, can do that job and automate almost the entire process. So can most of their competitors.

Clicking on the Tools button opens a menu with two choices: Batch Export and Batch Label. We'll use the second one first. Before opening the dialog box, the user selects the directory with the target files in the pane to the right of the button. As you can see in Figure 16.5, the dialog box is divided into four sections. Each has its own function and activation button. Here is what each does and how it is used.

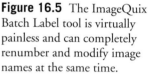

Figure 16.5 The ImageQuix Batch Label tool is virtually painless and can completely renumber and modify image names at the same time.

Batch Label

This first option is used if you want to create a completely new file name or make a complex modification to the existing one. That can be handy if a naming format uses the couple's name, or the desire is to provide a straight sequence of numbers starting with the numeral 1. Keep in mind that padding zeros so all the numbers have the same number of digits is a very good idea. See the "Padding with Zeros" section below for the details.

Some studios like to add a name or an event number, or match the original file name, so they don't use the Batch Label tool at all. That's okay, but prefixes like _dsc, or a camera code like D30_640 make it harder for clients to note the names of favorites and complicate reading invoices.

Find and Replace

This is the easiest way to convert part of a file name to something else while keeping the same number sequence. That pesky camera prefix can be swapped for the couple's or the studio's. Using the Pad with Zero option is a good idea here as well.

Pad with Zeros

If there are over 100 files, but less than a thousand, each file number (even if there are letters in front) should take up four places. If you set the Pad that way, the first number will be 0001, and the nine-hundred and fifty-first will be 0951.

Remove Prefix

This is the one our studio uses to handle the labeling, since we just use the basic number and any suffixes added during processing. The new file name has the exact same number as the original file and the appropriate zero padding. If the image is a variation of the original, like a black-and-white rendition or a close crop, then we add a hyphen and letter or number code to the end of the file name. For example, 1885-c is a cropped version. 1885-s is a sepia-toned rendition.

Watermarking, Resizing, and Exporting Images

Now we'll return to the Tools button and select the Batch Export option. That opens the dialog box shown in Figure 16.6. ImageQuix makes new copies of the source files with the appropriate dimensions and compression to display properly over the Internet and load quickly. You can also use the tool to resize images for other purposes by setting different compression and resolution ratios. Rather than

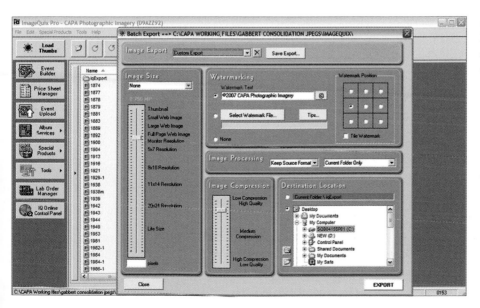

Figure 16.6 The Batch Export dialog box offers the ability to set a variety of options for the proofing pages.

use ratios and arithmetic settings, the program offers sliders with commonly used reference terms. The user can also specify a target image size and opt to create TIFFs, thumbnails, or web-ready images for use in other applications.

The section labeled Watermarking controls the creation of a stamp placed on each file as it is generated to prevent image piracy. The watermark can be either a line of text or an image file. Both can be placed in a section of the image or tiled, using the radio buttons on the right side of the Watermarking section. Checking the None radio button in the bottom left of the section disables the feature.

The Destination Location section shows the currently selected directory, and the one chosen by the Export button in the lower-right corner of the dialog box. The default works well. The program will create a new subdirectory named iqexport.

The Event Builder and Grouping Images

Even a small wedding assignment can produce over a hundred final pictures for proofing, and large ones a lot more. If all of the pictures are placed in one directory on the website, visitors will have to scroll through lots of thumbnails and a series of pages to view the images. One way to simplify viewing is to arrange the pictures into categories. We use Pre-Ceremony, Ceremony, Portraits & Formals, and Reception. Each set is placed in a subfolder after the renumbering/resizing process. ImageQuix can be set to use that directory structure as the files are sent to the server during the upload process, which divides the webpages into those groupings. To easily take advantage of this feature, all the newly generated files should be moved into subfolders *before* the event is created.

Once the files are in place, click on the Event Builder button and open the dialog box. Figure 16.7 shows that both the Event Builder and the Grouping dialog box can be accessed by clicking on the Edit Groups button. If the files are already in subdirectories, all you need to do is choose the parent directory and use Add Grouping for Sub-Folders option. Groups can also be added manually with the edit functions. They can also be reordered in the display stack using the arrows above the listings. Once the files and groups have been selected, and the other event details set up in the dialog box, the job is ready to load onto the ImageQuix server.

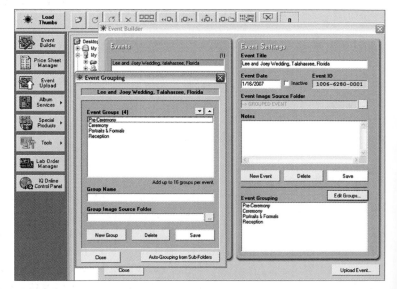

Figure 16.7 Using groups to organize images when building a proofing event can make shopping much more convenient for clients.

Uploading Files and Creating the Web Galleries

Resizing and labeling the images doesn't take long, and then the proofs are ready for the trip to the remote server. The ImageQuix program handles all the details of moving the files, setting up the remote site, and building the pages to incorporate the same look as your existing website. Clicking on the Upload Event button in the lower-right corner of the Event Builder dialog box opens the Event Upload tool, shown in Figure 16.8.

There are four sections, and most will already be filled in if the workflow described above is followed. Most vendors use File Transfer Protocol (FTP) to move the images to the remote server. When the job is run, the files are sent automatically—if you have a live Internet connection. The program will manage all of the technical details, passwords, etc. It will use the settings and use the text you provide to customize the page.

Be sure to *triple-check* the details. If there is a typo in the actual event name once it is sent, the event will be made inactive and have to be recreated. That will incur additional fees. It is possible to add, delete, and even edit images on the remote server after they haven been uploaded.

During the upload process, the program will generate the thumbnails and webpages, then transfer the larger files. Don't be alarmed if the progress bar starts showing twice the number of images you expected being moved. It shows the total number of images, both full size and thumbnails. Let's go though the options and the process in detail.

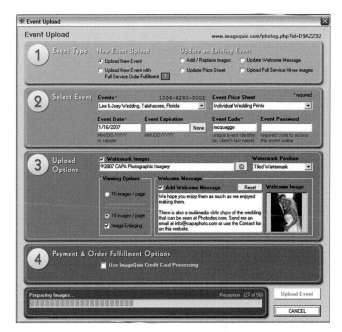

Figure 16.8 Sending the files creating the web pages and shopping cart is as simple as checking the details and pressing the Upload Event button.

Configuring the Upload Options

Event Type

The Event Upload dialog box is used to work with both new and existing events. For first-time sessions, the user chooses the Upload New Event radio button and can also enable the Full Service mode if desired. To modify an existing event, use the options on the right side of the first section of the box. This lets the user upload or delete existing images that are already on the remote server, load a new or modified price sheet, change the image or text on the Event Welcome Page, and upload high-resolution images used for Full Service fulfillment.

Select Event

Use this block to choose the proper event from the drop-down list and verify the details before proceeding. Most of the blanks will be filled in based on information you have already provided.

Upload Options

This block lets the user set up the watermark options, which deters visitors from copying pictures. The online proofing system also has features that limit the ability of visitors from saving images using the Save or right-click and Save browser functions. We'll see those shortly.

This is the place to configure a Welcome page. The initial page shows a list of all the photographer's events. Clicking on the link takes the visitor to the Welcome page. You can add a text message and a picture. There are also two display options for the proofing gallery. The 10-pictures-per-page version shows somewhat larger previews, but does not allow seeing an enlarged copy of the image. The 18-pictures-per-page option lets the viewer see a larger rendition. All the displayed images will have the same watermarks set up in that section.

We always use the 10-picture with Preview mode; while the smaller mode lets the viewer access all the same shopping cart options, the larger proofs tend to sell better.

Payment and Order Fulfillment

ImageQuix offers an optional credit card processing service for photographers who don't have their own merchant account with a bank. The fee is six percent of the order for Full Control and three percent for Full Service events. We use PayPal for our Full Control postings.

Note

The proofing site software can't directly incorporate Flash interfaces (since they are hidden in the Flash movie file). You may want to have a simple HTML page with the appropriate links and a simple design (maybe with a logo?) to use as a shell for the links to individual events.

We do have a link on our Flash proofing page. We put a link to the galleries in the text, which is loaded and viewable as HTML text. Potential buyers can see the proofs and order using the ImageQuix site if they know your account number.

Working with Online Proofing and Sales Systems

The Proofing Viewer

As soon as the site is online, you are notified of the posting and can view and test the new listing. If your website has a direct link to your ImageQuix events, so can the public. The entire array of active events will be shown. If a specific wedding (or any other type of listing) is protected by a password, visitors will have to use it to actually see the proofs and shop. Ask the couple if they want a password during the initial consultation. If they wish, we usually use the groom's last name. Then we note that on the Welcome page without actually disclosing it. Wedding guests should know who the groom was, and be able to access the images.

Figure 16.9 shows the proofing gallery using the 10-image and large-preview option. The large image of the picture under the mouse cursor on the right is shown in the pop-up window on the left. Notice how moving the mouse over an image turns the area white, and prompts the viewer to move the mouse to see the picture. This also happens in the larger window. This feature, along with the watermark, will defeat basic attempts to "lift" the picture for unpaid use.

Viewers have several tools to help them browse, select, and buy images. Both the thumbnails and large pages have a set of options with each picture. The shopper can designate favorites, compare images, look at black and white, sepia, and color versions, and add items to the shopping cart. The products, quantity, and prices are shown when the viewer chooses the purchase option.

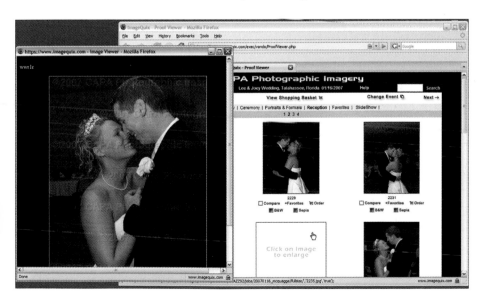

Figure 16.9 The online proofing interface provides access to large picture previews and the shopping cart.

The Sales System

The user can put any item into the cart, and it will tally the cost, and show shipping and sales tax information. A thumbnail of each picture in the cart, along with the order details, is updated with each additional selection. When the buyer chooses to complete the transaction, the final tally is made, the user information is collected, and a payment option chosen.

The photographer has complete control over the purchase configuration. You can allow or prohibit cash and check sales, allow credit and debit cards, and use PayPal. The system lets you examine credit card transactions in detail if desired. An invoice is generated and a notice sent to both the buyer and seller when the buyer completes the purchase. Payment will vary based on the method of payment and the policy of the bank or credit provider (including ImageQuix).

An online control panel is available for tracking and checking on orders and visits, and to see which images are drawing the most attention. The photographer can update the sales conditions and modify the price sheet at any time. It's also possible to use the e-mail tracking system to make special offers to visitors and do follow-up marketing.

Choosing and Working with a Lab

Some photographers don't worry about printing at all, and just give the image files to the couple; others do all the lab work in-house. Some even own labs that take in outside work from others. The rest of us rely on service providers to fill our orders. No matter the volume, the lab becomes a business partner, and its print quality, product line, prices, and turn-around time become a part of the photographer's business model.

The move to digital product has been a slow process for many labs. Most now offer workflow and ordering software as well as online services for submitting images for printing. Some are very knowledgeable and offer solid support for both their software and the imaging process itself. It's possible, just as with the other programs used in this book, to get a trial version. Some programs offer more workflow options or editing functions than others. If it can replace a commercial program, you can use the money for something else. If the program is cumbersome, or the lab doesn't have the products or support you need, shop around.

Is It a Good Fit?

There are labs, and there are *labs*. The emphasis depends on what the facility offers that makes the photographer's work better and improves the studio's business model. Some offer lots of support to the beginning professional, some offer deep

discounts to photographers who send color-corrected work. Some only take new clients at set times of the year. Some offer special products for given markets, and some are tuned for high volume; some do custom work and have highly trained (and expensive) graphic artists and retouchers. No matter the lab, there is always a trade off between price and service. If you need more hand-holding, the prints will cost more.

We work with two labs, one for high-volume jobs like sports and proms, and another for weddings and jobs that need that extra touch. It's sort of like the two options with ImageQuix. The full-service labs offer extras, but generally cost a bit more per unit. If that means more time shooting, and your prices are set to allow the margin, great. Also consider the quality of the products, and if they can handle both the volume and type of work that suits your needs. One lab may not do it all—you can send jobs to more than one vendor.

Luck Color Labs in Chattanooga is our full-service provider, and it is two days closer when it comes to shipping than our volume provider. That makes a difference in turn-around time. They are also one of over two dozen labs that offer Full Service support via ImageQuix.

Know the Lab's Technical Details and Make a Trial Run

No two labs or photographers are exactly the same. Even if the lab is a perfect fit to your style and budget, there is some getting-to-know-you work required that is best done before the first real order is sent for processing. Most labs provide software to make the ordering process simple and to make sure the files match their basic requirements.

That often does not meet the exacting needs of precisely sized prints for an album, and the basic settings may not include color management. Even when it does, your idea of managed color and profiles may not be the same as the lab's. Many labs offer to print a "calibration run" if the photographer requests one. They may require one and inspect it before approving an account that includes photographer-managed color and print "as-is" discounts.

Here is an example. Let's say a lab uses a custom 254 dots-per-inch (dpi) setting, but the set-up guide says 300 is okay. The prints will have just the slightest line on one side. That's fine for a standard 8x10 with a border. If you need the image to run right to the edge of the paper for a flush-mount album, that white on the edge may require a reprint. The same is true if you and the lab use a different color space, or disagree about the appearance of neutral or 18 percent gray. Most labs are very supportive when it comes to setting up a new client. They know it pays off in the long run with better results and fewer support calls or reprints.

Some labs offer deep discounts on large prints and some specialty items after the Christmas rush. That's a good time to test that new software on a 16x20 and build up your portfolio sample and bridal show displays. Studios also have a slow season as people recover from the spending binge of the holidays. Consider a gift certificate sale that passes on the lab discounts if used during the lab sale. You can mark up the big prints and still make money. The sale can be billed as a "Good Customer Thank You bonus." The difference between the sale and your regular prices can be listed as a discount.

Processing a Lab Order

In the days of film, sending a lab order meant physically shipping the negatives to the vendor, usually in some sort of mask to let their technician know how to crop the image and a set or matching paperwork. Digital orders are faster and easier, but still involve setting up the job and shipping the files, either via the Internet or on a disc.

Most labs provide a software solution that prepares the files, much like we just saw with the ImageQuix program. Once again, there are varieties of programs that do much the same thing, each tailored to a specific vendor. To demonstrate the workflow and show how typical lab software works, we'll use the one in service at Luck Color, Fuji's Studio Master Pro. We are going to use it to pack a print job for Luck Color Labs.

No surprise, it's produced to support Fuji printers and papers, and that's what this lab uses. There are other programs that are tweaked to Kodak products, as well as some aimed more towards the lab than specific photographic media or hardware producers. From a photographer's perspective, the bottom line is ease of use, the products and editing features offered, combined with the overall value of the lab in both price and support. Change labs and expect to change software. Even if both labs use the same program, the products and packages will vary.

Some photographers use the lab software to adjust color, crop, and make similar corrections to files before they are packed and sent to be printed. Our workflow uses dedicated programs that are not tied to a specific product line and can produce output for the web, print, and multimedia use. That means that all we normally do in Studio Pro is to set the print order, but you can use it to crop and make image adjustments for supported file types. Since we start with Nikon RAW—and have the proofs already online—image processing is done well before StudioMaster Pro launches.

The following demonstration shows how a typical wedding job is set up in our studio. We won't bother with a detailed tutorial. Different programs will have slightly different menu options and procedures. In the past several years, we have used a variety of lab software programs, and they all perform basically the same

function. The rest of this section will provide a solid introduction to online order-ing. Then we'll finish the topic by actually uploading the files to the lab via FTP. (If that's a new term, not to worry. It's fairly simple and the software's free.)

Organizing Files and Creating a Job Ticket

The first step is to get the files ready. We create a folder for each size of print and pull all the images for that format into the folder. If there are multiple copies desired, we append that to the file name or use a second folder that notes the quan-tity. The final file listings and number of prints are tallied and rechecked before we launch StudioMaster Pro and placed into a master folder named with the job name and date. This process makes finding the files and setting up the order in the program a very short process and saves possible confusion or missing a print request.

The next step is to create a job listing. Think "paper order form": the electronic version collects the same information as in a traditional paper order form. It sets up the order "container" in the program, links it to our lab, and the information is sent with the files automatically. It contains our account ID number, the lab's order ID, and our contact information.

Loading the Images into the Job and Making Adjustments

The screenshot in Figure 16.10 shows StudioMaster running with the Load Images dialog box open. Remember the folders we sorted the images into above? All that we have to do is select those files, and they are imported into the lower portion of the program's interface as thumbnails. You can adjust the size and num-ber of thumbnails for easier viewing. The icons at the top of that work area are the typical shortcuts for menu items.

The thumbnail section is used to sort images. Some photographers use StudioMaster as a DAM workflow solution and mark up images much as we did in Chapter 13 with iView Pro. If you use a Fuji camera, it may well do the job, since the program can read Fuji RAW formats and even capture images directly from supported Fuji cameras.

Tip

Different lab programs support different file formats and printing papers, and some support remote camera capture. When shopping for a new lab, consider visiting the website of any vendor that has products (like paper or RAW formats) that you would like to have supported. Their list of preferred labs may just have what you need.

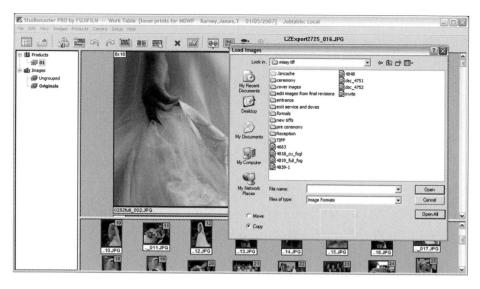

Figure 16.10 Loading images into StudioMaster Pro.

Once the images are visible in the thumbnail section, they can be selected and placed in the work area. There they can be adjusted, cropped, and linked to products. We normally have made all the enhancements and retouched the files before they are imported, but often save the final print cropping for this part of the workflow. That makes it easy to use the same image for different print sizes.

The tools provided in most lab software should be easy to understand for anyone who is used to editing images with programs like Photoshop or Bibble Pro. Figure 16.11 shows an image with before and after renditions and the controls

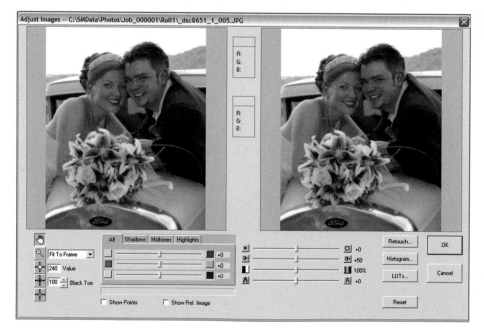

Figure 16.11 Adjusting images with StudioMaster Pro.

for tweaking the color balance. If you make copies of the source files when the lab folders are set up (rather than placing the originals there), be sure to plan for how the final edition is saved in the total workflow. It's poor form to have differences in color or cropping if the client orders another copy.

Setting the Images' Printing Instructions

Lab software is linked to products during installation, and these should be updated before starting a new order. This ensures that the list is complete and that the items are properly linked to a current price sheet. Some software has this as a separate database; some are included with the interface that is used to select the products. "Products" are anything that can be produced using the images. Most often, these are prints in standard sizes. They can also be album pages, coffee cups, refrigerator magnets, calendars, buttons, purses, and anything else the lab can do with the picture. Some labs, like Luck Color, can produce the prints for a wedding album and send them directly to an album company.

Readying the Order for the Lab

Once all the products have been selected, it's time to pack the files and get them into production. The packing process is usually done by the program; you just have to know (or tell it) where the final file or files reside. Files, plural, because some programs, like StudioMaster Pro, can divide the package into several files.

Check with your lab's technical contact for details on how to do this. Large files may or may not work for upload because of ISP or the remote server limits. If you are sending the files on disc, the files have to be small enough to fit on the media. A full album at high resolution can fill more than a DVD can hold. StudioMaster Pro has a dialog box (big surprise) that lets the user set the target directory and similar options for each job. It's shown in Figure 16.12.

The exact options and the packing and transfer procedures will vary between programs and from lab to lab. The main thing is to make sure the lab knows what to produce and that the files are in the right format and resolution. Here are a few things to watch for.

Figure 16.12 Setting options before packing a job.

Compatible File Names and Formats

Not all operating systems can read the same file names. If your system is on one platform and the lab is on another, your existing files names may not be usable at the other end. In most cases, the ISO 9660 file names used for data CD-ROM

are readable by most systems. There are some differences in TIFF format between Macintosh systems and Windows machines. Check with the lab to be sure.

Appropriate Resolution and File Size

The same is true of resolution. Some software automatically outputs files for transfer at the proper resolution for the lab's equipment. Some don't. And what may be okay for one photographer may be not up to par for another. Remember the value of a test run.

Color Compatibility and Color Profiles

Another thing to check before even editing the files or outputting them as proofs is to check the color calibration and the output color profile. If you are using one and the lab another, all bets are off when it comes to matching skin tones and neutral shades. Did somebody mention a test run?

The Lab Has the Required Information and Priority

Finally, double-check the lab's procedures for setting up a job and verification. If you send the files via the Internet, is there a confirmation procedure? For example, Luck Color Labs asks the person sending the file to e-mail the staff once the packed file has been sent. Checking is even more important if the send is a rush job or when there are special handling considerations.

Getting the Job to the Lab

Almost there—everything except the actual transport to the lab. Sometimes the lab is close enough for a visit; sometimes the photographer does not have a fast Internet connection. In those cases an optical disc, either a CD-R or DVD-R platter is a good solution.

The fastest mode of transfer for those with a broadband connection and a supportive lab is via an FTP upload. FTP stands for File Transfer Protocol and dates to the early days of UNIX. It is simply a data transfer protocol that lets us move large files, or a large number of files, between two computers. Some software has built-in FTP capability, like ImageQuix. Many still require the photographer to use a third-party program to move the data.

The screen shot in Figure 16.13 shows FileZilla at work moving files from the author's computer to Luck Color Labs. This is a typical FTP application that is popular and free. The information on obtaining a copy is available in Appendix A, "Resource Guide," on the companion website (www.courseptr.com/downloads). As you can see, the interface is very much like that of any folder application used with a Windows or Macintosh computer.

Figure 16.13 An actual FTP session sending packed files to Luck Color Labs.

The only difference between a file transfer between two local directories and the lab is the need to connect the machines, exchange log-in information (like a user name and password) and the background networking tasks that the FTP protocol and software manage automatically. Once the job has been sent, all that's left of the order process is to get the prints back from the lab and deliver them to the client.

Next Up

There are other ways to provide the images to clients, ways that offer added chances to show our creativity and make additional sales—multimedia presentations and albums. We'll take each in turn. Next, Chapter 17 shows how to add motion and sound to your images, both for proofing and as a final product.

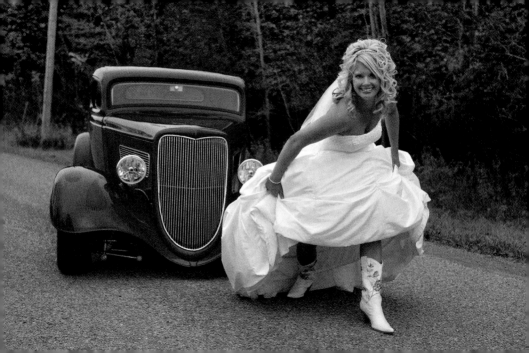

17

Multimedia Marriages, DVDs, and the Electronic Album

Slideshows are nothing new. In fact, several of the programs we have already worked with offer the ability to output a basic slideshow. ImageQuix, as we saw in the last chapter, has one built into their shopping cart system. So, why have a chapter dedicated to multimedia? It's just like asking, "Why have a professional photographer?" when Aunt Susie is bringing her digital camera. The answer is the same: "Professional quality results."

A professional multimedia production is not a simple slideshow. Rather than just a series of images, the production tells the story of the day in a different way from still images and video. Properly executed, it adds value to a wedding package, increases individual print sales, and can be a good-selling product in its own right.

This chapter shows the basics of how to use images, sound, and multimedia effects to bring professional production into your workflow, from proofing to a polished production. We have the images already; those used for our proofs can be turned into an online production or DVD that can be shared with clients and anyone else interested in the wedding. By using dedicated software, it's possible to have a production with fancy visual and audio effects up and running a couple of days after the wedding.

Our studio goes even farther with multimedia for high-end packages and promotional items. If the bride or groom has an iPod or another multimedia device, they get proofs and the final ProShow production in portable format. Selected

images (with branding) are also collected into a screen saver they can share. We do that with portraits, too. Their proud display at work and to friends is a mini-billboard for the studio and our work.

Multimedia Production—More Than Just a Slideshow

Mark Ridout is an expert at the craft, and we have shared the speakers' podium at photographic workshops. He doesn't even offer proofs. He provides a multimedia album of the wedding along with a complete set of high resolution JPEGs on DVD for a fixed price. During one conversation on the topic, he noted that he has seen brides shed tears watching his productions. "I never got that response from an album," he said.

Of course, you can't get that kind of mileage out of a basic slideshow routine, just as you can't get a good 16x20 bridal portrait from a cell phone image. It takes practice and the right tools. By now, it should be obvious that imaging software takes many forms and that the right program can add both quality and improved workflow to your efforts. Basic slideshows let you string images together and fade from one to another, and not much else. A polished multimedia production looks and sounds more like a well-executed broadcast-quality documentary.

There are two questions many people tend to ask when they hear about online multimedia. How much work is it, and what about the cost of all the bandwidth required when visitors stream the videos? The answer to both is really in the software. Mark and I both use Photodex ProShow Producer. It's one of three multimedia production tools developed by Photodex; there are also Standard and Gold ProShow editions.

Owners of the Gold and Producer products can upload complete Shows (at full resolution) to Photodex servers and distribute them via the web for free. Watching the highlighted Shows and contest winners is a great place to get ideas and spark those creative juices. Figure 17.1 shows a screen capture of Rose Mary Lalonde's contest-winning Show playing over the Internet. Her entry is a good example of how Producer can both showcase your work with multimedia effects and make it more accessible.

For Mark, Rose Mary, myself, and other ProShow users, the production is a major marketing tool. The finished product is placed on the web as a high-resolution streaming video

Figure 17.1 Free online sharing is a great marketing tool as well as a proofing venue.

complete with sound track, special effects, and branding. If you own a copy of ProShow Gold or Producer, Photodex provides free web servers to stream your productions. Everyone who attends the wedding can see your work. The neat thing is, it doesn't require any extra bandwidth on his website and—with a bit of practice—takes less work and time than a traditional album.

In our studio, we offer both multimedia and albums in our complete packages, and the option of one or the other in less expensive bundles. The proofs for all weddings are also offered as a multimedia DVD, and that is always a good seller. The Show is hosted for a limited time on the Photodex website. The process of preparing the Proofing Show actually saves time, when it comes time to design an album (more of that in the next chapter). Let's start with the proofs and see why it's worth owning dedicated multimedia software.

The basic Proofing Show contains two versions of the multimedia production on a single DVD. There is one version with fancy motion and slide transition effects and a second that has simple fades, no motion, and places the image number on the picture during playback so the viewer can copy it down to order prints. There is a menu to let the user choose which Show to see, and the disc works in all standard DVD players as well as on PCs.

Sounds complicated, but it's really simple with the right tools. The Photodex Standard edition ($29.95) is aimed at the casual user; ProShow Gold adds sophisticated motion and transition effects and costs $69.95. Producer is a serious professional product and is priced at $249.95.

Gold will do the basic job needed for preparing a proofing presentation. For really professional production and output, Producer has the muscle to make our work shine—and clients smile and ask for more. We'll look later at why Mark and I went for Producer. Let's start with a simple proofing collection. As with the other programs, feel free to follow along with a trial version if you don't own a copy. I'll show you step by step how we do our Proof Shows, and then explore some of the high-end features in Producer.

First, the Proofs

Our Proofing Shows are a key element of our studio's selling strategy. We produce a basic Show with all the selected images as soon as we get the images sorted and adjusted. Using the workflow already outlined, that can be in a day or so. (In fact, a simple Show of the ceremony can be shown at the reception if you have Producer and somebody at the shoot who can use the program and is not tied down behind a camera—Producer can read RAW images.)

We post the Show on the Photodex site as soon as it is ready and send copies to the parents of the couple. Then we meet with the newlyweds and view the production together. By then we also have a second Show with an album design. The combination lets them see the images in an ideal setting, with soundtrack, the extra impact of motion, and the focus of pan and zoom effects.

Introducing Photodex ProShow

The ProShow products all use the same basic interface. The fancier versions offer more tools, accessed from the same basic menus and dialog boxes. I'm going to be using the high-end ProShow Producer throughout this chapter, but the first set of Proof Shows can also be done using ProShow Gold. Let's start with a quick tour of the interface. A free trial version of all three products is available at Photodex.com, if you want to follow along with your own images. The basic Show only takes a few minutes to create.

The first step is to create a new Show. When we choose New from the File menu, the program asks us for a show title and to choose the aspect ratio. The aspect ratio should match the screen size of the target device. You can use 4:3, which matches a standard TV and monitor, 16:9 widescreen, or set a custom ratio. Take the time to set a Show name; it is used later for setting up Play menus.

The ProShow work area is divided into sections underneath the usual menu and tool buttons on the top of the main window. You can add and adjust the layout of the various panes. For simplicity, I'll stick to the program defaults. Figure 17.2 shows the program running with an untitled Show just as it will look when a new Show is opened. See the horizontal row of boxes that say Slide? This is the Slide

Figure 17.2 The ProShow Producer user interface is designed for speedy production.

List that holds the images in a Show in the order they will play in the production, running from left to right. When images are added, a thumbnail replaces the empty box. Just below the Slide List is the Sound Track area. When we load audio, it will show as a wave form.

The set of thumbnails above the Slide List on the left is the File List. It can also show the names of the files in the selected folder. The Folder List is just above the File List. Choose a folder and see the contents in the File List. Navigating and selecting files in these sections works the same way as file and folder handling in the operating system.

To the right of the Folder and File List area is the Preview window. It shows the currently selected portion of the Show. It can also be used to run a preview of the production, using the controls just below the preview image. Below those tools is the Size Meter. It graphs the size of the current contents of the Show, based on the files and the type of output. (A web version will take less room than a DVD, etc.)

Adding Content to a Production

Photodex did something very smart when it came to designing the Producer interface—they made it easy to use drag-and-drop editing, while still providing precise control with dialog boxes. We'll do almost the entire proofing production using the mouse.

All we have to do to add pictures to a Show is select them in the File List and drag them into the Slide List area. When you do, the program will create thumbnails and display them. Wedding proofs are pretty much shown in the order they were shot. We've already culled and arranged them for the ImageQuix online gallery.

My normal import method into Producer is to place all these files into a single directory, sort by creation date, select them all (using the right-click fly-out menu), and drag them onto the Slide List. That's all there is to importing any supported file format. If you are following along with the program, select a set of pictures and drag them onto the Slide List.

The import process can take several minutes if you are bringing in a good number of large files. The program is generating thumbnails and previews, as well as indexing the new material as project resources. The same thing happens when you import a sound track or other materials.

The actual source files are left untouched. You can edit them in another program and the images used in the program will be the newly edited versions. Your content can be updated on the fly. That's a powerful feature. If you keep the same names and file locations for the final retouched images, any multimedia Shows that use those pictures will have the new content.

Once the resources have been created, the images are shown in the Slide List with the default times for each image and transition displayed. The transitions are shown as icons located between each slide. The defaults are 3.0 seconds for each slide with a simple fade the same length between images. Figure 17.3 shows our production after adding the slides.

Figure 17.3 Adding images is as easy as drag and drop.

Let's look a bit closer at the results. See the green checkmarks in the lower right-hand corner of each thumbnail in the File List? That notes that the image has been loaded into the Show. A neat feature if you are loading individual images into a production.

Locate the green bar under the large picture in the main Preview area. Just below it is a horizontal line that looks like it has raised vertical bars on it. This is the Track Bar. On the Track Bar, above Slide 79 is a little dart called the Track Bar Indicator. Drag the Indicator back and forth on the Track Bar, and the Show will preview in the window as placement changes. There is a vertical reference line in the Soundtrack area beneath the Indicator that shows the current position for working with audio effects. (More on that later.)

Just what you can import into a production will vary with the version of the program. The Standard Edition is quite limited. Gold will handle most standard image formats. Producer can handle Photoshop PSD and RAW images (RAW support is limited at this point to the unedited form), a number of video formats, and all the traditional image types.

Once the primary slides are loaded, select and add title or credit slides to be shown at the beginning and end of the Show. We usually choose a favorite image as the

title and add a blank slide. (You can add one by right-clicking at that location on the Slide List and choosing the Add Blank Slide option.) Blank slides are great for adding captions and credits at the end of a Show and can be used to run out short runs of extra audio.

Tip

While ProShow Producer will import virtually any resolution, it's a good idea to match the source file to the intended platform. Very large source files will yield larger project files. Several versions of a wedding DVD and a Windows Autorun executable (.exe) format, with and without numbers and using high-resolution TIFFs, may run over the limit of a 4.7GB disc. The same Shows with full-sized JPEGs should fit fine.

Transitions—Adjusting the Ins and Outs

Loading the slides was easy, but the default transition is a plain "A/B fade." That's the term for a transition that darkens to black and then lightens back up to show the next slide. We are going to add visual variety the quick and easy way, using some of those 280 variations.

The first step is to be sure we are in the correct panel of the Producer interface by selecting a slide in the Slide List. (The Folder View, Preview, Light Table, and Slide List are all selectable areas, so you have to make sure that menu actions are directed at the proper collection). Next, right-click and choose Select All from the context-sensitive menu. Everything in the Slide List will be selected, noted by a slightly darker tone in the gray areas. Now open the Slide menu and choose the Randomize Transitions option located about two-thirds of the way down the list, as shown in the left side of Figure 17.4.

See the change in the transition icons between the images in the Slide List? The icons are now all different. Previously, the transitions were all the same; now they are randomized. They have changed from the A/B transition shown in Figure 17.3 to a variety of shapes. (I actually ran the command before the screenshot was made to be able to show both the menu and the result in the same image.)

Some transitions will work well visually; some won't. The transition is an effect that has motion. The goal is to have a shift in the visual design, which either makes a smooth transition between the two pictures or which draws the eye to the key element of the new image's composition. The best way to match them is to play the Show and note any transitions that don't "work." We'll do that in just a minute.

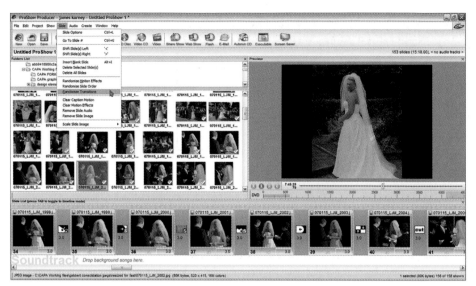

Figure 17.4 Setting random transitions with the Slide menu.

ProShow can randomize the order of slides in the Show, and also add program-generated motion effects. We won't show that just here; placing slides in the shooting order works best for most images in a wedding, since that is the order of occurrence during the actual event. We'll look at motion later in the chapter. It's easier to evaluate the way the images and transitions interact first.

Multimedia is different from working with single still images. What we just did was to adjust one element of the production—the way each slide blends into the next slide. The amount of time the slide is on the screen, the time it takes to shift from one to the next, and the way they shift, all have a lot to do with the impact on the viewer. We are starting with the adjustments that are easiest to manipulate and see so that readers who have not worked that much with multimedia can see the results, and those new to ProShow can get up to speed on the program's controls.

Previewing and Working with Transitions

There are several ways we can preview a production in ProShow Producer. There are Play, Stop, First, and Last Slide buttons in the Preview area of the interface. The Show can run in that pane or shift into a Full Screen Preview mode. When using that option, a right-click menu is available for controls.

Let's use the Preview and Track Bar Locator to examine our Show. (Remember the little dart above the active slide?) You can actually place it anywhere on the Track Bar line, and the action in the Preview pane progresses exactly as the pointer is moved. You can even move it back and forth to see the effect in both directions.

> **Caution**
>
> Be careful to use the Stop command, not Close, if you want to go back to working in the regular interface. Close will close the program. ProShow includes an Autosave feature, but it's still a very good idea to save your work at regular intervals. We also make sure to save the Show file before outputting the production or burning a disc. Both operations use a lot of system resources.

My favorite technique for editing and previewing is to run the Show in full-screen mode, then stop it and use the Preview area and Locator when I want to look at specific elements of the production. I make several passes. The first is to get an overall sense of the flow of the Show. I stop if there is a transition that just does not work or to move or remove a slide that appears visually out of place. One or two passes, and the Show has the right slides in the right order with the right transition.

Choosing a new transition takes just a little practice and developing an eye, just like composing pictures. You want the effect to draw the viewer into the image, and the effect should suit the mood and the distinctions between the two pictures. Always keep in mind that a transition is a blending of both slides in the mind of the viewer. Selecting and previewing a specific transition is done by left-clicking on a transition icon, and then using the Choose Transition dialog box, shown in Figure 17.5.

See the picture in the lower left-hand corner of the Choose Transition dialog box? When you hold the mouse over one of the transition icons in the box,

Figure 17.5 Choosing and previewing specific transitions.

the preview will show exactly how it will look working with the slides at that point in the Show. The two rows of icons to the right of the preview are "quick picks." The most recently used selections are there on the bottom row, and the top holds four transitions: a simple Cut (no special effect), two (Linear and Blend) A/B crossfades, and Random (for those who have trouble choosing). Click on the icon and the new transition is placed.

Tweaking the Timing

The default running time for every slide and transition is three seconds each. That works well when doing the initial edits. You already know what the images look like, and the goal is to get the slides in the right order and have visually appealing transitions. Once that is done, it's time to adjust the time each of the slides is on the screen—to suit the needs of the viewer rather than an editor.

For proofs, we like to offer a little longer viewing time. That's easy. Select all the slides using the right-click menu; then change the timing on the first slide and all the rest will be adjusted as well. Eight seconds is what our setting tends to be, and we add a little more to the best picks. Then it's time to play movie critic. Run a full-screen preview with a notepad. See any jarring transitions? Note any slides, transitions, or timings that should be cut, lengthened, or moved for better effect.

When the Show ends, use the notes and make the corrections. Then it's time to add the music. If you are very musically inclined, the sound can come sooner. We like to wait and focus on the visual effects first. For basic proof productions, the soundtracks are simply an additional layer of interaction. Our more polished productions, like custom multimedia albums, call for more work on the timing and content of the audio. They also get the benefit of Producer's advanced features like layers and keyframe motion effects, as we'll see a bit later in the chapter.

Adding the Soundtrack

Audio editing is worthy of a book in itself, and Producer has some very sophisticated soundtrack tools, but we don't have to get that complicated for our Proofing Show. Right now, we are going to take advantage of a ProShow feature that automates the process of matching music to the slides.

The first step is to get the sound files into the production. Click Show, then Show Options from the top menu. See the Soundtrack icon on the dialog box's left column? Click on it and the view in Figure 17.6 is displayed. (Click on the other icons and a different set of tools is presented.) To add an audio file to the list, click on the green Add button located on

Figure 17.6 The Show Soundtrack dialog box lets you add audio and play files to preview them.

the left-hand side of the large open area. Figure 17.6 shows the built-in audio player that can be used to preview a track either before or after a file is imported.

See the two buttons on the lower-right side of the dialog box in Figure 17.6? We are going to use the Sync Show to Audio function once the audio tracks are selected. When the button is pushed, ProShow will calculate the average times that each slide and transition can have to make the music exactly last for the duration of the production. Then it applies the settings. If the amount of music is not in the proper range for a reasonable (or possible) running time, the user is notified and asked to adjust the amount of amiable audio.

We have already added two files to the show's soundtrack list. Now note the up and down buttons. They are used to select the files in order in the list. Soundtracks play in the production in the order in which they appear, from top to bottom.

It's a good idea to have a rough estimate of the audio playing time and the number of slides and transitions that are to be shown when planning a soundtrack. (The number of slides in a Show and the current total running time are calculated and displayed just above the Preview area). Once you are close to the desired running time for the Show, use the Sync Show to Audio button. If the resulting display times are too long or short, add or remove audio files and re-sync the production.

As each soundtrack is added to the production in Producer, a waveform showing the audio file appears underneath the Slide List, as shown in Figure 17.7. The green section is the first track, the blue the second. (The program uses several colors to make it easy to tell where one clip ends and another begins.) This makes it easy to see just where the music is located and get a visual cue about the way the clip interacts with the images. We'll see how we can edit using the waveform in Producer after we finish our proofing project.

Figure 17.7 The Slide List with the soundtracks in place.

Adding Captions

The basic Show is almost complete. Now it's time to add captions. ProShow Gold and Producer can place captions with special effects, such as gradient fills, fancy fade-ins and dissolves, variable opacity, and scrolling as a layer on the slide, and each caption can be tailored individually. You can be as fancy or simple as desired.

Both editions let us add captions either to individual slides or globally to all the images in a Show. To add captions to a single slide, we use the Slide Options dialog box.

Choose the first slide in the Show and double-click on it. That opens the Show Options dialog box. This image will be displayed first—our title slide. The Show Options box is used to place text on individual slides. The left side of the dialog box has a set of icons that indicate the controls by specific function. Click on one and you get the appropriate box. Right now click the Show Captions button, and the dialog box will look like the one shown in Figure 17.8.

Don't let the number of buttons, data boxes, and drop-down menus intimidate you; most are context-specific and offer interactive modes that save you from having to actually enter numbers. We are going to set a simple caption and add some effects.

Figure 17.8 Using the Slide Options, Captions controls to define a caption.

You can have multiple captions on a single slide. The captions can move with special effects. They can be tweaked with fancy design elements (like gradient fills, outlines, custom fonts, and kerning and leading—in short, almost all the tools found in draw programs). The controls are all well labeled, and the quickest way to learn them is by working with a few captions and trying the different options. The font, type size, and placement options work just like the controls in most word processors.

To add a caption, use the Text box near the top left of the dialog box. As you type, the caption appears in a bounding box in the Preview pane. The bounding box can be moved to place the text exactly in position, and the control points can be dragged to expand or contract the size of the caption. Once the wording, size, and font are as desired, it's time to select and preview any effects.

The Text Effects (set using the controls near the bottom right) are used to set how the caption appears on the slide at three points. You can adjust the way it enters the frame (it can appear there or "arrive" using one of the motion effects in the dropdown menu), how it behaves during the time the slide is on the screen, and how the caption finishes (it can be static or use the same array of motion effects).

See the Caption Interactivity section at the bottom on the right? We chose Open URL from the Action box and used Destination to point it to our website. While the caption is displayed during the Show, the user can click on it to visit that site. Special effects, like a pulsing outline, can be used to indicate the active link.

To add a new caption, or remove an existing one, use the buttons in the Caption List box at the top of the main dialog box. The Play button, located in the lower left of the dialog box under the Preview area, lets us see the caption effects without having to return to the Show. Once the text and effects are as desired, close the box using the Done button in the lower right-hand corner.

Adding a Watermark

Now it's time to add a watermark. This is a Producer copy-protection feature that is simple to use. The watermark is a graphic that is superimposed over each slide as it is shown. This brands the image to discourage people from making unauthorized copies. Producer offers other copy-protection features; here we'll just use this one. We use a transparent GIF image containing our logo, the copyright symbol (©), and the year.

The Show Options dialog box has the controls, which are accessed by clicking on the Watermark button in the left column. If you want to use a graphic, enable the Use Watermark Image check box at the top of the dialog box, as shown in Figure 17.9. Then use the Source box just below that to browse and locate the desired file.

Then use the mouse to place and size it, just as we did with the caption. Set the opacity to a level that lets the watermark do its job, while still allowing the user to see the details of the underlying image without real distraction. Our logo is a set of letters

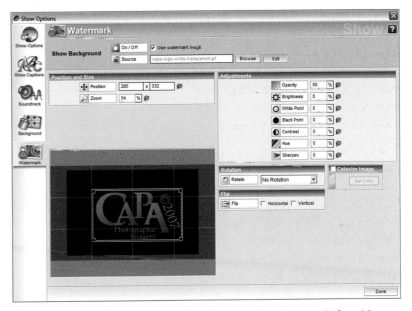

Figure 17.9 The Show Options dialog box contains the controls for adding a watermark.

with a gradient fill, and an opacity setting of about 45 percent works well for most weddings. There are additional controls to adjust the contrast, brightness, color, etc., that can be used to tweak the appearance of the watermark to match the needs of the Show. When finished, click the Done button.

Saving the Show and Creating the Proof Project

As mentioned before, in our studio we create two versions of the Proofing Show, one with numbers on each slide and one without. If that is the only difference between the two versions, all we have left to do is save the file, then add the file numbers, save the numbered version with a new name, and create the disc. We actually get a good bit fancier with the unnumbered edition, but more on those enhancements later.

To save a Show, open the File menu and use the Save As option. We use the first names of the bride and groom. ProShow lets us combine multiple Shows into projects. Now that we have one Show, we can create a project. Open the Project menu and choose the New Project option. Give the project a meaningful name, like the last name of the new couple.

Projects are combinations of Shows, or variations of the same Show that are output as a single product. ProShow can generate interactive menus, live links, branding elements, and PC Autorun executables. (This is a Show that runs on a PC just like the DVD, complete with menus—even if the computer does not support DVD playback or even have a DVD drive). The following section will show how we blend all of that into a presentation DVD and provide it to potential clients, with copy protection and time limits as desired.

We usually place two versions of a Proofing Show on a single DVD. A basic one with numbers lets the viewer see the image numbers and makes it easy to select prints or make suggestions during album design. The other, the one we are about to create, is the same set of images and soundtrack, with the addition of motion and special effects. Then both can be put onto a single DVD with two Shows, studio branding, and a fancy menu.

Now it's time to add the file numbers of the images and Save it as a second version. The numbers will appear just like the watermark over each slide as it is shown. The watermark is global, the same for every slide. The numbers are generated using a macro, and created using the Captions tool located in the Show Options dialog box. (Don't worry about the word *macro* and having to program events; they are already designed and ready to use.)

Click the Macro button grouped with the Text controls in the Show Captions dialog box. In Figure 17.10, the Insert Macro dialog box is shown over the Show Captions controls. Choose Predefined Macros from the Show Macros For drop-down choices at the top. See the second entry in the middle column of the box? That's the one we use. It adds just the first part of the file name. You can see the short-hand code for the macro on the preview behind and to the left of the Insert Macro dialog box. These codes can be mixed with user-entered text. If you know the codes, they can also be entered manually.

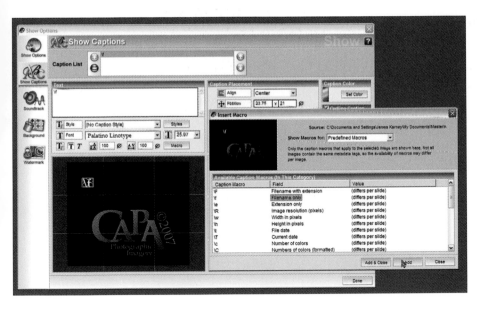

Figure 17.10 Adding numbers to each slide is easy with ready-to-use macros.

The pre-defined macros let you add and display attributes like filename, size, creation date, and other details that are collected and added as the Show is rendered. Stock photographers might enjoy placing details like image size and resolution. We're just interested in the ability to superimpose the file name without the extension. That is the same as the order number for the picture in the online shopping cart. I've already placed the macro as a caption and adjusted it. The /f in the upper-left portion Preview area is the macro. As each slide is displayed, the file name will be placed in that location.

Click the Done button and the macro is in place. The effect can be seen at once. All the thumbnails in the Slide List now display the file name. Most users won't want the file name to show on the title and credits that play at the start and end of the Show, or any that tell the viewer how to order, etc.

Removing a global caption (one made using the Show Options dialog box) from an individual slide is easy. Select the slide and open the Show Options dialog box. Choose the Show Captions icon. In the Captions List, there are three check boxes in front of each caption. Uncheck the middle one. The caption, and any macros associated with it, is deactivated for that slide.

Saving the Numbered Show and Updating the Project

Now we are ready to save this version of the Show. Open the File menu and choose Save As. In our projects, we usually name this Show with the same name and add the word numbered. Now we have two Shows and can turn to making our production a real project. The Project menu is used to open, close, add, and remove Shows from a project. Depending on your current settings, the existing project or

just the current Show may be open. Use the Project menu to open the Proofs Project, and then add the new Show to the first one.

Once this step is complete, the ProShow interface should display two tabs just under the menus on the left side of the program interface, as shown in Figure 17.11. The names on the tabs are taken from the ones set in the Show Title box in the General Show Options section of the Show Options dialog box. Don't worry if they don't match the file names. In fact, we often make them different. The Show Title is the name that will appear in the program's user menus when your client wants to select a version to play.

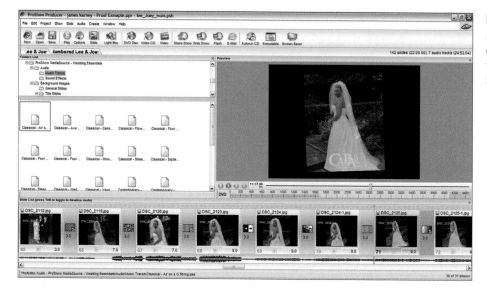

Figure 17.11 The project now has two Shows, as depicted by the tabs with their titles located just under the menu bar.

Determining File Size

There are some elements of the interface that have not been properly introduced yet. Up until now, we have not paid any attention to file size. The real issue with file size is the capacity of the target media. Depending on the version, ProShow can be used to author DVDs, CDs, screen savers, iPod movies, and more.

The size of the final Show or project varies with the output media, since different formats have different specifications and overhead. (For example, the exact same content will be much greater for a DVD than a screen saver.) When you have two almost identical Shows, due to fit on one DVD disc, then the size can simply be doubled. If the Show gets too big, then the source files will have to be made smaller.

An average Proof Project, using full-resolution JPEGS, should fit on a DVD. The Show used as an example in this chapter has 142 images, seven audio tracks, and a menu. The DVD version will take up 1.7GB and the EXE another 115MB. The

math is pretty simple, two DVD Shows, and one EXE. The total is about 3.5GB All that fits easily on a single DVD. ProShow handles creating the proper output files, menus, thumbnails, managing file locations, and all of the background file location and management details for you during output.

See the green bar and the letters "DVD" just underneath the main Preview pane in Figure 17.11? That scale notes the size of total current Show content, along with a ruler that displays the current output type. Clicking on those letters will cycle between the supported output types. The unit of measure will change to note the current size against the allowable media—640MB for a standard CD and 4.7GB for a standard DVD. If a single Show will exceed the size of the output media, the excess will be shown in red on the measurement bar.

One way to look at ProShow projects is to consider them as a collection of files that are combined and presented to the viewer. The format of the output file will vary both in size and quality based on the viewing device, the resolution, and the type and number of files that it contains. ProShow will perform file compression and optimization during rendering. We've found that using full-size JPEGs generates a smaller file size that starts with 16-bit TIFFs.

Each type of output, DVD, CD-ROM, Flash, etc., has a different design. An Autorun file will, in general, be smaller than a CD-ROM version of the same production, which will be smaller than a DVD. That's good, because the CD-ROM holds a lot less data than a DVD.

More Than a Simple Burn—Output Options

Once the Shows are all in the project—looking and sounding the way we want—it's time to create the actual output files. The controls for output are located in the Create menu. Open it and choose the type of export desired. A dialog box will open with different options based on the type of product you are creating. The Output Options dialog box similar to the one shown in Figure 17.12 will open.

The title bar and options vary depending on both the type of output selected and which edition of ProShow you're using. That includes the types of output and the special effects that can be added during the process. The Photodex website has the details for the

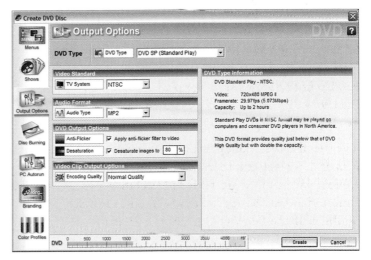

Figure 17.12 Output options vary between the different editions of ProShow, but all have the same basic Output Options dialog box.

current product line, and that is the best place to check. Producer will have the greatest range of formats and features. Walk through the submenus and choose the extras desired for your production.

As you can see from the details in Figure 17.12, there is often a variety of resolution and compatibility output options. For most general use, the defaults will work fine in North America. Users in Europe may have to change the NSTC settings to PAL to be compatible with their TV systems. The Information panel next to the options should provide the needed facts to set things right.

Setting Up Menus

While a single Show can be created in such a way that the program will play as soon as it is loaded in a player, a production with multiple Shows or options needs a menu. Custom menus can really increase the professional appearance of a production and promote business. ProShow includes a dedicated editor as part of the array of output tools. Clicking on the Menus button located on the left side of the Create dialog box opens the main Menus dialog box, shown in Figure 17.13.

The menu shown in Figure 17.13 is already completed. It includes background artwork, a title, a portrait of the couple, and two menu options. The portrait is actually a link to the

Figure 17.13 Menus can be used not only to offer selections to a Show's viewer, but also to provide a branded, professional appearance.

primary Show, as is the first caption (which doubles as the first menu option directly underneath). The process only took a few minutes. The customizing features are extensive, but easy to use. They can produce very professional results, especially if you have the Producer Edition. Going into all the detailed steps click by click is beyond the scope of this chapter, so I'll just highlight the process.

The background image behind the portrait of the couple is one of the menu theme images selected using the scroll list at the top of the dialog box. Choosing one brings it into the Preview area and adds it to the menu. We usually use a template with space for two Shows, each with a thumbnail image and a caption. The first is the unnumbered Show, with the couple's name. We list that as the Feature Presentation. The second uses a different thumbnail and is captioned as Numbered Proofs. Adding these adjustments is done using the Customize Menu dialog box. Open it by clicking on the Customize button located on the right side of the Create dialog box when the Menus option is selected, as shown in Figure 17.13. That will open the controls shown in Figure 17.14.

Figure 17.14 The Customize Menus dialog box has all the controls needed to produce a polished user interface for output.

The basic layout of this dialog box should be familiar by now. Use the icons in the column on the left to choose the set of tools to display. In Figure 17.14, the Shows icon is active. That's the one I used to add the portrait to the menu. That's done using the Set Thumbnail button on the right side of the panel just under the Show listings.

Menus can contain several pages, depending on how complicated the user interface needs to be to offer the appropriate options. We only have two Shows and don't really need extra pages. The simplest approach is to add captions and link them to the two Shows in the project. Figure 17.15 shows the Menus dialog box with the Captions option selected.

See the box around the caption reading "Play Feature Presentation"? It was selected with a mouse click. Then the action was set to have the first Show run when a user chose that option. That's done in the set of boxes in the lower-left corner of the box labeled Caption Options. The process was repeated for the second Show. Choose the action in the top drop-down box, then choose the Show in the bottom one.

The Caption List at the top of the page is used to add, remove, show, and hide captions. There are several standard captions already defined. They are Previous (goes back one Show), Next (plays the next Show in order), Loop All (runs the Shows over and over), and Play All. Any user-defined captions are added to the list. The check marks turn a caption on (if checked) or off.

Figure 17.15 Setting up menu captions and actions.

We also added a sound track that plays while the menu is on the screen using the Music menu under the Customize Menu options. One you have a menu set as you want, the Save Theme and Save Layout buttons on the bottom can be used to store a design and all the settings for future use. We do that and then customize the images and captions for that project.

Setting the Burn Option and Adding the PC Autorun File

Photodex uses its own video rendering and burning engines to produce output. The first time you make a DVD or other optical platter, check the Disc Burning options. (Click on that icon on the left side of the Create dialog box.) If sending the files directly to a drive, make sure the program lists the correct target drive. ProShow can also create an ISO file that can be used by third-party programs to burn the Show to a drive. If that is what is being done, set the file name and location for the file using the same menu.

Our Shows almost always include a PC Autorun file. This lets a user load the disc into a PC optical drive and use all the same features they would enjoy with the program in a DVD player. If the Show is created using Producer, you have extra copy protection and sales opportunities available.

All that has to be done to add a basic PC Autorun file to a program is to check the Enable button at the top of the PC Autorun dialog box, as shown in Figure 17.16. There is no need to worry about a menu listing. The Show will use the

same menu as the one set up for the regular production. If the viewer has Autorun enabled on their PC, the menu will automatically appear shortly after the disc is inserted in the drive. If not, they can click on the Show icon to launch the menu.

The dialog box lets us set the output quality, adjust the display settings that the Show will use, and tweak performance settings. The ones set as defaults will work well most of the time. The program manual offers details on the use of these options.

Now look at the Protection settings in the right-hand column of the dialog box. The author can set how many times the Show can run before locking out, how many days it is available, and install an unlock key. There is also the ability to add a link to a website where the viewer can purchase the unlock key or an unrestricted version of the Show.

Figure 17.16 Adding a PC Autorun file adds value and increased copy protection options to a production.

Branding and Burning the Production

The project is ready for burning now. All that is required is to press the Create button. But Producer owners can do even more to customize the way the Show is presented to polish the performance. Click on the Branding icon in the left-hand column, and the dialog box shown in Figure 17.17 is presented. Once again, I've already made modifications to demonstrate the possibilities.

Our studio uses branding to display both our logo and a copyright notice as the Show loads. All that is required is adding a graphic file (created in an editor like Photoshop) to replace the one provided by Photodex with Producer. (It is only a feature with that version of the program.) The preview shows how the final loading animation will look.

Figure 17.17 Branding offers the ability to advertise your business as the production is loaded.

The options allow the user to adjust the color of the text and the moving bar that shows the loading progress. When the Show is loaded on a computer, the animation will indicate the progress (usually only a few seconds) until the menu is displayed.

Once all the desired options have been set, the project is ready to be output onto media. The time and resources required will vary with the type of file being created. You can create DVDs, CD-ROMs, ISO files for later burning, and (for Producer owners, Flash and iPod movies). Check the Create menu or program documentation for details.

It's always a good idea to test a Show on all compatible platforms once the output process in finished. For the kind of Show we just created, that means running it on both a DVD player and a PC. Check the menus, look for typos in captions, and let the Show run. Sometimes there are flaws that only become obvious on the "big screen." That's why we save files. If needed, open the files, make the changes, then burn another disc.

That is the Proofing Show process. It took longer to describe than perform. Now let's take a brief tour of some of the advanced features that ProShow offers those willing to extend a bit more time.

Getting Things Moving

The real power in Producer is its professional controls, those that go far beyond the basics we have mostly used so far. This chapter is too short to really teach all the advanced techniques, but we can play with two of the most potent tools— motion and sound editing—and really add some style to our production.

Ken Burns is famous for his video documentaries, like the ones on the Civil War and baseball. The majority of the Civil War series used a combination of stills, motion effects, and audio to tell the story. Those same techniques can be brought to your own Shows, using the tools in Producer. With most weddings, our feature Show has a lot more polish than the basic Proofing Show that is displayed with the numbers. That means using some of Producer's advanced features. The primary tool is motion, making the picture pan and zoom to draw the eye and tell a story. Let's start there.

The Importance of Eye Carriage

A single image, a still, is a slice of time. The viewpoint and the action are frozen. Cropping a picture lets us frame the key element of the image. Motion, the ability to pan and zoom, offers the ability to turn the single painted, static, nature of a single image into a series of vignettes. The direction of movement, the amount

of enlargement, the amount of time each element stays in view in relation to the others—all contribute to the effect.

"Eye carriage" is the term used to describe how the eyes (and the mind behind them) travel as they take in a scene. For still images, the only way to control both the content of an image, and the possible way the viewer's eyes will view it, are limited to cropping and adjusting contrast. Both Gold and Producer add the element of motion. We can pan and zoom (in and out) while the image is displayed. Producer offers even more control: the ability to break the motion and timing into individual frames.

While the skills involved in making motion work are the stuff of college courses, most photographers have little trouble in creating effective motion effects once they learn the basics. The "eye" a wedding shooter develops, and the ability to track and anticipate a subject, can be translated into close-ups and sequences that bring the viewer to almost the same point of awareness as the photographer. Most animation tools are complicated to learn and use; Gold and Producer let us add motion effects with just a mouse and an interactive Preview area.

Double-click on an image in the Slide List. The Slide Options dialog box opens. Now click on the Motions icon, and a dialog box like the one in Figure 17.18 opens. See the "two" images? They are really just the two sides of one picture.

When photographing the wedding, I framed the groom watching the bride's parents lifting her veil. It tells the story as a still, but it's fixed in time. With Producer's

Figure 17.18 The basic controls for adding motion are all available using the mouse.

pan and zoom effects, the image opens with a close-up of the groom's face, then pulls back and pans left to show the bride's face after taking in the action of the veil. The transition effects that bordered this image and the ones before and after were specifically selected to accent the visual flow and the position of the subjects. Here's how it was done.

Motions with the Mouse

When you open the Motions dialog box for the first time with an image, the before and after are the same, and the entire image is shown. That's because the picture never moves while it is being displayed during playback. It's easy to change that fixed display into an animation that runs for the duration of the play time for that slide.

The image preview in the Motion Effects dialog box is interactive, letting the user add pan and zoom effects directly, rather than having to enter zoom factors and motion coordinates into dialog box forms. Click in the first slide. Use the mouse wheel to zoom in and out, and the left mouse button to drag the image around in the frame. First I dragged the groom into the center of the field with the left button, then spun the mouse wheel to crop his face to the desired size and location in the full frame.

In the second window, I panned the picture to get the bride's face more centrally located and zoomed in a bit. Producer calculated the motion effects and entered the proper values into the setting boxes. Users can also enter or adjust the values manually. Pressing the Play button below the left window previewed the effect. I tweaked it a bit, then added a longer time for the slide so that the movement would appear smooth. The program calculated the math needed to produce the effect without any need to add numbers into boxes.

The best way to get familiar with both the interface and motion effects is to use them. As you get more experience, then its time to branch out and play with manually adjusting the numbers to get precise placement and adding Key frames to control the exact timing and placement of the effects during playback. Key frames are a Producer feature that lets us divide the motion effects during a playback into segments, and each segment can have its own settings. You can really do some elaborate motion effects using them. That level of detail is worthy of a couple of chapters in a dedicated book. Let's look at another basic example that demonstrates the concept.

Same dialog box, different image, and a variation on the pan and zoom effects. As I arrived at the wedding location, the bride was out walking wearing jeans and her veil. She was waiting for the rest of the bridal party and her gown. The still picture was cute, but only as an accent image in the album. It became the opener in the multimedia version. The still in the right window shows the entire picture that

is displayed as the slide fades out. The one on the left is the same image, but zoomed and cropped to show only the hands holding the food.

As the title slide dissolves, the viewer sees the image in the left Preview window in Figure 17.19. The eye is drawn to the hand holding the takeout. As the image pans to the right and becomes smaller, the eye is drawn with the motion and it becomes clear that this is the pacing and waiting bride.

Figure 17.19 Using a simple pan and zoom effect.

The key to using basic motion effects is to use the motion the same way the eye studies a scene to gain understanding of the picture elements and the perceived motion or action it contains. Zooming in can be used to force the eye to look more closely, by cropping; pulling back will reveal more information with a wide-angle long shot. That is exactly what was done in this example.

A good way get a better understanding is to pay attention to the way the camera's motion and point of view are used in movies. Each shot is crafted to use eye carriage, cropping, wide shots, and motion effects to bring the viewer's attention into the picture and to focus on the desired portions of the scene.

Looking Deeper into the Interface

ProShow Producer has a very versatile interface, and often offers several ways to accomplish a task. Open a Slide Options dialog box by clicking on the image in the Slide List. Now double-click on the left side Preview image. The result will

be the dialog box shown in Figure 17.20. The screenshot is the same slide we have been working with, captured as the preview was playing during the closing transition.

See the red arrow under the timeline located at the top-left side of the interface? The Play/Stop toggle button is located just to the timeline's left. This is a great aid when working with precise timings, and it can be toggled to manage both motion and caption effects with individual slides. It pays off in productivity to play and experiment with the interface and explore its options.

See the torn black edge effect to the left of the bride? This is the leading edge of the exit transition. This effect was chosen to enhance the sense of movement and eye carriage into the motion effects in the next slide. The bride is getting visually smaller and "walking" to the right. These kinds of both visual and image content transitions add meaning and visual continuity to the production. The goal is to have the mind and the eye follow the action with ease and understanding. The best way to gain a sense of these elements and develop skills in adding them to your work is to view productions and movies that use them well, and then experiment with similar effects. Photodex has design contests with winning entries that can be seen on their website. That's a good place to start developing both your eye and ear for good production.

Figure 17.20 The Preview interface provides an alternate way to work with effects on a single slide.

Consider the Possibilities

This chapter provided an introduction to how ProShow Producer can be used to enhance both the wedding photographer's product line and marketing. The more people who view proofs and are impressed, the more sales follow. ProShow productions cost a lot less than paper proofs, and clients can share the viewing experience. A polished production is a product in its own right, either as a stand-alone sale or part of a deluxe package. Finally, Photodex Sharing lets both the photographer and the couple showcase the images from the event without additional cost. Not a bad combination.

There is a lot more to Producer than we have room to cover in this book. Advanced features like layers (that let us work with more than one picture on a single slide), sophisticated sound editing (like cross-fades), and the ability to use a template that can automatically add photographs as they are captured, including via wireless transmission (allowing real-time slideshows for events like receptions) are all in its bag of tricks and the subject of another book.

Next Up

While some photographers are offering the clients all image files, and others are providing multimedia products, there are still a lot of clients who say "Show us the album," both when shopping and when they make the deal. Chapter 18 covers the types of albums, techniques for designing popular flush-mount and short-run press products, and working with the lab and the album company to develop an efficient workflow and profitable relationship.

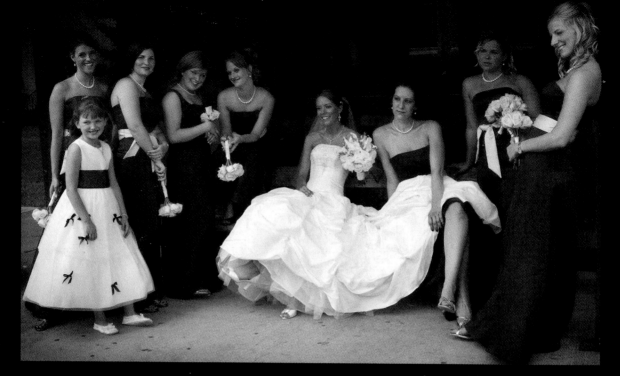

Photograph by TriCoast Photography

18

Albums Demystified

Albums are a major reason why many couples hire a wedding photographer. They want their pictures arranged and bound into a custom book. Professional albums are more than just a device to hold pictures. They are a crafted storybook using a series of images arranged to tell the story of the day. Today's market offers more than the traditional hinged book with a collection of individual prints dry-mounted under mats or slipped inside archival inserts.

The key word in albums is variety, both in the range of products, and how they are produced. This chapter provides an overview of the market, the selling process, the workflow production, and the basics of layout and design. That's a lot of information. Novices often don't understand all the details involved in producing albums. Many photographers simply stick with one type of album, and often the method they first learned.

It's impossible to get a complete education on albums and their design in a single chapter of a book, or even an entire volume. Some issues are a matter of personal preference, knowing your clients, and experience. Also, there is a wide range of products and production technologies, not to mention the variations of individual vendors.

The material in this chapter is organized so as to make it easy for both newcomers and "old salts" to get value from reading it. First we cover the current crop of products, then the complete workflow, and then turn to the specifics of actually designing and laying out the product. There are valuable tips on choosing and working with labs and album companies, as well as an introduction to layout software. We'll also explain the common "gotchas" and how to avoid them.

Something Old, Something New... the Custom Wedding Book

Traditional albums still exist, but alongside a range of options, from small "bragging books" with soft covers to fine leather-bound volumes with flush-mounted photographic pages. Each page displays multiple images in custom layouts with artistic backgrounds. There are also coffee table books with glossy book jackets, produced using short-run printing presses, with a quality that rivals fine art books.

These products tell the story better and offer incredible flexibility in both layout and design. They let the photographer include more pictures at lower cost—and often with greater profits, that is, if you can keep production time and expenses to a minimum. This chapter shows how it's done. Before we get into the design and production, let's look more closely at the products and discuss how to choose the types that best suit your style of work, clients, and workflow.

Some albums can be done completely by the photographer. Others require a bindery or printing house. In either case, you need a supplier. Our studio commissions Classic Albums in Brooklyn, New York to produce most of our albums. They can do the entire job, if you send the files. The firm was founded in the 1930s; they offer a full range of designs, from the traditional mat styles, to flush-mount albums, to the latest short-run press editions. There is more information on them in Appendix A, "Resource Guide," on the companion website (www.courseptr.com/downloads).

There are several firms that provide similar products and services. Most will create a sample album at a substantial discount. Just as with professional photo labs, it's a good idea to establish a working relationship with a firm and know their order process and delivery times before actually sending in a job for a paying client. When shopping, price is important, but there are other considerations.

We do the design ourselves, let our lab handle the printing, and then send the prints for binding. Let's start with a look at the most common types of albums, how they are produced, their relative benefits and features, and how they fit into the wedding market. Along the way, I'll point out the relative level of effort and skills required to produce the different styles and to add options. That can be handy if this is your first foray into book production.

Parts Is Parts and Some Wedding Albums Have More Than Others

As mentioned, there are many different types of wedding albums, in all kinds of sizes, using a variety of production methods, binding styles, and mounting techniques. The following list provides a good introduction. Trade shows and

seminars are good places to examine them. The pictures in this chapter and on vendors' websites are helpful, but getting a hands-on look is well worth the effort.

All Albums Are Not Created Equal

Some clients consider buying a consumer-grade product and doing the album themselves. They should be advised that less-expensive products do not protect their prints (and the memories they contain) as well as a professional product, and they may have acids and other contaminates in the paper, which can damage photographic prints. Also, the professional albums offer a wider range of materials and features.

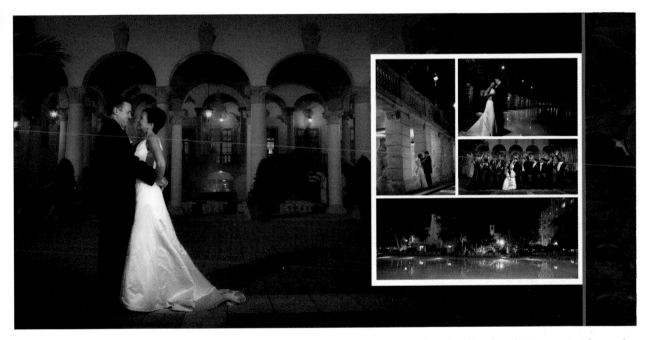

Figure 18.1 Professionally designed and bound custom albums showcase the photographer's work and are a treasured record of the wedding for the client. (Design by TriCoast Photography)

Another selling point in the photographer's favor is the production of a one-of-a-kind design, crafted to the couple's choices and style. Professional albums come in several price ranges. Costs vary with the quality of the materials and the number of extra features. It's a good idea to obtain samples and swatch books to show clients the different options, which can be used to show how your products differ from those bought at a local store. Here are some of the custom enhancements that can be added to most albums.

Custom Cover Materials

The outside of the book is usually bound with a leather or fabric covering. With a custom design, the couple chooses a material to suit their style, color, and price

preferences. Some covers are more durable, easier to keep clean, or come in a wider range of colors.

Your vendor should have a set of leather swatch books that have samples of the different grades, finishes, and colors of coverings available. A telephone chat with the sales staff at the album company can provide you with good tips on quality and the nature of the different grades of materials.

Cameos and Insets

The front cover of a leather- or fabric-bound album can be crafted with an insert or cameo as part of the design. We often make a composite that contains a portrait of the couple placed with a reproduction of their wedding invitation. We'll show how the image is created later in the chapter.

When selling and printing an inset, make sure that the picture will crop to the desired size and shape. The opening can be round, oval, square, or rectangular. For example, if the picture was shot for an 8x10 format, is there enough image area to make a 5x7? Check the submission requirements for mounting space. Part of the image will be covered to enable mounting it in the opening.

Photographic Covers

Another cover option is to use a photograph or composite image as the actual cover. The album company can treat an image or convert it to a canvas, and wrap that as the front and/or back cover of the book. Another option is a Lucite cover that contains a photograph. These can be made for both the front and back covers.

Custom Sizes and Designs

One size does not fit all. While the most common sizes run in the 10x10, 10x15, and 12x12 inch range, the couple can choose just about any size album that suits their display plans or the layout of the pictures inside. Custom books can contain the exact number of pages needed to display all of the desired pictures and allow creative designs and layouts, which a small number of pages can't accommodate.

Figure 18.2 Photographic covers are becoming more popular. This example shows a print bound in a sheet of Lucite.

The size of the album affects the price. There are more materials in a bigger book, and the prints are larger as well. Lab print sizes don't always match the page sizes. That means wasting paper, which has to be paid for and trimmed. We promote a standard 10x10-inch size for wedding albums and 5x5 inches for companion sets. That makes both layout and sizing simple. The same page content can be used for both books.

Quality and Custom Liners

Just as with the cover, the client can choose from a variety of inside linings. These are the fabric sheets on the inside of the covers, and sometimes they also are used as a "flysheet" to protect the first and last pages. They range from simple fabrics to bas-relief pressed paper with hand-painted designs. The couple may also use an heirloom fabric if they wish.

Imprinting and Special Pages

Adding the name of the bride and groom, the location, and the date of the ceremony is another popular way couples customize the product. Some albums can be fitted with additional paper forms, like pages that were used in the guest book for the wedding.

Tip

We always make the bride and groom write out the exact wording for their album, and agree that the spelling and content is what they both want. Then we copy and verify the lettering. Save the paper. Typographical errors and unusual variations in spelling names can cause real problems if the album arrives and something is wrong. The cover will have to be replaced and the book rebound. That is expensive and takes time, not to mention dealing with the upset couple, as the pleasure of seeing the images turns to something else.

Gilded Edges

Many styles of albums have edges that are sanded and covered with special metallic tape. These can be set to match the cover color. A popular option is to gild the edges with golden, sliver, copper, and colored coatings to enhance the appearance and blend with the color of the coverings. Imprinting can be done in the same tone to further accent the design.

Presentation Boxes and Cloth Covers

The emotional value and cost of the album make it worthy of a custom case or fine fabric sack to protect it from exposure damage. Including such an option adds to the presentation and perceived quality of the product. There are custom cases that can be used to add visual appeal when the album is displayed on a bookshelf.

Companion Albums

Many photographers offer companion albums for the couple's parents, grandparents, and members of the bridal party. They can contain pages that are specially designed for the purpose or are copies of some pages in the main album. The latest trend is to create smaller "bragging books" and short-run, full-color press volumes. Classic Albums can actually take the same image files used for the photographic album and reformat them to allow for the margins and gutters of the press run and produce both at the same time.

The Sticking Point

In spite of all these differences, there are some basic parts that are common to all wedding albums: content (the pages and the pictures), the covers, and some type of binding system. We produce the pictures. The album company provides the rest. Notice that the list includes both pages and pictures. If the book is printed using a printing press, then the pages are printed with the pictures on them using high-quality magazine paper stock. If we are using actual photographic prints, then they must be physically mounted onto the pages.

How the images are bound to the pages is a good place to start discussing album types, because that part of the process determines if the assembly can be done by the photographer or by the album company. There are two types of album that can be assembled by the photographer, stick-on and slip-in.

Stick-On Mounting

Stick-on albums have pages with an adhesive on each side, covered by a removable sheet of paper. There are stick-on books starting to become available that allow the user to remove and replace the prints; most still use a permanent adhesive. The album is assembled by removing the protective sheet and *carefully* positioning the print.

Once everything is properly aligned, pressure is applied to bond the print to the page. The extra emphasis on the word "carefully" indicates just how important it is to get things placed just right with perma-

Figure 18.3 Inexpensive and simple to produce, stick-on albums are available in smaller sizes.

nent-mount books. With permanent models, if the print is not perfectly flat—is not exactly lined to the underlying page—then the entire album may be unusable. That can be expensive if you are mounting one of the last pages!

These types of albums range in size from small-square and wallet-sized books to full-sized albums. They come with covers that range from soft-paper and cloth to quality leather. We use them for small gift books. The risk, and cost, of a mislaid print is not so great. They can fit in a purse or desk drawer at work. Shown off, they promote the photographer as well as let the owner share the images of the wedding day.

One nice thing about stick-on albums is that they can be purchased ahead of time and stored as studio stock. Keep an eye open for sales and special offers. That's a good way to obtain a few to use as samples of your work to pass around during that first client interview. For clients who want a book in a hurry, these albums are the answer. All that you need are the prints, the book, and a steady hand.

Slip-In Albums

If the thought of messing up a print when placing it on the page, or the limitations of pre-defined page counts, gives you pause, consider slip-ins. Each page has two sides, and both sides have a border that forms a sleeve with an opening on the top. The picture is slid into an insert, which is then slid through the opening. The border holds the assembly on the page. Mats are used to form an exact frame around the picture.

There are all kinds of mat designs. Some mats have a single frame for one print. For example, a 10x10-inch page can take mats that hold one 10x10 square print or an 8x10-inch print in either a vertical or horizontal position. Others are designed to show a mix of prints in an arrangement, like two wallet-sized images with a 5x7 on a single page.

Some labs offer templates in their ordering software for producing collage prints sized to match the dimensions of an album page, with set locations to place smaller images. That makes it easy to create basic designs. If you use individual prints cut to size, they have to be taped into place under the mat.

Figure 18.4 Slip-in styles are another option for the photographer who wants to provide a simple design that can be stocked in advance and assembled in-house.

Slip-in albums are available in a wide range of sizes, but you have to order them from the album company, specifying the number of pages and the type of binding. The main advantage of the slip-in album is in-house production. You can charge for your time, rather than outsourcing the work. The problem is you still have to do the work, and the product lacks the polish of its dry-mounted and printed counterparts.

It takes about a month to get a custom-made slip-in album from the vendor. They have to cut, build, and bind the book. You have to do the design and have the proper collection of mats on hand to take the sizes of prints that are to be laid out on each page. This may crimp your style. Mats are often sold in boxes that all contain the same style of cut-outs.

> **Tip**
>
> Photographers who have never worked with albums before and have little design experience may feel more comfortable using a slip-in model for their first project, perhaps as a sample that can hold several portfolio images.
>
> The basic steps and overall construction is a good introduction, and the prints can be easily exchanged at any time.
>
> Some firms offer a basic assortment of mats, allowing the ability to experiment with different layouts and designs.

Dry-Mounted Matted Designs

Print-mounting is a process that sandwiches a sheet of adhesive between the front of the page and the back of the print. The assembly is pressed, trimmed, and often finished with a gilded edge. Mats are placed over the prints in this type of album, with similar designs to those found in slip-in books.

These albums are done at the bindery, and the pages are treated with finishes to protect the prints during handling and enhance preservation. The turn-around time once the prints are at the vendor runs about three to four weeks.

Flush-Mount Designs

Dry-mount albums don't have to have mats. Prints can be bound to the page, trimmed, sanded, and edged to provide a single smooth page. By binding collages of images printed on a single page, the designer has complete freedom over placement. By using drop shadows, borders, background, and good use of eye carriage and white space when placing images, designers can craft custom albums that are truly one of a kind.

Figure 18.5 There are several styles of traditionally mounted albums. This style uses mats to frame a series of prints on a single page.

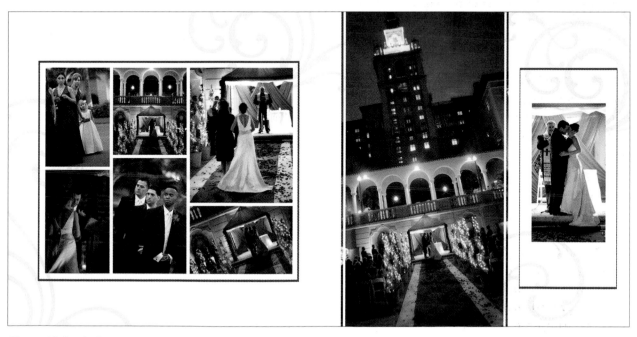

Figure 18.6 Flush mount designs offer the most layout flexibility. There are no mats, so the designer can use the entire area for images. Facing pages can be laid out as a panorama. (Design by TriCoast Photography)

Some flush-mount albums offer the added advantage of panoramic layouts. The print is cut or folded in the center, but with a very fine line. The two pages have only a 1/16-inch separation when opened. As long as a key element of the image (like the bride or groom's face) is not on that line, the two pages form a single panoramic print. We will work with this type of design later in the chapter. A flush-mount album takes three to four weeks in the shop to produce.

Short-Run Full-Color Press

The most recent addition to the ever-expanding collection of wedding album types is the short-run book. Unlike the other books, this is actually created using printing rather than photographic technology. The printer produces four-color output on very high-quality paper stock that is designed to show photographic images well. The pages can be bound in hard-cover or soft-cover form. The result is a volume that looks like a top-of-the-line coffee table book. Photographic covers and book jackets are also available to complete the design.

The designer must allow for the hidden part of the page called the *gutter*, on the inside of the book, which will not open out because of the binding. The exact amount

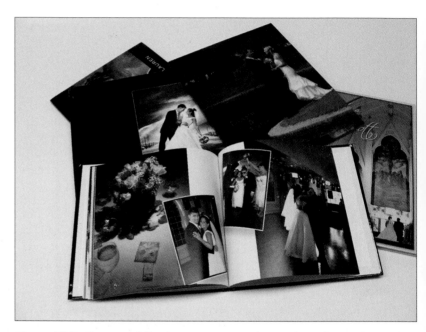

Figure 18.7 Short-run full-color presses are used to produce albums that rival the quality of coffee table books, The same design software used to produce photographic prints for mounted albums can output files that can sent directly to the printer for this type of product.

varies with the bindery system. Companies like Classic Albums can take the files for an album and make adjustments to them to produce a short-run edition of a photographic wedding album. They then return both to the studio. We offer a package with a flush-mount or matted photographic album for the couple and a pair of smaller coffee table editions for the parents of bride and groom. The standard turn-around time for a short-run press book is about three weeks.

Binding Options

There are several different ways to bind pages to the spine of the book. (This is the back part that keeps the pages in place and allows them to be turned.) There are a number of different methods. The one used will vary with the type of album,

the number of pages involved, and the company. When considering styles, become familiar with the bindings used and how they affect the appearance and layout capability.

Other Options

So far, the list has focused on the high-end full albums. There are also specialty products that can house images. When shopping for a product line, check out the binders, proof books, and print boxes in the catalog. There are also presentation folders and matted frame sets that hold several small prints. They can be used to up-sell paper proofs and gift prints to the client. We offer some of these with our high-end packages, which can be given as gifts to the bridal party or family members.

Pricing and Selling Custom Albums

Producing (and pricing) a custom album can be as simple or as involved as the photographer desires. Some take the easy way and hand the entire job to a third party. There are independent designers and album companies that will take your files, prepare proofs, and see the job through to conclusion.

"All" you have to do is sell the client, set the price, and pay the invoice. Prices vary, and so does ability and service. Those considering this approach should either stick to a well-known firm or get references. Actually, references are good in both cases.

Another option is to make the design yourself and have the vendor handle the rest of the production. We actually handle the design and printing ourselves (the prints are made by our lab), then let Classic Albums do the rest. That gives us the most control and reduces the price we pay for the product.

Caution

Many studios use ink jet printers to make their photographs. Before making a set for an album, talk it over with the customer service department of the album company. Many will discourage ink jet prints. The album process was designed for traditional chemical prints. Many only will mount ink jet output at the photographer's risk.

Pricing the finished product for the client is another matter. Some studios charge a fee for each image, plus a per-page fee, and then add the covers, extras, and a production fee. We don't like all that adding, and would rather be pushing a shutter button than those on a calculator.

Most of our album sales are focused on the flush-mount or coffee table styles. That limits the hassle of dealing with mats and offers us the most flexibility during layout. The result is often more pictures for less cost. We estimate an average of four images per page. The final count may vary. We let the bride and groom know that album layout is a creative process and that a precise number of pages is hard to predict.

We use a per-page fee, add the basic production cost (there are set fees for things like printing, covers, etc.), then tack on any extras with markup. A basic design is shown to the clients, and they choose the color, imprints, cameos, etc. The package may include a basic album (with a set number of pages). Usually the final album has more pages and several extras, which add to the total price.

One goal in all of our album sales is to make the choice easy on the client. That makes it much easier on us. If they have to dicker over including an image because of the cost per picture, or try to price out the value between flush-mount and matted, the sale can drag on for a long time. When we offer a design, the page count may be greater than the pages in their package or the estimated number, but the couple rarely changes more than a couple of pictures.

Then it's time to add the extras. If the order is large, we usually offer the cameo at cost, or upgrade the leather or liner fabric as a bonus. If they are looking for more value, we tend to add prints as an incentive, not scrimp on the design. Printing a few 8x10s works better for us than doing a redesign and dropping the album fees.

We normally have two or three meetings with the clients. The first is to show the proofs and discuss album options. They choose a type of album and note any pictures they particularly want in the album and if any are to get special treatment, like conversion to black and white or toning effects.

Then the design is created. Once it's ready, we post proofs on the website and use ProShow Producer to create a multimedia presentation, which is shown to the clients at the approval meeting. The couple can see the actual pages, and we use iView to examine high-resolution versions if they wish to look at details of the images.

Album companies have detailed order forms that have to be used to detail the type of album, the layout specifications, desired options, and calculate the price. We fill out most of the information during the final design approval, the one before the images are sent to the lab for printing. That way we make sure the order exactly matches the desires of the client. We also present the final invoice and collect any remaining fees at this meeting.

When the prints are ready, we have the third meeting. They get to see the pages as they will appear in the album, and make a final approval. In some cases, they will change their mind on a picture or add extras to the order, like a cameo. Adjustments are made and the order is sent to the bindery.

Now let's turn our attention to the specifics of creating the album.

Album Production Workflow

Albums can contain well over a hundred images, spreading over 30, 40, or more pages. Some images may need retouching, and there is the matter of quality control and working with the lab, the album company, and the client. We have a standard workflow set up in our studio, which is used to manage the entire process from the time the order comes in until the finished album comes back from the bindery. The following list details the steps.

Order Checking
The first step is going over the order and making a checklist. We note all the details of the client's order: the start date, the projected delivery date, the projected number of pages, and which prints have to be included. We also verify all the financial details. The checklist is a Word document that is kept in the album project folder. A printed copy is kept with the order form.

Setting Up the Workstation
The next task is getting the computer ready for design and layout. All the software required for the job is checked for program updates. That includes FotoFusion (our album layout program), LightZone and Photoshop (our editors), and DisplayMate, the software used to color-calibrate the system. Once that is done, we calibrate the monitor and turn our attention to the files.

Digital (and Sometimes Physical) Asset Management
There are always more images shot at the wedding than ever end up in the album. We cull and sort the "keepers" and the "possibles" (both ours and the clients') into a set of folders with the same categories used for the online proofs. They are stored in a master folder, which has the name of the client and the order date, plus the word "album." The master folder also has copies of the order, the clients' must-have picture list, and any other project-related documents.

The actual wedding images used for the layout are 16-bit TIFFs. We generate them from the processed RAW Bibble Pro or LightZone files. Why use TIFFs instead of the JPEGs? We will be resizing, and maybe retouching and tuning the color balance of the images during the layout. Editing JPEGs several times (and then using the results in a full-page composite) can result in artifacts and poor image quality.

There are also image files that are used by the designer for backgrounds, borders, and accents. We keep those in a separate folder, which can be shared by all album projects. Once all the files are ready, it's time to start making pages.

Create the Design

How this step is handled varies with the type of album. In most cases, we use LumaPix FotoFusion to lay out the pages in the computer. As individual images are added to a page. they are retouched as needed (matching color balance with the other pictures on the page, skin blemishes, etc.). For matted albums, we use the lab's software with the appropriate templates for that type of album.

Generate, Proof, and Send the Lab Files

Once all the pages are designed, we generate a set of full-page JPEGs and water-mark them. These are used as digital proofs. The client is asked to approve the design. Any needed changes are made and verified with the client. Once all is in order, the high-resolution set of JPEGs is generated and sent via the Internet to the lab.

Numbering and Final Proof

When the prints come back from the lab, they are inspected for errors or damage (using care in handling the prints—cotton lab gloves are a good idea). Then the pages are arranged and checked against the layout and placed in order. The order of the pages is double-checked, and the back of each print is carefully numbered using a special soft lead art pencil provided by Classic Albums. The pages are laid out in order, based on the numbers they were given, and the layout is confirmed.

Caution

This is one of the most critical steps in the production process. The mounting team can only work from your numbers. If a page is mislabeled, all the pages from that point forward may be in the wrong place. That will be your problem, with both the delay and the cost of new prints and repair.

Then we meet with the clients and show them the proofs (remember to use the lab gloves). Double-check the order and see if they want to change any options. It happens. If the change requires another lab run, let them know how long the delay will be. We also remind them of the turn-around time for the final album—including shipping time. With standard ground transport, it can take four to six weeks to come in.

Pack the Job and Ship to the Bindery

Carefully pack the prints between stiff cardboard. The album company often has suggestions on securing the package and can make recommendations on the most efficient shipping method for their location. We insure the package for the cost of the prints, and the total shipping fees (from lab to us to bindery to us).

Check the Album and Deliver

Before we call the client and set up the delivery, we always go through the entire album and look for any problems that may have slipped past the quality inspector at the bindery. Flaws are very rare in the finished product, but who wants to have the bride be the first one to spot a problem? Things to look for are pages out of order (usually from misnumbering a print), loose cover materials, uneven or crooked prints, and anything that does not match the order—like a misspelled name or the wrong liner.

In the rare case that a problem is found, call the album company and explain the situation. Get an idea of how long it will take to correct and if they are going to cover the cost of the repair. That information will be very handy when you call the client to explain the delay.

Archive the Job

Once the client has accepted the album, we can archive the files. We save both the master FutoFusion collage file and the source images, as well as the JPEGs that were sent to the lab. That makes it easy to handle a request for a repair if the album is damaged or to generate a new order if a family member wants a companion book.

An Album Layout and Design Primer

The words "layout" and "design" are often used interchangeably, but they are separate terms. "Layout" is the actual act of working with the physical structure of the pages, and placing the design elements on them. Think of the layout as working with a map. We have to define the area, the borders that must be kept free for trimming, mat borders, taping, and binding. These are all things that take away the usable space. The remaining areas are the "safe zones."

Inside the layout, we create the design. "Design" is the way the visual elements (pictures, backgrounds, text, and enhancements, like borders, frames, and drop-shadows) are crafted to interact, set a mood, and tell the story. The colors, cropping, and the visual relationships form the design.

Slip-In and Dry-Mounted Albums, a Simple Approach

If the product is either a slip-in style or a matted edition composed of individual prints, the layout and design process is fairly simple. Fix the list of selected images. Choose the mats that match the spaces where you want the images, and size the pictures to fit those openings.

The traditional way of assembling matted albums was to order individual prints, then have them mounted. Today many labs offer software with album templates that are exactly matched to mat styles. The design process becomes a fill-in-the-blank exercise. Just place the images into the appropriate openings on the virtual mat. The lab creates a single print with a collage that has all the pictures in the right places. Then the prints are placed into the album.

If you want to explore that option, check with your lab and the album companies. Most offer help with their products in setting up the software and learning how to use it. Another option is to use Adobe Photoshop with template plug-ins which match the mats you want to use. A search of the web and the ads in magazines like *Professional Photographer* and *Rangefinder* will yield sources for these products.

When we produce either of these types of albums, the couple chooses the images, and we select the mats and sizes of prints. The more impressive images, and group poses, tend to be printed larger. The pictures vary from "full page" (the actual viewable area depends on the usable safe area), down to a mix of 4x5s and wallets for less-important pictures and accent images from the event.

The Freedom of Full-Page Designs and the Layered-Layout Look

Mat-less albums (flush-mount and short-run press styles) give us the whole page (inside the safe area) as a canvas. There are no fixed areas that we have to use, and most of these types allow spreading the design over two facing pages, a panorama. Pages can be collages, with one picture as a background, or the design can mimic the look of a matted collection. It's possible to change color schemes and add decorative elements at will. (One should be sensitive to good taste when making embellishments.)

Even though the layout is the same, the deliverables needed by the vendor vary. Flush-mount albums require a single print per page, sized to allow for trimming and mounting. Short-run press books need a computer file that can be used to generate the printed page. Some vendors require JEPGs or TIFFs, some will work with PDFs. In either case, the files have to be set to the printer's specifications.

There are several types of programs that can be used to lay out the pages and create the prints and files needed for production. Photoshop is one option, and there are actions and plug-ins available to make the task easier. Graphics programs like InDesign and CorelDRAW are another option.

We use LumaPix's FotoFusion Extreme, designed with wedding albums in mind. The program runs on Windows PCs and Intel-based Macintoshes running Windows with BootCamp or Parallels. A trial version is available at www.lumapix.com. We'll use it to demonstrate the album layout and design process. Program controls and features will vary, depending on the software you choose and the type of album being crafted, but the workflow and critical steps stay the same. Let's take a tour of the program while we discuss the layout and design process.

It Starts with the Virtual Page

When photographers take a picture, we have to work within the confines of the viewfinder and consider the crop of the final image. The same thing is true of page layout. We have to work within the dimensions of the page. Depending on the type of album, there will be a set amount of "dead space" on the edges of the page, which are trimmed or covered during assembly.

The first step, no matter the kind of album, is to set up the pages so we can tell where it's safe to place our design. Many programs refer to the entire layout area as the canvas. So will we. We'll use FotoFusion to demonstrate setting up the canvas as a virtual page. (Only the FotoFusion Extreme Edition allows multiple pages; the other editions are intended for single pages and collages.)

Figure 18.8 Setting up the virtual page.

Since we are not going into a detailed tutorial, I won't explain the precise steps for FotoFusion, just focus on the process. There will be enough information to let you follow along, if desired, with either FotoFusion or a favorite layout program. (If you want a quick introduction to the program's interface and commands, check out the tutorial video on the LumaPix website.)

Figure 18.8 shows a 20x10-inch page open underneath the Canvas Size dialog box used to set its parameters. We'll use this as a visual aid to help describe the parts

of a page in layout terminology. You will need a basic understanding of these terms to configure your program to match the album assembly requirements.

We define our standard pages using the full area of the open album. This presents the entire canvas as it will appear with the book open, just the way the client will view the finished product. The one in the figure is a two-page spread or "double truck," that is, two 10x10 pages side by side. We'll see the design advantages shortly.

Notice the Album Two-Page Spread option selected in the drop-down menu at the top of the dialog box. If the page is cut, or has a border, then we have to be careful of where we place an image so that important parts of the composition are not obscured. That means we have to know just how much of the page is unavailable and how much is.

Setting Margins and Gutters

Margins are a safety factor in the printing industry. They provide a bit of extra space in case something isn't lined up just right. With albums there is always a part of the edge of a page that is either covered by a mat or trimmed to provide a clean appearance after mounting. Gutters are the inside margins when pages are laid side by side.

Gutters often have a different setting from an outer margin. We set out outer margins for flush-mount albums at 1/4-inch and the gutter slightly over a 1/16th of an inch. The gutter increases by about an inch for short-run press books. That's because all we have to worry about with flush-mounts is the physical cut that separates our 20x10 print into two 10x10s. Short-run books are bound, so we have to add gutter space for the part of each page that is held by the spine of the book and the way the page opens when viewed.

See the Printing Zones boxes in the middle of the dialog box? That's how the location of green lines on the pages is set. The lines show the locations of margins and the gutter spread. There are four entries, one for each side of the page. The graphics just under each box show which side of the page the box controls. The one on the left is the left side for single pages, or the gutter in two-page layouts. A fine blue line in the center of the gutter denotes the exact center. (Its visibility varies with the magnification of the work area and is not shown in Figure 18.8.)

Setting the Bleed

"Bleed" is a printing press term: the ink is allowed to "bleed" over the edge of the page past the margins. Like margins, bleeds are a safety zone. The background portion of a design is extended outside the actual printable area. In Figure 18.8, the bleed area is shown as the space outside the red lines

Safe Inset boxes are used to set the bleeds in FotoFusion. Printing presses and digital photo printers don't always line up exactly. If these devices aren't lined up right (or if the source file and the photo printer aren't using the same dots per inch), there will be a slight white line on one side.

Staying Inside the Lines

Once the settings are entered, the lines show where it's safe to place images. The process is repeated for additional page sizes as needed. Different page sizes, and single-page versus double-truck layouts, usually require different margins and gutters. Our 10x10 albums usually have a 10x10 single page on the right-hand side, to appear when the album cover is opened. That's common in most books. It called a "recto" page, from the Latin word for "right." Most of the inside pages are 20x10 panoramas. Another page is often created for a cameo.

The margins show where it's "safe" to place images. Backgrounds and full-page pictures can run right to the edge. Most designers avoid running smaller pictures too close to the margins and leave space between pictures. Part of good design is leaving open areas.

Caution

Check with your lab or the print shop running the press job BEFORE setting any bleeds, and make sure that the safe zones match their requirements. Improper settings can cause problems. We sent test runs to our lab after getting the EXACT dpi settings for their equipment. We were told 300 dpi would work fine, and the first batch came back with a white line down the left edge of every print. We found that the real setting was 254. They just assumed the larger dpi setting would be okay. That extra may be okay for matted designs, but not for flush-mounts. We'll come back to this topic when the conversation turns to output.

Design Elements and the Layered Look

Albums contain pages and pages contain design elements. Pictures are the most common, but not the only components. With matted albums, the "open space" is covered by the mat. Free-form designs (flush-mount, short-run press, and any other collage-style albums) let us build a design from the bare canvas on up. We can layer elements, and even lay one object on top of another.

Let's look at a finished page in FutoFusion. We can use it to identify the primary elements and see how they work together to produce the desired look. The example is taken from the first page of a 10x10 album and is placed to be seen by itself on the right-hand side of the book as the cover is opened. We can also use it to discuss some basic design principles.

Figure 18.9 Designs are built in layers from the background up.

There are four primary design elements on the page shown in Figure 18.9. From the bottom layer up, they are the page, the background, the graphic showing the invitation, and the black-and-white portrait of the bride and groom. FotoFusion works much the same way as the traditional manual layout process.

We start with a blank page, add a background, and then place the other design elements over that. Here we have two items laid over a background. There are also two accents. Both the portrait and the invitation have slight drop shadows on their right and lower sides.

Tip

When placing anything that has noticeable lighting (like pictures) or creates a lighting-type effect (like shadows), it's a good idea to make them all the same in both direction and width. Mixing them up will jumble the design and confuse the viewer's eye.

Our design *seems* simple. Even on a simple page, there is planning required. You have first to decide on the pictures for a given page. There may be just a single image, one primary picture with supporting images, or several pictures that make up a series. I usually choose the image(s) as the first step, then consider a back-

ground, and then arrange the design. That often involves changing a background, adding and subtracting pictures, and cropping the final selections.

It's important to choose a background that visually complements the mood and the colors of the primary elements on the page. The same thing is done when adding accents like borders and drop shadows. I like to vary the backgrounds and the accents, but I am careful to keep from becoming too "creative." The book must be designed to work as a whole, and there must be a good fit between one page and the next. The viewer should feel continuity, both in the design and in the story being told as each page is viewed in order.

Consider our current example. Since it begins the book, it also serves as the title page. The mix of wedding portrait and invitation makes the topic clear, identifies who the book is about (in the production version the portrait was smaller and the full names visible), and sets the tone for the pages to follow.

The original invitation was recreated in CorelDRAW and exported as a TIFF. One of the nice things about digital layout is the ability to produce all kinds of virtual elements and textures. (Scanned copies of invitations don't work as well.)

Our background started out as a photograph of a piece of parchment. Over time, we have assembled a variety of background images, from white satin to black leather, and on to colorful cloth and floral arrangements. The color of the original image was too blue to blend well with the invitation, so we used the editing tools inside FutoFusion to shift the tone of the background.

Figure 18.10 Adjusting the attributes of the background layer.

Image Editing During Design

Shifting the appearance of an image during layout is a very common task. In some cases we want to permanently retouch the source file, say to remove a distraction. In this case, we don't want to alter the real file, just change the way it looks as the background for this page. Good design programs, like FutoFusion and PhotoDex Producer, let us do that.

See the Image dialog box in Figure 18.10? It lets us perform all kinds of adjustments to the selected image in the current layout. We can adjust color, add transparency, shift the gamma, convert a color image to black and white, and add a sepia effect, just to name a few. The changes are not made to the source file; it stays the same. The rendering engine shows the results in the work area, and renders the copy in the final output file the same way. This feature is a real plus, and should be high on the decision list when choosing your layout program.

Let's say you want to actually retouch an image and make the change permanent. Then you tell FutoFusion to use an external editor to open the file and do the work. When you save the results, the modified version is placed in the layout. Our copy of FutoFusion is set so that it will open the source file in one of three editors, chosen from a drop-down list.

The image on the left in Figure 18.11 is a good example of an image that might benefit from retouching some distractions. See the traffic signal just behind the bridesmaid? A round trip in Photoshop could bring back a picture with a little more tree and less technology. On the other had, the pole does add a bit of perspective to the scene. (We removed the signal in the final edition.) Many elements of a design are a matter of personal preference, as well as how much time one has to work on the project. Spending several minutes touching up each of say, 150 pictures, may not be a good use of your resources.

A Little Focus on Design

Before moving on to the next topic, let's take a minute and look closer at the design. It incorporates the basic principles already mentioned. The background is a floral pattern, which has been softened using the Image adjustment dialog box. We just wanted the variations for this picture. The color and intensity of the background was matched to compliment the skin tones of the subjects, the pastel dress worn by the bridesmaid, and the bride's bouquet.

Now observe how the two pictures are positioned on the page. The image on the left is set so that the two visible faces (the bride and the groom) are looking towards the center of the page and the other picture. The full face of the bridesmaid in the picture on the right is doing the same thing there. That is an example of the eye carriage principle introduced in the preceding chapter.

The picture on the left, with the bride in the center, is placed to have the newly-weds be the first point of eye contact and dominate the design. Its larger size and placement on the left side of the page also helps to bring the viewer there first. The one on the right is off-set toward the outer edge of the page. The image, and the bridesmaid's face, is smaller in comparison to the other picture. Those factors add to the visual importance of the left image. The two pictures are joined as a set to show the full interaction of the couple and a very close friend in a moment of joy. The pictures were sized and arranged to add a dynamic feel to the page.

Both pictures have slight drop shadows, which impart a three-dimensional effect to the page. This works well with these pictures on this background. If the background were dark, matching colored borders in a complimentary color would have worked better.

Working with Multiple Pages (and a Little More Design)

While we lay out individual pages, we need to be able to work with all of them as an entity as well. Having to open, output, and manage separate files for each page would be a DAM nightmare. It would make it much more difficult to create panoramas. When choosing a layout program, look for the ability to produce the whole album as a single package and using DAM tools for managing your projects. FutoFusion is an example of a program with the right stuff.

Figure 18.11 shows a panoramic view, the full wide space of a double-truck (two pages designed as a single page) layout. FotoFusion knows that we actually have a two-page spread, but lets us work on both in the same work area. That's the minimum requirement for multi-page capability, and a must-have for serious panoramic layout and design.

Figure 18.11 The ability to work with multiple pages is a necessary feature in an album layout program.

See the lines running down the center of the two pages? They denote the gutter. The album has been set up as a 10x10-inch format with most pages forming a 20x10 panorama, just like the one in the figure. The pages are formed by binding two 10x10s side by side. We lay the pages out on a single 20x10 page. The blue line in the center shows the cut; and the space inside the two green lines on either side of it indicate where not to place anything important. In this case, the line falls across the bridesmaid's shoulder.

Care was taken to size and crop the image to avoid having the line fall on her head or her hair. The amount of the image that is not visible or split will vary with the vendor and the product. Most of our new ones are the Designer Series models from Classic Albums. There is no extra charge for a panoramic layout, with a gutter less than 1/16th of an inch. Hinged albums with mats can have up to an inch or so between the two pages on an open book. That includes the borders, the edges of the pages, and the binding.

There is a panel of thumbnails, one for each set of pages, just to the left of the work area visible in Figure 18.12. These are seen by clicking on the Pages button. They can be used to visually locate a page and open it, or to compare the contents of several pages without having to swap them out in the work area. You can also use this panel to move pages within a project, add pages from another project, or delete pages.

Now we have a different panel open in the left side of the work area in Figure 18.12, the Tree view. Each page is listed by number. Click on a page and it opens in the work area. Click on the little box in front of the page number, and the listing expands to show the files it contains, organized by category. This lets the user easily identify the files, see how they are placed on the page, and adjust the stack order.

Figure 18.12 The Tree panel in FutoFusion is a handy digital asset management device.

See the word "Collage" with several files listed beneath it just above the pop-up menu? (The menu is opened by clicking on a page number.) The files are shown as they are stacked in layers in the collage. Notice the two pictures visible on the page. The upper picture is on a layer stacked underneath the one on the lower right of the couple kissing.

The menu to the right opens when you click on a file number in the Tree list. It lets you move an object up and down in the stack order, group objects, and perform similar tasks. These tools can be very useful when you want to select and work with an image that is partially hidden under another, or to group several objects to maintain relationships when they are moved around the page. Grouping also lets you apply the same enhancements to all the members at once. We use this to add drop shadows and borders, etc.

The background on this page is a picture taken at the wedding, showing the ceremony in progress. We used the FutoFusion layer controls to slightly desaturate it and lower the contrast. This is an example of how local controls in a layout program can be used to craft design elements from existing images. Another example is cropping pictures. If we do that in an external editor, the source file is now cropped. If we use FotoFusion, the entire picture is still available in the source file for use elsewhere.

Consider toning. FutoFusion offers a sepia control, but we prefer the extra control in LightZone for that task. So we open the file there, make the adjustments, then use Save As to provide a new source image.

The Joy of Templates—Why Start from Scratch?

The less time it takes to design an album, the better—as long as we get a quality result. One way to speed up the process is to reuse existing designs. For matted albums we can use templates that let us just fill the openings with images. As mentioned before, many labs offer such solutions for popular designs, using third-party software like Roes (available from many labs) or PhotoBook Software (from DigiLabs).

You can have the same ease of use in FotoFusion. Just save a page or a complete project as a template. The program will save all the layout settings, frame placements, and frame enhancements. Load the template, choose a design, and add the images. It lets you add pages from templates and other projects to a current design.

Figure 18.13 shows an open template. The checkered area is the background, with the lines denoting the safe areas superimposed. The gray boxes are the frames. Drag an image over the frame and it is automatically sized and adjusted to the attributes for that frame.

Figure 18.13 Templates let us reuse layouts and designs in multiple projects.

The icons at the top of the Pages panel are used to add, remove, and shift the locations of pages in the series. You can also duplicate pages and add more from other projects. It's possible to make layouts that have the same "openings" as the ones for specific mats used with dry-mounted mat albums. Then you are free to use any lab with those types of products, not just those that offer a matching design program.

Getting Ready for Export and Working with the Lab

Once the design is ready, it's time to check the work and output the files. That includes re-examining each page for problems, as well as ensuring that the specifications match those required by the lab (or your printer) and the album company.

Final Pages Check

Below is the detailed list of the things we look for; depending on the program, the best order and way to perform them may vary. This list works well with FotoFusion.

Color Correction

With several images on each page, we have to make sure that the critical colors match on all of them. If your design program supports color correction and can make color adjustments, this step can be done on the page. If not, the images may have to be brought into another program like Photoshop.

We choose one image on each page as a reference and make sure the skin tones, the white areas, and neutral tones don't have improper color casts. Any needed adjustments are made. Then all of the other images are compared to it. They are adjusted as needed.

The quick way to do this is by dragging each of the secondary images over the reference file so that a skin tone and a white area are next to each other on both prints. One simple way to achieve this is by placing the bride in the picture being adjusted, so that her face and the gown in each image are overlapped. Make any adjustments to the image being checked, and then use the Undo Move command. In most programs (including FotoFusion) the picture will be placed exactly as it was before.

Image Inspection

Double-check each picture on the page for any items that might still need retouching. The Edit command can be used to open the file in an external editor like LightZone or Photoshop. Once any edits are made, double-check the picture's placement in the design. When all the images have been examined, it's time to perform a final page check.

Page Checks

Open the canvas settings. Are the margins, gutter, and bleed set properly? Is the page size correct? Is the type of page (single or facing pages) set right? Make sure that no important part of an image is outside the green lines or directly on the cut line.

Next, look at the page as whole. Do the borders, drop shadows and other design elements match well? Do all of the colors work well together?

Finally, compare the page with the pages before and after it. Does the page fit well in the overall flow of the album? Is the design of this page consistent with the flow of the story being presented?

Once all the pages are ready, the proofs can be prepared and the final job sent to the vendor making the book. Since proofing methods vary, and since they also involve outputting files, we go straight to the final output process and working with the lab.

Rendering the Image Files

Knowing the Printer

The album is almost ready for output. Before the files are created, the rendering engine has to be properly configured. The settings have to exactly match the requirements of the album company doing the binding or the printer doing the short-run press job.

Some studios like to use one lab for all their work. We use one lab (Luck Color) for our direct fulfillment orders, which are handled via the ImageQuix system. For albums and volume orders (like sports and schools) we use DPI in Charlotte, North Carolina. That's because DPI offers significant discounts for clients who send orders "as-is." They don't crop or color-correct images. We have to set up FutoFusion to the precise dots per inch of their printer. (There is more on their services in Appendix A, "Resource Guide," on the companion website—www.courseptr.com/downloads.)

That's okay, because the album company also wants an exact print for panoramic pages. We have to make sure there is no shift or enlargement at the lab. That could result in an important part of the page falling outside the safe zone.

For photographic prints, find a lab that is willing to print the firsts exactly as sent, then get the answers to the following questions. Use them to configure your output, and then send several files as a test run before sending the first full album to the lab. Here's what you need to know.

Required Color Space

What is the color space that the printer uses? Most are still set to sRGB. If your files are output using say, Adobe sRGB, the colors won't look right.

Dots per Inch

What is the exact dpi setting of the printer? It's imperative that the dpi of the output file exactly matches the dpi of the printer. There are still many labs that tell clients something like, "Just use 300 dpi and send us a good looking JPEG; we can handle it." Printers vary and scaling (enlarging or reducing a 300 dpi JPEG can crop a print or leave an unprinted area on one side of the print. Not good. DPI has printers that are set to 254 dpi, exactly.

File Format and Compression

What is the preferred file type and are there size requirements? Most labs that print "as-is" will take either high-quality JPEG or TIFF files without problem. That's because the image does not have to be modified in any way. (Of course, the source design images have to be of good quality.)

Submission Method

How are the files going to the lab? Most will be able to take the mass of files over the Internet (assuming you have a good fast connection), but may have a preferred time for handing very large jobs. Some may ask that you send in the files on a CD or DVD.

DPI has developed their own ordering software. We use it and have a really good record of just what was sent and ordered. Their operation is centered on high-volume traffic, and they handle a lot of school and sports work.

Exporting and Visually Proofing the Files

The screenshot in Figure 18.14 shows the FutoFusion Export dialog box. We need to give the output files a name (the program will append the page number to a primary name as each file is generated). We also need to fill in the appropriate settings to match the lab requirements.

We also set how the program will run the pages. Let's take the example of a 10x10 album where most of the pages were laid out as a 20x10 double-truck. We could run the full page, and get 20x10-inch files, based on the dpi setting. That works fine if we want to pay for 20x10s, but 10x10s are cheaper, and we (or the album company) will have to cut the pages anyway.

Instead, I've chosen Double Page Separate, located just where the bride's hair is touching the top of the preview box. Now the program will produce two 10x10s for each double-truck, and adjust the numbering scheme.

When the dpi is entered into the Export form, the program will calculate the dimensions of the page and note the dpi in the boxes next to the dpi setting. As a rule, we always set the output quality to "Very High" when preparing JPEG files for the lab.

Once all the adjustments and desired options have been entered, it's time to see the results. Press the Preview button. The program gathers the source files, renders the job, and shows a temporary full-size version in the window. If things are

Figure 18.14 The Export dialog box can be used to both visually proof and render the output files at the specified resolution.

as desired, click the Render button and the full job is written in the chosen format. Once the files are ready, all that's left of this part of the job is sending them to the lab.

Alternate Output Methods and Products

Most layout programs can output more than just JPEGs and TIFFs. FutoFusion can produce Adobe Acrobat PDFs, Photoshop files for retouching or additional design enhancements, GIFs and PNG files for the web, or reduced-size images to use in promotional print products like mailers and brochures.

The program also offers a direct e-mail output option. The user can specify the file quality and size, add watermarks, create an e-mail envelope with message, and send the results, all from within FotoFusion. We use this feature to get quick approval of any final changes. This makes it easy to get the couple's okay on a layout change or to verify any outstanding items without the need for a meeting. The reply also provides a record of their approval. See Figure 18.15.

FutoFusion does more in our studio than just albums. The precise layout and collage features make it a natural for DVD covers, posters, class and sports teams, etc. During our tour, we didn't get into the program's text handling. It can place and enhance text just as easily as an image.

Figure 18.15 E-mail proofs are a quick way to get client approval for modifications to a design.

Final Steps

Once the image files have been sent to the printer (yours, the lab, or the printing press company), the workflow will vary as described earlier in the chapter. Don't archive the files just yet. It's common for relatives and friends to order images, and even pages, from the album when the couple shows off the finished product. Also the pages can be handy as examples for an upcoming bridal show. That's the positive spin.

The other aspect is that you may need to resend a page (or even the job) to the lab. Accidents and mistakes happen, and prints get lost in transit. On rare occasions, a print can get damaged during production or the file was corrupted on the disc or during transmission.

After a decent interval, several months after the album has been delivered, we move all the files related to the event into our back-up storage system. The FutoFusion collage file is left on the master drive. It has all the basic file information as well as the layout. If we do need to bring up an old project, we simply move the source files onto the same drive with the original folder names and the entire design loads fine. It is possible to reconnect the files from a different drive or folder, but that takes some extra work.

Next Up

Smart photographers don't consider delivering the prints and album the end of the arrangement with the new couple. Most brides have a wedding party with at least one prospective bride—a potential client. The bride and groom will need portraits of themselves and probably new children before long. Let's look at building a lasting relationship.

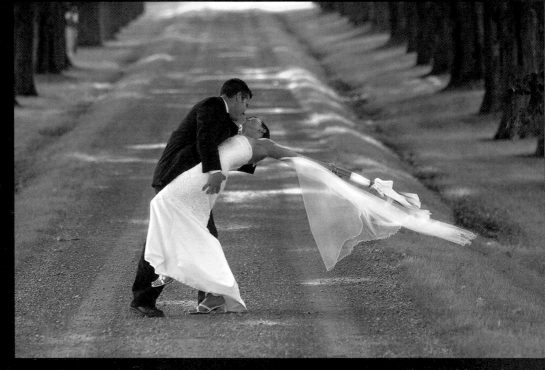

19

After the Honeymoon

We've covered the wedding, processed and printed, designed an album, and made a slick slideshow. The money's collected and everyone is happy. Done? Not quite. Before we close our discussion, let's talk a bit about making the most of our new clients.

Smart photographers don't consider delivering the prints and album the end of the arrangement with the new couple. The bride and groom will need portraits of themselves, and probably new children, before long. There is often a prospective bride in most wedding parties—a potential client. And there is the possibility of residual sales and additional assignments from a number of new contacts—if you take the time to do a bit of planning and follow-up marketing.

Add Value to the Delivery

Nothing says thank you quite as well as a small gift. There are several ways to use your images as gifts to the client that also promote your services and repeat business. We offer a set of Thank You cards or wallet-sized prints to enclose with the notes they already plan to use.

It's easy to add some text, like their names and a brief message using Photoshop, FutoFusion, or CorelDRAW. The individual wallets cost about 10 cents each. Offer them with your logo on the pictures and the studio contact information on the back. The couple will be mailing a sample of your work to their guests, at least the ones that rate a Thank You. See Figure 19.1.

We also offer a free Birth Announcement-New Baby session certificate for their future family additions, and a lifetime membership in our Portrait Club. That allows them a free sitting (not the prints) once each year. Both offers lead to print sales.

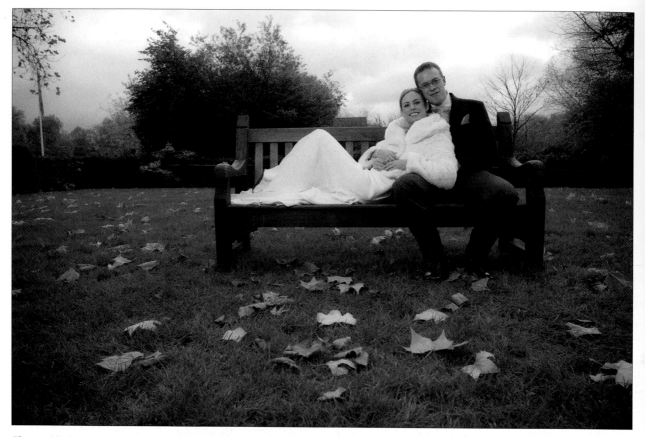

Figure 19.1 Portraits of the couple, either from the formals or the engagement session, make great additions to Thank You notes for gifts and a great marketing item for your studio. (Photo by TriCoast Photography)

And Don't Be a Stranger

We mail a reminder of the Club membership on their anniversary, and add them to the primary studio mailing list. Periodically we send out a newsletter, timed to coincide with photo buying habits. For example, in the fall we promote Christmas card orders, and the summer edition highlights high school seniors. They also have news of our activities, sales offers, and we also showcase current images.

Share the Images (with Permission of Course)

There are some great images in this book; each came from a wedding assignment for a paying client. While not all assignments center on beautiful clients and take place in great-looking venues, they all provide an opportunity to make great pictures. And the really good images can be used in marketing materials, portfolios, sample albums, slideshows, and mailings. That is, if you get permission.

Some states allow verbal permission, but it's always a good idea to get it in writing. The wedding contract can be used to cover the bride and groom. The rest of the wedding party can be handled using a group release that is filled out before the ceremony.

We select several of our best images late each year, and have large prints made and mounted during the sales, which most labs offer in the slow season just after New Year's. If you are planning to enter print competitions, say for the Professional Photographers of America, that's a good time to have them printed as well. Keep in mind that competition prints involve extra work and finishes. They usually are not offered at the discount price.

Another marketing tip for photographers who don't sell frames and mounting—offer to let the frame shop you use display the large prints when you are not using them yourself. They may even offer a discount on the price, since they need good-looking prints to show off the quality of their work.

Prints of bouquets, gowns, rings, and cakes are also marketing tools. See Figure 19.2. A free copy given to the vendor (again with your logo and contact information) can lead to additional referrals. That kind of networking is how many established wedding photographers get most of their bookings.

Figure 19.2 Well-executed images of rings, cakes, and other wedding items are good marketing tools that can lead to referrals when shared with the provider. (Photograph by Mark Ridout)

Know Where to Find the Files

We covered DAM (Digital Asset Management) in detail earlier in the book. Once all the work has been done, add any retouched files, album designs, slideshows, and web copies to the archive. Then include the documents, like the permission forms to use the images, contact information for the client and their families, etc.

It's not uncommon for a couple that didn't have the money for an album to come back a year or so later and ask about pricing; the same is true for the parents and a companion album for them. Many times a client scrimps on the photographic purchases to pay for extras on the wedding day.

Keep copies of the entire set in both master archives, whatever format your studio uses.

A Closing Note

Wedding photography is an assignment that photographers seem to either love or hate. It is one of the most demanding jobs, since the pictures have to be right the first time and the pressure is always on to be ready, shoot fast, and still come up with stunning images worthy of national publication.

On the plus side, we get a first-row seat at the party, and the challenges are part of the fun. It is also a line of work that is undergoing dramatic changes in both style and technology. It's imperative to keep both a professional and creative edge to continue to succeed. The true professional is not competing with another photographer or worried about the prices or tools someone else has chosen (except to study and learn from). The real competition is with the self, to avoid thinking that you have mastered the craft.

Years ago one of the world's most famous and revered photojournalists, W. Eugene Smith, said, "Never have I found the limits of the photographic potential. Every horizon, on being reached, reveals another beckoning in the distance." That is both the wonder and the challenge of the craft and art of photography, to always see the world through fresh eyes and be ready to capture the moment.

Good luck on the adventure that is professional wedding photography.

Figure 19.3 The most important tools of the wedding photographer are a sense of adventure, a fresh creative eye to see each subject as the picture it has the possibility to become, and the willingness to work to bring it forth. (Photo by Mark Ridout)

Index